for A. C.-B.

## ACKNOWLEDGEMENTS

*I would like to thank all the people whose help, advice, and encouragement contributed to make this book possible:*

*The artists, who provided continual assistance:*
*Barry Flanagan, Walter De Maria, Jan Dibbets, Christo and his wife Jeanne-Claude, Hans Haacke, Peter Hutchinson,*
*Robert Morris, Dennis Oppenheim, Charles Ross, and Alan Sonfist.*
*I am particularly indebted to Nancy Holt, for answering all my questions with patience and kindness, and to*
*Michael Heizer, who invited me to stay in his house in Nevada and whose friendly collaboration aided me greatly.*

*The people who allowed me to access their archives and documents:*
*In the United States:*
*Elizabeth Childress, Virginia Dwan, Carla Grosse (the Guggenheim Museum, New York), Jeff Levine*
*(the John Weber Gallery, New York), Jennifer Mackiewicz, Amy Plumb, Cornell University (Ithaca),*
*and the Paula Cooper Gallery (New York).*
*In England:*
*Sarah Tooley (Waddington Gallery, London) and Robert Violette (Anthony d'Offay Gallery, London)*
*for the Richard Long archives.*
*In France:*
*Michel Bourrel (Capc, Bordeaux), Annick Jean and Suzanne Bernard (Les Cahiers du Musée national d'art*
*moderne, Paris), Jean-Hubert Martin and Corinne Le Neun (Chateau d'Oiron), Catherine Schmitt*
*(Documentation du Musée national d'art moderne, Paris), and the Yvon Lambert Gallery (Paris).*

*Serge François and the Department of Foreign Affairs, for permitting me to travel throughout the United States.*

*Michèle Lévy-Bram for her help in revising much of the translation.*

*And, for various reasons, the following people:*
*Anne Cartier-Bresson, Gilles Courtois, Jean-Pierre Criqui, Denys Riot, and Daniel Soutif, who read parts*
*or all of this book, Xavier Barral, Anne Chevry, Catherine David, Sylviane de Decker, Patrick Faigenbaum,*
*Marick Gautier, Claude Gentiletti, Weston Naef, Vanessa Nahoum, Valérie Perthué, Jean-Marc Poinsot,*
*Marion Sauvaire, Tom Vinetz, Olivia Barbet-Massin for her invaluable work,*
*and finally Dominique Carré, dont la confiance et l'amitié ne m'ont jamais fait défaut.*

# Land Art

# Land Art

Gilles A. Tiberghien

ART
DATA

English translation : Caroline Green.
Editing : Allison Saltzman.
Design : Atalante / Paris.
Cartography : Philippe Mouche.

Original French edition
© 1993, éditions Carré, Paris.

First UK edition published in 1995 by
Art Data
12 Bell Industrial Estate
50 Cunnington Street
London W4 5HB

ISBN : 0 948835 17 6.
Printed in Italy.

# FOREWORD

Few works constituted the original framework of this book. Few works remain today as its memory. However, as impermanent as they were, as ephemeral as some of them still are, they are nonetheless an indispensable link to the understanding of the history of art of our time. Like all great stories, the basic plot can be summarized in a few words. At the time of the emergence of these artworks, modernism had alienated everything connected with the pictorial and sculptural arts.

At that time, art seemed to have reached its end, as if put to sleep, condemned to resign itself to its own essence. It was an unusual era, when the opinions of the critics were substituted for the practice of the artist, when the passion of life was such that there was no escape except through philosophy, preferably Old World philosophy. A few artists persevered, clinging to certain traditional standards—the line, the cross, the cube, and the spiral—attributing to them a universal value. As a result of their work, the gallery space exploded, as did the criteria of taste and aesthetic pleasure. One sought emotion in the meaning of the work of art, and often a basic knowledge of the work, through photography or even television, sufficed in that regard. The new expressive gestures were mechanical; Pollock's famous movements were relegated to the realm of the nonessential, and taking their place was the ballet of excavator arms and bulldozer scoops. During these years, feet and inches were replaced by measurements calculated in miles (sometimes as a distance traveled) and in tons of overturned earth. From these works emerged the feeling of a possible yet definitive separation from the art world. Unless, in turn, it makes the same journey, and follows in the footsteps of the artists, in what Smithson has called "the steps of the surveyor."

*Éditions Carré, Paris, 1993*

# INTRODUCTION

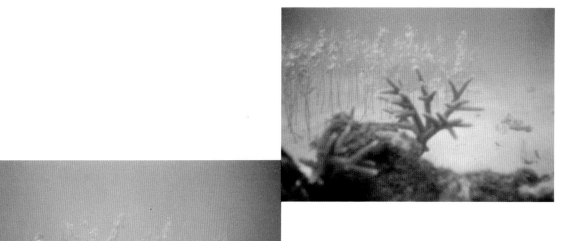

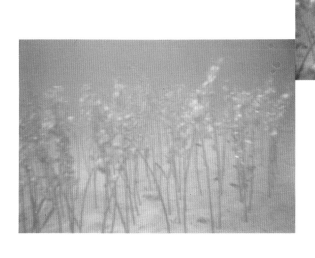

Peter Hutchinson, *Flowers Triangle*, Crown Point, Tobago, Antilles, 1969.
Triangle of yellow flowers planted in the sand in shallow water
(approximately three meters deep), 182.8 x 182.2 x 30.5 cm.
*Ocean Projects: Hutchinson and Oppenheim* exhibition, New York,
Museum of Modern Art, October 21–November 30, 1969. Collection
of Holly Solomon, New York. Photograph courtesy of Peter Hutchinson.

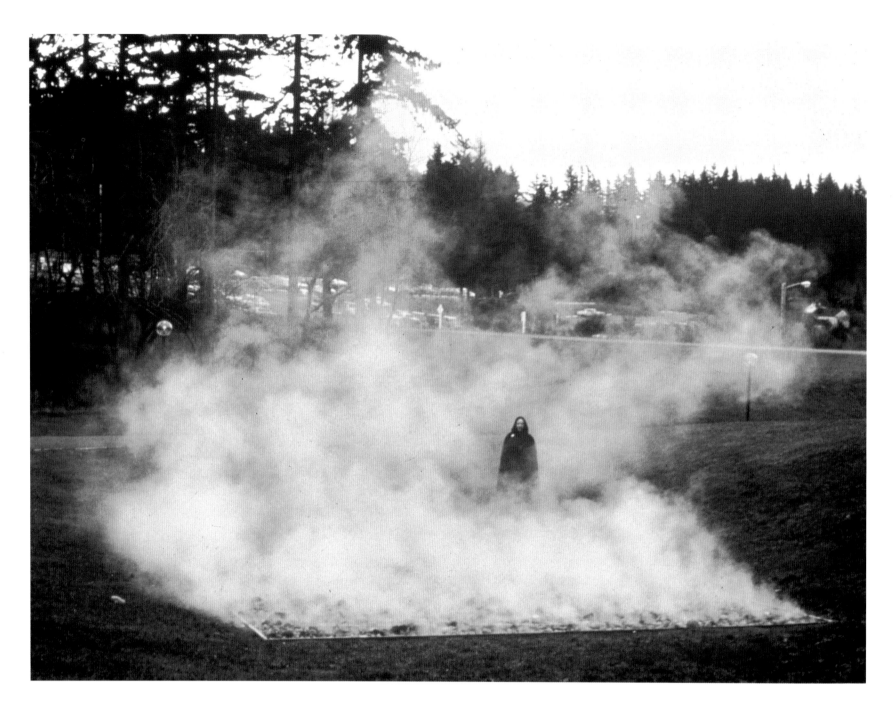

Robert Morris, *Steam*, 1974.
Second version: multiple vapor vents placed under a bed of rocks surrounded by wood of variable dimensions.
Collection of Western Washington University, Bellingham. Courtesy of the Guggenheim Museum, New York.

Common sense would seem to advise against writing a book on Land Art, not because the subject has been abundantly discussed, but rather because the term itself is extremely vague. None of the artists discussed in this book belonged to anything resembling a movement (or even an artistic tendency) with the name "Land Art," with a status in contemporary art history comparable to the status of Futurism, Surrealism, or Constructivism. Except for Walter De Maria, these artists do not use the term Land Art to describe their work, and because it is unclear what the term covers, the use of even more vague designations, constituting even more vast groups, has been preferred: for example, "process art," "environmental art," "ecological art," "total art," and so forth.

The word earthworks,[1] credited to Robert Smithson, has also been used to designate these artists' creations. In addition to its very specific origin, this term is too limited to be appropriate to works by Jan Dibbets, Richard Long, or James Turrell. Even Michael Heizer generally refuses to use it—preferring instead "sculptures"—and Robert Morris's work can not be categorized as earthwork either. However, as it is necessary to label the works presented here, "Land Art" seems to be the less problematic of the two terms.[2]

The fact that this term was chosen by De Maria is already a recommendation in itself, since he is undoubtedly the first artist since the beginning of the 1960s to have conceived, if not completed, relevant Land Art works. His projects in this medium seem to have been fairly numerous, if we believe Heizer, who met and befriended him in the middle of the 1960s.[3] As for Smithson, it was not until 1970 that he created his first real earthwork, *Partially Buried Woodshed*. His previous project, from 1966, *Tar Pool and Gravel Pit*, pairing a

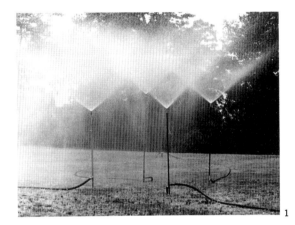

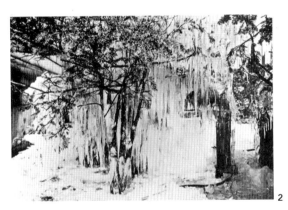

**1** Hans Haacke, *Fog, Water, Erosion*, Seattle, Washington, summer 1969.
Water and wind, irrigation system. Courtesy of Hans Haacke.

**2** Hans Haacke, *Fog Dripping From or Freezing on Exposed Surfaces*.
*Earth, Air, Fire, Water: Elements of Art* exhibition, Museum of Fine Arts, Boston, 1971.

minimalist aesthetic with references to early geologic ages, was never completed. However, the word *earthwork* was the title of an exhibition organized in 1968 at the Dwan Gallery in New York.

The term Land Art also has the advantage of being broad enough to include very diverse works. In a certain sense, *land* is more understandable than *earth*, even if, metonymically, the latter designates the entire planet (which, as will be seen, is important). In any case, it is clear that all the artists affiliated, to some extent, with Land Art prefer to utilize the element earth, even if some of them choose other media—air, water, or fire. Hans Haacke, in making reference to simple visual or sensory experiences, works more with water (*Fog, Swamping, Erosion*, 1969; *Rhine Water Purification Plant*, 1972), and with air (*Sky Line*, 1967) than with earth. At the *Earth Art* exhibition at the White Museum in Ithaca in 1969, Haacke showed *Spray of Ithaca: Falls Freezing and Melting on Rope*, a stretched cord transformed into a gigantic icicle of ice and snow. Later, in the *Earth, Air, Fire, Water* exhibition at the Museum of Fine Arts in Boston, he presented a similar work, *Fog Dripping From or Freezing on Exposed Surfaces*, which also used the principle of frozen drips of water, this time hanging from tree branches.

This exhibition in Boston is particularly interesting because it also included works by Long (three photos of work dating back to 1967), Dennis Oppenheim, Smithson and Heizer (for their work with earth), Charles Ross (for his utilization of fire—*Solar Burn, One Day, One Week, One Month*, 1971), and Christo and Jeanne-Claude (for air and land—the design for *5,600 Cubicmeter Package*, shown at Documenta IV at Kassel in 1968; photos of *Wrapped Coast* and sketches of a project, *Wrapped Walk Ways*, for the museum in Boston, finally

completed in 1977–1978 in Kansas City, Missouri). Among the other participants in the show were Dan Graham, Newton Harrison, Douglas Huebler, Peter Hutchinson (who in 1969 had been included with Oppenheim in *Ocean Projects: Hutchinson and Oppenheim* at the Museum of Modern Art in New York), Neil Jenney (also exhibited at the White Museum), Allan Kaprow, Alan Sonfist, and Andy Warhol.

During this period, many artists worked with natural materials, often fascinated by their evolution and their organic decomposition. To better observe this process, the artist became almost a laboratory assistant engaging in "artistic experiences." In 1969, for example, Peter Hutchinson[4] attached five gourds to a cord about 3.5 meters long, to the bottom of the sea. While floating, the gourds formed an arc that the artist photographed under water. At the end of the 1960s, this so-called "technological art" was popular with Hutchinson as well as Newton Harrison and Charles Ross. Simply because they worked in a natural environment, Harrison and Ross have been incorrectly associated with Land Art, which is distinguished by its lack of interest in (and even an extreme distrust of) technology.

Others, like James Pierce or Ian Hamilton Finlay, could be identified with the *earthworkers* as well. Finlay, born in 1925, did not belong to the same generation,[5] and Pierce was not active artistically until the 1970s, but their work has more similarities to landscape gardening than to the works by the Land Art "sculptors," who themselves are neither botanists, nor doctors, nor agricultural engineers, as the famous gardeners and topiary artists of past centuries had been. The Land Art artists' development is characterized by the search for new forms, new models, and new

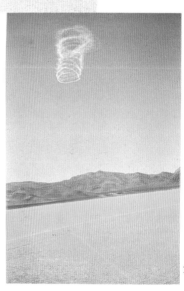

**1** Dennis Oppenheim, *Whirlpool Eye of Storm*, El Mirage Dry Lake, southern California, 1973.
Airplane, jet of smoke over 3/4 mile by 4 mile area. Duration: 1 hour. An airplane pilot, directed by radio from the ground, drew a tornado in the sky using a jet of smoke. Courtesy of Dennis Oppenheim.

**2** Hans Haacke, *Sky Line*, Central Park, New York, June 23, 1967. Courtesy of Hans Haacke.

concepts, even if they draw their references from megalithic art and pre-Columbian civilizations. Their sculpture goes beyond its "domain of competence," as Greenberg would say, to confront its own limits, to place itself at the confines of other arts—architecture, painting, photography, cinema. But the privileged medium remains earth.

The interest in the experience *in situ* is common to all the Land Art artists, although this alone is not enough to characterize them. The number of artists concerned with this issue is endless, and basically defines, at varying levels, contemporary sculpture in general. In Rosalind Krauss's text "Sculpture in the Expanded Field,"[6] the importance of the site is one of the specific elements of this expanded field of classification that supposedly characterizes "postmodern" sculpture.

The specific phenomenon of Land Art is the result of the intercrossing trajectories of a diverse group of artists who all belong to the same intellectual generation,[7] artists whose first exhibitions were held at the end of the 1960s. Land Art is not really a movement or a school in that there are neither leaders nor manifestoes. Yet this group of artists is not the result of chance; they all come from American minimalism (Morris) or show a similar or parallel evolution (De Maria, Heizer, Smithson). For still other artists, because of their interest in exhibitions outside the gallery setting and their work with earth and other natural elements, their inclusion within the group resulted from exhibitions such as the one held at the White Museum in 1969. Christo and Ross are not Land Art artists, but they contributed to its history nonetheless. The same is true for Flanagan and Haacke.[8]

Land Art is situated at a crucial moment in modern sculpture. The different sensibilities expressed within it work to give

these artists an identity, one that for many of them tends to evolve, but which nonetheless allows them to be associated with one of the most impressive artistic adventures of the second half of the century. If Walter De Maria, as the oldest, was the first to outline

the basic idea behind Land Art, Michael Heizer created its foundation. In 1968, he had already completed about twenty ephemeral pieces (trenches and drawings on the ground) in the deserts of the American West and, since *Double Negative* in 1969, he has continually constructed monumental works. Smithson was the most speculative of the group; his critical production during these years was considerable.[9]

In contrast, Oppenheim draws his works on the ground; he does not construct. His interest in the body, which appears to stem from his works in this period, leads him almost simultaneously towards Body Art. Long, who shows an almost religious respect for the earth, turns away from these artists at the beginning of the 1970s, and objects to any affiliation with Land Art, as does Hamish Fulton.[10] Similarly, Jan Dibbets does not participate, except for one film and one exhibition.

In their intersection, the paths of these artists form a common subset whose distinguishing parameters are the type of materials used, the work *in situ*, and the artistic history that they inherit (schools, collective expositions, artistic currents, and artists who influenced them).

The aim of this book is not to review the artistic practices that could be classified as Land Art. It is rather to define a moment of contemporary history that appears exemplary, in certain respects, in that it is situated at the turning point between modernism and that which contested it, battled it, indeed, and ultimately replaced it.[11] The number of imitators is significant—often mediocre but sometimes very talented, and by definition, never innovative. These people will not be discussed here, except to establish a brief relationship between them and a particular artist. The time frame in question spans from the end of the 1960s to the beginning of the 1970s. Any deviation from this is only justified if the works in question belong to artists active in this field since its conception.

Without making this into a history book, it is important to keep in mind the context in which Land Art was born. However, only the first chapter, "Minimalism and Beyond," has a specifically historic slant. The other chapters are constructed around themes that allow varying approaches to the same works of art. It is important to emphasize that these works lend themselves particularly well to this type of treatment. Speaking of the art of the 1960s, and of the Land Art artists in particular, Harold Rosenberg wrote in 1972: "Today, chance itself cannot prevail against the potency of aesthetic recollections. In

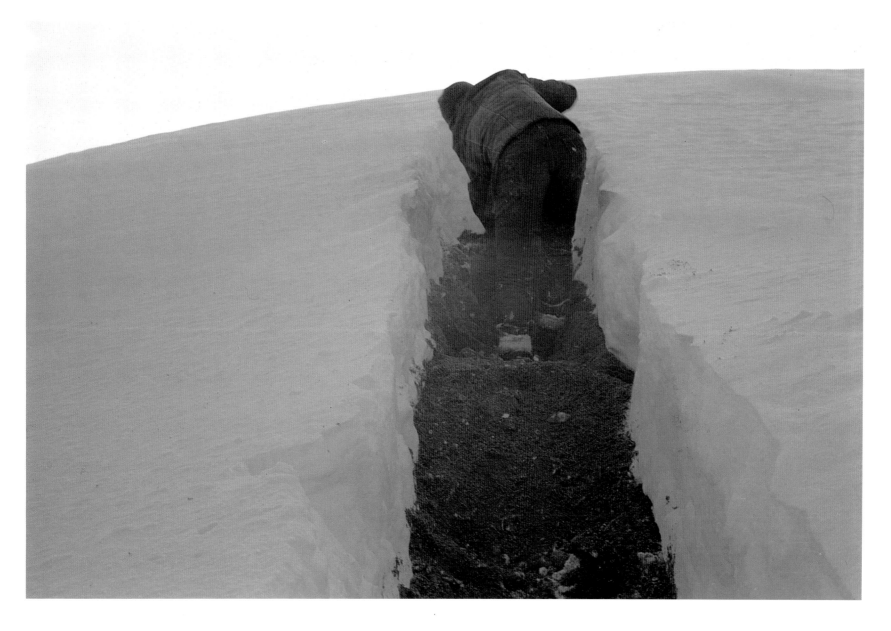

Dennis Oppenheim, *Negative Board*, St. Francis, Maine, 1968. Snow and ice, 3 x 4 x 100 feet. Courtesy of Dennis Oppenheim.

art, ideas are materialized, and materials are manipulated as if they were meanings. This is the intellectual advantage of art as against disembodied modes of thought, such as metaphysics."[12] This explains why Land Art has been classified within the general category of "conceptual art," which is justified in certain respects, if one considers that artists' and critics' texts are necessary for the comprehension of these works. The discourse of the spectator is relevant as well, and the spectator's experience—not just his vision but his presence—is required by the artist.

Access to these monumental sculptures becomes an issue, as they are often situated in deserts. Thus, knowledge of them is limited to commentary and photographic reproductions. Nothing prevents us from visiting these sites; on the contrary, everything invites us, initially even the artists themselves. What surprises us, and what contrasts with the media's portrayal of certain works—works that often are no longer visible, such as *Running Fence* and *Spiral Jetty*—is that they are quite demanding of the spectator. They do not give themselves over as they are; the viewer must struggle to see them, to the point of traveling numerous miles in the heat, desert, and dust before finally "discovering" them. Scholarly discourse ignores this type of imperative. It

claims that one object is as good as another, and the contemporary art public has gradually come to agree with this mistaken idea.

Art is certainly a way of thinking. From this point of view, the complex relationship that these works have with theory is especially striking in the case of extremely speculative artists, particularly Morris and Smithson. For them, as for others of the era, their texts are not simply commentaries or informative supplements; they are components of the work, inseparable from it. The modernist tendency by which each art tends towards what Greenberg calls its "area of competence" is not valid here. Thus, an obvious sign of the emergence of postmodernism is visible in the literary production of some artists who seem to award texts the same importance as objects.[13]

Artists' theories are like scientific theories, in that they are both rooted in the same process of imaginary elaboration. But artists' theories do not prove anything; at most, they produce real effects, which, in transforming the world, also have the function of helping us to know it, in a certain sense. That this is not their primary aim is irrelevant; knowledge is a compelling part of the pleasure that works of art give us— and even if this is more evident in contemporary art, it is also true of art in general. Due to their particular nature, these artists' theories are *fictions*.[14] When science originates these theories, as is the case, for example, with Smithson's speculations on entropy, they become a form of science-fiction. Science-fiction, like comic strips, played a large role in the art of the 1960s in the United States. The term *earthworks*, which originally comes from a military engineering register, is taken from a novel of the same name by Brian Aldiss, a book Smithson took with him on his trip to Passaic in 1966. The plot of the book unfolds in a world devastated by ecological

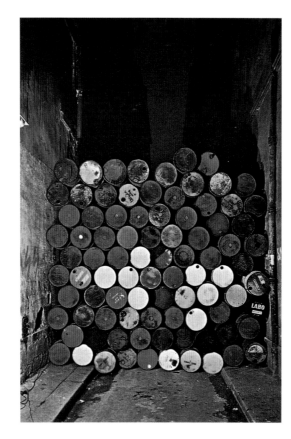

Christo and Jeanne-Claude, *Wall of Oil Barrels—Iron Curtain, Rue Visconti, Paris, 27 juin 1962.*
240 barrels of oil, 14 x 13 x 5-1/2 feet. Photograph by Jean-Dominique Lajoux. © Christo 1962.

catastrophe, characteristic of Smithson's world. Smithson was also fond of the novels of J.G. Ballard, in which he found a literary echo of his ideas about time and the phenomena of crystallization.[15]

The speculations put forth in the writings of Morris, Holt, or Ross, for example, can sometimes seem naive, with conclusions wholly incongruous and contrary to all truth. But to think of them as such would be to consider their texts as autonomous and independent from the works of art to which they are presented as counterpoints. They could be discussed as "authorized narratives," "performative or allegorical texts."[16] Beyond the question of what to call them— actually quite relevant on the level of theory—regardless of the models they borrow from, all these writings share a primarily functional value for their authors. And it is essentially this way that they must be considered—even if they hold literary interest in other respects. The art critics thus have at their disposal a textual medium to enrich their own writings at varying degrees; they choose their own levels of interpretation or appropriate the intentions claimed by the artists as needed. But as many of the artists are critics themselves, the professional critical texts undergo in turn a comparable fate in order to constitute a theoric *corpus*, on which the created works of art become more and more dependent. Nonetheless, this aspect, this conceptual component of Land Art requires a physical commitment from the artist, to obtain the photographic or cinematic documentation of ephemeral works or of monumental creations, which distinguishes Land Art from true conceptual art.

In the art of the 1960s, there is an attempt to redefine art through art, a desire to escape from the traditional classifications constructed by modernism. In a certain sense, these artists are reviving what

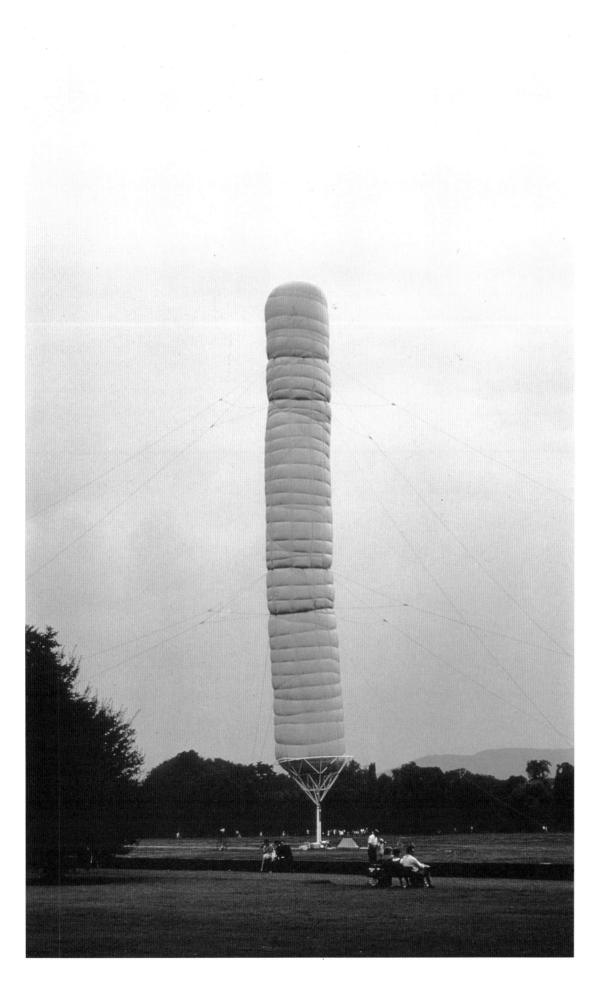

Christo and Jeanne-Claude, *5600 Cubicmeter Package,*
*Documenta IV, Kassel,* 1967–1968.
Height: 280 feet, diameter: 33 feet. Photograph by Klaus Baum.
© Christo 1968.

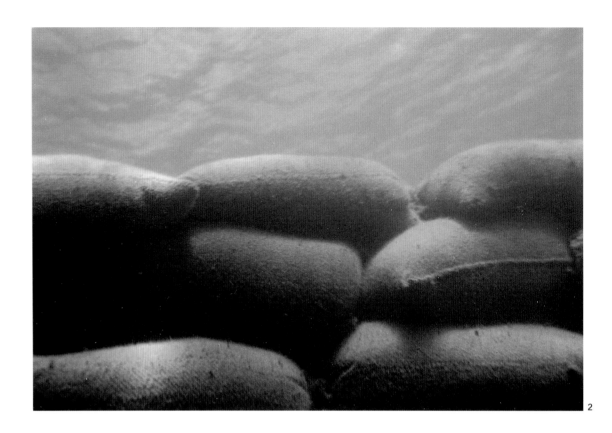

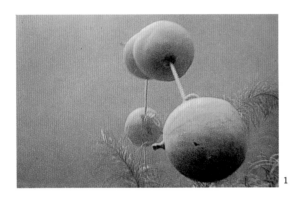

1 Peter Hutchinson, *Threaded Calabash*, Tobago, Antilles, August 1969.
Five gourds threaded on a rope attached to a coral reef nine meters deep. From the exhibition *Ocean Projects: Hutchinson and Oppenheim*, Museum of Modern Art, New York, October 21–November 30, 1969. Courtesy of Peter Hutchinson.

2 Peter Hutchinson, *Underwater Dam*, Tobago, Antilles, 1969.
Sacks of sand forming a dam in an underwater gorge three meters deep. From the exhibition *Ocean Projects: Hutchinson and Oppenheim*, Museum of Modern Art, New York, October 21–November 30, 1969. Courtesy of Peter Hutchinson.

the German Romantics attempted at Iena during the brief period in which the magazine *Athenaeum* was published (1797–1800): proposals, simultaneously theoretical and artistic, irreducible to a single *genre*, that invent the discourse itself within which they are formulated. This is what Smithson did; his texts still surprise us with their innovation, and because in discussing the works of his time—his own or others'—he uses categories, concepts, and images from extremely varied domains.[17] There is no previously existing theory that allows evaluation of these kinds of practices. Their diversity, and the paradoxes they conceal, often require that the critic or the historian himself create a polymorphic discourse, capable of constructing a theory about its subject.

Instead of the traditional question, "What is art?" assuming a certainty about art's nature, which has since been disputed, we ask "When is there art?" at the risk of the obvious response: "When there is a museum," since the museum is our art space *par excellence*.[18] In a modernist conception of history, largely dependent on Hegel, the museum appears as the moment of exaltation and culmination of art. The fact that the museum as an institution is almost contemporary with this vision of the end of art permitted the critics of the nineteenth and the beginning of the twentieth centuries to refer to an essence of art, as a standard against which works could be measured. In seeking to find new parameters that allow a definition of what art is, the Land Art artists have produced new objects. Their move away from museums and galleries is also a desire to reinvent art, in a certain sense. But moving away from these spaces is also *extending* them.[19] The artists thus vacillate between the traditional discourse on art, confirming its disappearance, and the conceptual and plastic elaboration of something which they continue to claim "in the name of art."

This situation is common to all the artists of the 1960s. What is particular in Land Art is the desire to get to the heart of

Peter Hutchinson, *Paricutin Volcano Project*, Paracutin, Mexico, January 1970.
300 kilos of bread and mold on the rim of a volcano. Courtesy of Peter Hutchinson.
"Photographs of mold formation created by placing plastic-wrapped wet bread on a crater edge and permitting it to await the reaction of the volcanic stones and heat of the sun and rocks." (*Earth, Air, Fire, Water: Elements of Art*, Museum of Fine Arts, Boston, 1971).

this paradox by finding a specificity of art through objects that are no longer specifically artistic.[20] In using earth as a medium, as a material, they have not attempted to make nature into a new museum, even if some—like De Maria with his *Earth Rooms*—have inverted the polarities in parody. Land Art is not primarily an art of landscape; it is but one factor, one component, essential for certain artists (Long), yet almost nonexistent for others (Heizer). The earth—dirt—on the other hand, with its power of provocation (evident simply from the troubling effect of its presence in the middle of a rectilinear room) its considerable and deeply archaic symbolic weight, is what gives Land Art acts their radicalism. The deserts and unpopulated spaces keep the cultural institutions which generate new art worlds at a distance. It is important to keep in mind that this distance is critical, not naive, as the ideological climate for a return to the land, prevalent at the end of the 1960s, might lead one to believe.

In the early years when the Land Art phenomenon is not yet rationalized, its history is formed around historical developments and events that reconstruct its lineage and reconfigure its image.[21] Art becomes a discourse on the lack of reality in art. Moreover, the more this reality seems questionable, the more monumental the works by certain Land Art artists become. Harold Rosenberg has analyzed all these paradoxes in a brilliant series of articles, later assembled in his book *The De-definition of Art.*[22] Nonetheless, to understand this phenomenon it is useful and even necessary to have recourse to certain concepts of art philosophy, as well as to the less official critical categories of the artists and critics of the period. Hegel allows comprehension of the monumental but not the ephemeral nature of certain works; through Aristotle, a certain order of time of artistic

1

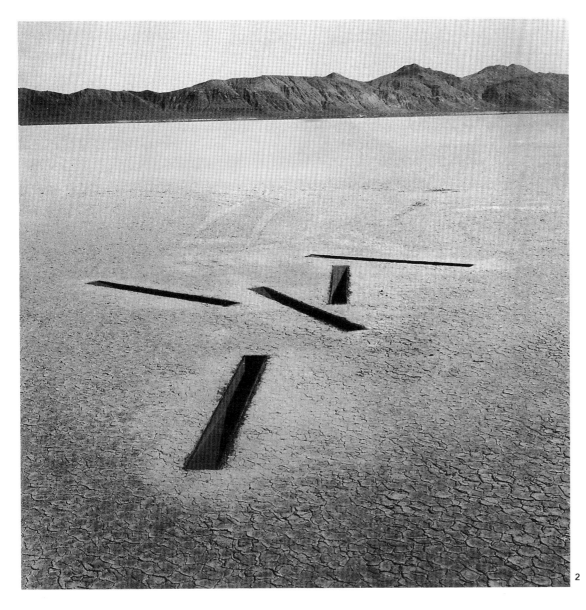

2

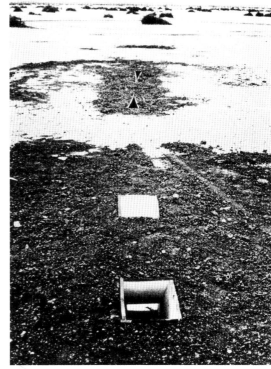

4

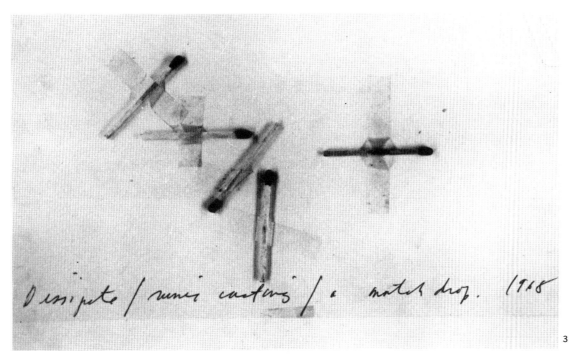

3

**1** Michael Heizer, *Windows* (left), 1968, *Matchdrop* (right), 1969.
Stadlische Kunsthalle, Düsseldorf.
Etched block of basalt in the sidewalk.
*Windows*: 1 x 3 x 1 inches; *Matchdrop*: 9 x 15 x 1/4 inches.
Photograph by Michael Heizer.

**2** Michael Heizer, *Dissipate* (*Nine Nevada Depressions 8*), Black
Rock Desert, Nevada, 1968.
Wood placed on the flat bottom of a dried-up lake, 45 x 50 x 1 feet.
Commissioned by Robert Scull. Photograph by Michael Heizer.

**3** Michael Heizer, *Matchdrop Dispersal*, 1968. Photograph by
Michael Heizer.
"The matchsticks were employed as a dispersing device. They were
dropped from two feet above a sheet of paper and taped down. The
photograph of this dispersal became the drawing for *Dissipate*.
(Matches are always applied to disintegrative tasks; the original
drop-drawing could catch fire at any time.)" (Michael Heizer, "The
Art of Michael Heizer," *Artforum* [December 1969].)

**4** Michael Heizer, *Windows*, 1968 (dismantled, foreground and
middle ground).
Wood placed on the flat bottom of a dried-up lake, 1 x 1 x 4 feet.
*Compression Line*, El Mirage Dry Lake, Mojave Desert, California,
1968 (dismantled, background).
Wood placed on the flat bottom of a dried-up lake, 16 x 2 x 2 feet.
Photograph by Michael Heizer.

production can be grasped, but the relationship of this temporality to artistic theory cannot be understood without rethinking the idea of fiction beyond any reference to simple *mimesis*.

This book is an endeavor, not a wholly-formed theory. It began because of my fascination with certain works of art. I had become interested in them through my association with landscapists, whose work presented certain affinities with this type of artistic process.[23] It was in trying to clarify this interest that I came to explain its origin and to understand the artworks that had created it—those works I have grouped under the name Land Art, based on the historical developments that I was able to construct[24] and that I have therefore attempted to describe here. But it is not a linear history; rather, it is a group of points of view from which, I hope, will emerge the object of this introduction. Throughout this project there was a permanent interchange between historical inquiry, direct relationship with the works, and the conceptual process. The large number of images should allow the reader to follow me in this undertaking, which I fear has too often become only a dry and schematic outline (for which the images should compensate).

I have undoubtedly favored certain artists, but only because I felt that the importance of their work justified this treatment. At the same time, I discussed only certain aspects of their work, those which specifically served my purpose. Obviously, I could not take their entire artistic production into consideration; I had to make choices between works that this book concerns. Visiting these works—as well as the meetings that I had with several of the artists—gave me the feeling that the disenchanted art world we find ourselves in is but one world among many,

**1** Dennis Oppenheim, *Parallel Stress*, May 1970.
A ten-minute performance on a concrete pier between the Brooklyn and Manhattan Bridges, Long Island, New York. Oppenheim's body was photographed at the most accentuated bending point; a position he repeated in a cavity in the ground at an abandoned dump on Long Island. Photographs by Robert K. McElroy. Courtesy of Dennis Oppenheim.

**2** Newton Harrison, *Air, Earth, Water Interface*, 1971.
Wood, earth, water, grass mixture, incandescent lamp, and artificial lighting, 10 x 95 x 190 inches. Courtesy of Newton Harrison.

**3** Walter De Maria, *Darmstadt Earth Room*, 1974, Hessisches Landesmuseum Darmstadt.
Height: 50 cm, area: 170 square m. Photograph by Timm Tautert. © Walter De Maria, 1974.

and these radical and even historic processes allow us to catch a glimpse of other possibilities. Within Land Art there is an undeniable nostalgia, similar to the romanticism about which I have spoken. Contributing to something new, making typically American art, as Michael Heizer is interested in, is still a nostalgic way of thinking about art. At the same time, as Harold Rosenberg says, "The reduction of the arts to their material components corresponds to an awareness of the decomposition of inherited art forms."[25] The deserts, the quarries, the abandoned mines, the distant plains, and the mountainous summits give us the sense of a world where art takes on a new meaning, where museums disappear, and humanity is eclipsed. But, like the end of history itself, this process is endless—museums will always exist, and the idea of humanity as the inheritor of the classical age will not soon disappear—such that if Land Art holds an exemplary status in the contemporary landscape, it is because it acutely evokes a world which is not reconciled with the one we live in, a world where other artistic realms always seem possible.

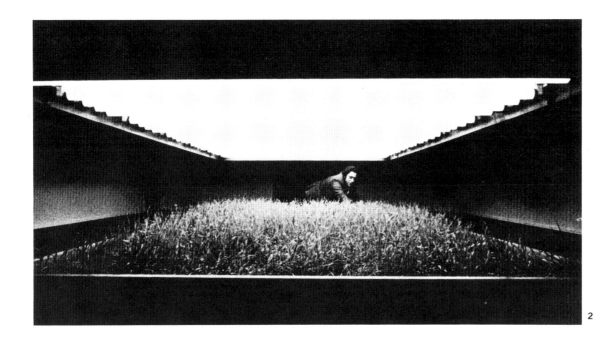

2

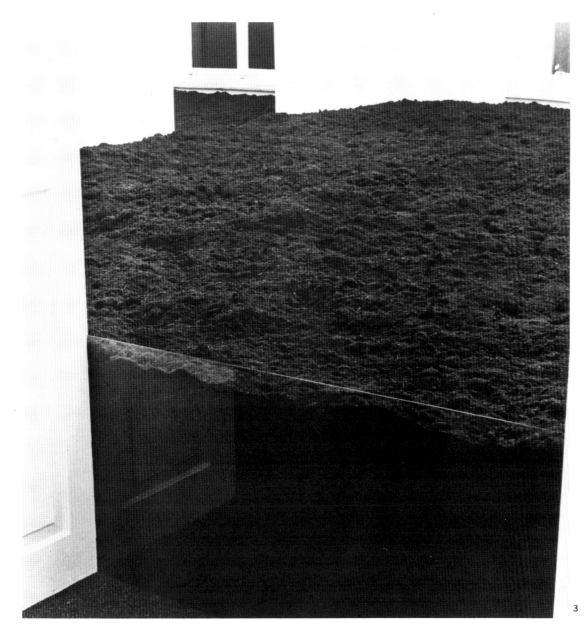

3

1. For example, see John Beardsley, *Earthworks and Beyond, Contemporary Art in the Landscape* (New York: Abbeville Press, 1984, second edition, 1989).

2. It is unclear why, if certain precautions are taken, this term is *"tristement lapidaire"* ("regrettably terse"), as Stephen Bann writes ("La sculpture anglaise et la tradition du paysage," *Artstudio* [fall 1988], p. 27).

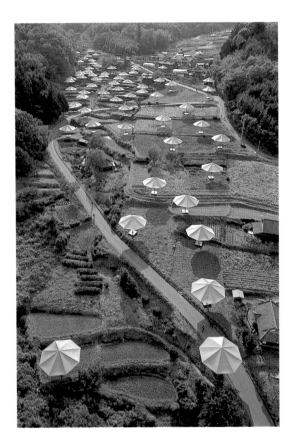

3. Heizer, who was twenty years old at the time, earned his living by repainting artists' studios, and thus met Walter De Maria.

4. Hutchinson had studied biology, specializing in the genetics of plants.

5. Finlay was only six years older than Morris, but he belonged within a completely different tradition; when Morris first received recognition for his minimalist works, Finlay had already reached artistic maturity.

6. Rosalind E. Krauss, "Sculpture in the Expanded Field," *The Originality of the Avant Garde and Other Modernist Myths* (Cambridge, MA: MIT Press, 1985), pp. 277–295. If, within this classification, only Robert Morris represents

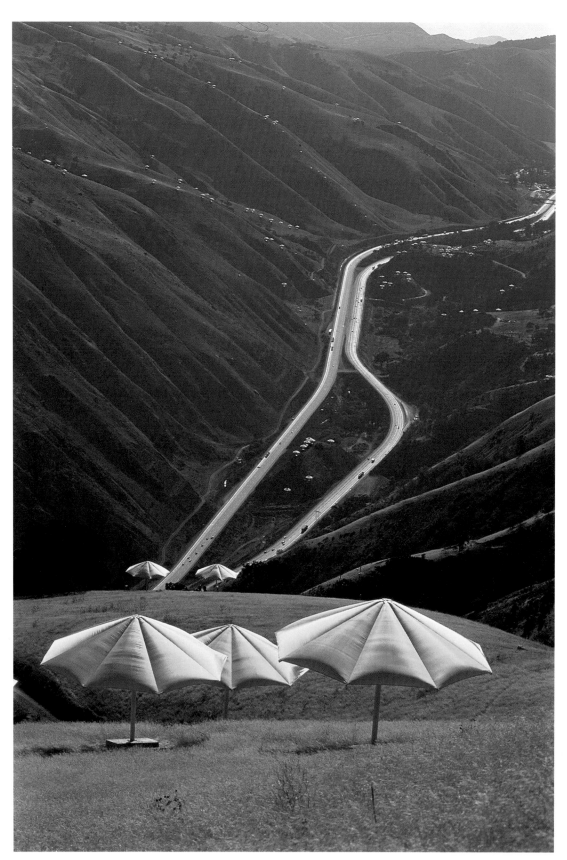

Christo and Jeanne-Claude, *The Umbrellas Japan-USA, 1984–1991.* Ibaraki, Japanese site. 3100 octagonal umbrellas, 19-1/2 feet high by 28-1/2 feet in diameter, were installed following a line 12 miles long in Japan (134 blue parasols) and 16 miles long in the United States (1760 yellow parasols). The installation lasted 19 days. Photo by Wolfgang Volz. © Christo, 1991.

the non-landscape/non-architecture relationship, Michael Heizer, Dennis Oppenheim, Walter De Maria, Richard Long, Hamish Fulton, Nancy Holt, and Christo, and several other artists (Richard Serra, Charles Simonds, Carl Andre, Alice Aycock, Georges Trakas, etc.) belong in one or many of the possible convergences of this combination. Thus, for example, Smithson appears in the "site construction" and "marked site" groups, as do Heizer and Morris, Morris being the only artist mentioned in the "sculpture" group.

7. That is, they had the same group of cultural and artistic references at their disposal, even if in terms of age the differences between them are fairly significant. De Maria was born in 1935, Smithson and Oppenheim were born in 1938, Heizer and Long (1944 and 1945) are the youngest, and Morris (1931) is the oldest.

8. Neither Flanagan nor Haacke belong within the complex of interrelations described here. However, it is important to mention them, since, although outside its confines, they contributed to the history of Land Art and to its *definition* (in the sense of clarity). By the nature of their work with earth, landscape, light, and sky, these artists shed their own light onto this moment of contemporary art, highlighting certain of its aspects. The case of Charles Ross is a bit more complicated, since, while he was in the group of artists at the Dwan Gallery, he was not in the *Earthworks* exhibition, and worked beyond the world of art galleries and museums to create *Star Axis* (a work which has an oblique yet significant relationship with Land Art and will be discussed in a following chapter).

9. See the explanation of Smithson's writings by the American critic Peter Shjeldahl (Peter Schjeldahl, "Robert Smithson Writings," *The Hydrogen Jukebox, Selected Writings of Peter Schjeldahl, 1978–1990*, Malin Wilson, ed., introduction by Robert Storr [Berkeley: University of California Press, 1991], pp. 135–140). According to Schjeldahl, *The Writings of Robert Smithson* "is the most significant book of American contemporary art writing in twenty years."

10. When Claude Gintz asked Richard Long what "Land Art" signified for him, Long replied, "For me, 'Land Art' is an American expression. It means bulldozers and big projects. It seems to be an American movement; it is construction on land that has been bought by artists, its aim is to create a large permanent monument. This does not interest me at all." (Richard Long, "Entretien avec Claude Gintz," *Art Press* [June 1986], p. 8.) Long told Ann Hindry that Smithson was an "Urban Cowboy." (Ann Hindry, "La légèreté de l'être selon Richard Long," *Artstudio* [fall 1988], p. 130.) Hamish Fulton, ironically discussing Heizer, Smithson, and De Maria, saw nothing in their art but the

extension of "the so-called 'heroic conquering' of nature." (Michael Auping, "An Interview with Hamish Fulton," *Common Ground: Five Artists in the Florida Landscape*, p. 87, as cited in John Beardsley, *Earthworks and Beyond, Contemporary Art in the Landscape*, op. cit., p. 44.)

11. Sidney Tillim, in "Earthworks and the New Picturesque" (*Artforum* [December 1968], p. 45), writes, "Earthworks, then, arrive at a moment when modernism is at the lowest ebb in its history, and is therefore implicated in, indeed signals, the weakness of modernism as a whole."

12. Harold Rosenberg, *The De-definition of Art* (New York: Horizon Press, 1972), p. 68.

Christo and Jeanne-Claude, *Running Fence, Project for Sonoma and Marin Counties, California*, 1975.
Collage, pastel, charcoal, pencil. Collection of Alvin Lane.
© Christo, 1975.

13. "What I am proposing, then, is that the eruption of language into the aesthetic field—an eruption signalled by, but by no means limited to, the writings of Smithson, Morris, Andre, Judd, Flavin, Rainer, LeWitt—is coincident with, if not the definitive index of, the emergence of postmodernism." (Craig Owens, "Earthwords," *October*, issue 10 [fall 1979], p. 126.)

14. "When the word 'fiction' is used, most of us think of literature, and practically never of fictions in a general sense. The rational notion of 'realism,' it seems, has prevented esthetics from coming to terms with the place of fiction in all the arts." (Robert Smithson, *The Writings of Robert Smithson*, Nancy Holt, ed., [New York: New York University Press, 1979], p. 71.)

15. Peter Hutchinson noted that science-fiction novels of the period were illustrated in an out-of-date, inappropriate fashion, and he adds, "The illustrators seem to have no link with the deeper ideas of the writers. This is reinforced by the fact that the writers have no idea about art. If they had, they would never put up with such illustrations. It would

make more sense to find contemporary art by Donald Judd, Larry Bell, Robert Smithson or Lila Katzen, for example, published in these magazines." (Peter Hutchinson, "Science Fiction: An Aesthetic for Science," *Art International* [October 1968], p. 32.) On Smithson and science-fiction, see Eugénie Tsaï, "The Sci-fi Connection: The IG, J.G. Ballard, and Robert Smithson," *Modern Dreams, The Rise and Fall and Rise of Pop* (New York: The Institute for Contemporary Art, and Cambridge, MA: MIT Press, 1988), pp. 71–74.

16. The choice of these terms was not unimportant. On the "*récits autorisés*," see Jean-Marc Poinsot, "Quand l'oeuvre a lieu," *Parachute*, no. 46 (March–May 1987). On the allegorical functions of artists' texts, see, for example, Craig Owens, "Earthwords," op. cit., pp. 43–57.

17. For an in-depth analysis of Smithson's writings, see Jessica Prinz, "Words *en Abîme*, Smithson's Labyrinth of Signs," *Art Discourse, Discourse in Art* (New Brunswick: Rutgers University Press, 1991), pp. 79–123.

18. Jean-Claude Lebensztejn, *Zigzag* (Paris: Flammarion, 1981), p. 20.

19. See Willoughby Sharp, "Discussions with Heizer, Oppenheim, Smithson," *Avalanche* (fall 1970); reprinted in *The Writings of Robert Smithson*, op. cit., pp. 171–178. This article has been reprinted in its entirety at the end of this book.

20. Which Judd, according to a viewpoint still dependent on exhibition spaces, formulates by saying that the specificity of his "specific objects" is precisely from their lack of specificity, their being neither painting nor sculpture.

21. For example, see Germano Celant, who, in the catalog essay of his *Conceptual Art, Arte Povera, Land Art* exhibition in Turin in 1970, attempts to integrate various recent categories within a larger group.

22. Harold Rosenberg, *The De-definition of Art*, op cit. See, in particular, the chapter titled "Art and Words," pp. 17–68.

23. See Michel Desvigne and Gilles A. Tiberghien, *Jardins élémentaires* (Rome: Villa Médicis/Carta segrete, 1988).

24. On this concept of historical development, see Paul Veyne, *Comment on écrit l'histoire, essai d'épistémologie* (Paris: Seuil, 1971), pp. 45–62.

25. Harold Rosenberg, *The De-definition of Art*, op. cit., p. 60.

# CHAPTER 1

# MINIMALISM AND BEYOND

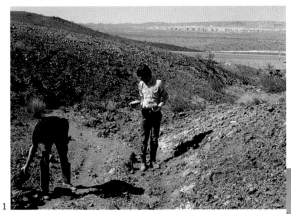

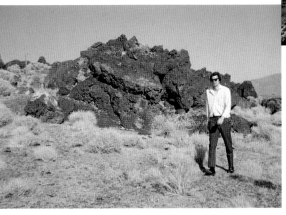

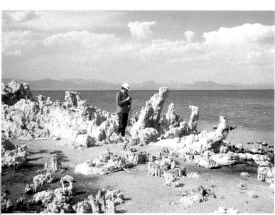

**1** Robert Smithson with Michael Heizer (at left), Lava Site, near Las Vegas, Nevada, 1968.
Courtesy of Nancy Holt.

**2** Robert Smithson, Lava Site, near Las Vegas, Nevada, 1968.
Courtesy of Nancy Holt.

**3** Robert Smithson, Mono Lake, Nevada, 1968.
Courtesy of Nancy Holt.

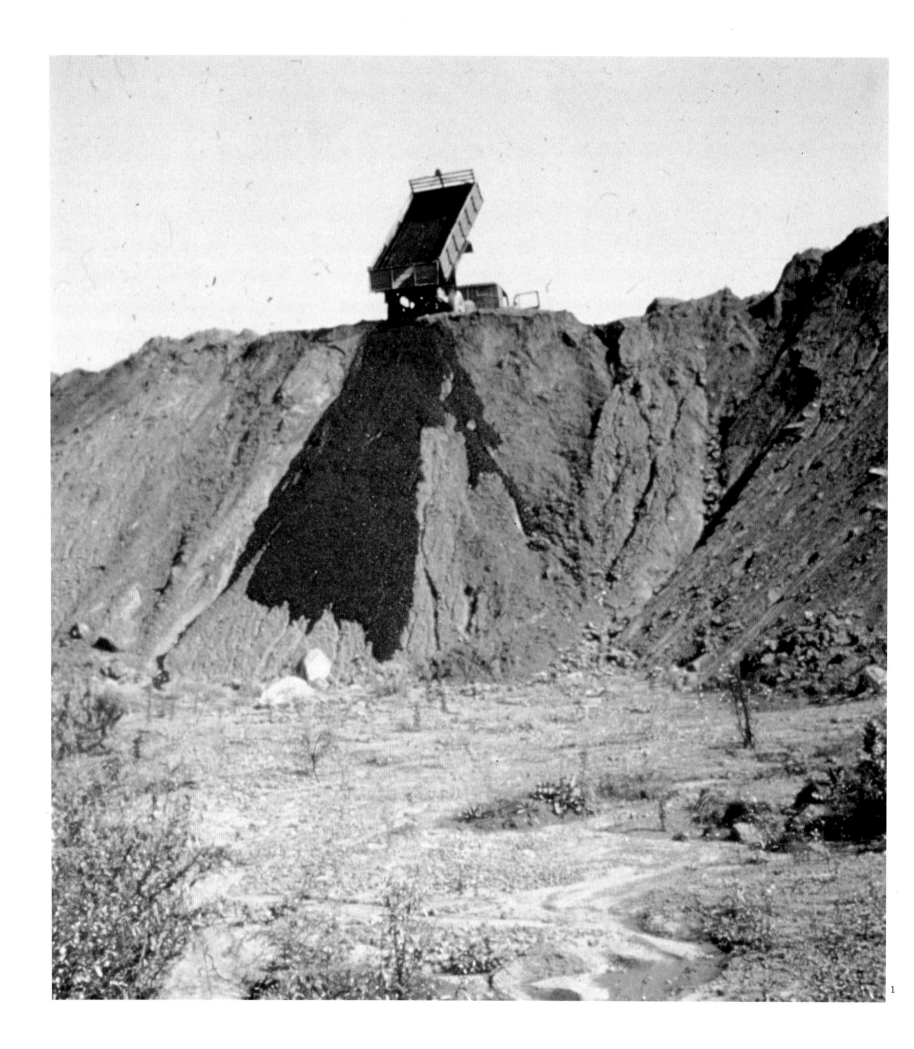

1

The origins of Land Art can be traced to distant eras of human history, to the spectacular remains left by ancient civilizations that have influenced contemporary artists. Nearer to our own time, however, the movement's ancestry can be found at the end of the 1950s and the beginning of the 1960s, when abstract expressionism ceased to dominate the artistic scene in the United States, and when the formal discourse of art criticism, represented by Clement Greenberg and his followers, became solidified. In 1961, Greenberg published *Art and Culture*, a collection of essays. Irving Sandler[1] emphasizes that "Greenberg did not intend for the thirty-seven essays in *Art and Culture* to provide only a record of his past opinions. Indeed, with an eye to the present and seemingly to the future, he freely revised his earlier writings, and reinforcing them with new essays…he honed his essays into a pointed polemic. The earlier, more open Greenberg was succeeded by a more dogmatic Greenberg, and it was this later, post-1960 Greenberg that would significantly influence the art criticism and even the art of the decade."

It is undeniable that Greenberg influenced the art itself; the young American artists who were trained in the early 1960s were often theorists as well, and their art became known because of their controversial theories. More than ever, the art world had become an ideological and theoretical battleground. Frank Stella, Jasper Johns, Ad Reinhardt, and Barnett Newman, to cite only a few, were no longer referring to individual passions, but to a more specific, group-generated idea about art. The words and writings of the artists, as well as those of the critics,[2] took on considerable importance.

Abstract expressionism, and the heroic myth that it conveyed, was no longer

**1** Robert Smithson, *Asphalt Rundown*, Rome, 1969. Photograph by Robert Smithson. Courtesy of the John Weber Gallery, New York.

**2** Robert Smithson, *Concrete Pour*, Chicago, November 1969. Courtesy of the John Weber Gallery, New York.
*Concrete Pour* was created for the Art Institute of Chicago, for the "Art by Telephone" show (whose title refers to the exhibition of paintings created by telephone that were imagined by Moholy-Nagy in 1922).
The instructions to complete the work were given by Robert Smithson to the museum via telephone; the artist did not even oversee the work's progress.

considered a model but nonetheless remained a reference point from which the artists strove to distinguish themselves—Robert Smithson's asphalt pours, for example. The importance accorded to an act, the idea that art was the expression of a creative individual, of unconscious forces, or of one's socio-political situation (in the manner of the surrealists or "committed" artists), or of one's existence (in the manner of the existentialists): this type of thought had long been prevalent. Greenberg, attracted in the late 1950s by painters such as Morris Louis or Kenneth Noland, was—with Harold Rosenberg—the first supporter of the abstract expressionists. However, he eventually came to reconsider his position. The following serves as explanation and clarification of Greenberg's shift in thought.

In the October 1962[3] edition of *Art International*, Greenberg identified "abstract expressionism" in the painterly sense, an artistic categorization borrowed from *Principles of Art History* by Heinrich Wölfflin. Thus, just as for Wölfflin the painterly style of the baroque period followed directly from classicism, for Greenberg, abstract expressionism supplanted the "quasi-geometric" style that had dominated abstract art in New York and in Paris after 1943. Abstract expressionism provided yet another example of the cyclical evolution characteristic of Western art since the sixteenth century.

Painters such as Clifford Still, Mark Rothko, and Barnett Newman, in turning away from abstract expressionism, succeeded in avoiding the opposed camps of "painterly" and "non-painterly" art. But in putting the emphasis solely on color, Still, like Rothko and Newman, took an initial interest in pictorial subjects, which Greenberg termed *tactility*. Regardless of the differences between these artists, one

notes a similar liberation of color in each of their work: color no longer has the function of merely filling an area, instead it has meaning essentially in and of itself. This autonomy is indicative of and inseparable from what Greenberg called an effect of "*openness*," evidenced, in particular, by enlarged canvas size and renunciation of virtuosity in execution. As Greenberg said, "size guarantees the purity as well as the intensity needed to suggest indeterminate space." And thus the famous "brush strokes," so prized a few years earlier, were no longer popular. At the time, Greenberg felt that *openness* "is the only way in high pictorial art in the near future."[4]

In "Modernist Painting," an article published in 1961, Greenberg gave a more explicit formulation for his theory of aesthetic modernism. Modernism, he wrote in this well-known text, is "the intensification, almost the exacerbation, of this self-critical tendency that began with the philosopher Kant. Because he was the first to criticize the means itself of criticism, I conceive of Kant as the first real Modernist. The essence of Modernism lies, as I see it, in the use of the characteristic methods of a discipline to criticize the discipline itself—not in order to subvert it, but to entrench it more firmly in its area of competence."[5]

Greenberg's theory was dominated by the idea of a teleology in which art history identifies itself with a process of purification, each art pared down to its essence, to the qualities unique to its medium. Through this process, each art form would become "pure" again and would find, in this "purity," its quality and its independence. For Greenberg, "purity" in art was synonymous with "self-definition," which was the objective of autocriticism.[6]

Painting, the art form on which Greenberg has written the most, aimed progressively toward the manifestation of that

**1** Ad Reinhardt, 1966.
Photograph by John Loengard, *Life Magazine.* © Time Warner Inc.

which was unique to its method of expression: its flatness. Accordingly, it abandoned all illusion of depth to promote a "pure visuality" that valued exclusively the optical quality of the work. In short, for both art and the way in which formal criticism envisages art, the content should dissolve completely into the form, leaving the visual or literary work irreducible to anything other than itself, so that meaning and medium become inseparable.[7]

It was this rigid partition between the arts, inherited from Gotthold Ephraim Lessing, in particular, this vision of an art copied from the model of organic evolution, that Robert Smithson critiqued. As he said to Allan Kaprow: "I find what's vain more acceptable than what's pure. It seems to me that any tendency towards purity also supposes that there's something to be achieved, and it means that art has some sort of point. I think I agree with Flaubert's idea that art is the pursuit of the useless, and the more vain things are, the better I like it, because I'm not burdened by purity."[8] His essay "Quasi-Infinities and the Waning of Space," which appeared in *Art Magazine* in November 1966, can be implicitly considered as an antimodernist manifesto. It unceasingly mixes spatial references and temporal parameters, conveying them through the layout of the article, which is cleverly composed in a checkerboard of illustrations and text.[9]

Ad Reinhardt also championed the idea that art had become the only subject of art. He was admired by Frank Stella, Donald Judd, Robert Smithson, and Michael Heizer, and certain painters referred to him as "Mr. Pure." "His dicta, as arcane as they may have sounded when first handed down from the scriptorium, have become nearly canonical for the young artists," wrote Barbara Rose.

The theoretical radicalism of Ad Reinhardt, as well as his corrosive humor, particularly attracted the attention of that generation. Smithson cited him in his texts on several occasions.[10]

Involvement with minimalism was of primary importance for the future Land Art artists. During that period, one also spoke of "systemic sculptures," "serial art," or "ABC art," all names rejected by the writers to whom they were attributed. "Minimalism" or "minimal art" (Richard Wollheim), was the name that ultimately prevailed. There were a number of shows from the early 1960s through 1966 that significantly marked the history of minimalism. The first minimalist exhibitions by Donald Judd and Robert Morris took place in New York at the Green Gallery, which closed in 1965. In 1963, Judd showed there, first with Dan Flavin and others, and again in December of the same year. The following year, Morris had a solo exhibition. Carl Andre, who had taken a job as a brake worker on the railroad in Pennsylvania, and who ceased making art from 1960 to 1964, participated in the collective show

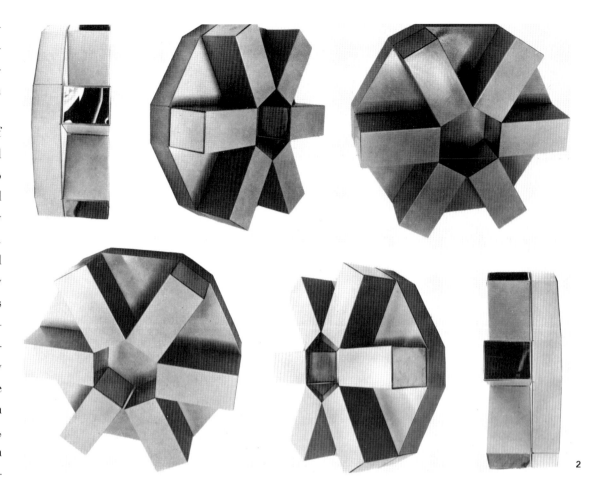

**2**

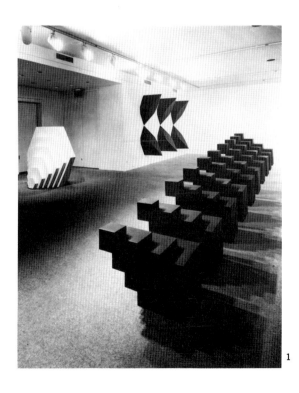

**1**

*Eight Young Artists* at the Hudson River Museum in 1964, at the request of E.G. Goossen. In 1965 he participated in *Shape and Structure* in New York, with Robert Morris, Donald Judd, Larry Bell, and Larry Zox. In 1966, at the exhibition *Primary Structures* at the Jewish Museum in New York, the above artists were joined by Walter De Maria and Robert Smithson. Smithson showed a piece called *The Cryosphere*, composed of six hexagonal modules, with each flattened point of the hexagon joined to the center (also hexagonal) by square pipes.[11] This exposition, devoted to minimalism in a certain sense, brought together three of the most important future participants of the Land Art movement.

Before creating these strange, deceptive, minimalist volumes, Smithson had shown "assemblages" at the Richard Castellane Gallery in New York, from

**1** Robert Smithson, installation, Dwan Gallery, New York, December 1966–January 1967.
From left to right: *Terminal, Doubles, Plunge*. Courtesy of Virginia Dwan.

**2** Robert Smithson, *The Cryosphere*, 1966.
Steel with pieces of chrome, six pieces, each 17 x 17 x 6 inches. Courtesy of the John Weber Gallery, New York.

March through April 1962.[12] At the time of his exhibition in 1965 at the John Daniels Gallery—recently opened by Dan Graham —he met Sol LeWitt and Dan Flavin, who introduced him to Donald Judd, for whom he then wrote a text for the Philadelphia Institute of Contemporary Art's *Seven Sculptors* exhibition catalog. In 1966, he showed his work (*Alogon #1*) for the first time at the Dwan Gallery in the collective show *Ten*, in which Flavin, Judd, Morris, and LeWitt, among others, participated.[13] At that time, New York was a vibrant intellectual and artistic center, but the scene was limited to a few dozen people exchanging their latest ideas. Some of the artists from the Park Place Gallery and the artists who used to show at the Green Gallery met regularly at Max's Kansas City, the "in" spot where the world of art mixed with the world of fashion.[14] A social and ideological milieu formed and gave birth to what would later be called Land Art.

The minimalists themselves had strong influences, of which three were essential: the constructivists,[15] Brancusi, and Tony Smith. From the first group, the artists cultivated a desire for anti-illusionism, evident in their sculpture and in the importance of the physical properties of the materials they employed. Even if Carl Andre criticized Rodchenko for stabilizing his sculptures with hidden fixtures instead of creating works that could support their own mass and weight, in 1970 he nonetheless declared that his work belonged within the tradition of the revolutionary Russian artists Tatlin and Rodchenko.[16] Flavin also recognized his debt to constructivism, the series of works dedicated to Tatlin being undeniable proof. He even claimed to be the successor of the Russian avant-garde. Judd, who had seen the works of Antoine Pvesner, said he admired them but

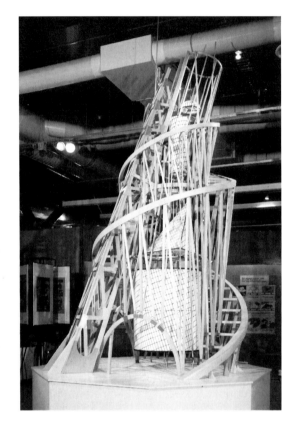

Tatlin, *Monument to the IIIrd International*, 1919–1920. Photograph of model from the Musée nationale d'Art moderne, Centre Georges-Pompidou, Paris.

affirmed, as did Morris, that he was not influenced by them. However, Morris did value the manner in which Tatlin used his materials, as well as Lissitsky's "treatment of sculpture as environment."[17]

Brancusi was a considerably greater influence. The modular character of his sculpture impressed the minimalists more than the beauty of the materials he used or the finely crafted aspect of his works.[18] Carl Andre, who called himself a disciple of Brancusi,[19] declared in 1970: "All I am doing is putting Brancusi's *Endless Column* on the ground instead of in the sky," and Dan Flavin saw in the same *Column* "some imposing archaic mythologic totem risen directly skyward." Richard Serra, discussing Brancusi's oeuvre, noted that the act of measuring the finite space from floor to ceiling anticipated similar ideas used later by Judd and Andre. "The idea of the infinite implied by the module extension was most impressive in Brancusi. It changed the sensibility of the entire Sixties..."[20] Richard Morris was particularly sensitive to the work of the Roman sculptor; he had written his thesis on "Form-Classes in the Work of Constantin Brancusi" under the direction of E.C. Goossen and William Rubin.

Tony Smith, who is often categorized with the minimalists and who did participate in the exhibition *Primary Structures* at the Jewish Museum, instead represented a model for the minimalists, as well as a moral authority.[21] Smith was initially an architect, and his relationship to sculpture was always defined by this beginning. For this reason, Michael Heizer later took an interest in him. However, Smith's work was harshly evaluated by the the critic Michael Fried, and he then found himself in the center of a controversy that went far beyond him, but that, *a posteriori*, seems to have been a crucial link between minimalism and

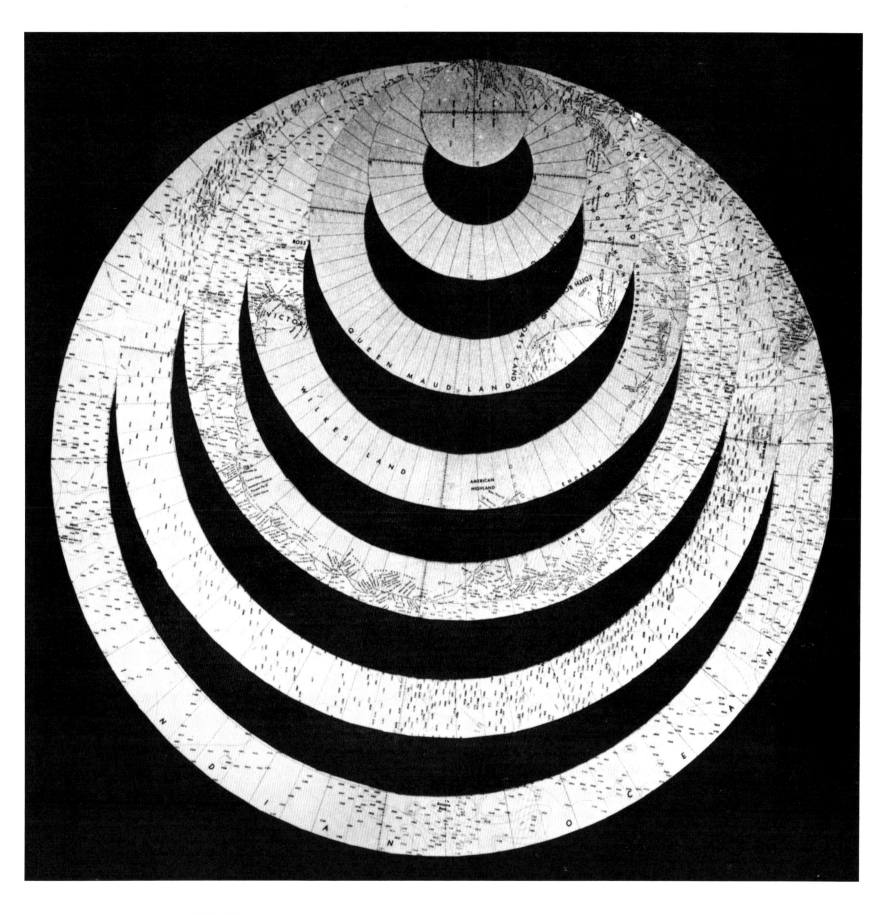

Robert Smithson, *Untitled Circular Map*, c. 1968–1970.
Cut paper, 21 inches in diameter. Courtesy of the John Weber Gallery, New York.

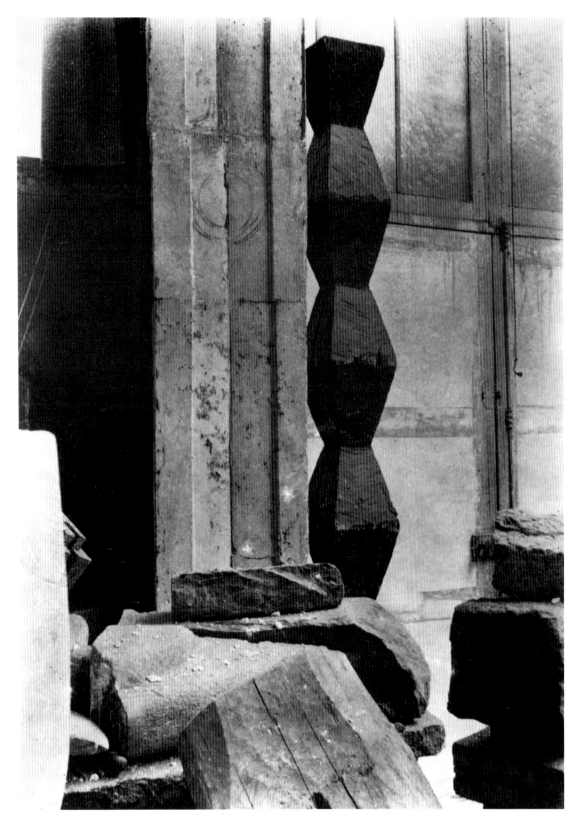

Brancusi, *Endless Column*, 1920.
Photograph from the Musée nationale d'Art moderne, Centre Georges-Pompidou, Paris.

Land Art. In a well-known passage from an interview with Samuel Wagstaff, published in *Artforum* in December 1966, Smith spoke of a drive he took on a New Jersey highway during the 1950s: "It was a dark night and there were no lights, or shoulder markers, lines, railings, or anything at all except the dark pavement moving through the landscape of the flats, rimmed by hills in the distance, but punctuated by stacks, towers, fumes, and colored lights. This drive was a revealing experience. The road and much of the landscape was artificial, and yet it couldn't be called a work of art. On the other hand, it did something for me that art had never done. At first, I didn't know what it was, but its effect was to liberate me from many of the views I had had about art. It seemed that there had been a reality there that had not had any expression in art. The experience on the road was something mapped out but not socially recognized. I thought to myself, it ought to be clear that's the end of art."[22]

It was the story of this trip that Fried denounced in his ensuing article, "Art and Objecthood," after having reproached the minimalists—of which Smith suddenly and strangely became the prime example—for the "theatrical" character of their work. Before attacking Smith himself, he dismissed the texts of Judd and Morris, commenting on them without distinguishing between the two, as if they spoke with a single voice. It is through this commentary that one can understand Fried's idea of theatricality and how he used it to denounce minimalism. The experience of minimal art, said Morris (as quoted by Fried), is "of an object *in a situation*—one that, virtually by definition, *includes the beholder*." This object—qualified by the word "new" to avoid the too-traditional term of sculpture—is of one large block, prohibiting the ability to discern its parts and obliging the spectator to

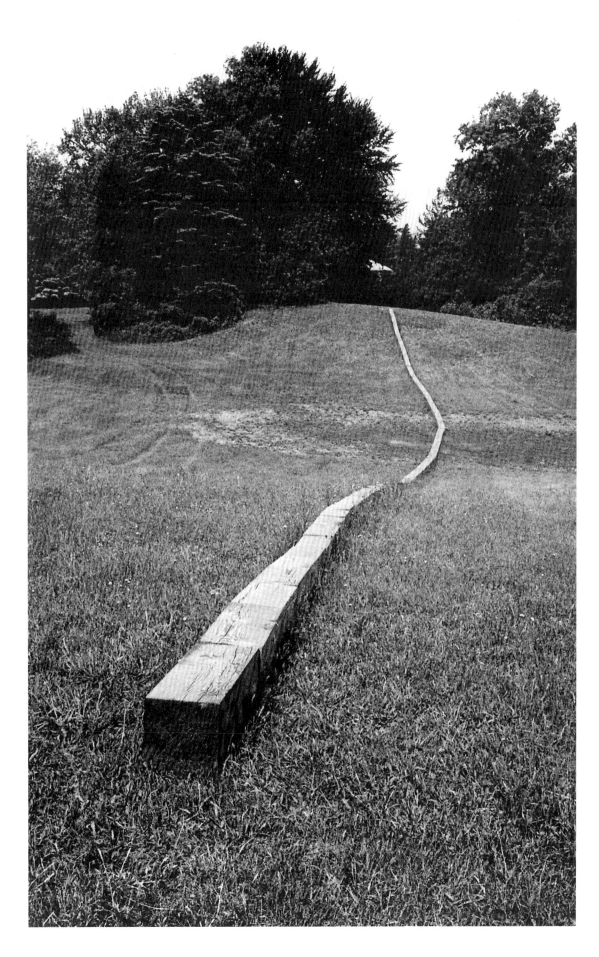

Carl Andre, *Secant*, Roslyn, New York, 1977.
One hundred sections of Douglas pine wooden beams, each measuring 12 x 12 x 36 inches; the whole work measuring 12 inches x 12 inches x 300 feet. Photograph by Gianfranco Gorgoni. Courtesy of the Paula Cooper Gallery, New York.

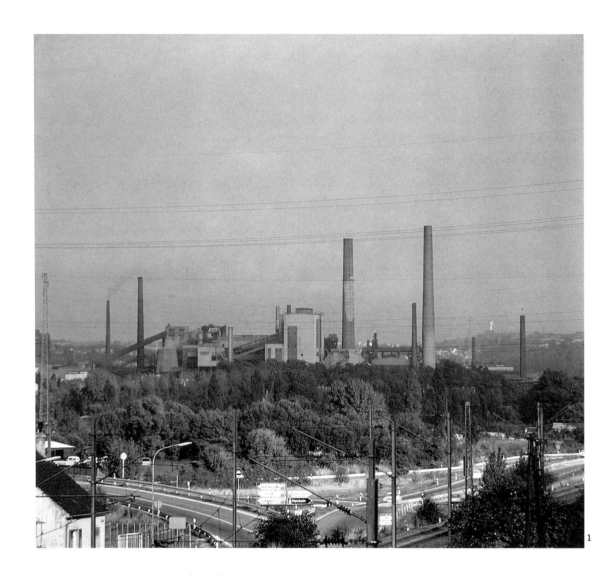

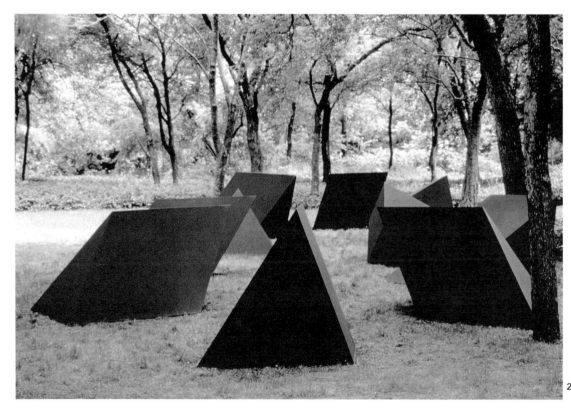

**1** Industrial landscape, east coast of the United States.
Photograph by D. Schwille, Magnum, Paris.

**2** Tony Smith, *Ten Elements*, 1975–1979.
Aluminum and paint, height of each piece approximately 4 feet.
Nasher Collection. Courtesy of the Paula Cooper Gallery, New York.
© D.M.A. 1988.

examine it from a distance. It is a physical as well as a psychological distance, and, Fried added, "It is, one might say, precisely this distance that *makes* the beholder a subject and the piece in question…an object."[23] In essence, what gives minimal art its theatricality is the situation it depends upon to create a "presence"[24] that Fried qualified as scenic. Thus these objects are presented as characters in a performance. Observing them, one has the sensation of being invaded by a silent presence.

According to Fried, three factors justify the similarities between minimalist art and theatricality. First, most minimalist works are at the same scale as the human body. Second, the experience of perceiving the works, first in their entirety and only afterwards in detail, corresponds to the way in which humans interact with each other. Third, and last, the works seem to possess an inner spirit, which stems from and reinforces the anthropomorphic correspondences. Fried, in naming theater "the interspecificity of what falls between painting and sculpture," was, in fact, defining an art that was neither painting nor sculpture, thus making reference to Greenberg's modernist theory that each art aims toward its own specific domain of competence.[25]

More than in the work of Robert Morris or Donald Judd, it is in Tony Smith's art that Fried finds this theatricality, particularly in the analysis of Smith's interview with Wagstaff. For Fried, if the places seen by Smith on that night were not works of art, it is because they corresponded simply to "empty *situations*," abandoned situations: situations without an object. One could term this absence of object a continual absence, much as Descartes discusses continual creation to explain that time, sustained by God, persists in its existence instant after instant. The object, the road, the countryside, the

expanse are continually *replaced*. These are not the objects that figure in Smith's nocturnal vision, but rather it is the fact of there being an object, an object possessing that generic quality of objecthood that characterizes all objects, whatever they are. Theatricality is the *mise en scene* of this permanent flight of the object.

In this text, Fried goes on to assert that for the minimalists, things *are*, they evoke nothing but the specificity of their material and the unique nature of their form. In a sense, they present no interest other than the structural repetition of identical elements. If "Smith's cube" (probably *Die*, 1962) is inexhaustible, this is, "however, not because of any fullness—*that* is the inexhaustibility of art—but because there is nothing there to exhaust."[26]

Fried's analysis is most similar to Greenberg's in his declaration that a modernist work of art should avoid being dependent on forms of experience that are not strictly circumscribed by the nature of the medium. As much as he is able,

Greenberg brings modern sculpture itself back to pictoriality, but to Smith, however, this "seemed a scope too limited to be able to produce experiences similar to those he had on the highway."[27]

Robert Smithson responded to Fried's article soon after its publication, in a "Letter to the Editor" in *Artforum*'s October 1966 issue.[28] The tone was scathingly ironic: Fried, "in a manner worthy of the most fanatical puritan," Smithson reckoned, "provides the art world with a long-overdue spectacle—a kind of ready-made parody of the war between Renaissance classicism (modernity) versus Manneristic anti-classicism (theater)." Although Fried was correct in discussing the "theatrical" quality of minimalism, he did not attempt to understand what sort of logic had driven the artists of the 1960s to arrive at that point. In retrospect, it is strange to think that at that time, minimalism was seen as art's enemy *par excellence*, just as it remains equally strange that Tony Smith became its scapegoat.

---

LETTER TO THE EDITOR OF ARTFORUM

Sirs:

France has given us the anti-novel, now Michael Fried has given us the anti-theater. A production could be developed on a monstrous scale with the Seven Deadly Isms, verbose diatribes, scandalous refutations, a vindication of Stanley Cavell, shrill but brilliant disputes on "shapehood" vs. "objecthood," dark curses, infamous claims, etc. The stage should subdivide into millions of stages....Fried, the orthodox modernist, the keeper of the gospel of Clement Greenberg, has been "struck by Tony Smith," the agent of endlessness. Fried has declared his sacred duty to modernism and will now make combat with what Jorge Luis Borges calls "the numerous Hydra (the swamp monster which amounts to a prefiguration or emblem of geometric progressions)...", in other words "Judd's Specific Objects, and Morris's gestalts or unitary forms, Smith's cube..." This atemporal world threatens Fried's present state of temporal grace—his "presentness." The terrors of infinity are taking over the mind of Michael Fried. Corrupt appearances of endlessness worse than any known Evil. A radical skepticism, known only to the dreadful "literalists" is making inroads into intimate "shapehood." Non-durational labyrinths of time are infecting his brain with eternity. Fried, the Marxist saint, shall not be tempted into this awful sensibility...

Robert Smithson, "Letter to the Editor," excerpt, *Artforum* (October 1967), reprinted in *The Writings of Robert Smithson*, p. 38.

The story of Smith's highway journey, though it contains other motifs, can be seen as an emblematic and intrinsic experience of the Beat Generation, similar to *On the Road* by Jack Kerouac. *On the Road*[29] was the most accomplished literary expression of this genre, a direct descendent of Breton's *"lâchez tout"* idea during the Dada era. The artists of the 1960s—who later became the principal protagonists of Land Art—explored natural sites, not so much to enjoy the beauty of the countryside but rather to better test the limits of art.

The expeditions of Michael Heizer, Walter De Maria, Richard Serra, Robert Morris, Carl Andre, Nancy Holt, and Robert Smithson in the deserts of the American West in some way prolonged Smith's experience, echoing his feeling of being confronted by a reality "that art had never experienced." But one thinks primarily of Smithson—his valuing of "post-industrial" sites and entropic landscapes, and his work as artistic consultant alongside a panel of architects in charge of planning the site of a future regional airport in Dallas[30]—when one reads this passage from the interview with Smith: "Later I discovered some abandoned airstrips in Europe—abandoned works, Surrealist landscapes, something that had nothing to do with any function, created worlds without tradition. Artificial landscape without cultural precedent began to dawn on me."[31]

In October 1968, the Dwan Gallery in New York (the Dwan Gallery in Los Angeles had closed in June 1967 after a Martial Raysse retrospective) organized an exhibition called *Earthworks*, representing Carl Andre, Herbert Bayer, Walter De Maria, Michael Heizer, Robert Morris, Dennis Oppenheim, Sol LeWitt, Robert Smithson, and Stephen Kaltenbach. In 1967, behind the Metropolitan Museum in

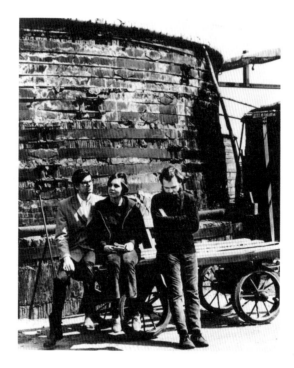

Robert Smithson, Nancy Holt, and Carl Andre, New Jersey, April 1967.
Photograph by Virginia Dwan.

Central Park, Claes Oldenburg had dug a hole and then filled it in again, giving it the status of invisible art and baptizing it *Placid Civic Monument*; this was also part of the exhibition. Smithson had written his most recent article about Central Park, calling its creator, Frederick Law Olmsted, a quasi-ancestor of the Land Art artists. Virginia Dwan later remembered, "The *Earthworks* show was one of the most important things in my art career...to me earthwork and minimal art were the high points of my gallery."[32] Four months after the opening of *Earthworks*, in February 1969, an exhibition entitled *Earth Art* was held at the White Museum at Cornell University. Although De Maria and Heizer did not participate, Oppenheim, Smithson, and Morris did, as did Richard Long from England, Jan Dibbets from the Netherlands, and Gunther Uecker from Germany. Works by David Medalla, Neil Jelley, and Hans Haacke (whose interventions in natural environments extended back to the beginning of the 1960s) were also shown. A panel discussion, in which some of the artists took part, had been organized for the occasion.[33] In the exhibition catalog, Thomas W. Leavitt,[34] the director of the museum at the time, wrote that one could not speak of an earth art movement as such, since the assumptions of the people involved were quite different, even if the materials they were using were the same. It was nonetheless already necessary to consider that this art "contained profound implications for the future of art and of art museums." The works were presented as complete opposites to the minimalist aesthetic, due precisely to the choice of materials, even though, according to Willoughby Sharp, "a common denominator of these works is their focus on physical properties—density, opacity, rigidity—rather than on geometric properties."[35]

Robert Smithson, c.1967.
Courtesy of Virginia Dwan.

Views of the *Earthworks* exhibition, Dwan Gallery, New York, October 5–30, 1968. Courtesy of Virginia Dwan.

**1** Robert Morris, *Earthwork*, 1968.
Carl Andre, three photographic enlargements of two works executed in Aspen, Colorado, summer 1968.
Robert Smithson, *A Nonsite, Franklin, New Jersey*, 1968.
Claes Oldenburg, *earthwork* project.
Stephen Kaltenbach, *Blueprint Project*, 1967.

**2** Robert Smithson, *A Nonsite, Franklin, New Jersey*, 1968.
Dennis Oppenheim, model, 1968.
Michael Heizer, photographic abstraction of *Dissipate 2*, 1968.
Robert Morris, *Earthwork*, 1968.

**3** Robert Smithson, *A Nonsite, Franklin, New Jersey*, 1968.
Robert Morris, *Earthwork*, 1968.
Walter De Maria, painting, 1968.
Carl Andre, three photographic enlargements of two works executed in Aspen, Colorado, summer 1968.

**4** Dennis Oppenheim, model, 1968.
3 x 6 x 1 feet (1 foot represents 1 mile).
"This is a reconstruction of the Cotopaxi Volcano in Ecuador, to be realized in Smith Center, Kansas, which is the geographical center of the United States. The model is executed in Cocoa Mat to simulate a Kansas wheat field. This mat is incised with irregular graduating concentric circles from the top to the bottom of the volcano."
*Earthworks* (Dwan Gallery: New York, 1968).

**5** Carl Andre, *Rock Pile*, Aspen, Colorado, 1968.

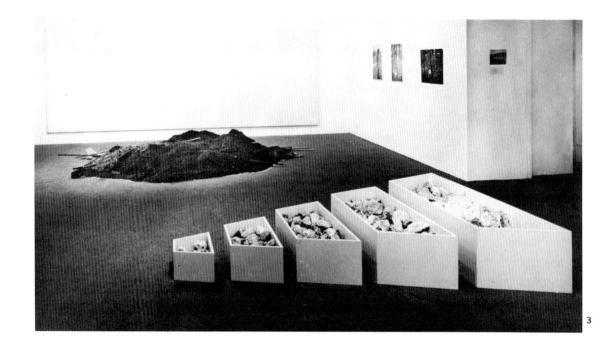

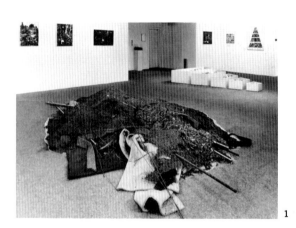

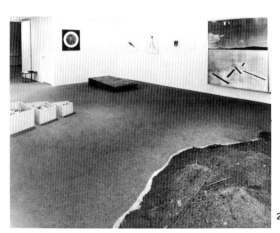

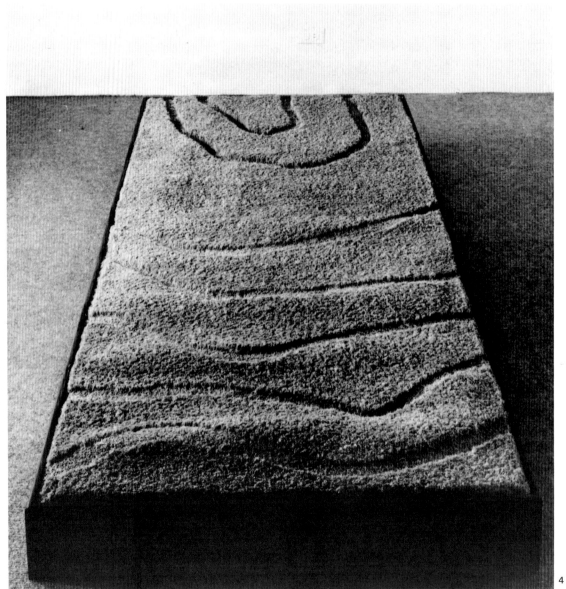

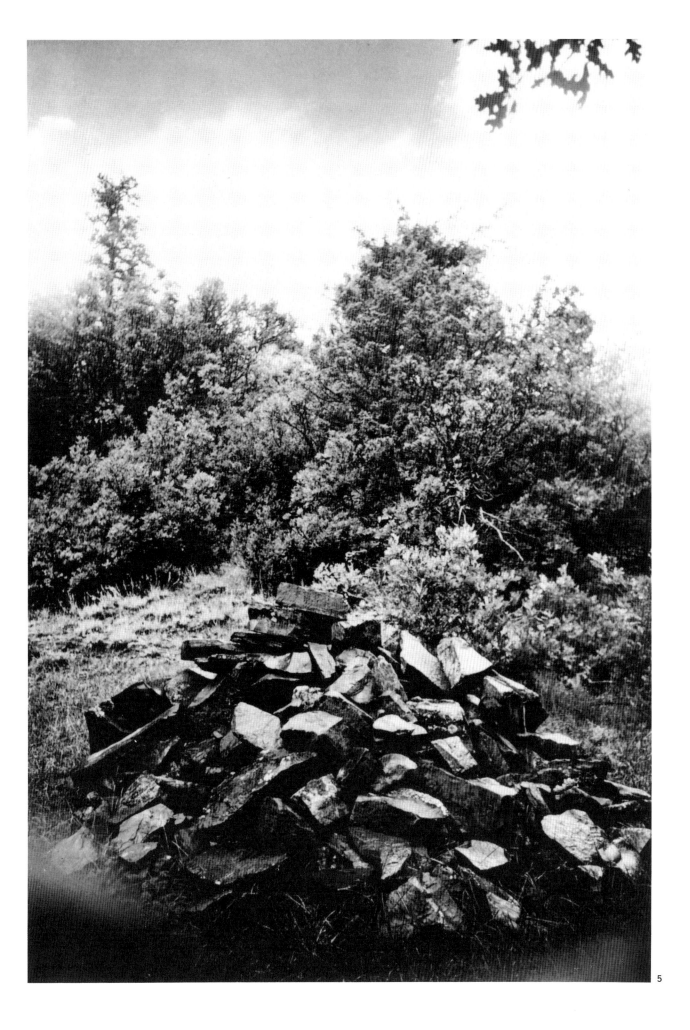

5

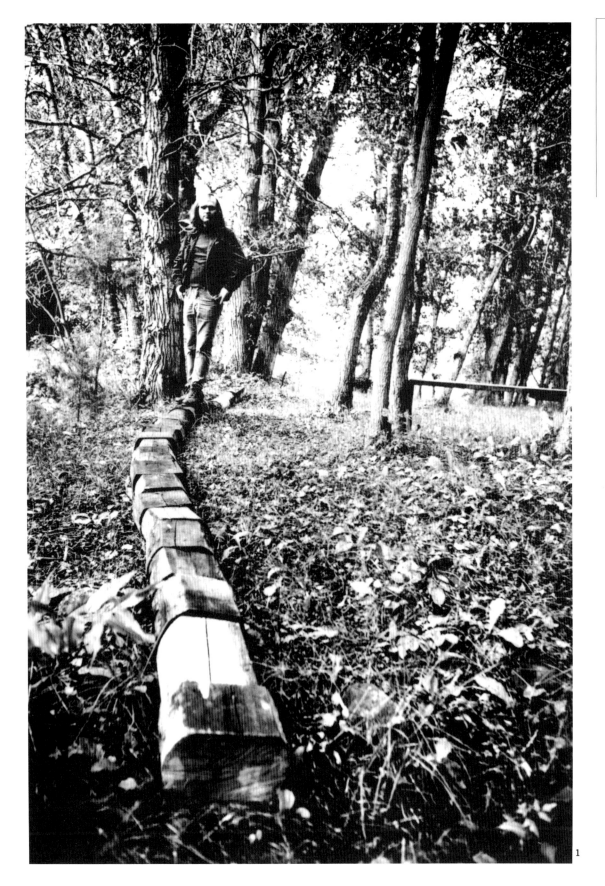

1 Carl Andre, *Log Piece*, Aspen, Colorado, summer 1968.
Approximately 100 feet. Courtesy of Virginia Dwan.

2 Carl Andre. Courtesy of Virginia Dwan.

*A back-to-the-landscape show is burgeoning at—of all places!—the Dwan Gallery, though you can't exactly call it a revival of the Barbizon School. The medium (and message) is Mother Earth herself—furrowed and burrowed, heaped and piled, mounded and rounded and trenched. Called "Earthworks," the show boasts projects by nine artists who reveal their geophilia in photos, models, and actual chunks of ground.*

*Robert Morris, for instance, has contributed a 6 x 6-foot pile of unsculptured terra firma. One of Claes Oldenburg's entries is a case of loam fraught with active earthworms. And Walter de Maria has sent from Germany a blown-up photo of a Munich gallery, whose floor he has carpeted wall-to-wall with dirt.*

*"We hope to get away from the formalism of studio art," says Robert Smithson, one of the show's prime movers, "to give the viewer more of a confrontation with the physicality of things outside. It's diametrically opposed to the idea of art as decoration and design."*

*Smithson, whose previous work has run to "perspective systems," has come up with a complex contribution that he calls a "non-site." It's a 5-part series of wooden bins, arranged in a perspective scheme and filled with limestone fragments from a mineral dump in Franklin Furnace, N.J. (a famous haunt for rock hounds). Shown with it is a blown-up aerial photo, pinpointing the actual sites from which the limestone was taken. The viewer can heighten his "participation" by touring them.*

*"This brings an abstract, rather than natural awareness of the landscape," says Smithson, who rejoices in the "dualism" between the rock (raw material) and its bins (an artificial, gallery-type scheme). "The earth to me isn't nature, but a museum. My idea is not anthropomorphic. It relates to man and matter rather than man and nature."*

*Even deeper into the ground thing is Michael Heizer, a 23-year-old ex-painter who comes from a family of geologist and mining engineers (his father is a digging anthropologist). Accompanying*

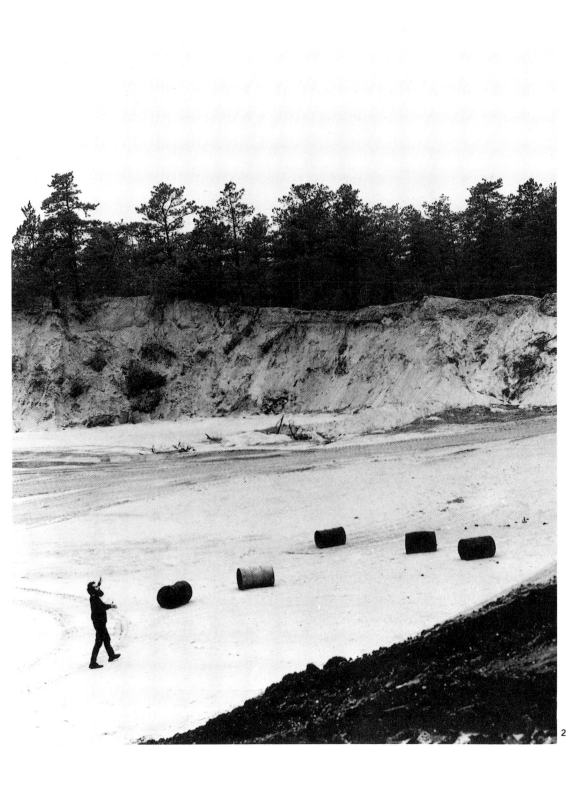

Smithson and his wife Nancy on a rock-hunt last summer in the West, Heizer put down a series of "earth liners" along a 520-mile string of dry lake beds running from Las Vegas to Oregon. His "conglomerate project" consists of eight 5-part clusters of light-catching trenches—12" deep, 12" wide, 12' long—positioned according to the sun's East-West trail.

"I refuse to draw limits because a work isn't practical," Heizer says. "In fact, my earth liners can be collected, if someone wants to put them in his yard. I did them in the desert because no one wanted them." (Actually, Heizer's desert works are "owned" by collector Robert Scull, who has already made a proprietary tour of them by helicopter.)

The "historical" work in the show is a grass-wall sculpture of 1955, done in Aspen, Colo., by 68-year-old Herbert Bayer, a versatile ex-Bauhaus man. A giant ring of turfy earth (shown in a blown-up photo), it might have been turned out by a cosmic Jello mold. "If we were a museum, of course," muses Virginia Dwan, the Minnesota Mining (hmm!) and Mfg. heiress who owns the gallery, "we could have started with the Mayans and Egyptians."

The notion for the show goes back two years, when Smithson was hired as an art consultant by Tippetts-Abbett-McCarthy-Stratton, an architectural-engineering firm working up proposals for a Dallas-Fort Worth airport. His ideas for "aerial art"—sculptured mounds of earth and gridworks viewable from low-flying aircraft—are under consideration. But so far, the airport has not got off the drawing board.

Grace Glueck, "Art Notes: Moving Mother Earth," *The New York Times* (October 6, 1968).

2

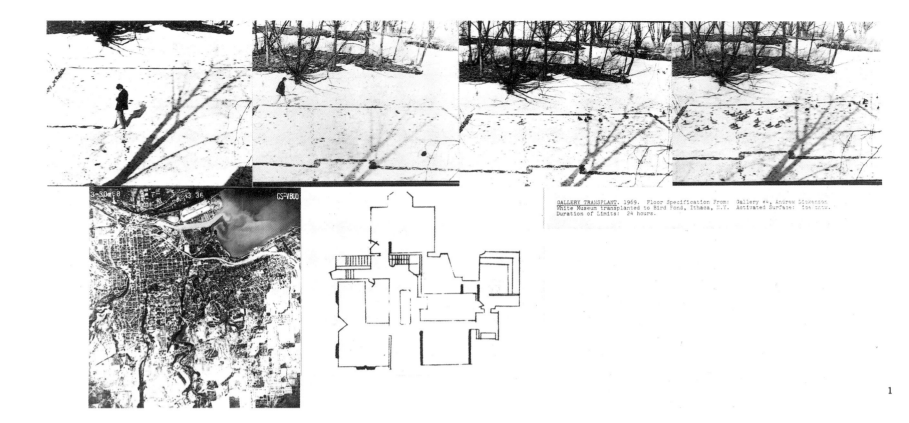

GALLERY TRANSPLANT. 1969. Floor Specification From: Gallery #4, Andrew Dickenson White Museum transplanted to Bird Pond, Ithaca, N.Y. Activated Surface: Ice snow. Duration of Limits: 24 hours.

1

**1** Dennis Oppenheim, *Gallery Transplant*, 1969.
Floor specification from: Gallery #4, Andrew Dickson White Museum transplanted to Bird Pond, Ithaca, NY. Activated surface: ice/snow. Duration of limits: 24 hours. Photo-documentation: black and white and color photography, 5 x 10 feet. Collection of Detroit Institute of Arts, Modern Arts, Detroit, Michigan.

**2** Hans Haacke, *Spray of Ithaca Falls Freezing and Melting on Rope*, February 6–8, 1969.
Stretched rope near waterfall, from one edge of the riverbank to the other. Courtesy of Hans Haacke.

**3, 4** Dennis Oppenheim, *Accumulation Cut*, Ithaca, New York, 1969.
4' x 100' cut made perpendicular to frozen waterfall. Equipment: gasoline powered chain saw. 24 hours required to refreeze. Photo-documentation: topographical map, black and white photography, 60 x 40 inches. Courtesy of Dennis Oppenheim.
"Oppenheim's original project, entitled *Woodcut*, was to be a trench in the steeply inclining slope bordering the shores of Beebe Lake on the Cornell campus, and ice saws were to be used to continue the cut into the frozen lake. When he began to execute the work a few days before the exhibition opened, Oppenheim decided to make the cut only on the frozen surface of the west end of the lake at the edge of the falls." *Earth Art* (Ithaca: Andrew Dickson White Museum of Art, Cornell University, 1969).

**5** Jan Dibbets, *A Trace in the Wood in the Form of an Angle of 30° Crossing the Path*, Ithaca, New York, 1969.
Private collection, Ghent, Belgium. Courtesy of Jan Dibbets.
"After exploring the woodland near Six Mile Creek several miles from the museum, Dibbets found a large clearing in the forest where a path crossed a naturally beautiful site next to the creek. With a clothesline attached to large rocks, Dibbets and a small crew of students marked out a large V on the ground, each arm of which was approximately five feet wide and one-hundred feet long. The turf within each arm of the V was turned over with pickaxes and shovels, except where the V was intersected by the path. Several times during the course of the exhibition, snow fell in the area, giving the work a continually varying appearance. Dibbets considers the long walk through the woods to the site of his work to be part of the piece." *Earth Art* (Ithaca: Andrew Dickson, White Museum of Art, Cornell University, 1969).

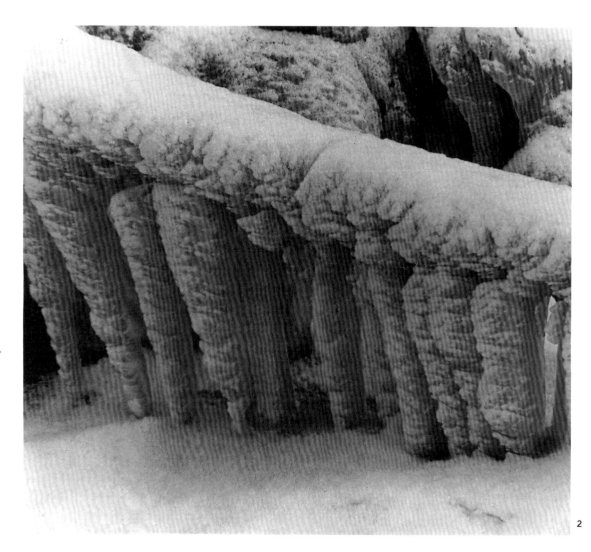

2

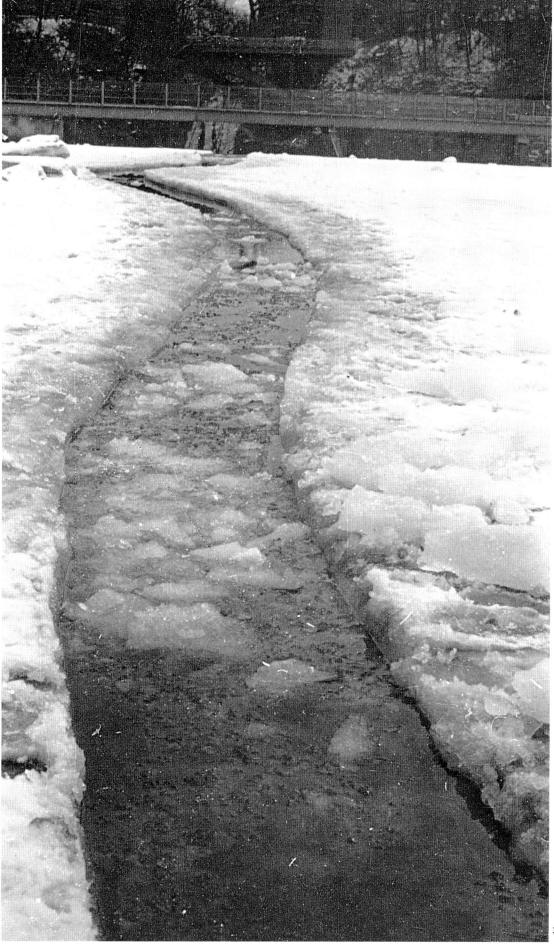

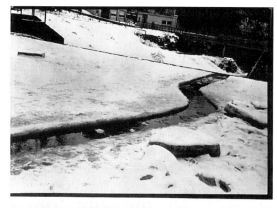

ACCUMULATION CUT, 1969.
Location: Ithaca, New York. 4' X 100' cut made perpendicular to frozen waterfall.
Equipment: Gasoline powered chain saw. 24 hours required to refreeze.

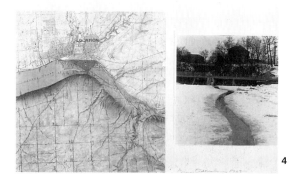

4

5

3

The absence of a pedestal or base, the importance accorded to the temporal dimension, and the formal simplicity of the works were supposed to singularize these new sculptures, yet all were inherited directly from minimalism. Heizer's "earthliners," shown under the guise of photography, exemplified this duplicity.

The use of materials found outside the artistic realm (industrially forged metals, car paints, Plexiglas, heat-resistant bricks, and so forth) gave minimalist works a "natural opacity," as Rosalind Krauss said, a ready-made nature that obliged the spectator to place himself in a relationship of pure exteriority. In Krauss's opinion, the minimalists broke away from the idea of sculpture as organized around an interior pole or focus, in the image of the body such that we immediately feel we occupy its center.

Even if the minimalists rejected all forms of anthropomorphism, Rosalind Krauss wrote, "our bodies and our experience of our bodies continue to be the subject of this sculpture—even when a work is made of several hundred tons of earth."[36] Michael Heizer's *Double Negative* and Robert Smithson's *Spiral Jetty* serve as fairly eloquent examples in her analysis. *Double Negative*, made of two grooved surfaces on either side of an empty space, is only visible, if one remains at ground level, from one side at a time. This structure forbids a central vision or a centered position, and constrains the viewer to the periphery. The work is thus a metaphor of the manner in which the ego knows itself—never from within; only through the way in which it appears to others.

Continuing with Krauss's interpretation, the same idea can be found in *Spiral Jetty* (1970). As with *Double Negative*, the work was designed to be entered. Although a spiral does have a center, the space surrounding the installation, the lake, and the

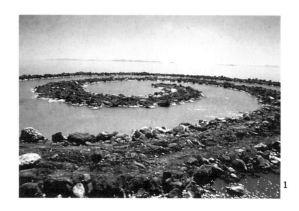

**1** Robert Smithson, *Spiral Jetty*, Great Salt Lake, Utah, 1970. Photograph by Gianfranco Gorgoni, Sygma.

**2** Michael Heizer, *Double Negative* (interior view), Mormon Mesa, Overton, Nevada, 1969–1970. Photograph by Gianfranco Gorgoni, Sygma.

sky favors an effect of expansion that placed the viewer in a permanently decentralized position. The spiral embraces the movement of myth, the great whirlwind that, according to Indian legend, carries along the waters from the depths of a lake to the Pacific Ocean. All of Smithson's works, from the completions of his first nonsites, were attempts to think about the idea of decentralization which he associated with the relationship between the size and the scale of his works. This relationship had already interested Barnett Newman, and would later intrigue Robert Morris, who returned to it in his "Notes on Sculpture."

One can better understand Rosalind Krauss's insistence on stressing concern with the body as a sign of continuity between minimalism and the works of the Land Art artists, when one considers that her analysis follows largely from a "phenomenological" lecture by Maurice Merleau-Ponty. The 1962 English translation of his book, *The Phenomenology of Perception*, was a great influence on the artists and critics of the period.

Merleau-Ponty's lecture probably reinforced, on the theoretical level, Robert Morris's interest in the theater. Morris's first "minimalist" sculpture, *Column*, a gray, square column, eight feet high with two-foot sides, stood in the middle of the stage when the curtain went up. Three and a half minutes later, the column fell. Three and a half more minutes passed before the curtain finally closed. Morris was to stand inside the sculpture and make it fall, but, after he hurt himself in rehearsal, he decided to rely on a system of ropes to topple the work. In 1964 at the Surplus Theater in New York, Morris posed as a lecturer and read an excerpt from *Essays in Iconology* by Erwin Panofsky. Each phrase was amplified, but with a delay after the moment in which it had been read.

Concurrently, on the same stage, Morris also showed a *"tableau vivant"* of Manet's *Olympia* that he progressively unveiled. In March 1965, he participated in a show during which he, nude and tightly tied to Yvonne Rainer, walked on two parallel beams while Lucinda Childs, dressed as a man, walked back and forth parallel to them as if pulled by a thread emanating from a point offstage.[37] This is just to show the extent to which Morris was concerned with the "theatrical" and how the theater could be said to characterize his art, without the term taking on the negative tone that it does in Fried's writing.

Similar scenographic concerns must have influenced Walter De Maria when he installed *Lightning Field* in a desert plain in New Mexico, surrounded by plateaus that confined his work as if it were the theater set of a future apocalypse. *Earth Rooms*, also by De Maria—shown in Munich in 1968, Darmstadt in 1974, and New York in 1977, where it is still visible—held the same interest for the *mise en scene*. In Munich, De Maria filled the three rooms of the Heiner Friedrich gallery with 1765 cubic feet of earth, to a depth of almost twenty-four inches. It was not only the gallery itself that was being shown—the space itself that made up the gallery—but also its origins through the element of the earth. The exhibition was also, and possibly primarily, an invitation to thought, as was *Lightning Field*.[38]

De Maria explained that the *Lightning Field* project "was born in the form of an afterthought, after the completion of *Bed of Spikes* in 1969," *Bed of Spikes* being a minimalist-style work that does seem to be a small-scale model for *Lightning Field*. If a certain number of De Maria's sculptures from that period carry echoes of minimalism, such as *4-6-8 Series*, *Pyramid Chair*, and *Instrument for La Monte Young* (all

**1** Robert Morris, *Site*, 1964.
Performance given in New York (with Carolee Schneermann), Ann Arbor (Michigan), Copenhagen, Dusseldorf, and Stockholm. Photograph by Hans Namuth. Courtesy of the Guggenheim Museum, New York.

**2** Robert Morris, *Untitled* (two columns), 1973.
Gray-painted aluminum, vertical column and horizontal column, 96 x 24 x 24 inches. Collection of Contemporary Museum of Art, Tehran, Iran. Courtesy of the Guggenheim Museum, New York,

**3** Walter De Maria, *New York Earth Room*, commissioned by the Dia Art Center, 1977.
250 cubic yards of dirt covering an area of 3600 square feet, with a depth of 22 inches. © Walter De Maria 1977.
Walter De Maria created his first *Earth Room* in 1968 in Munich at the Heiner Friedrich gallery, the second in Darmstadt in 1974. The third, installed in New York in 1977, became permanent in 1980, thanks to the Dia Art Foundation.

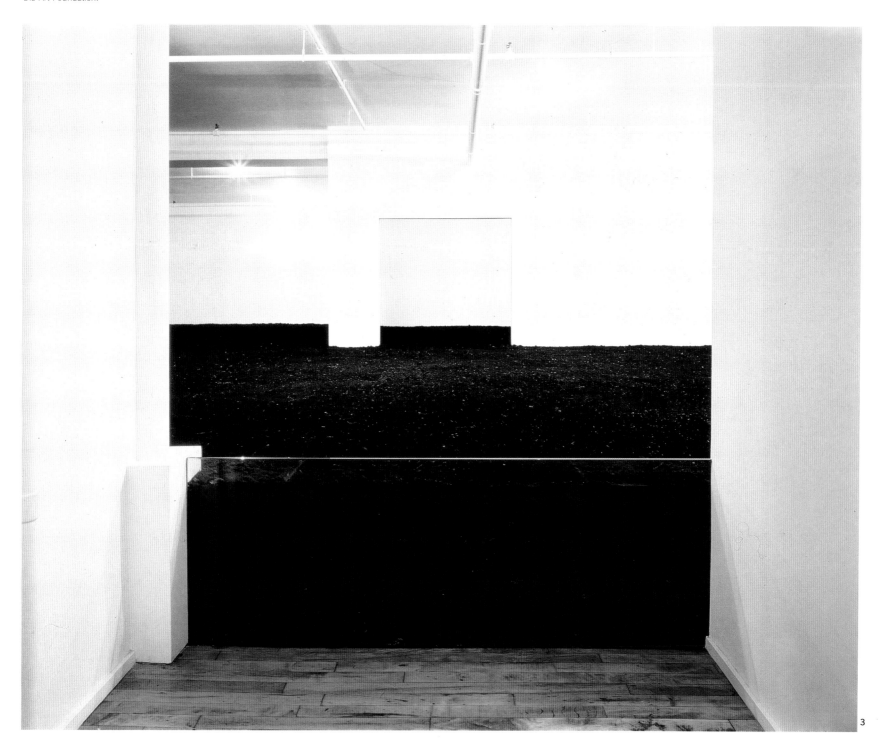

3

three dating from 1966), they also possess a sort of expressivity and aggressivity (for example, *Bed of Spikes*, that spectators can approach only after signing a paper agreeing to look at the work of art at their own risk) totally foreign to the minimalist movement.[39] Dennis Oppenheim also parodied rather than imitated minimalism in his early projects. In his work one finds the same questioning of the visible forms of art, as evidenced in his *Viewing Stations* (1967)—objects for seeing, not for being seen—as well as his *Gallery Decomposition*

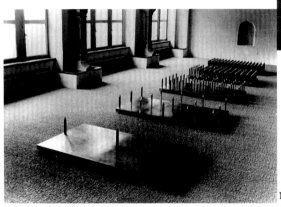

series. The latter, dating from 1968, consisted of displaying the materials making up the walls of the gallery, crushed into a powdery substance.[40]

In 1960, Walter De Maria wrote a number of essays on related themes.

He entrusted a few of them to La Monte Young, who published them in 1963 as *An Anthology of Chance Operations, Concept Art, Anti-Art, Meaningless Work, etc.* It was to finance this anthology that Robert Morris had staged the *Column* performance described earlier. One of the texts, "The Importance of Natural Catastrophes," anticipated the interest that Robert Smithson would later show in this type of phenomenon. De Maria wrote, "I like natural disasters and I think that they may be the highest form of art possible to

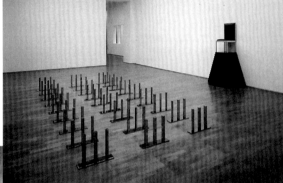

**1** Walter De Maria, *Beds of Spikes*, 1968–1969.
Installation from 1981, annual exhibition, Kunstverein, Saint-Gall, Switzerland. Stainless steel, five sculptures consisting of solid obelisk-shaped points, soldered in a grid arrangement on a metal plate acting as a pedestal.
Each plate measures 78.5 x 41.57 x 2.5 inches; each point, 10.5 x .9 x .9 inches. The number of points is successively 3, 15, 45, 91, and 153, from the first to the last plate, and the number of points along the short side of the plate is 1, 5, 7, and 9, respectively. The number of rows of points on each sculpture is equal to two times the number of points along the short side minus one. For example, the sculpture that has five points along the short side has nine rows [(5 X 2 = 10) - 1= 9 rows]. The sculpture that has only one point along the short side and that has three points total is an exception to the rule.
Private collection, Basel. © Walter De Maria, 1969.

**2** Walter De Maria, *4-6-8 Series*, 1966–1991.
Installation from 1991, Museum fur Moderne Kunst, Frankfurt. (Series of twenty-seven works.)
Four-, six-, and eight-sided rods in stainless steel. Each work is made of three rods arranged on a base of stainless steel. The series gives all the possible combinations of linear arrangement of the square, the hexagon, and the octagon. Dimensions: 16.18 x 78.74 x 314.96 inches. Photograph by Rolf Nagel. © Museum fur Moderne Kunst, Frankfurt, 1991.

**3** Walter De Maria, *Zinc Pyramid*, 1965.
Zinc, 7-3/8 x 19-7/8 x 19-7/8 inches. The top point of the sculpture is moveable and contains a small compartment.
Collection of Asher Edelman, Pully/Lausanne, Switzerland. Photograph by John Cliett. © Dia Art Center for the Arts, 1980.

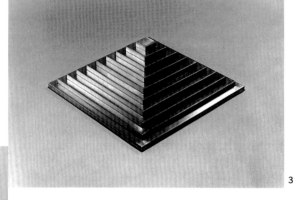

experience." Another text proposed the creation of an "Art Yard" and began: "I have been thinking about an art yard I would like to build. It would be sort of a big hole in the ground. Actually it wouldn't be a hole to begin with. That would have to be dug. The digging of the hole would be part of the art."[41]

Throughout the 1960s De Maria was constantly planning outdoor projects, some of which were partially completed, such as *One Mile Long Drawing*, created in 1968 in the Mojave desert. The "drawing" was formed by two parallel lines each one mile long and drawn in chalk. In the original project (1961), the lines were intended to be two walls. Similarly, in 1969, De Maria constructed *Las Vegas Piece*, consisting of two trenches, each one mile long, and two others, each one-half mile long, intersecting at right angles, similar to Heizer's *Double Negative*. The same year, De Maria began *Three Continents Project*, in the Algerian Sahara, by digging a one-mile trench oriented north-south. Another furrow dug in India and a one-mile square traced on the ground in the United States were to constitute the whole work which, after photographing it from a satellite and superimposing the three parts, would have produced a cross within a square. The project was never finished, and De Maria has been reluctant to speak about this work. All he has provided are documentary indications,

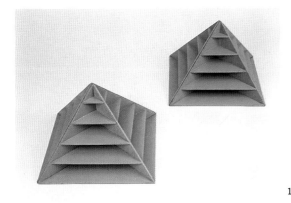

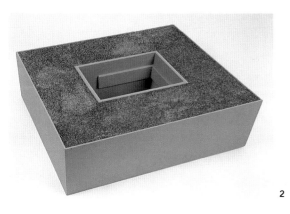

**1** Dennis Oppenheim, *Bleacher System*, 1967
Scale: 1:12, painted wood, 12 x 24 x 24 inches. Courtesy of Dennis Oppenheim.

**2** Dennis Oppenheim, *Excavated Sculpture*, 1967.
Model for exterior site, scale: 1:12, painted wood and earth, 6 x 16 x 16 inches. Courtesy of Dennis Oppenheim.

**3** Dennis Oppenheim, *Gallery Decomposition*, 1968, re-shown in 1992 at the warehouse of the Blum Helman gallery in New York. Plaster, gypsum, aluminum filings, sawdust, pigment. Photograph by the Blum Helman Gallery, New York. Courtesy of Dennis Oppenheim.

**4** Dennis Oppenheim, *Ground Mutations—Shoe Prints*, Kearney, New Jersey and New York, 1968.
Photo-d ocumentation: black and white photography, color photography, aerial map, 59 x 130 inches. Collection of Muscum of Finc Arts, Houston, Texas. Courtesy of Dennis Oppenheim.
"Shoes with 1/4-inch diagonal grooves down the soles and heels were worn for three winter months. I was connecting the patterns of thousands of individuals....My thoughts were filled with marching diagrams."

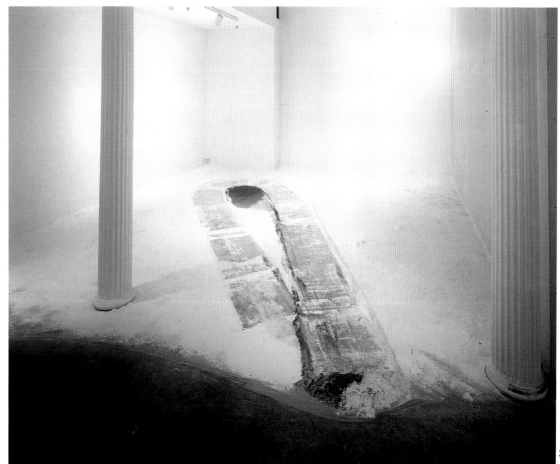

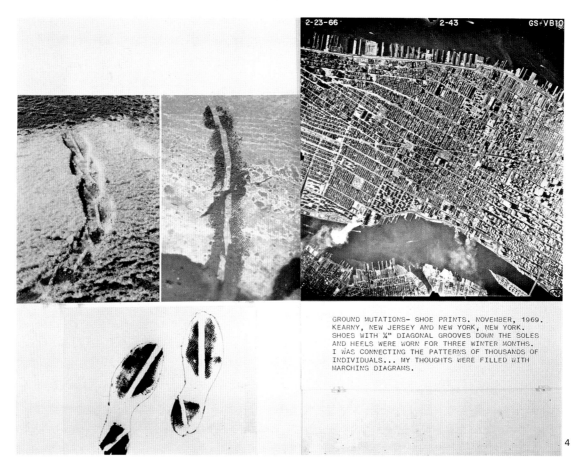

GROUND MUTATIONS- SHOE PRINTS. NOVEMBER, 1969.
KEARNY, NEW JERSEY AND NEW YORK, NEW YORK.
SHOES WITH ¼" DIAGONAL GROOVES DOWN THE SOLES
AND HEELS WERE WORN FOR THREE WINTER MONTHS.
I WAS CONNECTING THE PATTERNS OF THOUSANDS OF
INDIVIDUALS... MY THOUGHTS WERE FILLED WITH
MARCHING DIAGRAMS.

lists of figures, weights, sizes, and volumes, along with a chronology of facts that accompanied the project, typed on sheets of paper stapled in one corner—similar to the document available for visitors to *Lightning Field*. Additionally, aside from a few terse aphorisms, De Maria did not offer any personal interpretations, and emphasized that "the sum of the facts does not constitute the work or determine its esthetics."[42] This atti-

## THE TELEVISION-EXHIBITION: NEW ART SPACE

*"More and more artists are exploring the possibilities of the relatively new media of film, television and photography."* That was the first sentence of my introduction to the Land Art broadcast in April 1969...

*...Communication is acquiring dimensions that were unknown until today. In spite of all this, however, the trend seems to be in the opposite direction. The television exhibition Land Art showed situations created by artists in more or less imposing landscapes. Landscapes which were much less exotic for the artists themselves than for the unprepared spectator. These artists have all, in fact, lived or at any rate spent a considerable length of time in the areas that figure in their respective works. What all the projects had in common were the greatly magnified proportions of the pictorial plane: spacious landscapes replaced the painter's canvas. De Maria and Heizer worked with the smooth sandy bed of a dried-up lake. Heavy machines were used: Jan Dibbets, for instance, used a bulldozer to realize his perspective corrections on a beach. I think the almost irritatingly flattering reviews of the Land Art exhibitions are to some extent due to those impressive landscapes, but they were merely the starting point for a further-reaching process of formal change.*

*The ideas which had been reduced to a minimum, just as the gestures of the artists, were wrapped up in the landscape. In this way even the most radical idea became reconcilable. Identifications will not suffer from this problem.*

Gerry Schum, "Introduction to the Television-Exhibition Identifications" (this introduction was part of the broadcast televised on November 30, 1970), excerpt, *Gerry Schum* (Amsterdam: Stadelejik Museum, 1979), p. 74.

tude of withdrawal stands at the opposite extreme from artists such as Morris or Smithson, who, in taking a position on the art of that period, give us some indication of their thought processes.

The creation of exterior works whose direct viewing was problematic—either because the work was ephemeral and had disappeared, or because the best view of the work required an optical construction that altered its scale—caused the affirmation of a new artistic sensibility. It

was precisely in this area—and very indirectly through the minimalist legacy[43]—that American and European artists such as Richard Long, Jan Dibbets, Hamish Fulton, Barry Flanagan, and Hans Haacke became acquainted. Among these, all (except for Haacke, who, tied to the group Zero in Dusseldorf, had begun his artistic career in the early 1960s) received their training at St. Martin's School of Art in London—even Dibbets, who was the recipient of a scholarship grant from the British Council. They had as schoolmates, among others, Gilbert and George, and Bruce McLean. Anthony Caro, who had been supported by Clement Greenberg and Michael Fried, was at that time a professor in the sculpture department. Caro, influenced by his trip to the United States in 1969, took up the ideas of the "modernists," but without any pedagogical dogmatism. Other artists such as Philip King and William Tucker also taught at St. Martin's while pursuing their personal work. John Latham taught there as well, and was famous for having made his students eat *Art and Culture* by Clement Greenberg, and for then having them return it to the library in jars, in *papier maché* form. The young generation of artists to which Long and Flanagan belonged had shown their work in Frankfurt since 1967 and, later, in Dusseldorf.[44] Even before their work became recognized internationally, exhibitions such as *When Attitudes Become Form* (Basel, 1969, organized by Harald Szeemann) had allowed these sculptors some contact with New York artists on various trips to the United States.

Among the 1969 exhibitions that established Land Art were *Places and Process*, at the Edmonton Art Gallery in Alberta, organized by Willoughby Sharp and William Kirby, with works by Andre, Dibbets, Heizer, Long, Morris, and Graham (to name

a few), and *Other Ideas*, at the Detroit Art Institute, with Andre, De Maria, Heizer, and Smithson, with a catalog preface by Samuel Wagstaff.

Also in 1969, Gerry Schum, from the Fernseh Gallery, the "television gallery" that he had just opened in Cologne, asked eight artists—Smithson, De Maria, Heizer, Oppenheim, Long, Dibbets, Marinus Boezem, and Flanagan—to produce films with the title Land Art. These films, each about five minutes long, were broadcast on German television on April 15. Schum prefaced the presentation of the films and text that went with them: "The TV Gallery exists only in a series of transmissions…one of our ideas is communication of art instead of possession of art objects….This conception made it necessary to find a new system to pay the artists and to cover the expenses for the realization of art projects for the TV show. Our solution is that we sell the right of publication, a kind of copyright, to the TV station." From October 11 through 18 of the same year, *Self-Burial* was retransmitted on German television in the form of "nine photographs showing Arnatt progressively descending into the earth. Each one was shown twice each day for two seconds, cut into the daily television programming, with no introduction or commentary," wrote Lucy Lippard.[45] Similarly, without explanation of any sort, Jan Dibbets, in a film that was part of another series entitled *T.V. as a Fireplace*, showed, for twenty-four minutes each day, from December 24 to 31, 1969, the flames of a fire, as if the television itself were a fireplace.[46]

Although minimalism was a fairly important influence or ancestor for all of these artists, none had a real minimalist style, except for Robert Morris. Nevertheless, evaluating his activity at that time, it seems that for him, minimal art was

an occasion to experiment with new approaches to works that dealt with the body and perceptive space. Morris, the most grounded in minimalism of all the Land Art artists was, paradoxically, of all the artists affiliated with minimalism, the least invested in Land Art. Under both categories, Morris completed works of quality, but used aesthetics and processes that did not belong entirely to him. Heizer, Smithson, and De Maria borrowed certain elements from minimalism but did not give anything back in return; for Long, it was more an intellectual agreement based on certain artistic assumptions. Each of these artists had quickly passed through minimalism while pursuing different individual objectives.

1

2

**1** Invitation to the *Earthworks* exhibition, Dwan Gallery, New York, October 5–30 1968.
Courtesy of Virginia Dwan.

**2** Group photo taken at the *Earth* exposition at the White Museum, February 1969.
Carl A. Kroch Division of Rare and Manuscript Collections, Cornell University Library, Ithaca, New York.
From left to right: Robert Morris, Neil Jenney, Dennis Oppenheim, David Medalla, Jan Dibbets, Richard Long, Robert Smithson.

**1-2** Walter De Maria, *Cross*, El Mirage Dry Lake, Nevada, 1968.
Two lines in white chalk 3 inches thick, forming a cross 500 feet
wide and 1000 feet long. Photograph by Gianfranco Gorgoni,
Sygma.

**3** Walter De Maria, *Mile Long Drawing*, Mojave desert, California,
1968.
Created with the help of Michael Heizer. Two parallel lines 4 inches
wide and 1 mile long, 12 feet apart from one another.

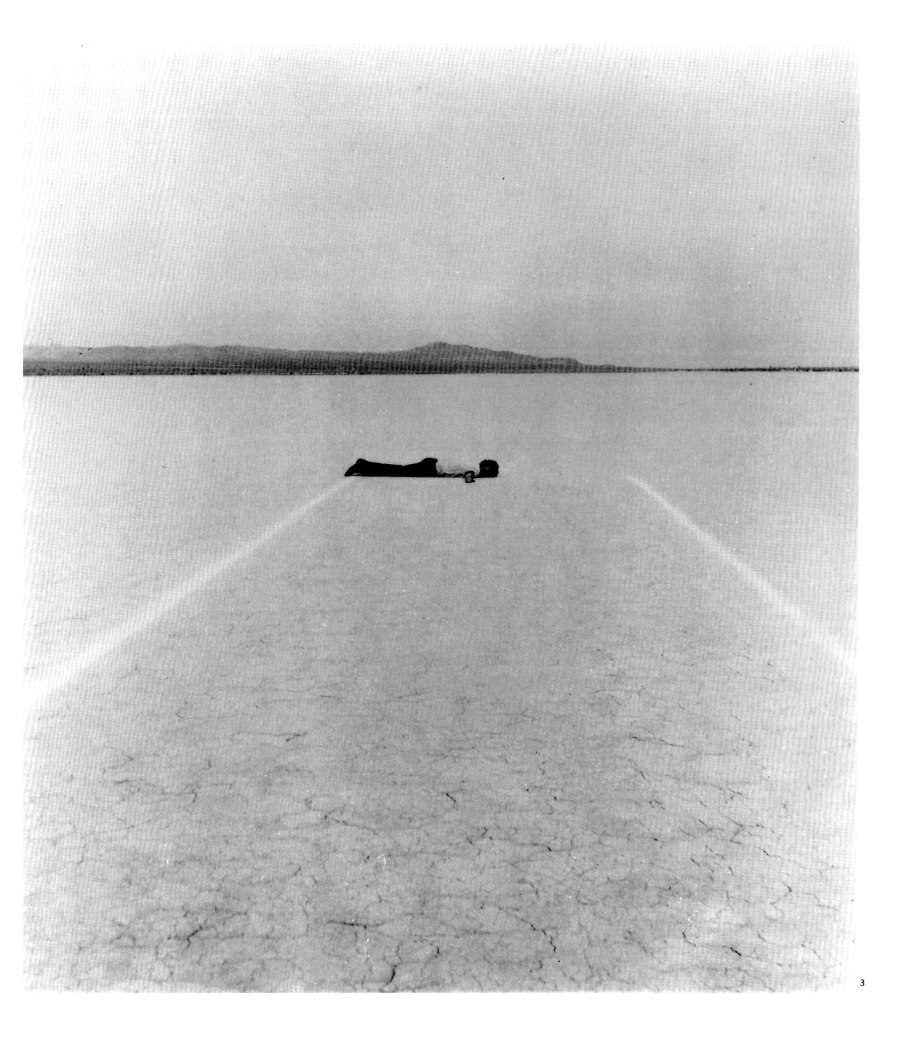

3

1. Irving Sandler, *American Art of the 1960s* (New York: Harper & Row Icon Editions, 1988), p. 46.

2. Clement Greenberg, E.C. Goossen, Rosalind E. Krauss, Michael Fried, William Rubin, and Barbara Rose dominated the critical theory of the period. Artists such as Reinhardt, Judd, Morris, and Smithson produced critical texts as well.

3. Clement Greenberg, "After Abstract Expressionism," *Art International* (October 1962), pp. 10–20.

4. Ibid., pp. 17–18.

5. Clement Greenberg, "Modernist Painting," lecture, 1960, published for the first time in *Art Yearbook 4* (1961), modified and reprinted first in *Art and Literature 4* (1965), then in Gregory Battcock ed., *The New Art, a Critical Anthology* (New York: E.P. Dutton, Inc., 1966), p. 101. For a presentation and a critique of Greenberg's position, see Leo Steinberg, "Other Criteria," *Other Criteria, Confrontation with Twentieth-Century Art* (New York: Oxford University Press, 1972).

6. Clement Greenberg, "Modernist Painting," op. cit., p. 102. "'The discussion regarding purity in art' stems from two types of specifications. The first is external in a certain sense, and demands that the notion of avant-garde be socially and historically defined....The second is internal, and requires a more precise investigation in the genre of 'content' that the new 'accentuation of form' eliminates or does not eliminate." Thierry de Duve, "Clement Lessing," *Essais datés I, 1974–1976* (Paris: La Différence, 1987), p. 78.

7. Clement Greenberg, *Art and Culture, Critical Essays* (Boston: Beacon, 1961).

8. Robert Smithson, "What is a Museum, Dialogue between Allan Kaprow and Robert Smithson," *Arts Yearbook* (The Museum World, 1967), reprinted in *The Writings of Robert Smithson*, op. cit., pp. 62–63. On the connection between Smithson and modernism, see the article by Jean-Pierre Criqui, "Actualité de Robert Smithson," *Qu'est-ce que la sculpture moderne?* (Paris: Centre Georges-Pompidou, 1986), pp. 318–321.

9. About this essay, Jessica Prinz wrote that Smithson "undermines Lessing's division of space and time and the classification of the arts based upon it." Jessica Prinz, "Words en Abîme, Smithson's Labyrinth of Signs," op. cit., p. 89.

10. Barbara Rose, "ABC Art," *Art in America* (October–November 1965); reprinted in Gregory Battcock, ed., *Minimal Art: A Critical Anthology* (New York: E.P. Dutton, Inc., 1966). Yve-Alain Bois emphasizes that Ad Reinhardt's influence was more due to his writings on theory than his painting, and that the label "minimalist" or "conceptualist" was no more agreeable to him than "mystic." (Yve-Alain Bois, "The Limit of Almost," *Ad Reinhardt* [Los Angeles: The Museum of Contemporary Art, and New York: Museum of Modern Art and Rizzoli, 1991], p. 13.)

11. Smithson declared that these, "...were linked up somehow in my mind with a notion of ice crystals." Hobbs saw them as the perfect example of minimalism as "cool" art. (Robert Hobbs [with Lawrence Alloway, John Coplans, and Lucy R. Lippard], *Robert Smithson: Sculpture* [Ithaca and London: Cornell University Press, 1981] p. 65.)

12. The chronology in the *Robert Smithson: Drawings catalog* (New York: The New York Cultural Center, 1974) indicates 1960. However, the complete catalog of Smithson's work, *Robert Smithson: Sculpture*, op. cit., gives 1962 as the date. Smithson had begun his career as a painter at the end of the 1950s. Similar to many American artists of that period, he was influenced by the abstract expressionists, as

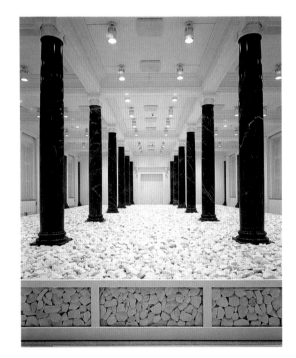

Walter De Maria, *5 Continents Sculpture*, Staatsgalerie Stuttgart, 1987–1988.
White rocks, steel frame, and acrylic paint; 262 cubic yards of rocks covering an area 42-1/2 x 77 feet, 29-1/2 inches deep. Collection Daimler-Benz, Mohringer. Photograph by Andreas Freytag. © Staatsgalerie Stuttgart, 1987.

his early works, paintings, drawings, and collages show. The influence of James Ensor is noticeable as well. The first exhibition of Smithson's work took place in 1958 in the apartment of the poet Allan Brilliant, and was followed by a show at The Artist Gallery in 1959, and a solo exhibition at the Georges Lester gallery in Rome in 1961.

13. Lucy Lippard has written, "In 1965, Smithson and Nancy Holt met Bochner, Hesse, Volmer (and me). Bochner met Hesse and LeWitt....In the same period, Tom Doyle brought his dealer, Virgina Dwan, to LeWitt's studio; LeWitt introduced her to Smithson; both ended up with Doyle in the stable of the Dwan Gallery, and Smithson helped Ad Reinhardt [a father figure of the coterie] with the *Ten* show there in fall, 1966, which made Dwan the hot bed of 'cool art.'" (Lucy R. Lippard, "Intersections," *Flyktpunkter/Vanishing Points* [Stockholm: Moderna Museet, 1984], p. 12, cited in Irving Sandler, *American Art of the 1960s*, op. cit., pp. 110-111. For information on this period in general, see chapter 5 of the same work.)

14. For Rosalind Krauss's recollections of the late-night discussions between Serra, Andre, and Smithson at Max's Kansas City in the 1960s, see Rosalind E. Krauss, "Richard Serra, Sculpture," *Artstudio* (winter 1986–1987), p. 33. See also Bruce Kurtz, "Last Call at Max's," *Artforum* (April 1981).

15. According to Buchloch, there are four main characteristics of constructivism. First, the existence of physical forces determining "the structure and the position of the sculptural construction." Second, the interest in the material specificity of the sculpture. Third, the importance of the site of the sculptural object, and the way in which it is presented. Fourth, "the desire to do away with an alleged autonomy of space, within which sculpture lies." (Benjamin Buchloch, "Construire (l'histoire de) la sculpture," *Qu'est-ce que la sculpture moderne?*, op. cit., pp. 254–274.)

16. Willoughby Sharp, "Interview with Carl Andre," *Avalanche* (fall 1971), cited in Benjamin Buchloch, "Construire (l'histoire de) la sculpture," op. cit., p. 270.

17. See Irving Sandler, *American Art of the 1960s*, op.cit., p. 246. On the connection between the Russian avant-garde and the minimalist artists, see Maurice Tuchman, "The Russian Avant-Garde and the Contemporary Artist," *The Avant-Garde in Russia 1910–1930* (Los Angeles: Los Angeles County Museum of Art, and Cambridge, Mass.: MIT Press, 1980), pp. 118–121.

18. E.H. Johnson, *Modern Art and the Objects* (London: Thames and Hudson, 1976), pp. 15–16.

19. Cited in Lucy R. Lippard, *Six Years: The Dematerialization of the Art Object* (New York: Prager, 1973), p. 155.

20. Dan Flavin, "In Daylight or Cool White: An Autobiographical Sketch," *Artforum* (December 1965), p. 24; cited in Irving Sandler, *American Art fo the 1960s*, op. cit. Interview: Richard Serra & Friedrich Teja Bach, March 14, 1975, in *Richard Serra: Interviews, etc. 1970–1980* (The Hudson River Museum, 1980), p. 49.

21. See Sam Hunter, "The Sculpture of Tony Smith," preface from the catalog of the *Tony Smith* exhibition at the Pace Gallery, New York, April 27–June 9 1979, p. 7. Also see Robert Hobbs, "A Meditation on Tony Smith's Sculpture," catalog from the *Paintings and Sculptures* exhibition that also took place at the Pace Gallery, September 23–October 22, 1983. According to these two authors, it is through the category of the sublime that Tony Smith's art must be understood. Jean-Pierre Criqui ("Trictrac pour Tony Smith," *Artstudio* [fall 1987], p. 39) wrote, "His art has more affinities with the concern of the subject present in Newman's or Rothko's work than with the desire for literalness found in minimalist productions." On the relationship between Tony Smith and minimal art, see Madeleine Deschamps, "Tony Smith et/ou l'art minimal," *Art Press*, no. 40 (September 1980), p. 20.

22. Samuel Wagstaff Jr., "Talking with Tony Smith," in Gregory Battcock ed., *Minimal Art: A Critical Anthology*, op. cit., pp. 381–386.

23. Michael Fried, "Art and Objecthood," *Artforum* (June 1967); reprinted in Gregory Battcock, ed., *Minimal Art, A Critical Anthology*, op. cit., pp. 116–147.

24. Term borrowed from Clement Greenberg, "Recentness of Sculpture," *American Sculpture of the Sixties* (Los

Angeles: Los Angeles County Museum of Art, 1967), reprinted in Gregory Battcock ed., *Minimal Art, A Critical Anthology*, op. cit., pp. 180-186.

25. Thierry de Duve, *Résonances du Ready Made* (Nîmes: éditions Jacqueline Chambon, 1989), p. 238.

26. Michael Fried, "Art and Objecthood," *Artforum* (June 1967), reprinted in Gregory Battcock, ed., *Minimal Art, A Critical Anthology*, op. cit., p. 144.

27. Yve-Alain Bois, "Promenade autour de Clara Clara," *Richard Serra* (Paris: Centre Georges-Pompidou, 1984), p. 25.

28. *Artforum*, at that time directed by Philip Leider, had become one of the most influential journals of the artistic avant-garde in the United States, as well as one of the primary supporters of minimal art, Land Art, and conceptual art. Michael Fried, who was a regular contributor to the magazine, eventually separated from it. One year later, Smithson wrote an article that referred to Tony Smith's interview attacking Michael Fried. Smithson wrote that Smith had been discussing a sensation and not a finished work of art. He also indicated that Fried did not analyze Smith's work, but instead essentially used only what was said at the interview. Smithson continued that one could not conclude that Smith was "anti-art." In reality, it was about an experience comparable to what is described in Anton Ehrenzweig's book *The Hidden Order of Art* (which influenced Smithson) as "dedifferentiation," and which is related to limitlessness. Fried, who rejected the "infinite," also spoke on the subject of Morris Louis about an "infinite abyss," which would open up behind the painted surface if innumerable conventions did not restrict our everyday as well as our artistic actions. Smithson also mentioned the critics who, dreading the experiences of the abyss, "cannot endure the suspension of boundaries between what Ehrenzweig calls the 'self and the non-self.'" One such

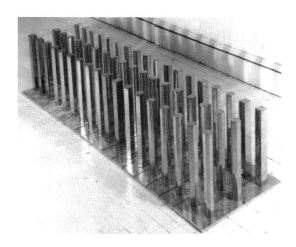

Walter De Maria, *4-6-8 Series*, 1966.
Stainless steel. Work in eighteen pieces, 16.18 x 20 x 4.47 inches, giving all possible combinations of lines consisting of the square, the hexagon, and the octagon. Photograph by Eric Pollitzer.
© Walter De Maria, 1966.

example is Michael Fried, whose fear is high but whose experience of the abyss is low. See Robert Smithson, "A Sedimentation of the Mind: Earth Projects," *Artforum* (September 1968); reprinted in *The Writings of Robert Smithson*, op. cit., p. 84.

29. One of Smithson's favorite books.

30. The office of Tippets, Abbet, McCarty, and Stratten was given the project of constructing the Dallas-Fort Worth Regional Airport.

31. Samuel Wagstaff, "Talking with Tony Smith," op. cit., pp. 381–386. Richard Long and Hamish Fulton's trips were related to a very different, typically English tradition. Nonetheless, it is important to remember that Hamish Fulton took his first long trips in 1969, in Wyoming, South Dakota, and Montana.

32. Virginia Dwan, "De mémoire parlée," *Virginia Dwan, Art Minimal, Art Conceptuel, Earthworks, New York, Les années 60–70* (Paris: galerie Montaigne, 1991).

33. Dennis Oppenheim, Robert Smithson, Neil Jenney, Günther Uecker, Hans Haacke, and Richard Long. Reprinted in *The Writings of Robert Smithson*, op. cit., pp. 160–167.

34. Thomas W. Leavitt organized the exhibition that he had originally conceived of in the summer of 1967. The idea for the show was a series of four traveling exhibitions devoted to each of the four elements: water, air, earth, and fire. The White Museum had been chosen to host the first part of this series, particularly because of its geographical location and its geological richness. Each artist was free to create either an outdoor or an indoor work. A detailed plan had been sent to the museum before the works were constructed, and the artists could consult with the academics in the various related university departments: construction, architecture, art, physics, applied mathematics, etc. The students often aided in construction.

35. From the text for the catalog *Earth Art*, from the exhibit at the Andrew Dixon White Museum of Art, Cornell University, February 11–March 16, 1969.

36. Rosalind E. Krauss, *Passages in Modern Sculpture* (New York: Viking, 1977, and Cambridge, MA: MIT Press, 1981), p. 20.

37. See, for example, Maurice Berger, *Labyrinths, Robert Morris, Minimalism and the Sixties* (New York: Harper & Row, 1989), which gives quite a lot of information on this period (particularly in the introduction and in chapter two).

38. "In a press conference, Walter De Maria once again stressed the meditative aspect of *Earth Room*: 'The mud (or earth) is not only there to be seen, but also to force people to think about it,' adding, 'God has given us the earth, but we have ignored it." Uwe Scheede, "Un américain en Allemagne, Walter De Maria," *Les Cahiers du Musée national d'Art moderne*, no. 33 (summer 1990), p. 54. The De Maria quotations come from unpublished documents to which the author of the article had access.

39. See Jean-Marc Poinsot, "Walter De Maria, les dangers de l'art," *L'Atelier sans mur* (Villeurbanne: Art Edition, 1991), p. 83.

40. "Here the artwork is seen both as a physical demolition of the gallery itself—an attack on its ideology of preciousness and separateness, dissolving its walls to let in the outside world—and as means of reversing the traditional aesthetic process wherein raw material is made into coherent form." Thomas McEvilley, "The Rightness of Wrongness:

Modernism and its Alter-ego in the Work of Dennis Oppenheim." *Dennis Oppenheim, Selected Works 1967–1990* (New York: Abrams, P.S. 1 Museum, 1990), p. 16.

41. Walter De Maria, "Compositions, Essays, Meaningless Work, Natural Disasters," *An Anthology* (New York: La Monte Young/Jackson MacLow Galleries, 1963, and Munich: Heiner Friedrich Galerie, 1970). For the Olympic Games in Munich in 1972, De Maria proposed that a shaft be dug into the hill, made of debris from World War II, that overlooks the city. The shaft was to be 9 feet in diameter and 400 feet deep (200 feet in the artificial part and 200 feet in the natural earth), thus linking the ancient past with recent history. This theme of the invisible can also be found in *Lightning Field*, as well as in *Vertical Earth Kilometer*, constructed for the Documenta in Kassel in 1977. A brass rod approximately 2 inches in diameter was introduced into a vertical well one kilometer long. All that is visible is the section in the middle of a red sandstone slab.

42. Walter De Maria, "The Lightning Field," *Artforum* (April 1980), p. 58.

Dennis Oppenheim, *Gallery Structure 2*, 1967.
Painted wood, 160 x 240 x 300 inches. Courtesy of Dennis Oppenheim.

43. Long recognized the importance of artists such as Andre and Judd.

44. "The Konrad Fischer Gallery, in Dusseldorf, was the first to offer these artists the space for experimentation and the methods of creation that were necessary to them. Konrad Fischer, who, as an artist, had exhibited with Long, Flanagan, and Dibbets in 1967 at the Dorothéa Loehr Gallery in Frankfurt, proposed that the artists create a work based on the gallery space. He showed work by Bruce McLean, Hamish Fulton, Richard Long, and Gilbert and George." Catherine Grenier, "La sculpture revendiquée," *Britannica, 30 ans de sculpture* (L'Etat des lieux, La Différence, and L'Association des conservateurs de Haute-Normandie, 1988), p. 16.

45. Cited in Lucy R. Lippard, *Six Years: The Dematerialization of the Art Object*, op. cit., p. 119.

46. See the catalog *Gerry Schum* from the exhibition at the Stedelijk Museum, Amsterdam, 1979.

# INORGANIC SCULPTURES

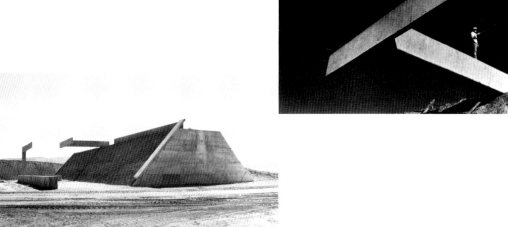

**1** Michael Heizer, *Complex I*, Garden Valley, Nevada, 1972–1974.
Reinforced concrete and compacted earth, 23-1/2 x 140 x 110
feet. Collection of the artist and of Virginia Dwan. Photograph by
Michael Heizer.

**2** Michael Heizer, *Complex I*, with *Complex II* (under construction)
in background.
Collection of the artist and of Virginia Dwan. Photograph by Michael
Heizer.

**3** Michael Heizer, *Complex I*, 1972–1974, detail.
Photograph by Gianfranco Gorgoni, Sygma.

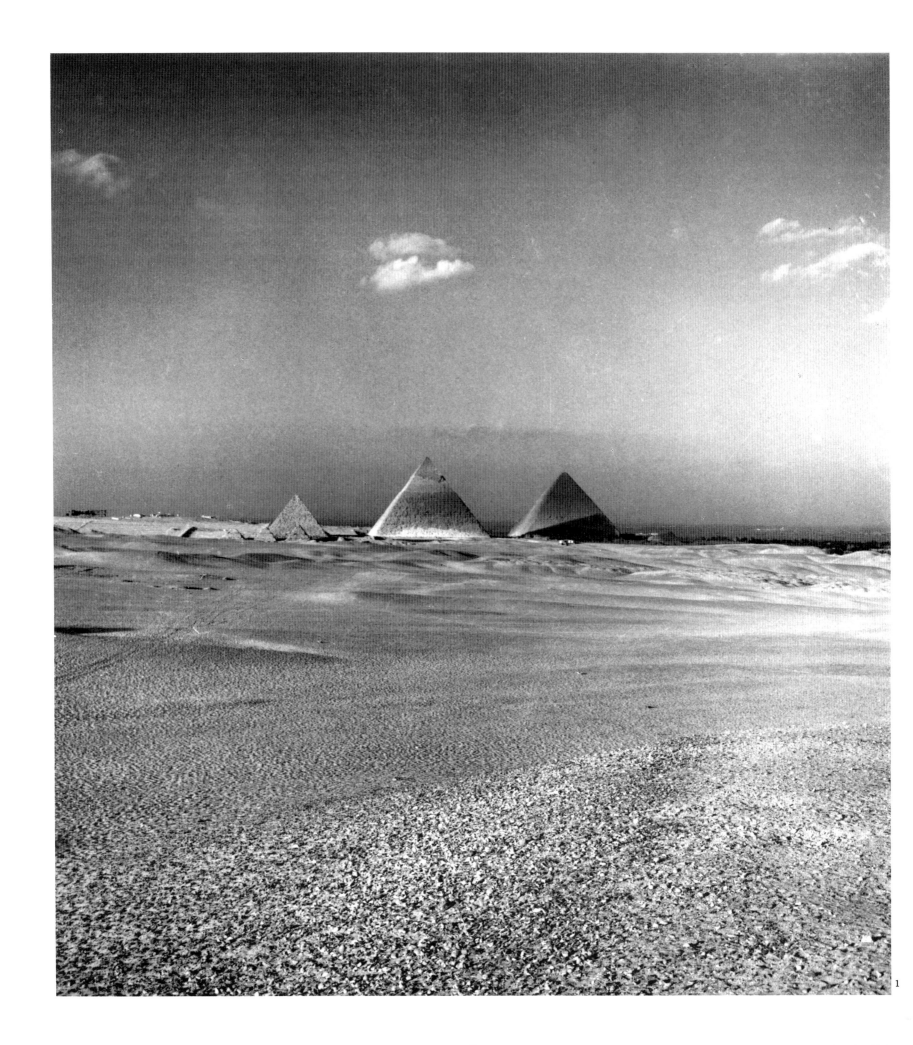

*"The subject is architecture, the result is sculpture."**

—Michael Heizer

Characteristic of the 1960s in the United States, and marked by the movements of anti-art, Fluxus, and neodadaism, was the questioning of galleries and museums as privileged places to display works of art. This dispute, linked to a socio-political critique of the art market, was invented by the Land Art movement. Access to art was no longer simply a visit to an exhibition, as the definition of exhibition itself broadened to include many temporal aspects: the artistic event, the experience of the spectator, and, increasingly, the economic and social context of the event, against which exhibitions henceforth appear as critical counterpoints. This new relationship to time also necessarily implied the use of sites nontraditional in their location—the American deserts, the forests of the Yucatan, the peaks of the Himalayan mountains, and the Dorset countryside—more than the simple fact of their being outdoors. It also called for a new, more active way of receiving works of art: flipping through a book of photographs rather than standing before a series of framed paintings, for example.

This "passing through minimalism" by several Land Art artists unquestionably defines their work as a challenge to architecture's role as exhibition space.[1] Their thoughts on the issues of the traditional function of museums, and the ability of such conventional exhibition spaces to welcome works of a new genre, progressively led them to turn to or rely on nature.[2] Consequently, more progressive and rational curators, like William Rubin, wondered: "Why should one presume that a museum structure is the right or best environment for all such objects? I think that the questions posed by certain Minimal and

2

1  The three pyramids of Giza, Egypt.
Photograph by Roger-Viollet, Paris.

2  Robert Morris, installation, Green Gallery, New York, December 1964–January 1965.
Photograph by Rudolph Burckhardt. Courtesy of the Guggenheim Museum, New York.

many post-Minimal works transcend the museum question."[3] In a text published in the October 1966 issue of *Artforum*, Robert Morris, in the midst of his minimalist period, speculated on the dimension and the scale of his "structures," the "new" objects which could not be given the traditional name of sculpture. Their nature, sometimes *private*, sometimes *public*, he wrote, "is because of our experience in dealing with objects that move away from the constant of our own size in increasing or decreasing dimension."[4] The larger the object and the more space it requires, the more our relationship to it becomes *public*—thus the minimalists' refusal of anything resembling personal experience or inner emotion. The size of the works forbids any private relationship with them. At the same time, the enclosed geometry of galleries and museums, and the visual constraints which they impose on the spectator, force a connection between the work and its exhibition space.[5]

This idea was also taken up by Robert Smithson in his article on his project for the Dallas regional airport in 1967: "'Sculpture,' when not figurative, also is conditioned by architectural details. Floors, walls, windows, and ceilings delimit the bounds of interior sculpture. Many new sculptures gain scale by being *installed* in a vast room....The walls in modern museums need *not* exist as walls, with diseased details on or near them. Instead, the artist could define the interior as a total network of surfaces and lines."[6] Morris, with no further explanation, claims that it is not the environment of the room that modifies the object, it is the object that modifies the environment of the room. Space, he continues, is no longer organized as if it were ordered by a group of objects: "Why not put the work outside and further change the terms? A real need exists to allow this next step to become practical. Architecturally

designed sculpture courts are not the answer nor is the placement of work outside cubic architectural forms. Ideally, it is a space without architecture as background and reference, that would give different terms to work with."[7]

It is no longer simply a question of installing sculptures outside, or in other architectural contexts—which would not really be new—but to give the works value in another way: if "the object is no longer sufficient by itself," the architecture which houses it cannot compensate for its deficiencies. Other parameters become important as well, time in particular: the time involved in experiencing the art itself—both the duration of the visit and the hour of the day. Reliance on time sets these pieces apart from works exhibited in museums, where art history is seen as a linear progression. Land Art defies classification, and can not be easily accommodated on a canonical time line.

Morris had already referred to the experience of time, saying that the comprehension of a work of art is only possible by viewing the work from every angle. This experience is founded on the phenomenological model of perceptive synthesis, made up of anticipation and memory. At the Green Gallery in 1965, Morris installed four cubes, each face of which was a mirror about one yard long. Placed on the floor, these cubes reflected the ceiling, as if the ceiling extended through them, so that their borders seemed to dissolve in their environment. Within the space of the exhibit, they created holes of virtual space which eroded what initially seemed to be a spatially well-defined gallery. Outside the gallery an identical device had been installed, reflecting the lawn and the trees. One year earlier, in the same space, Morris had shown "structures" evoking architectural forms. Rosalind Krauss sees these forms as the

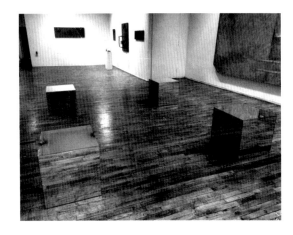

Robert Morris, installation, Green Gallery, New York, February 1965.
Photograph by Rudolph Burckhardt. Courtesy of the Guggenheim Museum, New York.

characteristic example of what sculpture had become, "the category that resulted from the addition of the *not-landscape* to the *not-architecture*."[8] She evaluates and manipulates these two negations, finally reversing them to express her theory more positively: "...the *not-architecture* is, according to the logic of a certain kind of expansion, just another way of expressing the term *landscape*, and the *not-landscape* is, simply, *architecture*."[9] Such a classification attempted to account for sculpture's break from the traditional categorization of art criticism, while still permitting an understanding of the system of transformations that characterized it at that time.

The history of the relationship between architecture and sculpture is complex. It assumes a foundation in ancient models of theory, models that a number of Land Art sculptors endeavored to reactivate, such as the *division* of functions that Hegel has discussed in his work.[10] For Hegel, any construction, sacred or profane, generally defines itself in a simple way (place of worship, place of shelter), contrary to sculpted works (images of gods and humans), presented as ends in themselves. If it is possible to return to a time before the division between architecture and the other arts, and to consider architecture as a concept rather than as shelter, support, or backdrop, it is necessary to find architecture that exists as works of sculpture do, without taking their meaning from a goal or an exterior need. However, contrary to sculpture, this architecture does not immediately translate its interior meaning into exterior form. These are "independent" works whose meaning, like the meaning of symbols, is to be found outside of them.[11]

This architecture prior to any division between the arts—what Hegel calls independent architecture—has no content other than its own form, and no correlation

between the two. Contrary to functional architecture (originally a cave hollowed from a rock, later a building whose different processes of construction make use of stone, wood, and other materials to construct walls, fences, and roofs), "with neither of these [methods of construction] can independent architecture begin and consequently we may call it an inorganic sculpture [*unorganische Skulptur*], because...in general it sets before us only a symbolic form which is to indicate on itself and express an idea."[12]

This "inorganic sculpture" is therefore a limited categorization, a working hypothesis to be considered within an aesthetic domain, much as the representation of nature in Jean-Jacques Rousseau's work represents a political philosophy. It only evokes a *representation in general*, a meaning that does not refer back to any specific object. Representation when nothing is actually represented becomes a pure presentation of a concept: "...a building which is to reveal a universal idea to spectators is constructed for no other purpose than to express this lofty idea in itself, and therefore it is an independent symbol of an absolutely essential and universally valid thought, or a language, present for its own sake, even if it be wordless, for apprehension by spiritual beings."[13]

These independent objects, neither sculpture nor architecture, which nonetheless contain aspects of both, correspond exactly to the constructed works of Land Art. These works' monumentality, their mass, and the tension that exists between their verticality and the laws of gravity, place them in the category of architecture. At the same time, the simplicity of their forms, lacking both anthropomorphic reference and spiritual connection, likens them to minimalist structures.[14] For Hegel, the earliest works descended from this

1 Bamian, Afghanistan, 450 A.D.
2 The Colossus of Memnon, Egypt.
Photograph by Roger-Viollet, Paris.

"inorganic sculpture" were obelisks: colossal statues like those of Memnon at Thebes,[15] and the pyramids. Their straight lines justify their inclusion in the category of architecture, yet their lack of right angles, which is what characterizes a house, classifies them as nothing but abstract forms.[16] Their construction in acute angles makes them "just simple crystals, shells enclosing a kernel, a departed spirit, and serve to preserve its enduring body and form. Therefore in this deceased person, thus acquiring presentation on his own account, the entire meaning is concentrated."[17] The pyramids are therefore already more than inorganic sculptures. These works show how architecture, in becoming functional, loses its independence and its own significance. In the case of the pyramids, the role of sculpture is to decorate an interior, a tomb. The minimalist artists, wanting to restore sculpture's autonomy, rediscovered and revalorized the elements common to it and architecture, allowing a return to a sort of original form.[18]

For Morris, the physical relationship between sculpture and its surrounding space requires that the sculpture be placed on bare ground to render obvious the laws of gravity to which it is subject. To better emphasize this relationship, the use of color is forbidden, as color is essentially optical, immaterial, and non-tactile, and therefore incompatible with the more tangible nature of sculpture. Only the physical qualities are important: scale, proportion, form, and mass.[19] Morris also expresses the need to comprehend the volume as a unique and discrete entity, and creates elementary forms toward this end: "In the simpler regular polyhedrons, such as cubes and pyramids, one need not move around the object for the sense of the whole, the gestalt, to occur."[20] It does not matter whether the shapes are regular or irregular; rather, it is

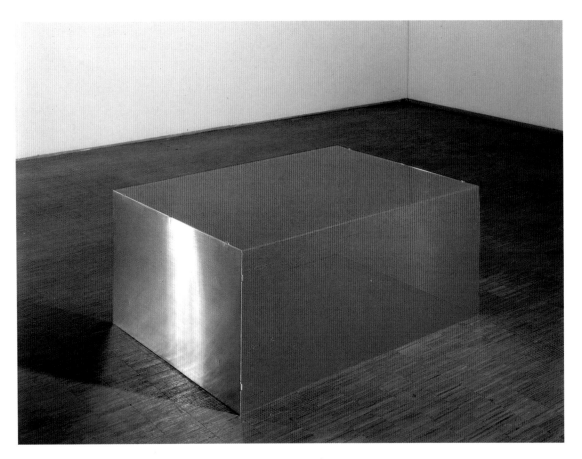

Donald Judd, *Untitled*, 1965.
Photograph by C. Bahier, P. Migeat, Musée national d'Art moderne, centre Georges-Pompidou, Paris.

abstract representation; abstraction brings one closer to physical structures within nature itself."[23] And Heizer himself declared, "Geometry is organic. The study of crystallography demonstrates that there is more geometry in nature than man could ever develop....There is no sense of order that doesn't exist in nature."[24]

Land Art artists' references to Egyptian and pre-Colombian civilizations and to megalithic art, as well as their recourse to a formal vocabulary inherited from minimalism, place them at the very heart of a complex set of problems that help clarify the paradigm of the crystal. Intermediaries between sculpture and architecture, between art and nature, crystalline formations[25] are comparable to minimalist objects. Smithson had already suggested this idea in his text on Donald Judd for the catalog of Judd's 1965 show at the Philadelphia Institute of Contemporary Art. He wrote, "If we define an abstract crystal as a solid bounded by symmetrically grouped surfaces, which have definite relationships to a set of imaginary lines called axes, then we have a clue to the structure of Judd's 'pink plexiglass box.'"[26]

To borrow from an analytical lexicon, one could say that these objects are "compromise formations;" their transparency lies in the fact that there is nothing to see in them other than exactly what one sees.[27] This is their *literal* side. At the same time, their opacity stems from their lack of interiority; they bring the viewer up against their massive presence and, having nothing other than themselves to reveal, they offer only half of a relationship. The viewer becomes the other half, and holds the responsibility of envisioning and actualizing all the spatial possibilities of the object.

It is in this new relationship to space, characteristic of the "inorganic sculpture" that Hegel discussed, that the large Land

the simplicity of the volumes that is important, the fact that they prohibit multifaceted or gradual evaluation, that they offer themselves immediately and indisputably as as one solid block. It is from this desire to avoid intimacy with the work that certain artists are drawn to designing in extremely large dimensions. These works refer to the pyramids of ancient Egypt, and to the pure crystals that Hegel discussed, also found in the work of the Viennese art historian Aloïs Riegl, as a paradigm of creation freed from mimetic concerns.[21]

Like Hegel, Riegl also states that Egyptian art "is the only one that presents the perfect example of pure crystalline conception in architecture."[22] The rejection of movement and color makes for a fundamentally anti-illusionist art, one which obeys the same laws of formation as nature. Smithson, pursuing this idea, wrote (after having cited Wilhelm Worringer, an art theorist himself strongly influenced by Riegl), "There is no escaping nature through

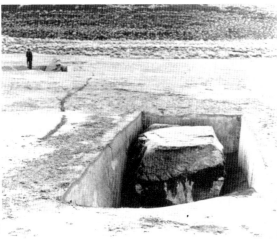

Art constructions are created, and this connection is dependent on the works' mass.[28] What interests Heizer, for example, are the materials that he uses and their weight upon the ground, which associates his work with megalithic art. *Displaced/Replaced Mass* (the first series, 1969) is formed of three rocks, each dozens of tons in weight, placed at equal distances from each other in the Nevada desert. The center rock lies on the ground horizontally, and the other two jut out of the ground at different angles. Works such as *Levitated Mass* (1971) or *Dragged Mass* (1982) are based on the same idea: "I realize there is expressive potential in materials, but I'm more interested in the structural characteristics of materials than their beauty. I think earth is the material with the most potential because it is the original source material."[29]

Mass by itself, however, is not enough to characterize an architectural object; an emphasis on mass can also evoke, to the contrary, an unarchitectural object, a disorganization of the forces that contribute to its elevation, freeing it from the laws of gravity. This is the case in Smithson's work *Partially Buried Woodshed*, constructed on land belonging to Kent State University. Smithson had twenty truckfuls of earth dumped on a shed, until its central beam collapsed. Here, the sheer force of inertia destroys the potential for architectural

**1** Michael Heizer, *Displaced/Replaced Mass 1*, thirty tons, 1969. Photograph by Michael Heizer.

**2** Michael Heizer, *Displaced/Replaced Mass 2*, seventy-two tons, 1969.
Photograph by Michael Heizer.

**3** Michael Heizer, *Displaced/Replaced Mass 3*, forty-three tons, 1969.
Photograph by Michael Heizer.

This work in three parts was originally purchased by Robert Scull. It is presently located in Silver Spring, Nevada.

tension. Literally, the mass "gets the upper hand," the building is submerged, emptied of its emptiness, and it becomes an *inorganic sculpture* restored to its primary form.[30]

Sculpture has become buried architecture. Christo and Jeanne-Claude demonstrated this idea in wrapping the Porta Pinciana in Rome (1974) and the Pont-Neuf in Paris (1985). By rendering the individual components indistinguishable, Christo turned architecture into mass, smothering it and essentially giving prominence to its inertia. Gordon Matta-Clark, younger than Smithson by five years, produced work that was completely the contrary in some respects. A prin-

cipal and vocal member of the group "Anarchitecture," he cut seemingly random voids into buildings, as if they were swiss cheese (*Splitting*, 1974). Thus in *Conical Intersect* (1975) on the Place Beaubourg in Paris, in an empty building scheduled for demolition that faced the Pompidou Center (at that time under construction), he opened up a conical section through which one could see the future museum. In this case, the architecture, in emptying itself, in ridding itself of its mass, became lightened and elevated. The air and light that penetrated it allowed the building to breathe.[31]

Undoubtably, it is this fascination with mass that is, in part, the origin of Michael

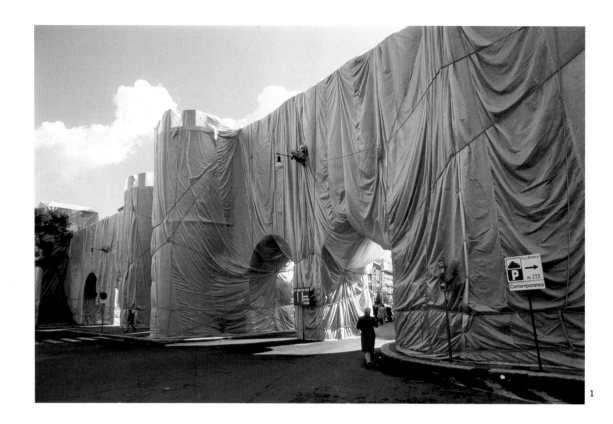

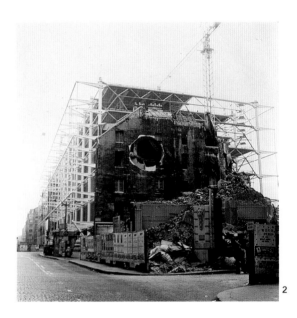

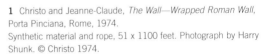

**1** Christo and Jeanne-Claude, *The Wall—Wrapped Roman Wall*,
Porta Pinciana, Rome, 1974.
Synthetic material and rope, 51 x 1100 feet. Photograph by Harry
Shunk. © Christo 1974.

**2, 3** Gordon Matta-Clark, *Conical Intersect*, 1975.
Photographs by Philippe Migeat, Musée national d'Art moderne,
Centre Georges-Pompidou, Paris.

**4, 5, 6** Robert Smithson, *Partially Buried Woodshed*, Kent State
University, Kent, Ohio, January 1970.
Wooden shed and twenty truckloads of earth. Collection of Kent
State University. Photographs by Robert Smithson. Courtesy of the
John Weber Gallery, New York.

**7** Robert Smithson, *Partially Buried Woodshed*, 1970.
Pen on paper, six drawings, 9 x 12 inches each. Courtesy of the
John Weber Gallery, New York.

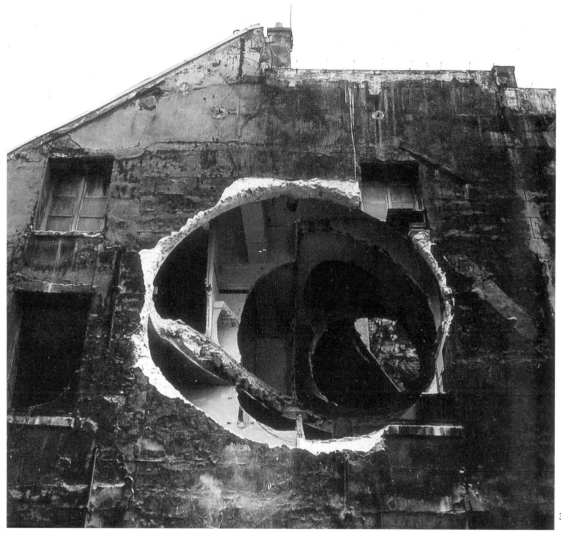

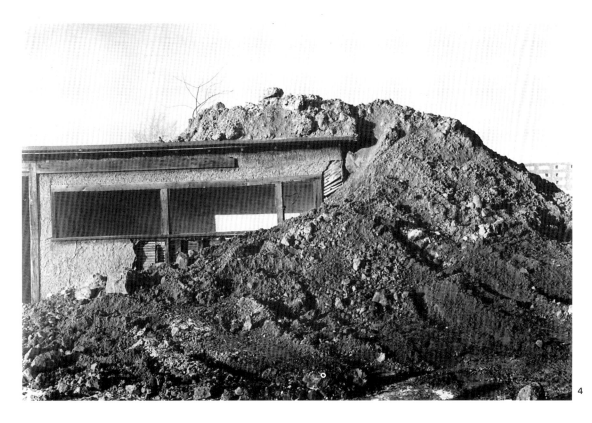

5

6

7

Heizer's *Double Negative*. The total length of this sculpture is 1500 feet and the width of each trench is approximately 32 feet, with a depth of approximately 55 feet. Earth and rocks, totalling 240,000 tons in weight, were moved with the help of bulldozers that excavated from two sides, banking up the earth in front of them, to form two horizontal ramps. The result was two promontories that faced each other without joining, leaving a gaping space between. Heizer gave a conceptual description of this work: "The *Double Negative*, due to gravity, was made using its own substance, leaving a full visual statement and an explanation of how it was made. In *Double Negative* there is the implication of an object or form that is actually not there. In order to create this sculpture material was removed rather than accumulated. The sculpture is not a traditional object sculpture. The two cuts are so large that there is an implication that they are joined as one single form. the title *Double Negative* is a literal description of two cuts but has metaphysical implications because a double negative is impossible. There is nothing there, yet it is still a sculpture."[32] It was in constructing *Double Negative* (he was only twenty-five years old at the time, which we often overlook, and in doing so, fail to realize the extent of his daring) that Heizer, in enlarging by a third the initial "sculpture," became conscious of its connection with architecture, in terms of its formal vocabulary, but not, however, its function: "When I was done it was as big as a building. I had accidentally combined an issue of architecture with an issue of sculpture. This was the origin of my interest in architecture."[33]

By Heizer's own admission, another of his works, *Complex I*, borrows from both the pyramid of Zoser, constructed in the third millennium B.C. in Saqqarah, Egypt, and from the great ball court at Chichen

Michael Heizer, *Double Negative* (under construction), Mormon Mesa, Overton, Nevada, 1969–1970.
Photograph by Michael Heizer.

Itza, in Mexico. From the former, he took the form of the primitive Egyptian tomb; from the latter, the serpent-head motif. He stylized the head, lengthening it considerably with the help of technical means that had been unavailable to the Mayans, allowing the structure to support the enormous load.

Michael Heizer had always been interested in pre-Colombian monuments. As a child he accompanied his father, an ethnologist and archaeologist, to Central America, but his impressions of the excavations and monuments that he had visited lay dormant until he began to construct his own monumental works. At the same time that the techniques that permitted him to build began to interest him, he became fascinated by the size and mass of these ancient sites, more than by their function or their symbolism.

Thus, to Julia Brown's question, "When you say working with the measurement of architecture do you mean a different scale than what was common in sculpture?" Heizer responds, "Not scale, size. Size is real, scale is imagined size. Scale could be said to be an aesthetic measurement whereas size is an actual measurement."[34] But is it the size—typically human, as it is for Morris—that determines the scale, or is it the opposite, is it the scale that determines the size? Does size or scale prevail for the viewer of *Complex I*? This work is without reference points, as it is in the middle of the central piazza of *Complex City*, situated approximately twenty-three feet below ground level, divorced from the landscape.

In the text on *Spiral Jetty*, Smithson addresses the same question. The spiral (now submerged beneath the waters of the lake), which coiled twice onto itself, was 1500 feet long and 15 feet wide, but its scale seemed to vary according to the spectator's

position. "Size determines an object, but scale determines art. A crack in the wall if viewed in terms of scale, not size, could be called the Grand Canyon. A room could be made to take on the immensity of the solar system. Scale depends on one's capacity to be conscious of the actualities of perception. When one refuses to release scale from size, one is left with an object or language that *appears* to be certain. For me scale operates by uncertainty. To be in the scale of the *Spiral Jetty* is to be out of it."[35]

*Spiral Jetty* is structurally similar to two later works by Smithson, *Spiral Hill* and *Broken Circle*, both in Holland. The scale of each of these works cannot be understood except in relation to each other. The broken circle is a sort of formal impossibility that requires an aerial perspective to be fully comprehended. At the same time, *Spiral Hill*, a parody of the tower of Babel, refers back to *Broken Circle* as its own center. When one asks Smithson whether he fears that he has isolated *Broken Circle* from the rest of the landscape, since he has created an object that can be fully perceived only from the crest of a hill, he responds, "I don't see it as an object. What you have there are really many different scale changes. Speaking in terms of cinema, you have close, medium and long views. Scale becomes a matter of interchangeable distances."[36]

In 1971, one year after its construction, *Spiral Jetty* was covered for the first time by the rising waters of the lake. During a brief ebb, salt crystals attached themselves to the edges of the jetty that had been submerged. Then, once again, the jetty found itself under fifteen feet of water. The structural development of each crystal echoed the form of the entire spiral, according to Smithson. The growth of a crystal is analogous to the movement of

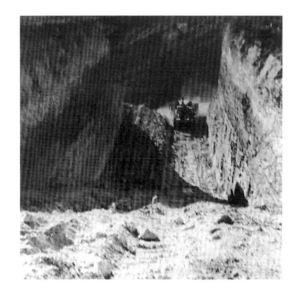

Michael Heizer, *Double Negative* (under construction), Mormon Mesa, Overton, Nevada, 1969–1970.
Photograph by Michael Heizer.

a screw in a hole, which is the same movement as a spiral, so it follows that "The *Spiral Jetty* could be considered one layer within the spiraling crystal lattice, magnified trillions of times."[37] This is a description that for Smithson, evokes Brancusi's drawing depicting James Joyce as a spiral-shaped ear, thus giving us, he said, a "scale" of comprehension, visual as well as audible, that allows us to reconsider art as merely "object." Like the spiralling motion, a sort of reversal of perspectives is produced, the reality coming up against a mirror in which viewers cannot differentiate between reflection and reality. In this dual realm, everything is to scale and, even when one can determine the size, the weight, and the volume, "...in the *Spiral Jetty* the surd takes over and leads one into a world that cannot be expressed by number or rationality."[38]

One can compare, for example, Smithson's creations to the less complex work of the American artist Charles Simonds. Simonds is often considered to be affiliated with the Body Art movement, but he is also associated with Land Art because he works with earth and mud and because his work contains architectural references. Beginning in the 1970s, Simonds built miniature models of houses, a few feet in size at most, that recalled Indian pueblos, but that he integrated into the walls of modern cities. As Claude Levi-Strauss wrote in a well-known essay, one could think that "in contrast to what happens when we try to understand an object or living creature of real dimensions, knowledge of the whole precedes knowledge of the parts," thus creating an illusion that permits us to derive "aesthetic" pleasure.[39] Actually, in Simonds's work the eye is immediately drawn to the detail, and no effect of *gestalt*, in the sense that Morris intended, is possible. Earth is used as a material to evoke an era prior to urbanization, even prior to the

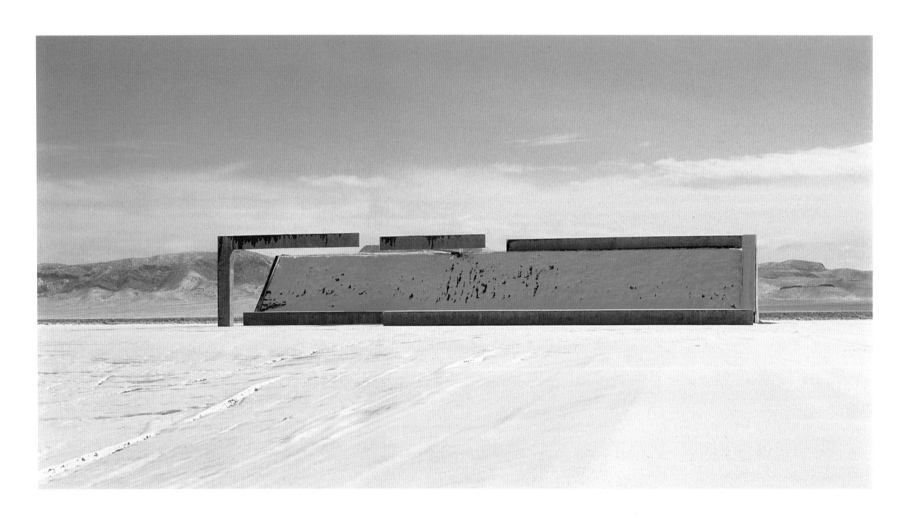

Michael Heizer, *Complex I*, Garden Valley, Nevada, 1972–1974.
Reinforced concrete and compacted earth, 26-1/2 x 140 x 110
feet. Collection of the artist and of Virginia Dwan. Photograph by
Michael Heizer.

European invasion of America. These models are a medium for the imaginary, and Simonds declares that their real size is at the same scale as the objects to which they are supposed to correspond: "the scale of my vision."[40]

The majority of Simonds's works are constructed in the towns whose forms they seem to miniaturize. It is as if the artist wanted to bring the towns back to an earlier age: his villages represent the cultural origin of humanity, while his use of earth itself as a material reminds us of our connection to nature. Simonds's motto is the Dogon belief that "there is no right size," so that for the mythologic "Little People" who inhabit Simonds's cities, as for the Dogons, the house "is a small city and the city is a large house and both reflect the world picture."[41]

The notion of scale is central to this discussion. Philippe Boudon made it a specifically architectural concept, as opposed to proportion, in particular: "In the case of proportion, measurement is made through the *transfer* of an element of a space to another element of the same space, the whole being considered as a closed system." An object's proportions alone do not reveal its dimensions unless in comparison to another object of known size. This dependency allows for ambiguity of scale, which assumes the passage from one space to another, whether real or imaginary. Such a definition also assumes an understanding of the architectural space as "the unity of the real space of buildings and the mental space of the architect (or of any other person) projecting into the real space."[42]

It is a commonly accepted principle that an object of unknown size within a fixed space can be measured by its relation to another object, of known size, in that same space. Each measurement is a

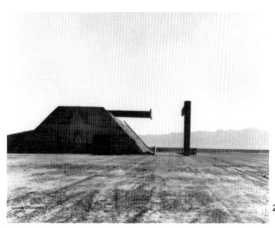

**1** Great ball court, Chichen Itza, Yucatan, Mexico, 10th century A.D.
Courtesy of Michael Heizer.

**2** Michael Heizer, *Complex I*, Garden Valley, Nevada, 1972–1974. Photograph by Michael Heizer.

**3** Stepped pyramid at Zoser, Saqqarah, Egypt, 2600–2700 B.C.

proportion of simple numbers, but in forming a comparison, one enters into the realm of scale. Heizer's work, size without scale, and Simonds's, scale without size, both refer to architecture, but for completely different reasons. Simonds remains in the "aesthetic" realm in the sense intended by Levi-Strauss. Regardless, for Simonds, architecture's role becomes that of a narrative. It permits the creation of fiction while also illustrating it. In Heizer's work, it is the opposite: narratives do not exist and are not possible. The object is there, imposing itself on us, unrecountable.

*Complex II* and *Complex III* are still under construction, closed in on three sides; Heizer at times refers to them as a city, where the visitor, incredulous at first, then stunned, cranes his neck at a forty-five degree angle, his body lightly tensed, without any possible point of reference, seized by a desire to alter his position in an attempt to comprehend the incomprehensible. No matter whether one recedes or approaches, one never finds the perfect distance. When the visitor goes around the work, he sees only the access ramps that lead to the center. Even with the variations of light, at noon, at sunset, or under a full moon, the same feeling remains. Incomprehensibility or the sublime?

According to Hegel, "[the] outward shaping which is itself annihilated in turn by what it reveals, so that the revelation of the content is at the same time a supersession of the revelation, is the sublime."[43] This explanation is a fitting description of an evening thunderstorm at De Maria's *Lightning Field*. If one pursues this interpretation, Heizer's work would be situated not in the symbolic, but in the sphere of indivision between architecture and sculpture that corresponds to what Hegel calls the "primitive need for art." Smithson's notion of scale is meant to be understood in

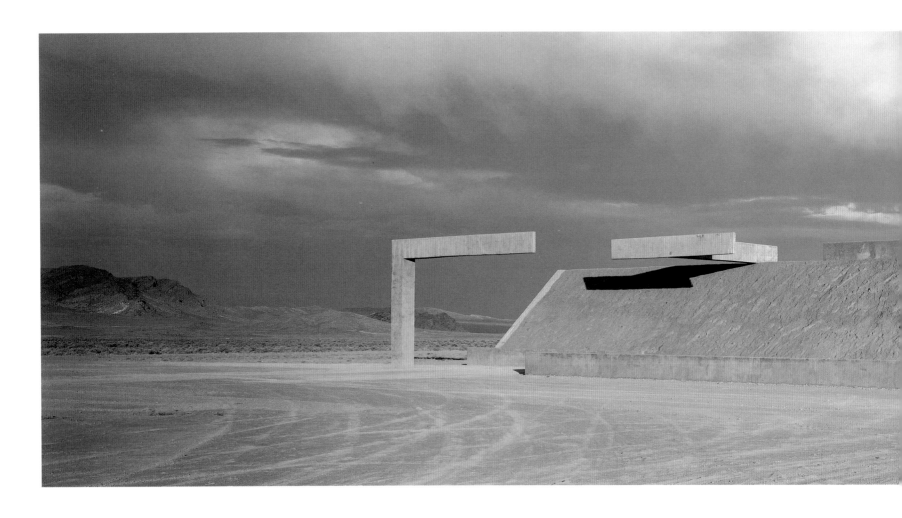

Michael Heizer, *Complex I*, Garden Valley, Nevada, 1972–1974.
Reinforced concrete and compacted earth, 23-1/2 x 140 x 110 feet. Collection of the artist and of Virginia Dwan. Photograph by Tom Vinetz.
"What if an artist is so confused by the society that he reflects other cultures in his work? Perhaps the indication is that present society has finally opened to requiring undifferentiated expression, or even more amazing, that time warps and does not extend indefinitely." Michael Heizer, "The Art of Michael Heizer," *Artforum* (December 1969).

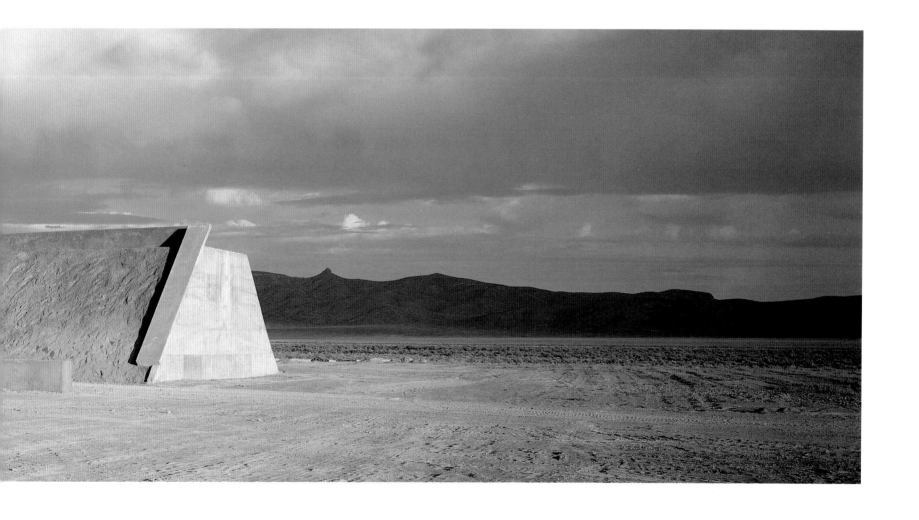

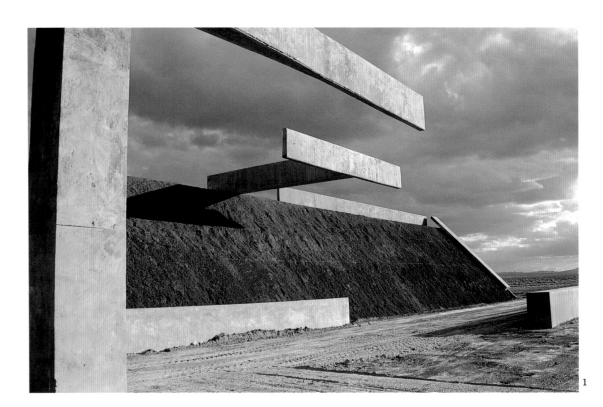

1 Michael Heizer, *Complex I*, Garden Valley, Nevada, 1972–1974.
Photograph by Michael Heizer.

2 Michael Heizer, *Complex I*, (under construction), Garden Valley,
Nevada, 1972–1974.
Photograph by Gianfranco Gorgoni, Sygma.

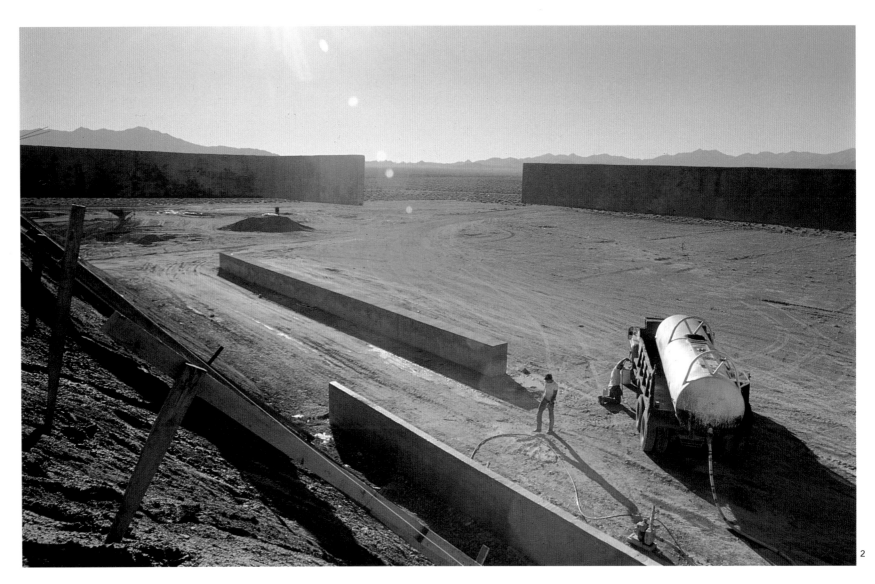

correlation with the site/nonsite dialectic founded on the passage of art from gallery to site, from maps, drawings, photos, and films to that which they represent, signify, or designate. And not only in the passage from one space to another, but in the passage from one time to another, simultaneously and at varying speeds. As in Simonds's work, this is the space of pure fiction, the space of Lewis Carroll—with whose work Smithson was quite familiar—the imaginary realm of *Beyond the Looking-Glass*, where what is large becomes small and what is small becomes large, continually and incomprehensibly.

Unlike Smithson, Heizer is troubled by the notion of scale. The viewer, half buried between the walls of his city and confronted by enormous sculptures, can see nothing of the surrounding landscape: only the sky remains visible. The space present is therefore necessary; the presence of the object itself, the excess of presence, creates the art: "It is interesting to build a sculpture that attempts to create an atmosphere of awe. Small works are said to do this but it is not my experience. Immense, architecturally-sized sculpture creates both the object and the atmosphere. Awe is a state of mind equivalent to religious experience, I think if people feel commitment they feel something has been transcended. To create a

transcendent work of art means to go past everything."[44]

Heizer's relationship to art is an ontological one—metaphysical, as he would say. His work also assumes a phenomenological approach, which, however, is less important than the search for the metaphysical, evident in his sculpture. All the Land Art artists have reflected on the *gestalt* and on phenomenology, but doubtless none more thoroughly or successfully than Morris, whose *Observatory* requires a spatial and temporal exploration by the viewer to obtain a coherent mental image of the object.[45] Completed in 1971 for the exhibition *Sonsbeek 71*, destroyed because of its fragility, then reconstructed in Holland in 1977, *Observatory*, like Heizer's *Complex*, brings many spaces of reference into play, requiring nonstop movement from exterior to interior, the interior of one circle being also the exterior of another. Similarly, the work maintains a double relationship of expansion and compression with the sky. But if in Morris's work, as in Smithson's,

Michael Heizer, *Complex II*, (under construction), Garden Valley, Nevada, 1988.
Photographs by Michael Heizer. The volcanic rock surface makes the work appear as if it were covered with earth. Construction was done at night so that the cement of *Complex I* could keep its color. *Complex II* and *Complex III* are currently under construction.

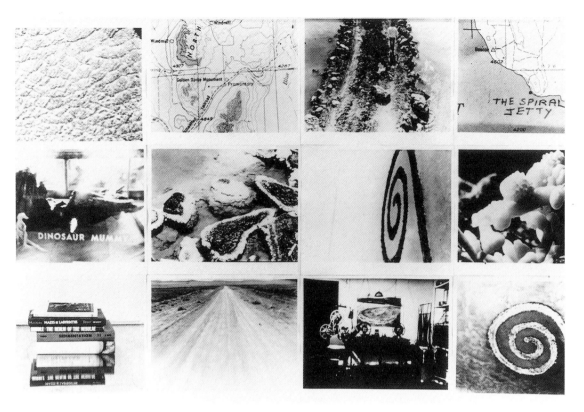

Robert Smithson, *Spiral Jetty Film Stills Photo Documentation.*
Document: 25 x 43-1/2 inches. Property of Robert Smithson.
Courtesy of the John Weber Gallery, New York.

"the size range of useless three-dimensional things is a continuum between the monument and the ornament,"[46] it is the human body that remains the unit of measure. The relationship of scale prevails, and the size is only interesting in that it permits the viewer to evaluate his or her own space. At the same time that it becomes familiar with the object, the ego discovers itself through the variations it perceives. Thus something that Morris had written several years earlier can also apply to *Observatory*: "In the perception of relative size the human body enters into the total continuum of sizes and establishes itself as a constant on that scale.... The awareness of scale is a function of the comparison made between that constant, one's body size, and the object."[47] This describes an *oriented* space, one that makes explicit reference to different directions that are determined by the rising and setting of the sun, and by the position of the equinoxes. In contrast to Smithson's work, in which the polarities cancel each other out, here the spaces fit together and even

glide into each other, and any *object*, whatever its size, loses itself in the unlimited scale of the *surd*.

At present, Smithson's spiral is underwater, invisible to those who visit the shores of Great Salt Lake. All that remain are the numerous photographs, and Smithson's film of the project, shot from a helicopter. The camera, perpendicular to the center of the jetty, takes a 360-degree panoramic shot while a flat, seemingly bored voice-over details the cardinal points and their intermediary positions, punctuating them each time with "mud, salt crystals, rocks, water."[48] The monotony of the voice "disorients" us, and the emptiness of the "absent presence" of the work makes us even more sensitive to the scale than Smithson could have imagined.

The connection between scale and size is expressed in a different fashion by each of the Land Art artists. For Heizer, the size clouds the scale, if it does not dissolve it within its transparent blue as a means of concealment. Nonetheless, it is not destroyed. Size is always evaluated in comparison to one of its elements, as opposed to proportion and scale, which are evaluated by their relationship to an exterior element. For Simonds, on the other hand, it is the size which is imaginary, and the scale is everything; the imaginary is essential, and is the core of his art. Yet his objects do exist, they are not merely concepts with names. Smithson positions himself between these two extremes. For him, size and scale are equally tangible. Morris, however, also considered size and scale to be equally real, but saw them as interdependent, since the body determines both of them simultaneously in its relation to its surroundings.[49] The following diagram summarizes this system of relationships. "Scale" and "Size" designate the scale and the size, respectively, and the plus and minus signs show the

status, whether real or imaginary, attributed to each by the four artists.

Heizer's art is undoubtedly less "literary" than that of Smithson or Simonds, or, if one prefers to use the term already established, more *literal*. But not less powerful. His gigantic *crystals* offer the eye nothing other than their size. One cannot evade them, circle them to measure oneself against them as one can with Morris's *Observatory*, or go from one sculpture to another, as with Smithson's *Broken Circle* to *Spiral Hill*, to lose all sense of measure. The object that

gives itself to the viewer is simultaneously what has already existed. The time of the present is already past.[50]

If one can speak of "primitivism" in Heizer's work, it is short of all representation, in the sense evoked by Hegel: "The original interest [of art] depends on making visible to themselves and to others the original objective insights and *universal* essential thoughts. Yet such national insights are abstract at first and indefinite in themselves, so that in order to represent them to himself man catches at what is equally abstract, i.e. matter as such, at what has mass and weight. This is capable of acquiring a definite form, but not an inherently concrete and truly spiritual one."[51]

**1** Robert Smithson, *Granite Crystal*, 1972.
Courtesy of the John Weber Gallery, New York.

**2** Robert Smithson, *Broken Circle/Spiral Hill*, Emmen, Holland, summer 1971.
*Broken Circle*. Diameter: approximately 140 feet; canal width: approximately 12 feet; canal depth: 10 to 15 feet.
*Spiral Hill*. Earth, white sand; approximately 75 feet at its base. The work, intended as a temporary installation, has become permanent at the request of the inhabitants of Emmen. Photograph by Gilles A. Tiberghien, 1992.

At that time, Smithson wrote that the following arrangements should be made to preserve the work:
"1. Digging the canal deeper (about 1-1/2 meters in all);
2. Filling in with sand the eroded areas in the pier;
3. Removing weeds from the hill.
Then, later in the spring, the permanent stabilizing and restoring with the wooden stakes can be done." (*Smithson Papers*, cited by Robert Hobbs, in *Robert Smithson Sculpture* [Ithaca and London: Cornell University Press, 1981], p. 214.)
As can be seen in recent photos, at present *Spiral Hill* is covered with evergreen plants and no longer has its original well-planned form, whereas the contours of *Broken Circle* have become much sharper.

Architecture and sculpture, as they exist, indistinguishable, in these "inorganic sculptures," are perpetually out-of-date. Additionally, Land Art is profoundly "unreal." In each of these artists' work, in diverse forms, there is something unnameable, something in the silence of the desert, which exists as if of an earlier time. "The relation to architecture is apparent. Sculptures of this size have never been built. The commemorative aspect is the fact that art is eventually a record anyway. Without trying, all art is commemorative."[52]

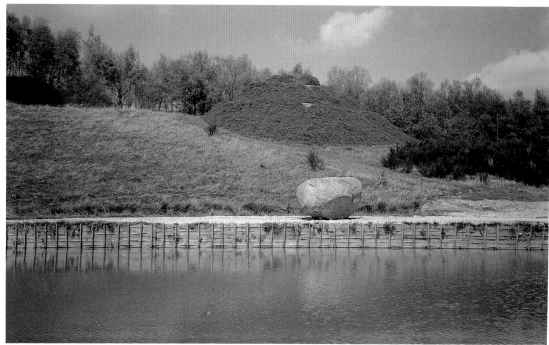

## DESCRIPTION OF MORRIS'S OBSERVATORY

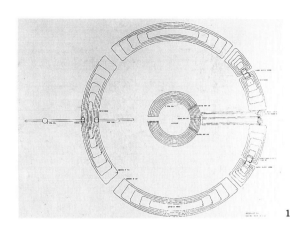

*The Observatory consists of concentric dyke-shaped rings: an outer ring of 91.20 m in diameter, and an inner ring of 24 m. The inner ring is built up of a row of impregnated pinewood planks (average 18 cm wide) connected top and bottom with girders, and covered with a layer of earth making an angle of 45°. The wood palisade is interrupted in four places: on the west by the 1.90 m wide entrance, and on the east by three vizier openings which measure 65 m across. The entrance and the central vizier opening are situated on the west-east axis. The two other vizier openings are situated 37° north and 37° south of the west-east axis. Each vizier opening affords a view of one of the marking points. Two of the three marking points are located on two different levels in the outer ring, called vizier dykes, accentuated by blocks of granite to form an angle of 100° between them. The outer ring consists of a dyke-shaped elevation, also with a gradient of 45°, which slopes down into a water-filled depth. A third marking point is situated at the end of a broad, rough track that has been drawn between the two steel vizier plates (3 x 3 x 0.02 m) between the vizier dykes cutting across the outer ring.*

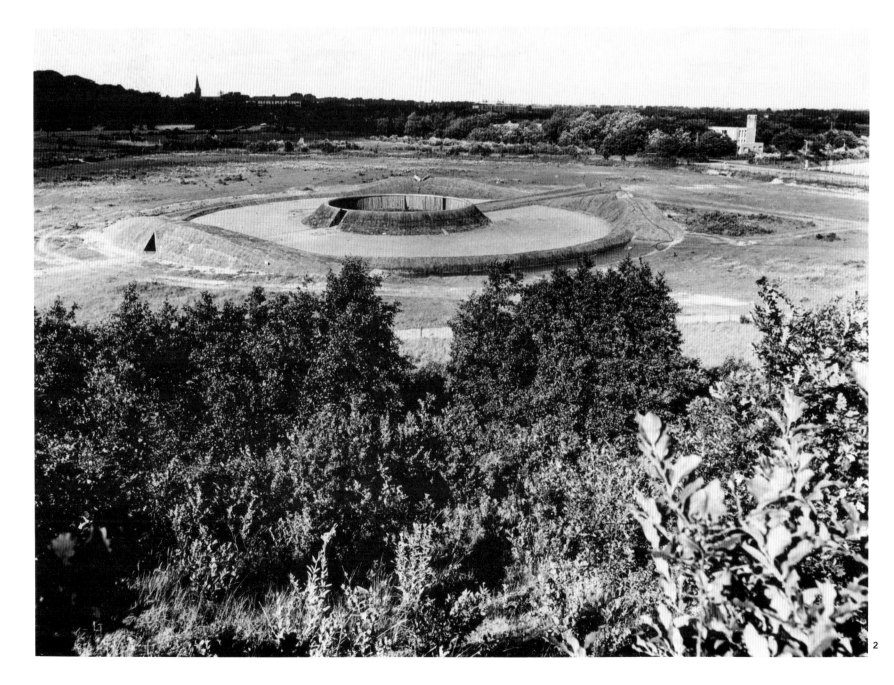

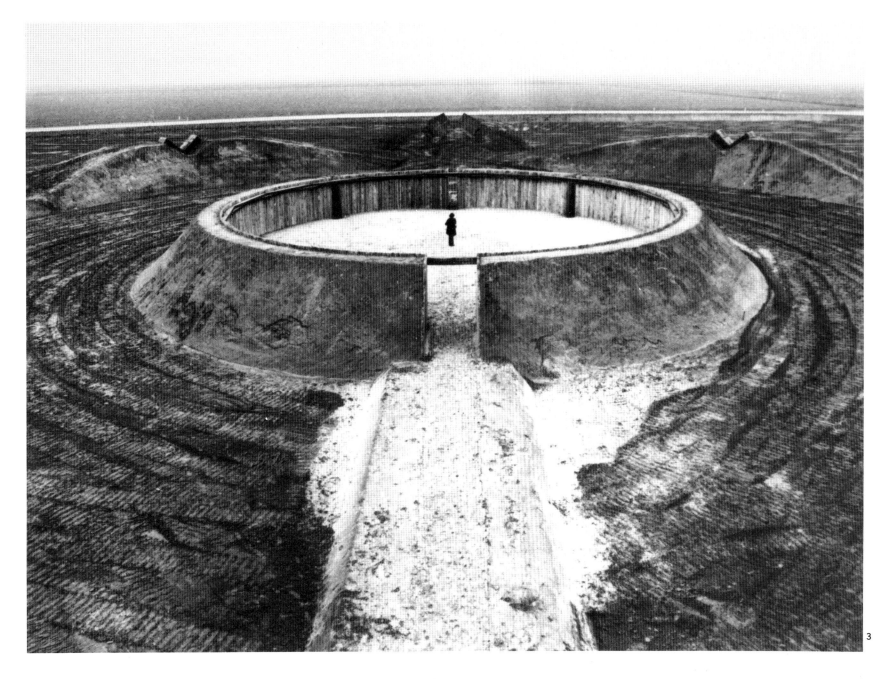

3

The plates are set slanting to the east, in such a way that the vizier edges of the plate form an angle of 60°. The first rays of the sun are caught between the plates, on the days of the year when day and night are exactly the same length. The north-eastern marking point is intended for observation of the first rays of the sun on the longest day (summer solstice); the south-eastern marking point is for observing the rising sun on the shortest day (winter solstice). The vizier dykes slope down into moats of a maximum depth of 2.5 m. On the other side of the moat the bank rises gradually into an elevation directly opposite the depth formed by the furrow which closes the outer ring.

In the middle of the 3.60 m high "tunnel dyke" on the east-west axis, a triangular wooden structure marks the entrance to the Observatory. The earth between the two rings has been removed down to 70 cm below the level of the surrounding area, except for a path on the east-west axis, which runs from the tunnel in the outer ring to the entrance in the inner ring.

Robert Morris, "Description of the Observatory in Oostelijk Flevoland," excerpt, *Het observatorium van Robert Morris* (Amsterdam: Stedelijk Museum, 1977).

**1** Robert Morris, *Observatory*, 1971.
Ink on paper, 42 x 85 inches. Collection of Gilman Paper Company, New York. Photograph by Rudolph Burckhardt. Courtesy of the Guggenheim Museum, New York.

**2** Robert Morris, *Observatory*, temporary installation in Ijmuiden, Netherlands, for the exhibition *Sonsbeek, 1971*.
Courtesy of the Guggenheim Museum, New York.

**3** Robert Morris, *Observatory*, Oostelijk Flevoland, Netherlands, 1977.
Earth, wood, and granite, diameter: 299 feet. Photograph by Pieter Boersma. Courtesy of the Guggenheim Museum, New York.

* "Interview, Julia Brown and Michael Heizer," *Sculpture in Reverse*, Julia Brown ed. (Los Angeles: The Museum of Contemporary Art, 1984), p. 36. A discussion of the Temple of Queen Hatshepsut at Thebes.

1. On Judd's and Morris's assimilation of real space into gallery or museum space, "a space which, until the contrary be proved, was the large, empty white room in which the Euclidean painter was supposed to put all the objects of his painting," and the paradoxes of such a conception, see Jean-Marc Poinsot, "In situ, lieux et espaces de la sculpture contemporaine," *Qu'est-ce que la sculpture moderne?*, op. cit., p. 323.

2. In an interview with Bruce Kurtz on April 22, 1972, Smithson declared, "[The museum is] an instrument of control and it's like building Cathedrals. I mean that's really an instrument of political control." (Robert Smithson, "Conversation with Robert Smithson on April 22nd 1972," Bruce Kurtz ed., *The Fox II* [1975]; reprinted in *The Writings of Robert Smithson*, op. cit., p. 201.)

3. Lawrence Alloway, "Talking with William Rubin," *Artforum* (October 1974), pp. 51–57. On the "shift away from the sacrosanct notion of the autonomy of a work of art, defended by Clement Greenberg, towards the notion of 'specific object'...and Carl Andre's concept of 'specific space' hinging on experiences of 'place,'" as well as on the ensuing consequences for the idea of the museum itself and its capacity to accommodate works of art of a new genre, see the brief statement by Catherine David, "L'invention du lieu," *Les Cahiers du Musée national d'Art moderne*, no. 17–18 (June 1986), pp. 114–118.

4. Robert Morris, "Notes on Sculpture II," *Artforum* (October 1966); reprinted in *Notes on Sculpture in Minimal Art, A Critical Anthology*, p. 230.

5. Robert Morris, "Notes on Sculpture," op. cit., p.233.

6. *The Writings of Robert Smithson*, op. cit., p. 47.

7. Robert Morris, "Notes on Sculpture," op. cit., p. 233.

8. Rosalind E. Krauss, *The Originality of the Avant-Garde and other Modernist Myths* (Cambridge, MA: MIT Press, 1985), p. 282.

9. Ibid., p. 283.

10. G.W.F. Hegel, *Aesthetics*, Vol. II, translation by T.M. Knox (Oxford: Clarendon Press, 1974), p. 632.

11. Ibid., p. 633.

12. Ibid., p. 633.

13. Ibid., p. 636.

14. According to Donald Judd, these "new works" in three dimensions were "neither painting nor sculpture." See "Specific Objects," *Arts Yearbook 8* (1965), and Donald Judd, *Ecrits 1963–1990*, translated from the English by Annie Perez (Paris: Daniel Lelong éditeur, 1991).

15. "The huge Memnon statues at Thebes had a human form; Strabo saw one of them preserved, chiselled out of a single stone, while the other which gave a sound at sunrise was mutilated in his time. These were two colossal human figures, seated, in their grandiose and massive character more inorganic and architectural than sculptural; after all, Memnon columns occur in rows and, since they have their worth only in such a regular order and size, descend from the aim of sculpture altogether to that of architecture." G.W.F. Hegel, *Aesthetics*, vol. II, op. cit., p. 643.

16. Ibid., p. 654.

17. Ibid., p. 653.

18. On the troubling similarity between these minimalist volumes and tombs (Tony Smith's *The Black Box*, with the suggestive height of six feet, Donald Judd's "boxes," Sol LeWitt's *Buried Cube*) see the unusual interpretation by Georges Didi-Huberman, "Ce que nous voyons, ce qui nous regarde," *Cahiers du Musée national d'Art moderne*, no. 37 (fall 1991), pp. 33–60; reprinted in Georges Didi-Huberman, *Ce que nous voyons, ce qui nous regarde* (Paris: éditions de Minuit, 1992).

19. Robert Morris, "Notes on Sculpture," op. cit. Judd's "specific objects" did have color. This is not the only difference from the structures created by Morris, but here the focus is on what these artists have in common.

20. Ibid.

21. Aloïs Riegl, *Grammaire historique des arts plastiques*, translated from the German by Eliane Kaufholz (Paris: Klincksieck, 1978), p. 64.

22. Ibid., p. 133.

23. Robert Smithson, "Frederick Law Olmsted and the Dialectical Landscape," *Artforum* (February 1973); reprinted in *The Writings of Robert Smithson*, op. cit., p. 122.

24. Michael Heizer, "Interview, Julia Brown and Michael Heizer," op. cit., p. 15.

25. Aloïs Riegl, *Grammaire historique des arts plastiques*, op. cit., p. 63.

26. Robert Smithson, "Donald Judd," 7 *Sculptors* (Philadelphia: Philadelphia Institute of Contemporary Art, 1965); reprinted in *The Writings of Robert Smithson*, op. cit., p. 22. This entire paragraph was also included in Robert Smithson, "Entropy and the New Monuments," *Artforum* (June 1966); reprinted in *The Writings of Robert Smithson*, op. cit., p. 17. Smithson added that the axes in question, however, did not correspond to any natural crystal, since without the tension and equilibrium established by the axes, Judd's box would collapse. What most interested Smithson was the exchange between interior and exterior. Moreover, he was as attentive to the crystal's structural development as he was to its form.

Five of the twenty reference images that Heizer collected beginning in 1971 and later published in the Museum of Contemporary Art catalog on the occasion of his exhibition in 1984: **1**. Mai-chi-shan, China, 692 A.D. **2**. Abu Simbel, Egypt, 1500 B.C. **3**. Goa Gadjah, Bali, Indonesia, 10th century A.D. **4**. Mamallapuran, India, 625 A.D. **5**. Ajanta, India, 470 A.D.

27. "Characteristic of a gestalt is that once it is established all the information about it, *qua* gestalt, is exhausted." (Robert Morris, "Notes on Sculpture," op. cit., p. 228.) Rosalind Krauss emphasizes that this phrase does not mean the gestalt is "an unchanging ideal unity" that comes before experience, since the signification of a gestalt always varies with experience (Rosalind E. Krauss, *The Originality of the Avant-Garde and other Modernist Myths*, op. cit., p. 54.).

28. E.H. Johnson (*Modern Art and the Objects*, op. cit., p. 40) notes the importance of the combination of two essential factors in Land Art: process and gravity.

29. Michael Heizer, "Interview, Julia Brown and Michael Heizer," op. cit., p. 14. *Displaced/Replaced Mass* was purchased by Robert Scull, from whom Heizer later bought it back. It is presently located near the artist's ranch in Nevada.

30. Smithson made this work a gift to Kent State University, stipulating that "Everything in the shed is part of the art and should not be removed. The entire work of art is subject to weathering which should be considered part of the work." See Robert Hobbs, *Robert Smithson: Sculpture*, op. cit., p. 191. See also Lawrence Alloway, "Robert Smithson's Development," *Art in the Land, A Critical Anthology of Environmental Art*, op. cit., p. 137. With this work, Smithson was returning to entropy, one of his favorite themes.

31. On Gordon Matta-Clark, see the catalog of the exhibition *Gordon Matta-Clark: A Retrospective* (with an introduction by Robert Pincus-Witten), organized in 1975 at the Museum of Contemporary Art in Chicago by Mary Jane Jacob.

32. Michael Heizer, "Interview, Julia Brown and Michael Heizer," op. cit., pp. 15–16.

33. Ibid., p. 34.

34. Heizer was already aware of the connection between architecture and sculpture because of his friendship with Tony Smith. Smith had long been interested in crystallography, and some of his works (for example, *Ten Elements*, 1975) were inspired by crystal forms that had the advantage of breaking with strict orthogonality, as Jean-Pierre Criqui points out. But, Criqui states, because they "also possess a plasticity, a fluidity of articulation that establishes a parallel to figurative sculpture," these sculptures had an "openly anthropomorphic" nature. After showing how the volumes making up *Ten Elements* form a unified whole, he adds that "other works—*Gracehoper, Smoke, Smog*— verge on architecture, an organic architecture in progress, that has no function." (Jean-Pierre Criqui, "Trictrac pour Tony Smith," op. cit., p. 49). Smithson's *Spiral Jetty, Broken Circle, Spiral Hill*, and *Amarillo Ramp* could be categorized between organic architecture (Smith's work) and inorganic sculpture (of which Heizer's *Complex* series is the best example).

35. Robert Smithson, "The Spiral Jetty," *Arts of the Environment*, Gyorgy Kepes ed. (New York: Braziller, 1972); reprinted in *The Writings of Robert Smithson*, op. cit., p. 112.

36. Robert Smithson, "The Earth, Subject to Cataclysms, is a Cruel Master," interview with Gregoire Muller, *Arts Magazine* (November 1971); reprinted in *The Writings of Robert Smithson*, op. cit., p. 179.

37. Robert Smithson, "The Spiral Jetty," *The Writings of Robert Smithson*, op. cit., p. 112.

38. *The Writings of Robert Smithson*, op. cit., p. 113. It would be useful to be able to cite the entire text. For example: "After a point, measurable steps ('Scale skal n. It. or L: lt. *Scala*; L *scala* usually scalae pl., l.a. originally a ladder; a flight of stairs; hence, b. a means of ascent') [Webster, 1969] descend from logic to the 'surd state.'" (Ibid., p. 112.)

39. Claude Lévi-Strauss, *The Savage Mind* (Chicago: University of Chicago Press, 1966), pp. 23–24, p. 35.

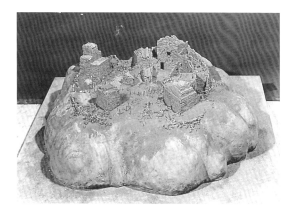

*Abandoned Observatory*, Charles Simonds, 1976. Photograph by Musée national d'Art moderne, Centre Georges-Pompidou, Paris.

However, according to Lévi-Strauss, even monumental works function as reduced models: "The paintings of the Sistine Chapel are a small-scale model in spite of their imposing dimensions, since the theme which they depict is the End of Time." (Ibid., p. 23.) This debatable point will not be discussed here.

40. Charles Simonds and Daniel Abadie, *Art/Cahier 2* (Paris: SMI, 1975), p. 11.

41. Lucy R. Lippard, *Overlay, Contemporary Art and the Art of Prehistory*, op. cit., p. 234.

42. Philippe Boudon, *Essai d'épistémologie de l'architecture* (Paris: Dunod, 1971; second edition, 1977), p. 45.

43. G.W.F. Hegel, *Aesthetics*, vol. I, op. cit., p. 363.

44. Michael Heizer, "Interview, Julia Brown and Michael Heizer," op. cit., p. 33.

45. In "Some Notes on the Phenomenology of Making," *Artforum* (April 1970), Morris stated that he was trying to create an experience of interaction between the body and the world, with the terms of this interaction being temporal as well as spatial, to thus bring to light "…that existence is process, that the art itself is a form of behavior."

46. Robert Morris, "Notes on Sculpture," op cit., p. 230. Regarding *Observatory*, Morris declared: "I hadn't had the idea of building an object, but shaping space, and I think that's also not…well, it is closed architecture, but it isn't architecture, so I think it's in between, if you want to say that…it lies between sculpture and architecture…" From "Interview with Robert Morris," *Het observatorium van Robert Morris/Robert Morris's Observatory in Ookstelijk*

*Flevoland* (Amsterdam: Stedelijk Museum, 1977).

47. Robert Morris, "Notes on Sculpture," op. cit., pp. 230–231. Here as well, phenomenology is an obvious source of theoretical inspiration for Morris.

48. Until the moment Smithson arrives at *North by Northwest*, thus making explicit the obvious reference to the famous scene in Hitchcock's film, in which Cary Grant is pursued by a plane. Robert Hobbs has pointed this out in his book *Robert Smithson: Sculpture*, op.cit., p. 193.

49. "When we say that an object is huge or tiny, nearby or far away, it is often without any coparison, even implicit, with any other object, or even with the size and objective position of our own body, but merely in relation to a certain 'scope' of our gestures, a certain 'hold' of the phonomenal body on its surroundings." (Maurice Merleau-Ponty, *Phenomenology of Perception*, translated by Colin Smith [London: Routledge & Kegan Paul, 1962], p. 266.)

50. Or possibly to come. Heizer, who questions the importance of making art for his "contemporaries," says, "Obviously these works are pointed at the future." (Michael Heizer, "Interview, Julia Brown and Michael Heizer," op. cit., p. 34.)

51. G.W.F. Hegel, *Aesthetics*, Vol. II, op. cit., pp. 635–636.

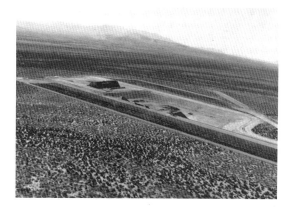

Michael Heizer, *Complex I* (at rear), *Complex II* (at left), (aerial view of work in progress), Garden Valley, Nevada, 1989. Collection of the artist and of Virginia Dwan. Photograph by Michael Heizer.

52. Michael Heizer, "Interview, Julia Brown and Michael Heizer," op. cit., p. 34. If, as Hubert Damisch says, "what has been called modern effort implies a kind of return to basics, to the foundations of art, to art's origins, if not to its essence" (Hubert Damisch, "Attention: Fragile," *Art Minimal II, De la surface au plan*, under the direction of Jean-Louis Froment, Michel Bourel, and Sylvie Couderc [Bordeaux: Cape, musée d'Art contemporain, 1987], p. 11). This "modern effort" was engaged for each art form within its "domain of competence," according to Greenberg's formula. This "return" to the actual foundations of art and not solely of the arts occurred for the artists who are sometimes classified as "postmodernists," such as Smithson and Heizer.

# CHAPTER 3

# THE LAND AND THE SITE

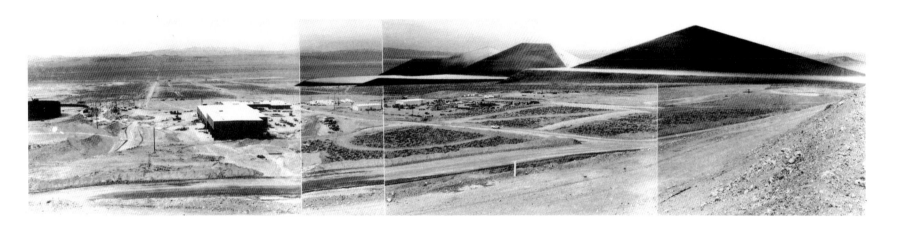

Michael Heizer, photographic study for *Geometric Land
Sculptural/Anaconda Project*, Tonopah, Nevada, 1981.
This work, commissioned by the Anaconda Minerals Company, was
never completed. Photograph by Michael Heizer.

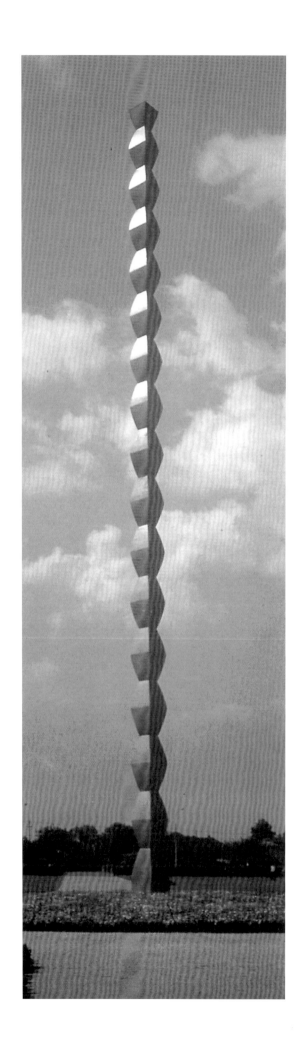

Brancusi, *Endless Column*, Tirgu Jiu, Rumania, 1935–1938.
96 feet 2-7/8 inches x 35-3/8 inches x 35-3/8 inches. Rights
reserved.

Although the site is of primary importance for the Land Art artists, its meaning varies for each of them, relative to the permanence of their work. In each case, however, the primary material used is earth, which includes rocks, sand, mud, tree bark, and volcanic deposits. Monumental sculpture, traditionally rooted by a pedestal to its place of inscription, was conceptually united with the place where it was situated and had always had a commemorative function. Rosalind Krauss has defended the well-known theory that the rejection by the *Societé des gens de lettres* of Rodin's *Balzac* was the symbolic sign of a change in modern sculpture, which no longer had a specific connection to its site. The disappearance of the pedestal, even though purely emblematic for Brancusi, accentuates the nomadic character of the work. According to Sidney Geist,[1] the same axial disposition, the same dimensions, and the same distance can be found in Brancusi's *Table of Silence, Gate of the Kiss,* and *Endless Column* (the three elements of the monument of Tîrgu Jiu, constructed in Rumania between 1935 and 1938 to commemorate the defense of the town against the Germans during World War I) as in the Obelisk of la Concorde, l'Arc de Triomphe des Tuileries, and the great circular garden of the Carrousel. Using this study as a basis, Krauss has seen in this parallel a "mental projection," a "conceptual telescoping" that prefigured Smithson's "nonsites." "The traditional sculptural monument establishes a vertical order, in which a representation dominates its place of installation," she wrote. With the *earthworks*, this order is changed. "Thus sculpture can reach vast proportions, not to encompass a site, but rather to take into account the challenge that the site poses to the form. The breakdown of the limits of the means of plastic expression as

**1** Brancusi, *Gate of the Kiss,* Tirgu Jiu, Rumania, 1935–1938. Travertine, 17 feet 3-1/2 inches x 21 feet 7-1/8 inches x 6 feet 1/2 inches. Photograph courtesy of Musée national d'Art moderne, Centre Georges-Pompidou, Paris.

**2** Brancusi, *Table of Silence,* Tirgu Jiu, Rumania, 1935–1938. Travertine, 31-1/2 inches high, 84-5/8 inches in diameter. Photograph courtesy of Musée national d'Art moderne, Centre Georges-Pompidou, Paris.

well as the nonsite may also initiate a practice that cannot be adequately defined using the term sculpture."[2] This is why, rather than use the word "sculpture," Krauss prefers to speak of an "expanded field."

The issue of the monument is closely linked with that of the site. In reflecting upon the space of sculpture, artists like Morris, Judd, and Andre—and before them, Barnett Newman, who had jokingly said that a sculpture was the thing one bangs against when one steps back to look at a painting—looked for solutions able to modify what Jean-Marc Poinsot calls their *"mise en vue."* For Morris, the move away from the galleries was a part of the logic of phenomenological reflection oriented towards the space and concerned with a certain type of self-experience. In the 1960s, Carl Andre, fascinated by Brancusi, made Brancusi's *Endless Column* run the length of the floor, in brick lines or in pieces of wood, inside or outside the galleries. At the *Primary Structures* show at the Jewish Museum in 1966, he exhibited a line of heat-resistant bricks arranged so as to "engender" a place. Andre declared, "A place is an area within an environment which has been altered in such a way as to make the general environment more conspicuous. Everything is an environment, but a place is related particularly to both the general qualities of the environment and the particular qualities of the work that has been done."[3]

Thierry de Duve's critical theory attempts to show that contemporary sculpture, of the last twenty years in particular, is an attempt to reconstruct the notion of site at the same moment that it tends to disappear.[4] He relates this definition to Tony Smith's experience, saying that the road is a place "intended to intensify the perception of the proliferating suburbs or of the industrial zoning that adjoins it, a sort of revealer of experience." This is an experience of

Michael Heizer, *Double Negative*, Mormon Mesa, Overton, Nevada, 1969–1970.
Displacement of 240,000 tons of rhyolite and sandstone. Collection of the Museum of
Contemporary Art, Los Angeles, California. Photograph by Gianfranco Gorgoni, Sygma.

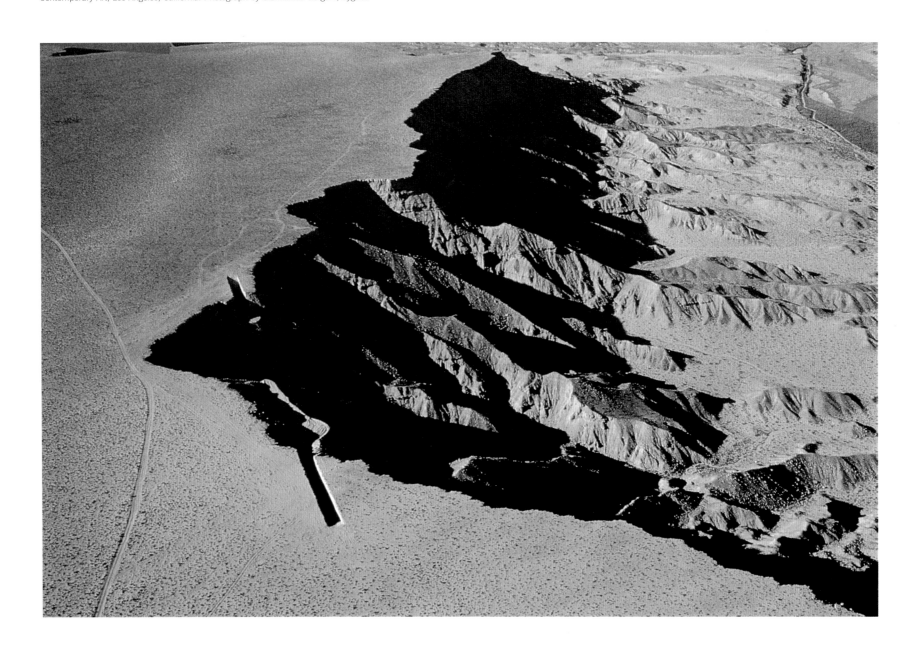

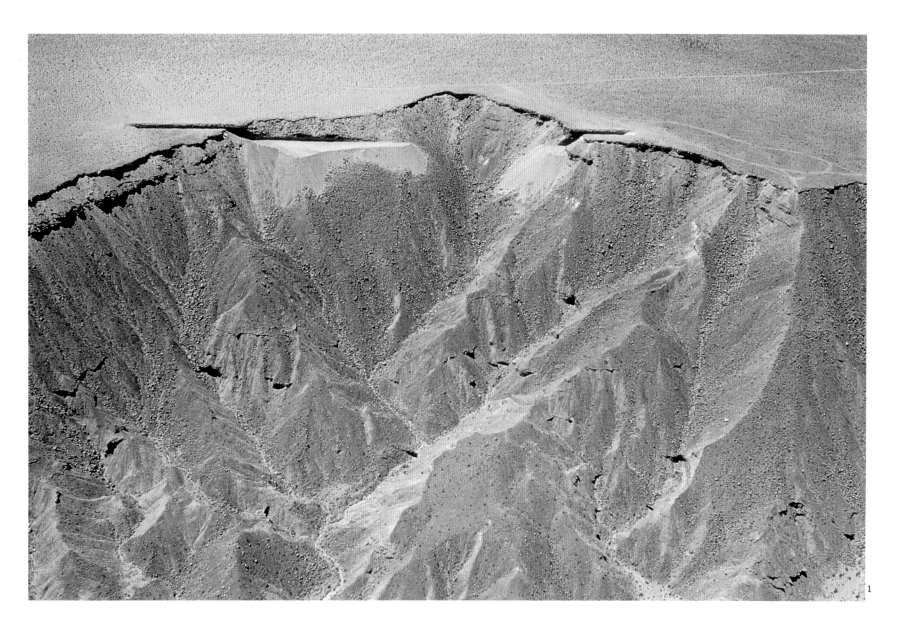

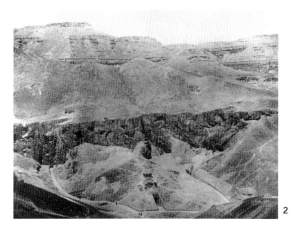

**1** Michael Heizer, *Double Negative*, Mormon Mesa, Overton, Nevada, 1969–1970 (aerial view).
Photograph by Gianfranco Gorgoni, Sygma.

**2** Thebes, Egypt, 1375 B.C.
Courtesy of Nate McBride.

the road, in the style of Long and Fulton, in which the artist is content to move some stones "to mark not a site, since only the artist is there to enjoy it, but a situation, and specifically, as Fried said, an abandoned situation."[5]

In many respects, this disappearance of the site is confirmed on the theoretical level by Smithson, who, of all the Land Art artists, was undoubtedly the most troubled by this issue. Insisting on the existing connections between language and art, he

wrote in 1967: "It is important to mentally experience these projects as something distinctive and intelligible. By extracting from the site certain associations that have remained invisible within the old framework of rational language, by dealing directly with the appearance of what Roland Barthes calls 'the *simulacrum* of the object,' the aim is to reconstruct a new type of 'building' into a whole that engenders new meanings....Tony Smith seems conscious of this 'simulacrum' when he speaks of an 'abandoned airship' as an 'artificial landscape.' He speaks of an absence of 'function' and 'tradition.'"

Referring to the interview between Tony Smith and Samuel Wagstaff, Smithson compared the road that Smith had traveled that night to the structure of a phrase: "Tony Smith writes about 'a dark pavement' that is 'punctuated by stacks, towers, fumes and colored lights.' The key word is

Michael Heizer, *Double Negative*, Mormon Mesa, Overton, Nevada, 1969–1970.
**1, 2** Photographs by Michael Heizer.
**3** Photograph by Gilles A. Tiberghien, 1991.

'punctuated.' In a sense, the 'dark pavement' could be considered a 'vast sentence,' and the things perceived along it, 'punctuation marks.' '...tower...' = the exclamation mark (!). 'stacks...' = the dash (-). '...fumes...' = the question mark (?). '...colored lights...' = the colon (:). Of course I form these equations on the basis of sense-data and not rational-data."[6] Thus, he continues, the horizon line contains a whole syntax of separate "things."[7]

The landscape becomes the punctuation of a place against the background from which it unfolds, and it is meaningless without the story that describes it. It is this story itself that only the place can make legible, like sentences that follow one another on the blank page of a book. This is quite similar to Carl Andre's definition: "My idea of a piece of sculpture is a road."[8] The place, or the site, allows something "other" to become visible; in this sense it is a non-place, prefiguring the discussion later elaborated by Smithson. It is an *abandoned situation*, but it is this abandonment which permits a huge investment of speech, its reflux in things. It radicalizes a situation where the loss of meaning (aesthetic, ethical, even political) is expressed by a need filled with significations. The world abounds with things which, once declared, can attain the status of object and finally of work of art, within the syntax of artistic discourse. Smithson wrote in the same text, "'Site Selection Study' in terms of art is just

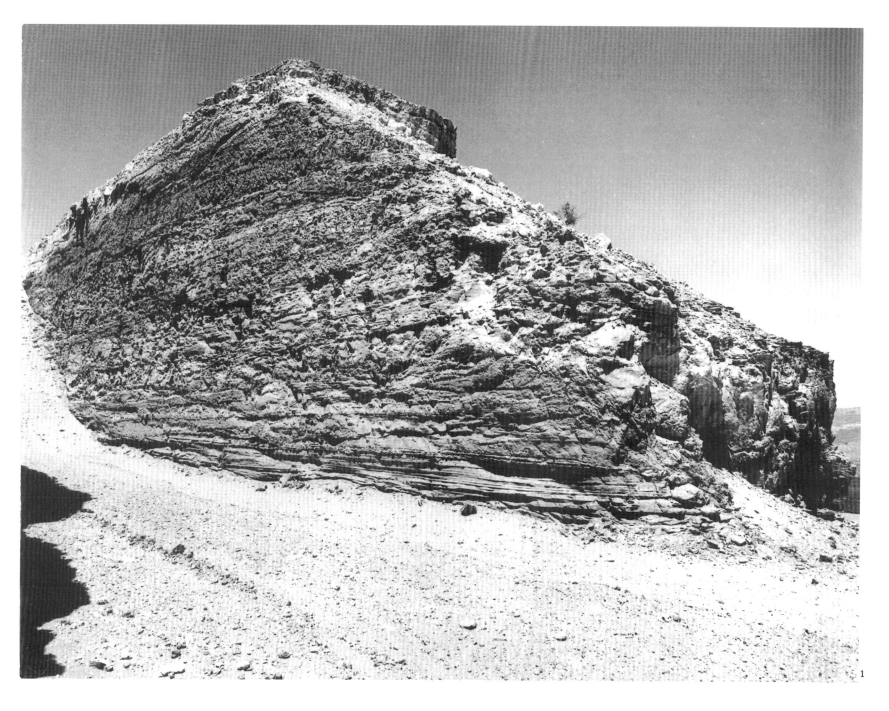

1

**1** Michael Heizer, *Double Negative*, Mormon Mesa, Overton, Nevada, 1969–1970.
Photograph by Michael Heizer.

*following pages:*
**2, 4** Photographs by Gianfranco Gorgoni, Sygma.
**3** View from *Double Negative*. Photograph by Tom Vinetz.
"What can be said about a work of art that can't even be seen. The north and
south cuts function simply to imply or persuade a volue in between. Whatever
sculptural qualities these setups might or might not have are coincidental."
From *Michael Heizer* (Essen: Museum Folkwang Essen and Otterlo: Rijksmuseum
Kröller-Muller, 1979), p. 30.

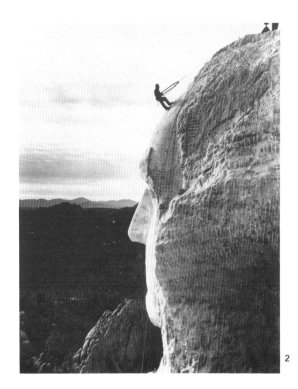

**1** Gutzon Borglum, *Mount Rushmore*, South Dakota, 1927–1941. Photograph by Hiroji Kudota, Magnum, Paris.

**2** *Mount Rushmore* (the head of George Washington under construction).
Photograph by Roger-Viollet, Paris.

**3** *Mount Rushmore* (the head of George Washington under construction).
Photograph by Roger-Viollet, Paris.

beginning. The investigation of a specific site is a matter of extracting concepts out of existing sense-data through direct perceptions. Perception is prior to conception, when it comes to site selection or definition. One does not *impose*, but rather *exposes* the site—be it interior or exterior. Interiors may be treated as exteriors or vice versa. The unknown areas of sites can best be explored by artists."⁹

Thus, Smithson does not seek to impose traditional meanings, inherited from critical, humanist, art historical categories, onto things. He simply wants to give the discourse a perceptible form, and to consider words as things in the general scope of language. If Smithson's first nonsites have a status comparable to Andre's "place," it is still necessary to specify that the process of "dematerialization" for Smithson is rather a sort of de-localization, whereas for Andre, once the exhibition is over, the lines of bricks are not carted away; instead, they completely disappear, and the artwork ceases to exist.¹⁰

These sites and works could be considered inseparable, which is meaningful in the context of the disappearance of the site. However, the relationship of sculptures to their sites is more complex, for geographi-

cal, historical, and semiological reasons. If the work is understood through its site, the site, inversely, is understood through the work, and takes on new meaning. From this point of view, it is undoubtedly Heizer who produced the most radical object in the whole history of Land Art: *Double Negative*. After leaving the Overton airport, and then anxiously watching the distance traveled tick by on the odometer, we finally approach the site, arriving on the edge of the plateau, and the valley appears ahead. The wide river in the distance, surrounded by greenery, contrasts powerfully with the desert of stones around it. Only then do we discover the gigantic excavation at our feet that irresistibly attracts our vision and leads it to the other edge of the fault. It is not necessary to point out that photographs cannot capture this experience, not only because of the limits of the medium, but also because one almost never sees in the reproduced images this *double* liquid highlighted by two patches of bright-green vegetation, which, at the site, are impossible to ignore. One of the effects of this contrast is precisely the austere and imposing beauty of *Double Negative*, its colossal simplicity.

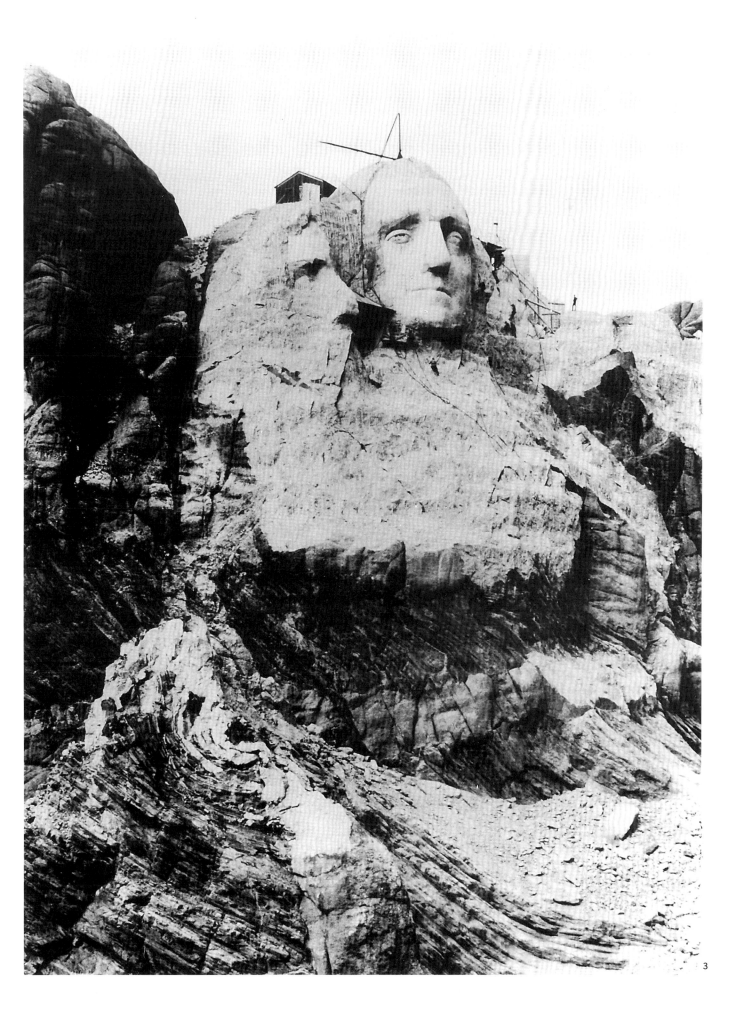

3

Certainly, it is impossible to get to the center of a work such as *Double Negative*, but this is essentially because the site *is* the work itself. Heizer liked to compare *Double Negative* to another sculpture, which is scorned, or at least, considered as completely minor: the *Mount Rushmore National Memorial*, created by Gutzon Borglum in South Dakota between 1927 and 1941. For Heizer, this memorial is a direct descendant of the realism characteristic of American art history, while still evoking the monumental sculpture of the four pharaohs of Abu Simbel.[11]

Heizer dislikes using the word "site" to discuss sculpture: "...I haven't yet seen a work of art that is referential to its location. This type of identification would have you believe that the art was related to the place, with the place being primary. The sculpture in the Dakotas [Mount Rushmore] is made of the material of its place, as is the *Double Negative*. The intaglio in the face of the mountain flows into the mountain. The sculpture does not use the mountain as content, but simply imprints it with recognizable image. This does not connote relationship to place. The faces themselves could be anywhere."[12]

This does not mean that the site holds no importance, but it does signify that the work does not belong to any specific site. The site does not come before the work, nor is it first in relation to it; rather, it is the work that constitutes the site and gives the site its identity. To think the opposite would be as simplistic as to think that the constraints of the material determine the forms of the sculpted object.[13] *Double Negative* could have been located elsewhere. It would have been a completely different sculpture, even if the concept had been the same. In this sense, Heizer has reason to keep his work independent from the general site. But his creation carries along *ipso facto*

1 Dennis Oppenheim, *Sitemarker 8*, Port Jervis, New York, 1967. Document: black and white photograph and text, 20 x 24 inches. Engraved aluminum post: 5 x 3 x 9 inches. Courtesy of Dennis Oppenheim.

2 Dennis Oppenheim, *Gallery Transplant*, 1969. Plan of gallery 4 of the Stedelijk Museum, Amsterdam, "transplanted" to a snow-covered slope near Kearny, New Jersey, January 1969. Document: black and white photograph, floor plan, topographic map, 6 x 40 inches. Courtesy of Dennis Oppenheim.

that of the site as well, thus engendering a relationship of reciprocal belonging.

Notably different from Heizer, Oppenheim admitted that it was the question of site, more than the use of earth as such, that drove him to construct his *earthworks*. With *Wedge* (1967), a portion of mountain in Oakland, California, replaced by a sheet of Plexiglas, Oppenheim began to become interested in earth as the material central to his work. His concern was more to create a dynamic relation with the site in terms of inscriptions or markings, than to build objects that resisted time.[14] The expression "Site Marker," used by Oppenheim in 1967 to designate the posts on which is written information about the site, is characteristic in this sense. Moreover, Oppenheim claims the heritage of Duchamp, his horror of the "*métier*" and his deliberate use of "found objects," while borrowing his conceptual system of documentation. He declared, "So, in the exhibition starting with the site-markers in '67, these were very much an attempt to deal with activities outside object making in an attempt to find a region that would again be fertile for so-called advanced art making."[15] In a sense, these markers were indicators designating pre-existing sites. According to Oppenheim, the location takes the place of the object. This was the origin of the idea of *Viewing Stations*, "observatories" constructed by the artist to exhibit the space of the gallery itself.

Oppenheim declared, "...my simple act of issuing a stake and taking up a photograph of the piece and claiming, pointing out where it was on the map and describing it on the document was sufficient because... the need to replicate, duplicate or manipulate form was no longer an issue. So, beginning with the site-markers started in a sense a journey: art is travel..."[16] This idea of travel is not the same as Richard Long's,

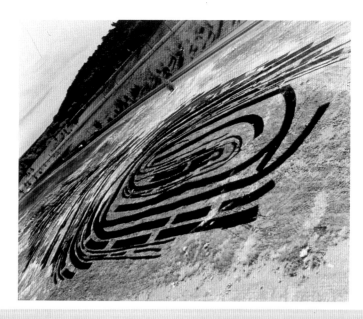

```
IDENTITY STRETCH. 1970-1975.
HOT SPRAYED TAR. 300' X 1000'  ARTPARK, LEWISTON, NEW YORK.
LEFT PRINT: RIGHT THUMB, ERIK OPPENHEIM. RIGHT PRINT: RIGHT THUMB, DENNIS OPPENHEIM.
PRELIMINARY PROCEDURE: THUMB PRINTS MADE ON ELASTIC MATERIAL, PULLED TO MAXIMUM, THEN
PHOTOGRAPHED. LEWISTON SITE SURVEYED FOR GRID INSTALLATION, USING WHITE MASON'S LINE.
SPRAY TRUCK WORKED WITHIN GRID, FOLLOWING APPROXIMATE COURSE MADE UP OF ENLARGED
PAPILLARY RIDGES OF ELONGATED AND PARTIALLY OVERLAPPING THUMBPRINTS.
```

Dennis Oppenheim, *Identity Stretch*, Artpark, Lewiston, New York, 1970–1975.
Tar, 300 x 1000 feet. Left fingerprint: Erik Oppenheim's right thumb. Right fingerprint: Dennis Oppenheim's right thumb. "Preliminary proce-dure: thumb prints made on elastic material, pulled to maximum, then photographed. Lewiston site surveyed for grid installation, using white mason's line. Spray truck worked within grid, following approximate course made up of enlarged papillary ridges of elongated and partially overlapping thumbprints." Courtesy of Dennis Oppenheim.

which focused instead on walking. This is because a voyage also suggests the idea of transport—here of *transfer*—which assumes that something—information in this case—is moved, not just the body. This notion of transfer is the basis of a certain number of operations, from the "transplantation of galleries" (Oppenheim completed a series called *Gallery Transplant* in 1969), to the projection on the ground of the enlarged right thumbprints of the artist and his son on a surface 1000 feet long and 300 feet wide (*Identity Stretch*, 1970–1975), as well as the markings drawn by the sun in the shape of a book on the artist's own body (*Reading Position for Second Degree Burn*, 1970).[17]

For Oppenheim, the site essentially plays the role of a surface for inscription on which produced objects and signs change their functions, so that the world becomes an *ensemble* to be deciphered. In *Directed Seeding-Canceled Crop* (1969, Finsterwolde, Holland), the artist's act symbolically substitutes for the process of production, of which nothing remains but the (aesthetic) form—a drawn X that follows the diagonals of the field—of its own (economic) negation. To re-state Jean-Louis Bourgeois's comparison, the site is like the score for the musician, which he "reads" while hearing the music.[18] This game of signs is extremely evident in the work of artists such as Oppenheim, Walter De Maria, and Richard Long, who intervene only "superficially" in the landscape.

More specifically, these artists are interested in the conventional signs that allow measurement of space and time. Since the beginning of the 1960s, Morris created objects (*Three Rulers [Yardsticks]*, 1963; *Enlarged and Reduced Inches*, 1963; *Swift Night Ruler*, 1963, etc.)[19] that all revolve around units of measure. Annette Michelson writes, "The subversion of

1  Robert Morris, *Three Rulers (Yardsticks)*, 1963. Wood and metal rulers painted gray, 41 1/2 x 12 inches. Abrams Collection, New York. Courtesy of the Guggenheim Museum, New York.

2  Robert Morris, *Swift Night Ruler*, 1963. Ruler covered with fluorescent paint, placed in a wooden frame painted in two tones of gray: the ruler is moveable along its longitudinal axis, 10 x 28 1/2 x 1 inches. Collection of Mr. and Mrs. Castelli, New York. Courtesy of the Guggenheim Museum, New York.

measure is a kind of primary theme in Duchamp as in Morris. It is linked to the notion of process (the measure creating itself through chance, falling) and more particularly to the creation of a socially-critical dimension of irony."[20] But in fact, as is true for scale and size, measurement is brought back to its original standard, the body. The body determines our perception of space, and its movement delineates the site, showing its potential lines, but also blurring its contours.

The problem of measurement is often linked to that of orientation. When the viewer walks through De Maria's *Lightning Field*, he perceives rocky silhouettes at the horizon whose boundaries seem to move with him. Far from being staid landmarks, the stakes (planted in the ground at regular intervals, in a rectangle one mile by one kilometer), produce an indifferentiation of points of view that only the vision of the Log Cabin, when the viewer is face to face with it, can break. The virtual space thus created by the work in daylight produces almost a *floating effect*. This is quite different than what one experiences when one walks through Morris's *Observatory*, where, in spite of the flatness of the terrain, the presence of trees along one whole side captures the eye. It is necessary only to enter the work, and to move from one circle to the other and throughout the zone that they delineate, in either direction, for the space to seemingly expand, the site to seemingly breathe. *Observatory* thus appears to vanish before the experience that it provokes. Such is Morris's wish: "I am concerned with spaces that one enters, passes through, literal spaces, not just a line in the distance, but a kind of space the body can occupy and move through."[21]

De Maria had already worked with the interference of units of measurement in creating *Las Vegas Piece* in 1969. The work

Walter De Maria, *Las Vegas Piece*, Desert Valley, Nevada, October 1969.
Collection of the artist. © Walter De Maria, 1969.
*Las Vegas Piece* is a right angle formed by two straight lines, each one mile long, oriented north-south and
east-west, whose respective north and west extremities join to form the angle. Off of each straight line there
is another line one half mile long, one toward the east, the other toward the south. Their respective east
and south extremities also join and form a square with the other straight lines. The lines are trenches in the
earth eight feet wide. The curved lines are formed by natural streams.

**1**  Lines in the Nazca desert.
Photographed by Roger-Viollet, Paris.
The majority of the lines in the earth in the Nazca region of Peru were created between 300 B.C. and 800 A.D. Certain "geoglyphs" measure more than 300 feet. The meaning of these lines is still unknown even if it is generally accepted that they are related to religious rites to assure the fertility of the soil. Maria Reiche, author of *Mystery on the Desert* (1968), asserts that these inscriptions were related to astronomical observations. The use of the earth as a surface for inscription, the geometry of many of these drawings, their large scale, and their sacred connotations, as well as the necessity to view them by plane to see them in entirety and without distortion, were a great inspiration to the Land Art artists. (See Robert Morris's article on p. 285 of this book.)

**2**  Richard Long, *Walking a Line in Peru*, 1972.
Photograph: 32-1/4 x 44 inches. Private collection. Rights reserved.

1

WALKING A LINE IN PERU

1972

was made up of four cuts in the ground, two that were one mile long and two that were a half-mile long, intersecting at a right angle in the Nevada desert, not far from *Double Negative*. One finds the same intention in *Lightning Field*, which forms a rectangle of one mile by one kilometer. Simply drawn in the ground, these lines evoke the lines of Nazca, Peru, that Richard Long had walked along (*Walking a Line in Peru*, 1972), and which, according to Morris, now have a radically new aspect for us—specifically because of minimalism—whose aesthetic has transformed our view. The network that they constitute, as an arrangement of markings, produces a flattening effect close to drawings, plans, or diagrams, from which the first minimalist works originated.[22] This is also the case, from a certain point of view, for any site traversed by Long, whose tracks mix with animal and other human prints: "A walk is just one more layer, a mark, laid upon the thousands of other layers of human and geographic history on the surface of the land."[23] The fundamental measurement nonetheless remains that of the human body; the footstep gives us an immediate evaluation of time and space, but cannot be used to conceive or calculate distances that extend indefinitely. During his travels, Long adapts his walks to nature, and in return, gives nature a physically intelligible dimension. In *surveying* the countryside, the deserts, and the mountains, he gives them a new configuration and composes them as sites (from this point of view, Richard Long's photograph in Rudi Fuchs's book, shown next to the photograph of *The Long Man of Willington*—the giant form of a surveyor drawn in chalk on the ground between the first and the seventh century— is emblematic).

It is most often from the sky that these works, and the sites that the works have

**1** *The Giant of Cerne Abbas*, Dorset, England, 1st or 2nd century A.D. Figure carved in chalk on the hillside. Depth of cuts: 2 feet. Length of figure: approximately 180 feet.

**2** Richard Long, *A Six Day Walk over all Roads, Lands, and Double Tracks inside a Six-Mile-Wide Circle Centered on the Giant of Cerne Abbas*, 1975.
Photograph and map, two panels, 14 x 21 inches and 28-1/2 x 29 inches. Courtesy of the Tate Gallery, London.

**3** The Long Man of Willington, England, probably from the 1st century A.D.
Figure carved in chalk on the hillside. Length of figure: 231 feet.

transformed, are best viewed. This is also true for the lines on the Nazca plain and other similarly enigmatic inscriptions that one finds in England such as *The White Horse of Uffington* in Berkshire, or *The Giant of Cerne Abbas* in Dorset. While working as a consultant on the Dallas-Fort Worth Regional Airport project, Smithson became aware of the importance of aerial views and how they transform our vision of the art. From this experience, he drew a certain number of conclusions regarding sites in his article "Toward the Development of an Air Terminal Site," which preceded the publication of "A Tour of the Monuments of Passaic" by six months. In *Studio International* in 1969, he published a text that explained the airport project, with which Robert Morris, Carl Andre, and Sol LeWitt were also associated.

The reproduction of *Aerial Map Proposal for Dallas-Fort Worth Regional Airport* illustrated Smithson's project, which, in map form, had the same structure that *Gyrostasis* had in three-dimensional form: the drawing of a crystalline formation growing in a spiral. An example of Sol LeWitt's project was *Box in the Hole*, which was part of the exhibition *Earthworks* at the Dwan Gallery. LeWitt was to intervene in the "sub-stratum of the site," and Smithson, in presenting this project, said, "He [LeWitt] emphasizes the 'concept' of art rather than the 'object' that results from its practice," thus integrating a typically conceptual process into a Land Art project. The work consisted of two small concrete cubes, one fitted into the other, buried in the ground. As his contribution, Robert Morris was to construct a circular "earth mound," 1000 feet in diameter, with a trapezoidal cross section, covered with grass, which would allow it to be "easily viewed from arriving and departing aircraft." As for Carl Andre, his project was tersely presented: "A crater formed by

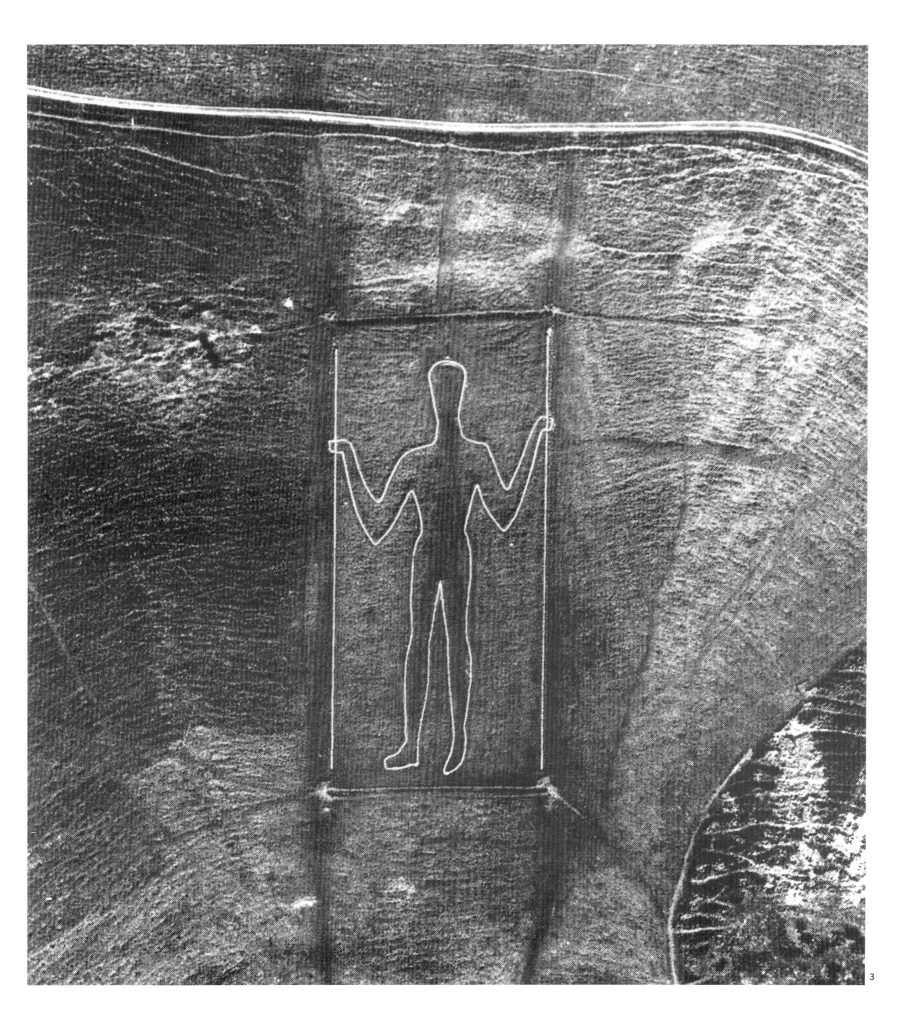

3

a one-ton bomb dropped from 10,000 feet. or An acre of blue-bonnets (state flowers of Texas)."[24]

It was during this period that Smithson became particularly interested in maps and their system of coordinates, which he immediately paralleled to crystalline structures. In choosing an aerial point of view of the site, he examined the viewer's temporal relationship to works of art. Seen from far away, the site seems to congeal the work within a crystal of frozen time. What exactly do we see? What part do we project and

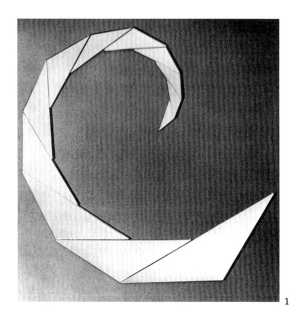

what part do we really see? "The straight lines of landing fields and runways bring into existence a perception of 'perspective' that evades all our conceptions of nature. The naturalism of seventeenth-, eighteenth-, and nineteenth-century art is replaced by non-objective sense of site[25] Smithson perceived more and more clearly that the extreme rapidity of the changes noticeable when one sees the earth from an airplane only reinforces the "imaginary" nature of the scale in his conception. In the scale thus conceived, our perception of the dimension of things—as well as the status of the object—are called into question.

**1** Robert Smithson, *Aerial Map—Proposal for Dallas-Fort Worth Regional Airport*, 1967.
Mirrors, 8 x 50 x 70 inches. Estate of Robert Smithson. Courtesy of the John Weber Gallery, New York.

**2** Robert Smithson, *Dallas-Fort Worth Regional Airport Layout Plan: Wandering Earth Mounds and Gravel Paths*, 1967.
Pencil and collage, 15-1/2 x 11 inches. Courtesy of the John Weber Gallery, New York.

**3** Robert Smithson, *Airport Site Map*, c.1967.
Pencil, 19 x 24 inches. Courtesy of the John Weber Gallery, New York.

**4** Sol LeWitt, *Box in the Hole*, cube buried in the Visser house, Bergeyk, Holland, July 1, 1968.
Rights reserved.

The move away from galleries also required a consideration of the ability to view works in other spaces, where classical perspective is subordinate and where it is not clear that it is less natural to look down from above rather than across. In any case, none of these artists ever demanded that his sculptures be inaccessible; Heizer's *Cité* is not a forbidden city to visitors, rather it is "protected"[26] before being fully completed. One can visit Heizer's *Double Negative*, and Smithson would have liked to see people come to walk on his spiral—which was hard to do then and is no longer feasible now.

De Maria, however, declares that "isolation is the essence of Land Art," but this does not mean that his works are necessarily out of reach. For example, *Lighting Field* was installed near the Log Cabin, a log cabin constructed at the beginning of the century and currently equipped for overnight visitors. Once there, they cannot leave before the next day, due to the distance, the absence of means of transportation, and the maze of paths. The experience of changing light, shifting space, and subsiding heat then begins. This is also an experience of waiting, for which isolation is necessary, an experience of passing time that

transforms our perception of things and of ourselves. But this wait is not pure receptivity. It is entirely tensed toward the event for which *Lightning Field* was constructed: the lightning that crashes down and transfigures the work, actualizing its strength, renewing the possible connection with an ancient sacred experience, and bringing to mind Heizer's almost religious vision of art.[27]

Smithson's views on the question of site evolved in an unusual manner. Early on, that is to say, since 1968, he saw the site in a dialectical fashion with reference to what he called the "nonsite," playing with its homonyms *sight* and *non-sight*, one functioning in connection with the other, like an exchange or transformation of vision. Previously, he had taken short trips with friends to discover and select various locations. In December 1966, he went with Nancy Holt and Robert Morris to see Great Notch Quarry in New Jersey; in April 1967, with Holt and Morris as well as Carl Andre and Virginia Dwan, he went to the Pine Barrens and Atlantic City; in October, by himself, he returned to Passaic. It was following this final outing that he wrote the article "The Monuments of Passaic." In the article (which, in a certain sense, is a parody of travel accounts written by nineteenth-century lovers of the picturesque), Smithson picks out a number of remaining industrial installations, elevating them to the status of monuments: the Bridge Monument, the Monument with Pontoons, the Great Pipes Monument, the Fountain Monument, and the Sand-Box Monument.

These monuments do not open up the site; they deny it by undermining it from within. The site itself becomes an anti-site: a place where time, rather than being collected in a commemorative object, rushes away and irreparably disappears. Lacking temporality, the space also loses its

Michael Heizer, *Untitled No. 5*, 1967–1972. Latex on canvas, 114 x 114 inches.

directionality, since the monuments do not serve as points of reference. Thus, discussing a moving bridge that pivots to allow a barge to pass, Smithson writes that it could be called "the Monument of Dislocated Directions." He calls this general disorganization *entropy*, which here has the effect of "decentralizing" the site in its relationship to the monument; "Actually, Passaic center was no center—it was instead a typical abyss or an ordinary void."[28]

Smithson's first nonsites, *A Nonsite, Pine Barrens, New Jersey*, followed by *A Nonsite, Franklin, New Jersey,*[29] were constructed in 1968. They were followed by a dozen others, constructed in 1968 and 1969. Without going into the detail and complexity of these works, of which certain aspects will be discussed in the chapter on maps, it is important here to touch on their guiding principle by discussing two works in particular. The nonsite in an artistic space (gallery, museum) makes reference to the site in a non-artistic space (mines, closed runways, abandoned quarries, etc.). Thus, the Pine Barrens is a little-used airport, in a region planted with dwarfed, stunted trees that recall the disorder of the urban fabric, devastated by unplanned and failed industrial complexes. In addition to these physical characteristics, Smithson was interested by a "historic" detail: during the Miocene period, the Pine Barrens was an island in the ocean, while the rest of New Jersey was under water. Robert Hobbs comments, "In other words, the Pine Barrens was a 'positive' land mass in the 'negative' of the ocean. Now, the prehistoric island is a 'negative,' a large, mostly uninhabited land area in populous New Jersey: it is both a Site and a Nonsite."[30]

Smithson's *Line of Wreckage, Bayonne, New Jersey*, (1968) is a photographic documentation composed of forty-two

1

1  Robert Smithson, *A Nonsite, Pine Barrens, New Jersey*, 1968.
Photocopy of a map, 12-1/2 x 10-1/2 inches. Courtesy of the John
Weber Gallery, New York.
"A Nonsite (an indoor earthwork): 31 sub-divisions based on a
hexagonal 'airfield' in the Woodmansic Quadrangle—New Jersey
(topographic) map. Each subdivision of the Nonsite contains sand
from the site shown on the map. Tours between the Nonsite and
the site are possible. The...dot on the map is the place where the
sand was collected." (Robert Smithson.)

2  Robert Smithson, *A Nonsite, Pine Barrens, New Jersey*, 1968.
Courtesy of the John Weber Gallery, New York.

*opposite page:*
Robert Smithson, *Monuments of Passaic*, 1967.
Photographs by Robert Smithson.
1  *The Bridge Monument Showing Wooden Sidewalks*
2  *Monument with Pontoons: The Pumping Derrick*
3  *The Great Pipes Monument*
4  *The Sand-Box Monument* (also called *The Desert*)
5  *The Fountain Monument: Side View*

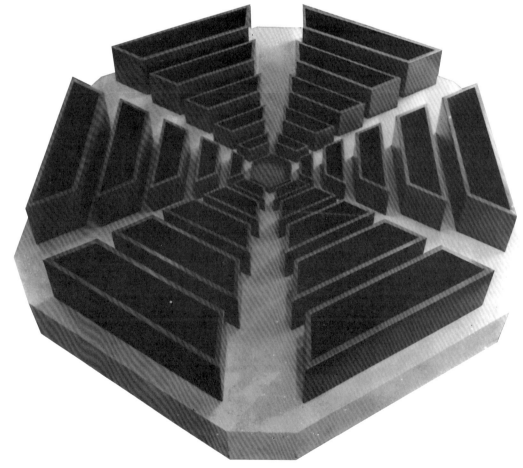

2

photographs and a map, displayed in four horizontal rows. The work is accompanied by a container filled with pieces of cement and asphalt. The site of *Line of Wreckage* is a narrow peninsula at the edge of the sea, originally a boat scrapyard that was later filled in with various materials—cement, asphalt, stone blocks—to construct a dike against the water. The corresponding nonsite is, in some sense, to the power of two, since the material that we see in the gallery has already been used. The nonsite is doubled, since the action of putting it in a container repeats the operation already completed in constructing the dike, yet in an artistically non-deliberated fashion. It is therefore the second event that gives legitimacy to the first (which previously resembled typical roadway construction work). Nonsite 2 constitutes the site to which it (*Line of Wreckage*) refers in nonsite 1, indexed to the built sites from where these materials were taken after demolition (buildings or sections of presently unused highway). In other words, the nonsite tells about the site in two ways: it gives it a form as per its metal, minimalist-looking containers, and it also provides certain information by means of maps, photographs, and films that permit it to be situated. But going to the designated space has no meaning unless one has access to the information from the exhibition, since the site itself is "formless," a pure loss of energy and material. The artistic experience occurs between the two, in this ebb and flow, which Smithson intensifies the following year with his mirror displacements.

The term nonsite takes on a different meaning when Smithson uses it to designate works that he has built, works whose artistic status is not simply a result of their status as index. *Spiral Jetty* and *Broken Circle*/*Spiral Hill* were constructed on "postindustrial" sites, in *entropic*

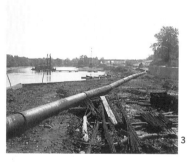

locations similar to the outskirts of Passaic: the former work is located near an old oil well and a disused pipeline, and the latter two works are found in an abandoned quarry.[31]

When Smithson planned the *Spiral Jetty* project, after visiting the Mono Lake region with Michael Heizer and Nancy Holt, he had heard that there were salt lakes in Bolivia where the water had a reddish color. Bolivia was too far away, so he selected the Great Salt Lake in Utah, where the water was colored by the presence of microbacteria. Smithson wrote, "As I looked at the site, it reverberated out to the horizons only to suggest an immobile cyclone while flickering light made the entire landscape appear to quake. A dormant earthquake spread into the fluttering stillness, into a spinning sensation without movement. This site was a rotary that enclosed itself in an immense roundness. From that gyrating space emerged the possibility of the Spiral Jetty."[32]

It was thus a painterly concern that determined Smithson's choice; he wanted the color of the lake to serve as a "background." The site itself gave the earthwork its definitive spiral form. Moreover, at first the artist envisaged the creation of an island. Therefore, there was an interaction between the final form of the work and its place of creation. Similarly, when Smithson created *Broken Circle*, he was interested in the opposition between the quasi-invisibility of this part of the sculpture (from a distance, it is indiscernible from the ground if the viewer is at its level) and the elevation of *Spiral Hill*. It was only in digging into the soil to flatten the terrain that he found the enormous rock that is now at the center of the work. This discovery frustrated Smithson, and his first temptation was to get rid of this morainic stone whose existence was unforeseen. This would have

proved to be extremely difficult, short of mobilizing the whole Dutch army, as Smithson himself said. At this point in the construction work he returned to New York, at which time the thing he had designated as a "black point of exasperation," a "geological gangrene," stopped seeming like an obstacle. The situation even ended by taking a favorable turn in his eyes, since this glacial remainder gave the work a new temporal dimension as a souvenir of a distant period of the earth's history, and because many primitive tombs, known as Hun's beds, located in the area were constructed with rocks from the same source. Smithson came to see the center of the rock and the summit of the spiral as indissociable. "Neither eccentrically nor concentrically is it possible to escape the dilemma, just as the Earth cannot escape the Sun. Maybe, that's why Valéry called the sun a 'Brilliant Error.'"[33]

The circular jetty of *Broken Circle*, which constitutes a "positive" extension of earth into the water, turning in a clockwise direction (the reverse of *Spiral Hill*), is intended to refer to the dikes constructed by the Dutch. In this way, the work attempts to correspond to the site in a general sense, to its country of location, as well as to its history, as was the case for *Spiral Jetty*. In 1972 Smithson planned many earthwork projects that were formally very close to *Broken Circle*, organized by an interplay of circles or of broken half-circles. For example, *Lake Crescents*, which was to rehabilitate a marsh site, thirty-five miles from Chicago, and was to be bordered with bright shrubs; *Lake Edge Crescent* in a open-air mine in Egypt Valley, Ohio, and *Coastal Crescent-Salton Sea Project*, in California, 750 feet in diameter, were to be made of sand, gravel, and earth. Speaking about these three projects, Hobbs wrote that "these pieces have strikingly similar formats with their component materials

1

2

*SITE*
*1. Open Limits*
*2. A Series of Points*
*3. Outer coordinates*
*4. Subtraction*
*5. Indeterminate Certainty*
*6. Scattered Information*
*7. Reflection*
*8. Edge*
*9. Some Place (physical)*
*10. Many*

*NONSITE*
*1. Closed Limits*
*2. An Array of Matter*
*3. Inner Coordinates*
*4. Addition*
*5. Determinate Uncertainty*
*6. Contained Information*
*7. Mirror*
*8. Center*
*9. No Place (abstract)*
*10. One*

*RANGE OF CONVERGENCE*

*The range of convergence between Site and Nonsite consists of a course of hazards, a double path made up of signs, photographs, and maps that belong to both sides of the dialectic at once. Both sides are present and absent at the same time. The land or ground from the Site is placed in the art (Nonsite) rather than the art placed on the ground. The Nonsite is a container within another container—the room. The plot or yard outside is yet another container. Two-dimensional and three-dimensional things trade places with each other in the range of convergence. Large scale becomes small. Small scale becomes large. A point on a map expands to the size of the land mass. A land mass contracts into a point. Is the Site a reflection of the Nonsite (mirror), or is it the other way around? The rules of this network of signs are discovered as you go along uncertain trails both mental and physical.*

Robert Smithson, "The Spiral Jetty," excerpt, *Arts of the Environment*, Gyorgy Kepes ed. (1972), reprinted in *The Writings of Robert Smithson*, p. 115.

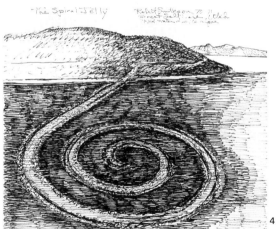

**1** Robert Smithson, documentation for *Nonsite "Line of Wreckage," Bayonne, New Jersey*, 1968.
Courtesy of the John Weber Gallery, New York.

**2** Robert Smithson, *Nonsite "Line of Wreckage," Bayonne, New Jersey*, 1968.
Courtesy of the John Weber Gallery, New York.

**3** Site of *Spiral Jetty*, Great Salt Lake, Utah.
Photograph by Gilles A. Tiberghien, 1991.

**4** Robert Smithson, *The Spiral Jetty*, 1970–1971.
Ink, 12-1/2 x 11-1/2 inches. Courtesy of the John Weber Gallery, New York.

rooting each to its specific site."[34] None of these projects was ever constructed.

For each of these monumental works, the nonsite system played a part, especially, for *Spiral Jetty*, whose construction was accompanied by a text (published in *Arts of the Environment* in 1972), photographs, and a film that contributed to its fame. These nonsites documented the work, yet at the same time they were an integral part of it. This intellectual and practical approach belonged only to Smithson, as Heizer, Oppenheim, and De Maria (to cite only the Americans) did not think in the same way. In 1970, Oppenheim explained that, as

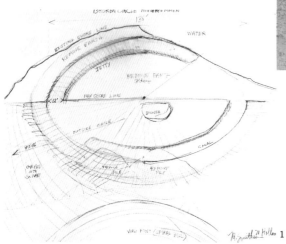

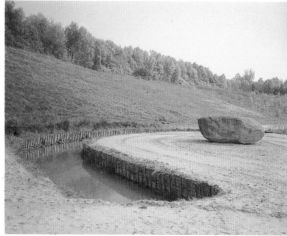

**1** Robert Smithson, *Broken Circle*, Emmen, Holland, 1971. Pencil, 12-1/2 x 53-3/4 inches. Courtesy of the John Weber Gallery, New York.

**2** Robert Smithson, *Broken Circle/Spiral Hill*, Emmen, Holland, 1971.
Photograph by Gilles A. Tiberghien, 1992.

**3** Robert Smithson, *Broken Circle/Spiral Hill*, Emmen, Holland, 1971 (under construction).
Courtesy of Nancy Holt.

**4** Robert Smithson, *Spiral Hill and Broken Circle*, Emmen, Holland, 1971.
Courtesy of the John Weber Gallery, New York.

*following pages:*
Robert Smithson, *Spiral Hill and Broken Circle*, Emmen, Holland, 1971.
Courtesy of the John Weber Gallery, New York.

different from Smithson, "I don't really carry a gallery disturbance concept around with me; I leave that behind in the gallery. Occasionally I consider the gallery site as though it were some kind of hunting-ground."[35] For Heizer, this is not the real issue. His works are always radically different. As for Richard Long, between his solitary journeys through the countryside, his exhibitions, and his books, there is a kind of separation that forbids thinking of one in terms of the other.

Richard Long's first solo exhibition took place in Düsseldorf at the Konrad Fischer gallery in 1968. Lines made of cut branches became lost in the depths of the

gallery and seemed to be interrupted by the walls. Thus, as Rudi Fuchs has emphasized, the walls were considered an integral part of the sculpture—without which Long would have obviously modified the direction of his lines. Long has never since considered stones, bark, or driftwood in an interior space and displayed in various geometric configurations to be a "removal" from the experiences undergone on the sites to which the maps and photographs refer. This art is about the expression of two completely different experiences: one the solitude of his walks, the other within the framework of a gallery or museum. Long's interior installation is a sort of theoretical equivalence, or, in a scientific sense, a *model*, of his walks within the sites, yet without an equivalent size, complexity, or intensity. The installation is a supplementary work, but for Long it also has great importance.[36]

Whether the sculpture has become the site itself, as in Heizer's *Double Negative*, whether the site and the sculpture are organized in a system of correspondences (formal with Smithson, social with Oppenheim, ritual with Long), or whether the site is used as a form of expansion of the space (as in the work of Morris, Holt, or Christo), what is obvious is a form of *retraction* that puts us *"face à ce qui se dérobe"*[37] in the

4

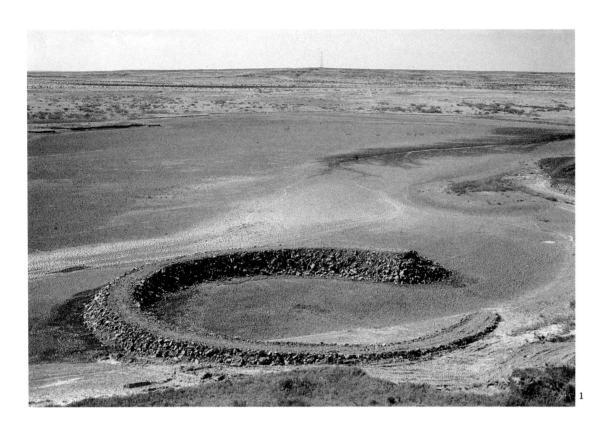

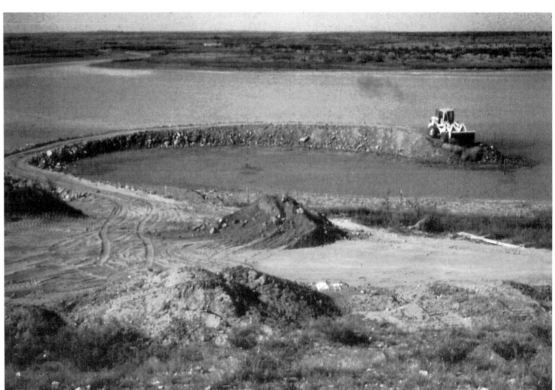

**1, 2** Robert Smithson, *Amarillo Ramp*, Amarillo, Texas, 1973.
Amarillo Ramp is the last work attributed to Smithson. He never saw it completed because the airplane that
he and Stanley Marsh were flying in to photograph and sketch the location crashed on the site. The work
was eventually completed by Nancy Holt, Richard Serra, and Tony Shafrazi (who had shown Marsh's ranch
to Smithson and his wife), according to Smithson's plans. The sculpture was a partial circle resembling a
serpent biting its tail. It was constructed on the edge of a lake that was often dry, but, according to
Smithson, might one day fill to submerge the work.

presence of something else: the photography, the book, the container, the gallery, or museum space. One could even speak of the total disappearance of the traditionally conceived site. The conceptual exercise of blurring the units of measurement through the juxtaposition of European and Anglo-Saxon systems (as De Maria does) also calls into question our spatial and temporal reference points. The site reveals the work to better hide it from us, and also conceals it to better lead us through the labyrinth of signs. We are continually moved from words to things, from consciousness to objects, from art to non-art, to fully experience the visible, or rather to verify De Maria's proposition that "the invisible is real." For the big Land Art "constructors," the problem was to find land on which to build. The American deserts do not belong to anyone who wants them; the ground, arid though it may be, is the property of the state or of individuals. To install a permanent sculpture, it was therefore necessary to buy the land, as Heizer and Nancy Holt did in Nevada, or, as Smithson did while searching for a site for *Spiral Jetty*, to find a system of concession that allowed him to alter the earth for a fairly long period of time.[38] De Maria built *Desert Piece* without authorization on an expanse of desert that belonged to the government. The first, small version of *Lightning Field* (1974, thirty-five metal rods each eighteen feet high, forming a rectangle of seven rods by five rods, the rods spaced two hundred feet apart), was created thanks to Virginia Dwan, on a ranch belonging to two collectors, Burton and Emily Tremaine, near Flagstaff, Arizona.[39] In 1973, at a time when Smithson was having difficulty obtaining the funds necessary to complete his projects, Stanley Marsh put his ranch in Texas at the artist's disposal, allowing him to begin to construct his last work, *Amarillo*

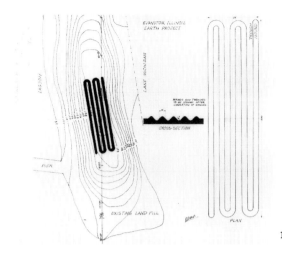

1

2

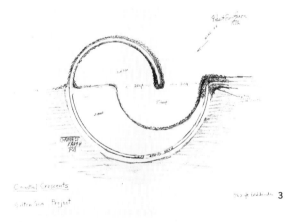

3

1  Robert Smithson, *Evanston, Illinois Earth Project*, 1968.
Ink on orange graph paper, 24 x 24-1/2 inches. Courtesy of the John Weber Gallery, New York.

2  Robert Smithson, *Stairway Approach to Lake Crescents*, 1973.
Pencil, 9 x 12 inches. Courtesy of the John Weber Gallery, New York.

3  Robert Smithson, *Coastal Crescent—Salton Sea Project*, California, 1972.
Courtesy of the John Weber Gallery.

*Ramp*. But access to the land was not the only problem; it was still necessary to finance these enormous works, and public commissions did not yet exist in this medium. What Virginia Dwan did for *Double Negative* or *Spiral Jetty*, no gallery owner would dare to do for other works. This is why many projects—specifically, those of De Maria and Morris—remained as sketches (for example, *Ottawa Project*, commissioned by the National Gallery of Canada in 1969, which could not be completed due to lack of funds).

Before De Maria introduced him to Virginia Dwan, some of Heizer's early sculptures were financed by Robert Scull, who himself already owned a number of works by De Maria. It was thanks to Scull that Heizer completed *Nine Nevada Depressions* and *Displaced Replaced Mass*. Later, in the same gallery where De Maria constructed his first *Earth Room* in 1968 in Munich, Heiner Friedrich gave Heizer financial support, allowing him to build *Five Conic Displacements* and *Munich Depression* in 1969.

The first earthwork financed by a city and by a number of institutions was *Grand Rapids Project* in 1973 (*Observatory* and *Spiral Hill/Broken Circle* were commissioned for a temporary exhibition and were not originally intended to be permanent). For a show organized by the Women's Committee of the Grand Rapids Art Museum, on the theme *Sculpture Off the Pedestal*, Morris proposed the redesign of an abandoned hill at the outskirts of the city by encircling it with a path at the base and another at the summit, connected by two x-shaped roads on the side of the hill: "From this date, the National Endowment for the Arts, the General Services Administration, and numerous state, county, and municipal organizations displayed increasing receptiveness to this sort of

art."[40] According to Morris, Smithson's view that artists have not only the capacity but also the social obligation to contribute to the restoration of the landscape for the general good became more and more essential as time went by. It was still necessary for this idea to become accepted, which was far from being the case at the end of the 1960s. The ecologists had already made public opinion sensitive to these issues, but nothing of real importance had been done in this direction. Land Reclamation, which today is almost obligatory for businesses that exploit the mineral riches of the earth,

was a new idea at the time. Beginning in 1972, Smithson, supported by Timothy Collins, a member of the Board of Friends of the Whitney Museum and president of the Collins Securities Corporation of New York, contacted the mining companies in the United States (Anaconda, Union Carbide, U.S. Steel, etc.) to convince them to restore the land they had destroyed. Smithson wrote to Ralph Hatch, president of Hanna Coal Company, to propose him to intervene on the site of Egypt Valley, Ohio. Conscious of the growing media awareness of these problems, he emphasized that it was not enough to re-forest the land to restore the area. "An earth sculpture, on the other hand, would provide a focus that would have positive visual value, and call

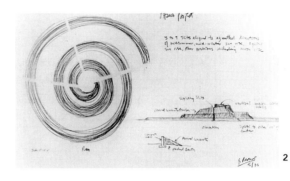

**1** Robert Morris, *Ottawa Project (9 Azimuths)*, 1970.
Pencil on green graph paper, 22 1/8 x 35 inches. Collection of the artist. Photograph by Eric Pollitzer. Courtesy of the Guggenheim Museum, New York.

**2** Robert Morris, *Ottawa Project* (three to nine slits aligned with the position of the rising sun on the summer and winter solstices, with the equinoxes, and with other reference points, notably the rising of the moon), signed May 1970.
Pencil on green graph paper, 22 x 37 inches. Collection of the artist. Photograph by Eric Pollitzer. Courtesy of the Guggenheim Museum, New York.

**3** Robert Morris, *Untitled* (study for the Jacques-Cartier park: granite stones in a line), 1970.
Pencil on graph paper, 22 x 35 inches. Collection of Galleria dell'Ariete, Milan. Photograph by Richard Burckhardt. Courtesy of the Guggenheim Museum, New York.

attention to the surrounding reclamation process." He developed this idea in a letter designed to be read in the context of what the organizers called "The First International Conference of Visual and Performing Art in Higher Education."[41]

From this point, things evolved rapidly. In 1973, the year of Smithson's death, the Senate proposed the following definition of Land Reclamation: "Reclamation means the process of restoring a mined area affected by a mining operation to its original or other similarly appropriate condition considering past and possible future uses of the area and the surrounding topography and taking into account environmental, economic, and social conditions..."[42] Such a definition was destined to pose a number of problems. In any case, the way had been paved, and, in 1979, the King County Arts Commission began a reclamation project under the title *Earthworks: Land Reclamation as Sculpture*, inviting seven artists (Herbert Bayer, Iain Baxter, Richard Fleischner, Lawrence Hanson, Mary Miss, Dennis Oppenheim, and Beverly Pepper) to propose "reclamation" projects on seven different sites. A symposium and an exhibition of projects at the Seattle Art Museum followed. Robert Morris was asked to reclaim a sand quarry in King county, which he did between August and December of 1979. In 1982, Herbert Bayer's project was completed on the outskirts of Seattle; in the town of Kent, *Mill Creek Canyon Park* was constructed in a small valley that was frequently flooded and that the municipality wanted to clean up. The result was an ensemble of five elements composing a system of concave and convex circles, broken rings, and mounds, serving as piers for a bridge that punctuated the site according to a formal positive/negative logic, recalling Bayer's sculpture in Aspen, Colorado, although in a much more elaborate

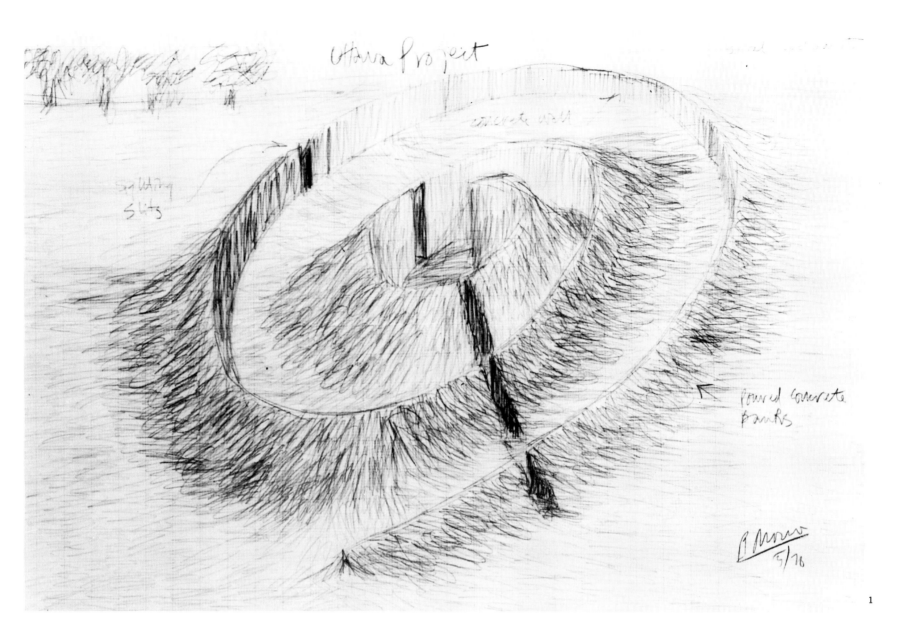

Ottawa Project

1

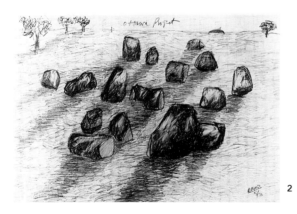

2

**1, 2** Robert Morris, *Ottawa Project* (Spiral 200' Diameter), 1970. Pencil on green graph paper, 22 x 34 inches. Collection of the artist. Photograph by Bruce C. Jones. Courtesy of the Guggenheim Museum, New York.

**1** Herbert Bayer, *Earth Mound*, 1955.
Earth, diameter: 40 feet. Aspen Institute for Humanistic Studies, Aspen, Colorado.

**2, 3** Herbert Bayer, *Mill Creek Canyon. Earthworks*, Kent, Washington, 1979–1982.
Four mounds of earth covered with grass. The structure also serves as a drainage system for rainwater.

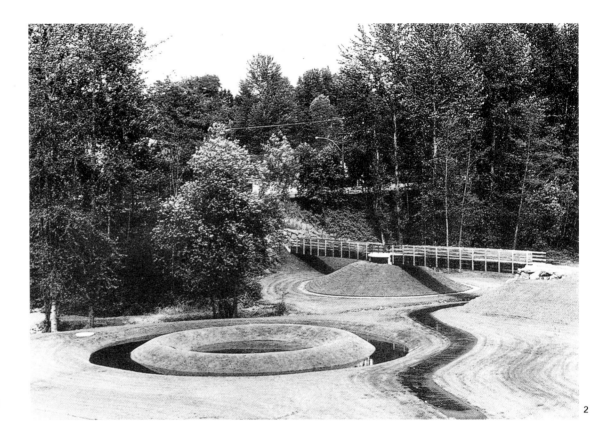

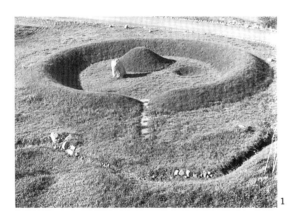

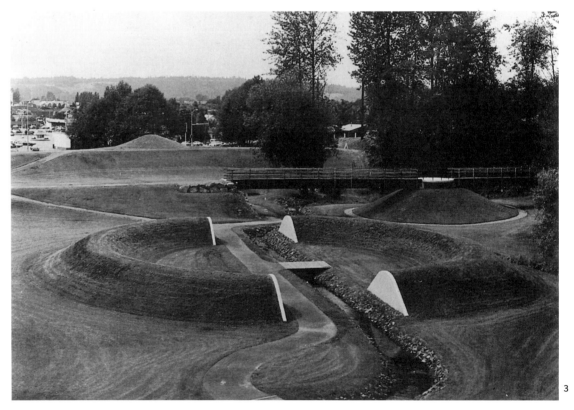

1

2

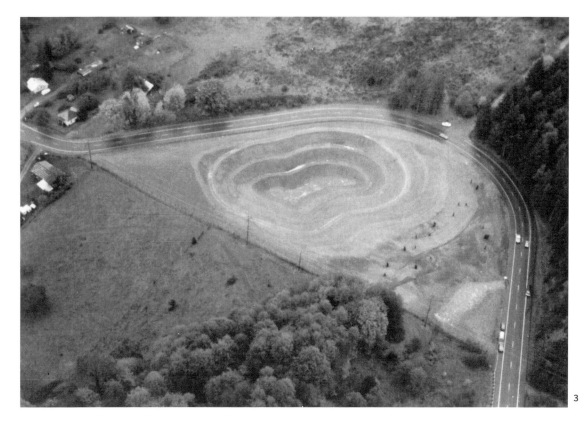

3

**1, 2, 3** Robert Morris, *Untitled (King County, Seattle Project: Johnson Pit, No. 30 Grade Contours—Sheet 1)*, 1979.
Ink on tracing paper, 24 3/4 x 47 in. Collection of the artist.
Courtesy of the Guggenheim Museum, New York.
Following a commission from the King County Art Commission inviting eight artists (Robert Morris, Herbert Bayer, Iain Baxter, Richard Fleischner, Lawrence Hanson, Dennis Oppenheim, and Beverly Pepper) to propose a land reclamation project, Morris redeveloped an open-air mining site. In a lecture given for the occasion, transcribed in the subsequently published catalog, Morris nonetheless showed his skepticism towards this type of operation. "(But it would perhaps be a misguided assumption) to suppose that artists hired to work in industrially blasted landscapes would necessarily and invariably choose to convert such sites into idyllic and reassuring places, thereby socially redeeming those who wasted the landscape in the first place." (Robert Morris, *Earthworks: Land Reclamation as Sculpture* [Seattle: Seattle Art Museum, 1979], p. 16.)

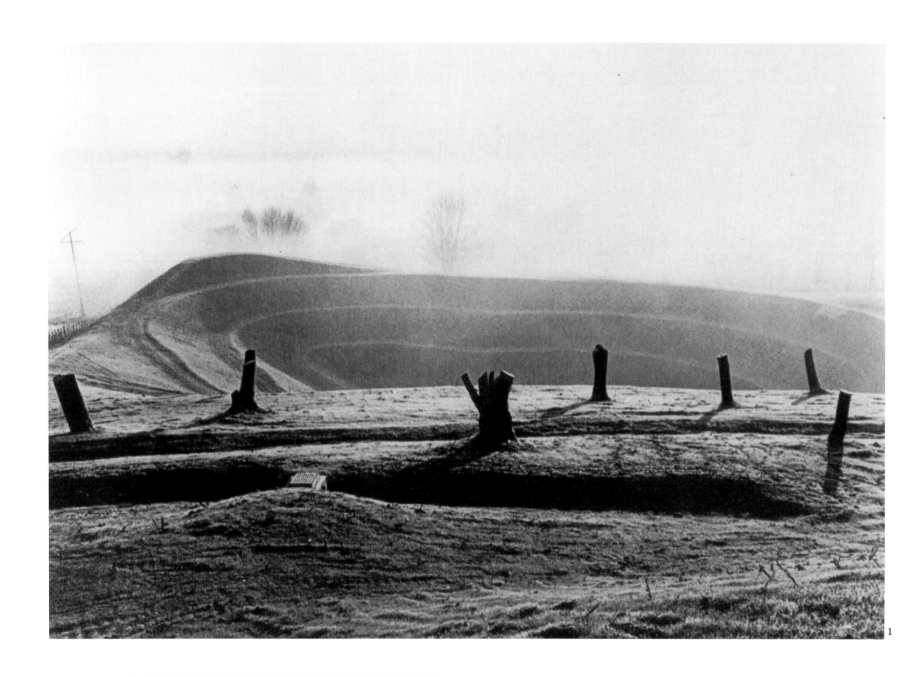

1

## SITE REHABILITATION PROJECTS IN THE EIGHTEENTH CENTURY

*England abounds with commons and wilds, dreary, barren, and serving only to give an uncultivated appearance to the country, particularly near the metropolis: to beautify these vast tracts of land, is next to an impossibility; but they may easily be framed into scenes of terror, converted into noble pictures of the sublimest cast, and, by an artful contrast, serve to enforce the effect of gayer and more luxuriant prospects.*

*On some of them are seen gibbets, with wretches hanging in terrorem upon them; on others, forges, collieries, mines, coal tracts, brick or lime kilns, glassworks, and different objects of the horrid kind: what little vegetation they have, is dismal; the animals that feed upon it, are half-famished to the artists' hands, and the cottagers, with the huts in which they dwell, want no additional touches, to indicate their misery: a few uncouth straggling trees, some ruins, caverns, rocks, torrents, abandoned villages, in part consumed by fire, solitary hermitages, and other similar objects, artfully introduced and blended with gloomy plantations, would compleat the aspect of desolation, and serve to fill the mind, where there was no possibility of gratifying the senses.*

Tan Chet-qua, of Quang-chew-fu, Gent. (Sir William Chambers), *An Explanatory Discourse* (London: W. Griffin, 1773), reprinted by The Augustan Reprint Society (Los Angeles, publication no. 191, 1978), pp. 130–131.

**1, 2** Robert Morris, *Untitled (Earthwork to Reclaim Gravel Pit, King County)*, 1979.
3.7 acres of graded earth south of Seattle, three stumps covered with tar, earth seeded with grass. Collection
King County Arts Commission. Courtesy of the Guggenheim Museum, New York.

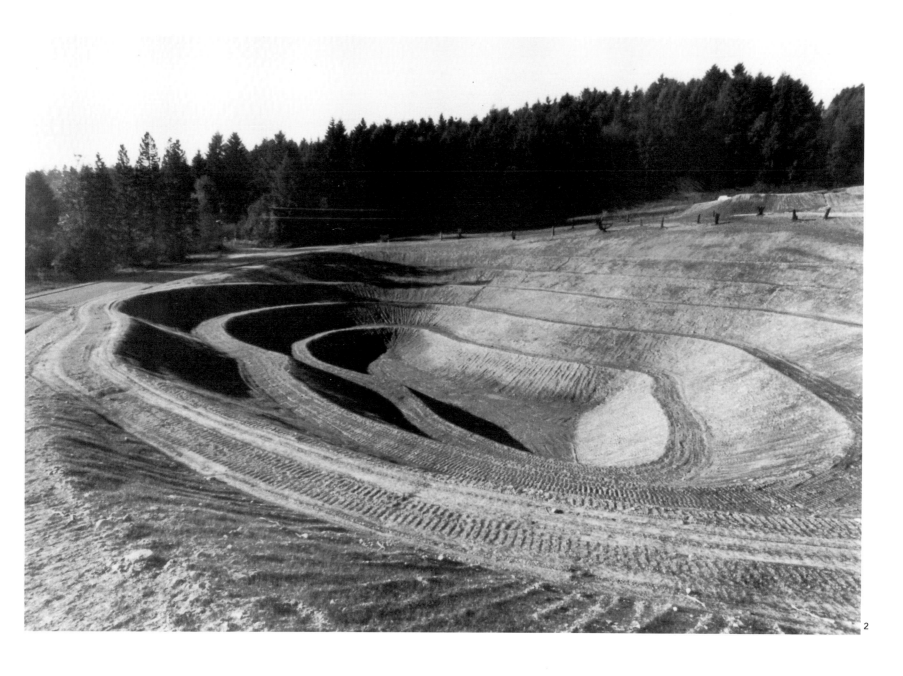

fashion.[43] On Bayer's recommendation, Heizer was contacted in 1981 by the Anaconda Mineral Company for the reclamation of a mining site at Tonapah. But the project was barely begun: *Geometric Land Sculptural/Anaconda Project* was interrupted when the factory shut down, and the work remains unfinished. However, the rehabilitation project in Buffalo Rock, near Chicago, was built after five years of negotiations. Because of his response to a public commission, Michael Heizer had the opportunity to create an ensemble of gigantic

sculptures, *Effigy Tumuli*, yet he declared that the idea of "Reclamation Art" was "frivolous."[44] In contrast, Smithson thought that art could be a "mediator" between ecological and economic interests. This point of view was not shared by Heizer, who did not believe in the social commitment of the artist. Morris, citing Smithson, did not reject this type of intervention, but he did hold a certain skepticism towards the idea, since art can be the object of all sorts of appropriations, and regardless of the desires of the artist, it can always serve other interests.[45]

**1, 2, 3** Robert Morris, *Untitled (Earthwork for Belknap Park, Grand Rapids)*, 1974.
Earth, grass, and asphalt, slope of a hill, two ramps forming an X with a platform at the intersection, approximately 260 x 800 ft. Collection of the city of Grand Rapids, Michigan. Photograph by Craig VanderLende. Courtesy of the Guggenheim Museum, New York.

**4** Robert Morris, *Untitled (drawing for Grand Rapids)*, 1974.
Ink on paper, 63 x 36 inches. The Grand Rapids Art Museum, Grand Rapids, Michigan. Courtesy of the Guggenheim Museum, New York.

Robert Morris, *Untitled (Earthwork for Belknap Park, Grand Rapids)*, 1974.
Courtesy of the Guggenheim Museum, New York.
The Grand Rapids Project was commissioned by the city of Grand Rapids and constructed in 1974, thanks,
in particular, to the support of the Women's Committee of the Grand Rapids Art Museum. This was the first
public commission of its kind in the United States.

Michael Heizer, *Geometric Land Sculptural/Anaconda Project*, 1981.
Commissioned by the Anaconda Mineral Company, the work was to be 4.845 feet long, 2.423 feet wide,
140 feet maximum elevation.

# NOTES

1. Sidney Geist, "Brancusi: The Centrality of the Gate," *Artforum* (October 1973), pp. 70–78.

2. Rosalind E. Krauss, "Echelle/Monumentalité, Modernisme/Postmodernisme, La ruse de Brancusi," *Qu'est-ce que la sculpture moderne?*, op. cit., p. 252.

3. Carl Andre, "Quotations from the Artists," *Carl Andre*, La Haye, Gemeentemuseum, August 25–October 5, 1969, cited in E. H. Johnson, *Modern Art and the Objects*, op. cit., p. 40.

4. Thierry de Duve, "Ex Situ," *Les Cahiers du Musée national d'Art moderne* (spring 1989), p. 39.

5. Ibid., p. 53.

Carl Andre, *Joint*, Windham College, Putney, Vermont, 1968.
186 ordinary bales of hay, 14 x 18 x 36 inches each, total length: 580 feet. Rights reserved.

6. Robert Smithson, "Towards the Development of an Air Terminal Site," *Artforum* (June 1967); reprinted in *The Writings of Robert Smithson*, op. cit., p. 47.

7. This term is reminiscent of Capability Brown, an eighteenth-century English landscape gardener. In December 1782, Hannah More told her sisters what he had once said to her: "He told me he compared his art to literary composition. 'Now *there*,' said he, pointing his finger, 'I make a comma, and *there*,' pointing to another spot, 'where a more decided turn is proper, I make a colon; at another part, where an interruption is desirable to break the view, a parenthesis; now a full stop, and then I begin another subject.'" (Dora Wiebenson, *The Picturesque Garden in France* [Princeton: Princeton University Press, 1978], p. 74, note 86). In his text on Serra, Yve-Alain Bois cites this passage (Yve-Alain Bois, "Promenade autour de Clara Clara," op. cit., pp. 22–23), but does not make the connection to Smithson's text. In fact, at this point in his study, Yve-Alain Bois contrasts Serra's art with the art of landscape gardeners, saying, among other things, that in the

former, and contrary to the latter, "there is no…full stop." (Ibid.)

8. Phyllis Tuchman, "Interview with Carl Andre," *Artforum* (June 1970), p. 57. Andre adds: "Most of my works—certainly the successful ones—have been ones that are in a way causeways—they cause you to make your way along them or around them or move the spectator over them." (Op. cit., p. 57.)

9. Robert Smithson, *The Writings of Robert Smithson*, op. cit., p. 47.

10. "When an artist sees sculpture as place, there is no room for actual sculptures to accumulate. Andre's works come

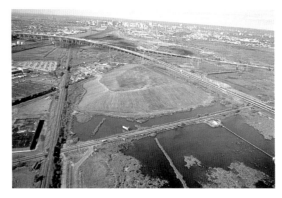

Nancy Holt, view of the *Sky Mound* site (Meadowlands, New Jersey, 1985).
Courtesy of Nancy Holt. Restoration in progress of an old garbage dump fifteen minutes outside Manhattan. At the summit of the hill of waste (the decomposition of which supplies gas to a portion of the city), Nancy Holt created a pool of water around which mounds of earth connected by sand pathways were to be constructed. According to precise calculations, the work will permit the observation of the rising and setting of the sun at the summer and winter solstices as well as the days of equinox. Because of a lack of funds, work is presently suspended.

into existence only when necessary. When not on exhibition, the pieces are dismantled and cease to exist except as ideas." David Bourdon, "The Razed Sites of Carl Andre," op. cit., p. 107.

11. The connection between the sculptures of Mount Rushmore and Land Art did not escape the critics. Giving an account of the *Earthworks* exhibition at the Dwan Gallery in *New York Letter*, Don McDonagh wrote: "Not since Gutzon Borglum began to chisel out the monumental faces of four presidents on the granite sides of Mount Rushmore in 1927 has there been comparable enthusiasm by sculptors for the great outdoors. Unlike Borglum, however, who was carving for the ages, the new crop of earth and stone movers luxuriate in the thought of nihilistic impermanence."

12. Michael Heizer, "Interview, Julia Brown and Michael Heizer," op. cit., p. 37.

13. One cannot help but subscribe to Jean-Marc Poinsot's theory: "It is necessary to do away with the idea that the

site, the surroundings of implantation, indeed, the context, contain the work. To the contrary, it is rather the work which contains the features or fragments of the site in which it is implanted." (Jean-Marc Poinsot, "L'in situ et la circonstance de sa mise en vue," *Les Cahiers du Musée national d'Art moderne*, no. 27 [spring 1989], p. 72.)

14. See Willoughby Sharp, "Discussions with Heizer, Oppenheim, Smithson," op. cit.

15. "Entrevue avec Dennis Oppenheim," *Dennis Oppenheim, rétrospective de l'oeuvre 1967–1977* (Montréal: musée d'Art contemporain, 1978), p. 16.

16. Ibid.

17. Among other examples. This process of transfer will be discussed in the chapters on time (chapter 4) and cartography (chapter 5).

18. Jean-Louis Bourgeois, "Dennis Oppenheim, a Presence in a Countryside," *Artforum* (October 1969).

19. "From 1961 until 1964, Morris produced more than two dozen objects and drawings of rulers, rods, and other devices for measurement that fundamentally challenged 'objective' or 'fixed' standards." Maurice Berger, *Labyrinths: Robert Morris, Minimalism, and the 1960s* (New York: Harper & Row, 1989), p. 33.

Robert Smithson, *Broken Circle/Spiral Hill*, Emmen, Holland, 1971 (under construction).
Courtesy of the John Weber Gallery, New York.

20. Annette Michelson, "Robert Morris: an Aesthetic of Transgression," *Robert Morris* (Washington, D.C.: Corcoran Gallery of Art, 1969). The author has found "six themes, originating in Duchamp's work, used, transposed, throughout Morris' work." Here, the reference to Duchamp's *Trois Stoppages Etalon* (1913–1914) is clear. On Duchamp and Morris, see Maurice Berger, "Duchamp and I," *Labyrinths: Robert Morris, Minimalism, and the 1960s*, op. cit., pp. 19–46.

21. Robert Morris, "Interview with Robert Morris," op. cit.

22. "Minimal art's diagrammatic aspect was derived from plans generated by drawings on flat pages. Most Minimal art was an art of flat surfaces in space. At best an object can be permuted in its positions or parts and as such it can be rotated on its own dense axis." Robert Morris, "Aligned with Nazca," *Artforum* (October 1975), p. 36.

23. Richard Long, cited in Lucy R. Lippard, *Overlay, Contemporary Art and the Art of Prehistory* (New York: Pantheon Books, 1983), p. 129: "Also it is not true to think that my landscape sculptures are never seen. They are sometimes seen by local people in the country, occasionally as I make them, or discovered by chance by people who might not recognise them as art but would nevertheless see them." ("An Interview with Richard Long by Richard Cork," Richard Long, *Walking in Circles* [London: Thames and Hudson, 1991], p. 248.)

24. Robert Smithson, "Aerial Art," *Studio International* (1969); reprinted in *The Writings of Robert Smithson*, op. cit., p. 93. In this project, Patrick Werkner sees a reference to Futurism's aesthetic of war (which I feel is unfounded), as well as an interpretation of abstract expressionism's drippings. Patrick Werkner, *Land Art U.S.A.* (Munich: Prestel, 1992), p. 140.

25. Ibid., p. 92.

26. From photographers and journalists, specifically, but, in compensation, Heizer generously welcomes visitors who make the effort to go and see this work.

27. See Michael Heizer, "Discussions with Heizer, Oppenheim, Smithson," op cit., p. 174; Michael Heizer, "Interview, Julia Brown and Michael Heizer," op. cit., p. 33. Also, see Barnett Newman's conception of place: he said that his aim was to create a place, not an environment, and he specified that he wanted his painting to give the viewer this feeling of place in such a way that the viewer becomes conscious of himself in realizing where he is. Thus "the on-looker in front of my painting knows that he's there and to me the sense of place has not only a mystery, but is that sense of metaphysical fact." (Interview with David Silvester, New York, spring 1965, cited in Harold Rosenberg, *Barnett Newman* [New York: Abrams, 1978], p. 246, reprinted in *Barnett Newman, Selected Writings and Interviews* [New York: Alfred A. Knopf, 1990], p. 257.)

28. Robert Smithson, The Monuments of Passaic," *Artforum* (December 1967); reprinted with the title "A Tour of the Monuments of Passaic, New Jersey," *The Writings of Robert Smithson*, op. cit., p. 55.

29. Excepting one piece that Smithson had constructed for the Walker Art Center, Minneapolis, for the exhibition *6 artists, 6 exhibitions: Bell, Chryssa, Insley, Irwin, Smithson, Whitman* (1968), but that he destroyed after seeing it. For more details, see Robert Hobbs, Robert Smithson: Sculpture, op. cit., note 32, p. 104. For a detailed description and commentary on the other non-sites, see the same text.

30. Ibid., p. 105.

31. Smithson wrote in 1973, "My personal experience is that the best sites for Earth Art are those which have been disrupted by industry, uncontrolled urbanization, or destruction of nature itself. For example, *Spiral Jetty* is constructed in a dead sea and *Broken Circle* and *Spiral Hill* are in a sand quarry." (Robert Smithson, "Frederic Law Olmsted and the Dialectical Landscape," op. cit., p. 124.) Constructed for the *Sonsbeek* international exhibition in Emmen, *Spiral Hill/Broken Circle* was overwhelmingly approved by the inhabitants of the city who thus prevented its destruction. It is generally written that this work contributed to the revitalization of the site. Hobbs explains that the quarry had already been designated to become a

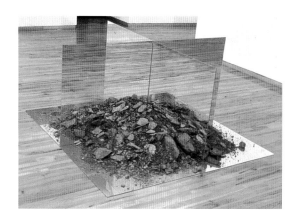

Robert Smithson, *Nonsite Essen*, 1969.
Courtesy of the estate of Robert Smithson.

community center by the time Smithson redesigned it with the help of Sjouke Zijlstra (a geographer who was at that time the director of the city's cultural center). However, twenty years later, this center still does not exist, and the road leading to the quarry is bordered by huge mining pits still in use, so that the area is not at all a pleasant countryside or a skillfully composed amusement park. However it is unclear whether this absence is missed.

32. Robert Smithson, "The Spiral Jetty," op. cit., p. 111.

33. Robert Smithson, "The Earth, Subject to Cataclysms, is a Cruel Master," op. cit., p. 183.

34. Robert Hobbs, *Robert Smithson: Sculpture*, op. cit., p. 223. According to Hobbs, *Creede, Colorad, Tailing Pond* was the only rehabilitation project that could have been completed, since one of the principal shareholders of Minerals Engineering, to whom the project was presented, was Timothy Collins, a friend of Smithson's. See *Robert Smithson, rétrospective*, musée d'Art moderne de la Ville de Paris, November 30, 1982–January 16, 1983, and Ithaca, New York (Paris: ARC, and Ithaca: The Herbert F. Johnson Museum of Art, Cornell University), p. 89.

35. Dennis Oppenheim, "Discussions with Heizer, Oppenheim, Smithson," op. cit., p. 171.

36. The stones that Long installed inside galleries came from quarries and not from sites that he visited. Discussing his walks in Islande, he said: "In this type of situation, it is fantastic to use rough stones and to make a sculpture like that. But it would be a mistake to bring these stones into a gallery and make a work of art." (Richard Long, "Entretien avec Claude Gintz," op. cit., p. 7.)

37. Translator's note: this is the title of a book by the French poet Henri Michaux. It has been translated in English as *Facing What Is Disappearing*.

38. Which lasted twenty years and which Nancy Holt recently renewed for twenty more years.

39. The Dia Art Foundation allowed for the construction of the current version of the work and provides for its upkeep. Virginia Dwan still possesses thirty-six steel rods from the original installation. But the Dia Art Foundation, created in 1974, merely carries on the work of Heiner Friedrich, who, with his wife Philippa de Mesnil, founded this institution. See David Sweet, "Earth in the Works," *Art & Auction* (June 1986), pp. 72–76. Patrick Werkner, *Land Art U.S.A.*, op. cit., pp. 132–133.

40. John Beardsley, *Earthworks and Beyond, Contemporary Art in the Landscape*, op. cit., p. 29.

41. See Robert Hobbs, *Robert Smithson: Sculpture*, op. cit., p. 219; Robert Smithson, "Untitled, 1971," "Untitled, 1972," "Proposal, 1972," in *The Writings of Robert Smithson*, op. cit., pp. 220–221; Claude Gintz, "Smithson et son autre," *Territoires 3*, (Paris: éditions Territoires, 1983), pp. 57–59.

42. Amendment 425, proposed by senators Jackson, Buckley, Mansheld, Metcalt, and Moss. Cited in Robert Morris, "Notes on Art as/and Land Reclamation," *October* (spring 1980), p. 88.

43. See Arthur A. Cohen, "Sculpture and Environments: 1937–1983," *Herbert Bayer Complete Work* (Cambridge, MA: MIT Press, 1984), pp. 151–188. The author rightly insists on the importance of Bayer to the Land Art artists, recalling that Smithson had a photograph of Bayer's *Grass Mound* (created in 1955 in Aspen, Colorado) displayed at the *Earthworks* exhibition at the Dwan Gallery in 1968. If Cohen is not certain that the differences he finds between Bayer and the earthwork artists are all relevant, he is clear, in any case, that the object of Bayer's work, as different from these artists, "was not about the subversion of traditional sculpture." (Ibid., p. 158.)

44. See Michael Heizer, *Effigy Tumuli* (New York: Abrams, 1990), p. 35.

45. See Robert Morris, "Notes on Art as/and Land Reclamation," op. cit., p. 88.

# CHAPTER 4

# TIME AT WORK

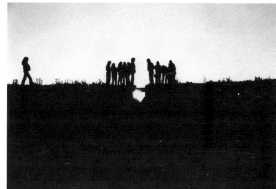

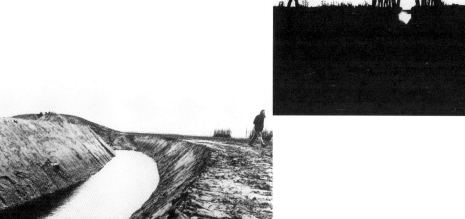

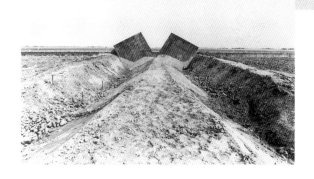

Robert Morris, *Observatory*, Oostelijk Flevoland, Netherlands, 1971.
Earth, wood, and granite: 299 feet in diameter. Courtesy of the
Guggenheim Museum, New York.

Dennis Oppenheim, *Time Line*, 1968.
1 foot x 3 feet x 3 miles. Two lines side by side following the separation of the time zones between Fort
Kent, Maine, United States, and Clair, New Brunswick, Canada, on the ice and snow of the St. John River.
Traced by a ten-horsepower snowmobile at thirty-five miles per hour. Time of execution: 10 minutes.
Refreezing index: 70 hours. Time: United States 3:15 pm, Canada 4:15 pm. Courtesy of Dennis
Oppenheim.

At the end of his article "Art and Objecthood," Michael Fried discusses the *inexhaustible* nature of minimal objects, which results not from their fullness but rather their excessive emptiness. In a sense, he sees nothing in them to exhaust: they are "endless the way a road might be: if it were circular, for example."[1] This non-finished, or "infinite," quality comes mainly from direct experience, described by Fried as "essentially a presentment of endless, or indefinite, *duration*."[2]

Fried emphasizes the *presence* of these minimal objects, and logically concludes that they are inseparable from the temporal experience of the spectator. Morris's claims of "phenomenological" inspiration, and minimalism's historical ties with *happenings* and other "performances" by Fluxus and the anti-art movement at the beginning of the 1960s, seem to support his theory. In fact, there are two trends visible within minimal art: the first, in Fried's tradition of literary criticism, situates art in *real* time and space; the second goes instead in the direction of a "detemporalization" of art, as evidenced by the recurrence of modular series of plastic works being produced by artists at that time.[3] Sculptures such as those by Sol LeWitt seem to result from a combinative system of rules that can be created with minimal ingenuity. Art in series produces an idea *in abstentia*: a timeless image that transcends the objects themselves just as myths transcend the human beings whose relationships they determine.[4] This form of "temporal recurrence" reduced art to its concept.

Artists such as Morris,[5] De Maria, Heizer, and Smithson, in advancing the "experimental" tendency of minimalism, were passionately interested in the relationship between art and time. In 1962, the art historian George Kubler wrote *The Shape of Time*, which made such an impression on

Robert Smithson, *The Eliminator*, 1964.
Steel, mirror, neon, and transformer: 20 x 20 x 28 inches.
Photograph by R. Bramms. Collection of Sylvio Perlstein, Anvers.
Courtesy of the John Weber Gallery, New York.

Ad Reinhardt that he either recommended or spoke of the book to all his close acquaintances. Smithson used it extensively in his writings. He cites it for the first time in 1964 to comment on *The Eliminator*, a work consisting of two mirrors that face each other and between which a neon light goes on at regular intervals. "*The Eliminator* is a clock that doesn't keep time, but loses it. The intervals between the flashes of neon are 'void intervals' or what George Kubler calls 'the rupture between past and future.' *The Eliminator* orders negative time as it avoids historical space."[6] In 1966, in "Quasi Infinities and the Waning of Space," Smithson also discusses this idea of "empty intervals," once again citing Kubler and his definition of *actuality* on the subject of Ad Reinhardt: "Actuality is...the interchronic pause when nothing is happening. It is the void between events." If one believes Smithson, this interval so obsessed Ad Reinhardt that he attempted to give it a "concrete shape—a shape that evades shape."[7]

In the 1960s, the process-oriented nature of art was emphasized, inherited from the previous generation's interest in action painting, of which Hans Namuth's film on Jackson Pollock is the most typical example.[8] With Pollock, the importance of the creator came forward, easily accommodating the existentialist interpretations of Harold Rosenberg. By contrast, the minimalists were concerned with objective assemblages legitimized, on a critical level, by the new tools of structural linguistics. Thus Smithson could announce that objects became interesting only once they were finished: "Art, in this sense, is considered 'timeless' or a product of 'no time at all...'"[9] For Smithson, the time inherent in a work of art is also a part of the artist, a time which, while not necessarily long, is deeply rooted in a dimension that joins past and future.

Smithson's interest lies in the present, which he and Kubler call "actuality," and which he uses to interpret the art of Reinhardt, Flavin, and, more generally, the "new monuments" that make us forget the future instead of reminding us of the past. These monuments, Smithson says, "are not built for the ages, but rather against the ages. They are involved in a systematic reduction of time down to fractions of seconds, rather than in representing the long spaces of centuries. Both past and future are placed into an objective present. This kind of time has little or no space; it is stationary and without movement, it is going nowhere, it is anti-Newtonian, as well as being instant, and is against the wheels of the time-clock. Flavin makes 'instant monuments'....The 'instant' makes Flavin's work a part of time rather than space."[10]

Many artists of this period and this sensibility were fascinated by the "instantaneous" dimension of time, which was linked to their fascination with the *fictional* dimension of reality. The interest in process, in flow, and in the passage and irreversibility of time were coupled with a desire to pass through the time continuum and to explore its other side: not *from above*, from the side of a *ciel intelligible*,[11] where reality is the theater of shadows that the artist has a responsibility to show us, but rather *from below*, perpendicular to the flux of time. Such a conception, which makes time into a quasi-being, is implicitly Aristotelian: each instant is a limit neither different nor identical to other instants. If the instant changes, it is destroyed in another moment identical to itself—which is hypothetically impossible—or else into itself—which is improbable because as long as the instant remains what it is, it cannot be destroyed. Moreover, for a passage, a flow, to be possible, the instant cannot be continually the same. It must change. Being

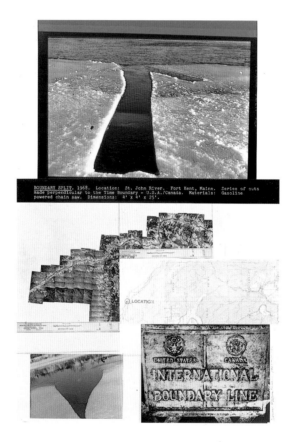

Dennis Oppenheim, *Boundary Split*, 1968.
Location: St. John River, Fort Kent, Maine. Series of cuts made perpendicular to the Time Boundary—USA/Canada. Materials: gasoline-powered chain saw. Dimensions: 4" x 4" x 25'. Photodocumentation: black-and-white and color photographs, topographic map, aerial map, 59 x 40 inches. Courtesy of Dennis Oppenheim.

neither different nor identical, it can be both one and the other, since time is not an object.

Evident here is the problematic nature of time, conceived as an interval or a limit, as in Kubler's conception. The *representation* that we have of time depends on the movement of things that we perceive. Thus, each instant punctuates the movement, and each position of the changing thing corresponds to an instant, in this case, the position of the artist's body. This development of time in space ensures the actual continuation of reality. One can then consider any vertical caesura introduced into the order of a narrative as a fictional effect. This type of *fiction* hovers at the limits of the real, much as the instant stands at the borders of time. Thus, testimonies, chronicles, and history are all fictions. They are partly such in all cases, in varying degrees, and they permit us to know the real by cutting and assembling whatever elements we have at our disposal.

If art no longer has an essence, if it aims toward nothing and expresses nothing, it nonetheless remains attuned to its own history (a history perhaps nearing its end), which artists today must necessarily reconsider within new scenarios. The concepts formulated by artists for their creations borrow from many domains: historical, scientific, literary, and artistic. The resulting discourse forms a set of hypotheses which, as different from scientific hypotheses, do not obey rules of simplicity or internal noncontradiction, for example, and, moreover, they are not systematic. This group of theories has essentially a working value only. These theories are atemporal and independent of specific conditions of observation and experimentation, but they were nonetheless integral to the ideas about consubstantiality of time and artwork that were being discussed in the 1960s.[12]

The idea of time is of central importance for artists who see their activity in phenomenological terms (Morris), or in simply existential terms (Long), or artists who bring the body into play (Oppenheim, who soon became engaged in the practice of Body Art). But these artists also think of their activity in speculative terms, which allows them to construct productive models, such as those appearing in Smithson's work.

In 1968, near Fort Kent and the Canadian border, Oppenheim drew a line in the snow on a frozen lake at the precise location of the international date line. This line, which he entitled *Time Pocket*, ran for one mile before bumping against an island in the middle of of the lake, then regained its course on the other side of the island and continued for another half-mile. The title of this work also evokes the movement of time flowing out in a pocket, itself nothing but an interstitial emptiness between two hours—the exact interval of the Aristotelian instant.

*Time Line*, in the same genre, was completed not far from *Time Pocket*, and followed the line of a time zone running between the United States (Maine) and Canada (New Brunswick). In a film created by Gerry Schum for the Fernseh Gallery, Oppenheim, filmed from an airplane, cuts through the snow on a snowmobile. The photo caption specifies that the line is "drawn by a 10 h.p. snowmobile going 35 mph. Time of execution: 10 minutes. Refreezing index: 70 hours. United States: 3:15 pm; Canada: 4:15 pm." What is obvious in this case is the representation of one moment, as an internal limit of time, through a fiction, which is the *Time Line*. *Time Line* creates one possible narrative of time, articulated around a system of international conventions that mark the jump from one hour to another. Here, time is a measure of movement.

TIME POCKET.1968.
Near Fort Kent, Maine. International Date Line reduced and plotted on frozen land-mass. Line truncated at island located in middle of a 1 mile plot and continued at other end of island for ½ mile. Equipment: Diesel powered skidder.

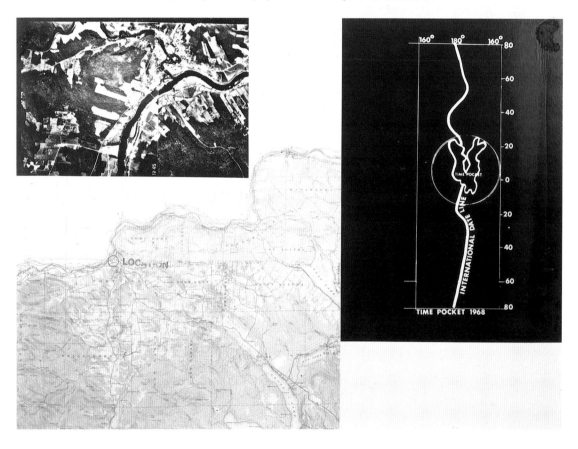

Dennis Oppenheim, *Time Pocket*, Near Fort Kent, Maine, 1968.
International Date Line reduced and plotted on frozen land-mass. Line truncated at island located in middle of a one-mile plot and continued at other end of island for one-half mile. Equipment: diesel-powered skidder.
Courtesy of Dennis Oppenheim.

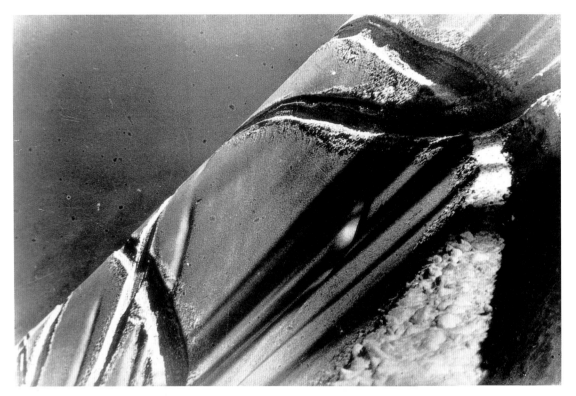

ONE HOUR RUN. 1968.
6 mile continuous track cut with a 10 h.p. snowmobile repeating the continuous route
for 1 hour. 1' x 3' x 6 miles. St. Francis, Maine.

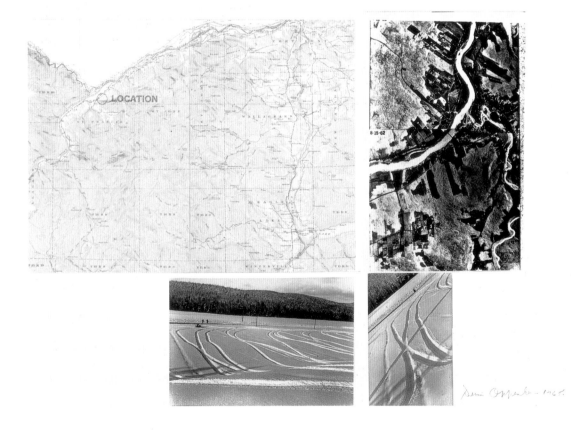

Dennis Oppenheim, *One Hour Run*, St. Francis, Maine, 1968.
Six-mile continuous track cut with a ten-horsepower snowmobile repeating the continuous route for one hour. 1 foot x 3 feet x 6 miles. Document: black-and-white and color photographs, topographic map, aerial map, collage, 59 x 40 inches. Courtesy of Dennis Oppenheim.

This fascination with time also comes from these artists' use of photography. The process of creating the work can have no artistic existence other than the one transmitted by the means of photography or film, unless it becomes the object of an *in vivo* representation, a performance. The outcome can even be destroyed through the medium itself, as illustrated by Oppenheim's *One Hour Run*, for example. Consequently, the artist becomes identified with and inseparable from the work.

The multiplication of media produces movement between what has existed and what has been photographed, filmed, reconstructed in models, or simply commented upon. Thus *Time Pocket* has the complexity of an object relevant in multiple modes of expression, and its definition or identity is therefore problematic. This is the basis of the legitimate attempt to integrate this genre of work within an expanded realm of classification. Time that unfolds in space is tangential to its line as well as to its own limit, since each instant of marking does not constitute the mark itself. From the simple addition of a series of points, a line does not result; the actualization of each point corresponds to its negation in power. This is undoubtedly why the feeling of danger or risk underlies many of Oppenheim's and De Maria's works from the late 1960s. Ten years later, this feeling becomes explicit in Oppenheim's "aggressive" art that use explosions and projectiles, such as the work he presented at the musée d'Art moderne de la Ville de Paris in 1980. This sense of risk is already present in his works on frozen lakes; death lurks on the other side of the ice.

As Dibbets did during this period with his "corrected perspectives," Oppenheim plays continuously with the idea of model and convention. In *Migration Alteration of Time Zones* (1968), he

imagines a modification in the conventional limits of time zones using the migrations of birds. For *Annual Rings* (1969), on both sides of a river he drew concentric circles in the snow, similar to the age rings found in tree sections, to create a border. He thus obtained two representations of time, one by accumulation, indicated by an ever-widening spatial surface, the other by subtraction, showing the passage of time. As Peter Frank and Lisa Kahane have noted, "Ironically, it is the cyclical time which is distinguished by a single line, and continually progressing time which is represented by concentric rings."[13] But if movement materializes time, it passes just as quickly, and leaves only an account of what it was, its memory, or rather the selective recomposition of some of its elements. This is marvelously illustrated in the photograph of lightning crashing down onto De Maria's *Lightning Field* (a photograph that is only a metaphor for the instantaneousness of the physical).

The relationship of these artists to time can be indicated along two axes, horizontal or vertical according to whether the accent is placed on the process of the work, its progress and its reception, or on its representation, through film or photography, or any form of theoric production. On the left axis of the diagram are works which exist as the visible result of a process, such as Heizer's *Double Negative* or Morris's *Observatory*, to cite only two examples.

On the right side of the axis are works whose process remains present yet is frozen by and in a photograph. For example, *One Hour Run* or *Time Line*, destroyed by the first snowfall. Or *Five Conic Displacements*, whose deterioration has been recorded by Heizer's photographs. This is also true of Long's work, since the work, ultimately, has no reality other than the moment of its execution. In a text

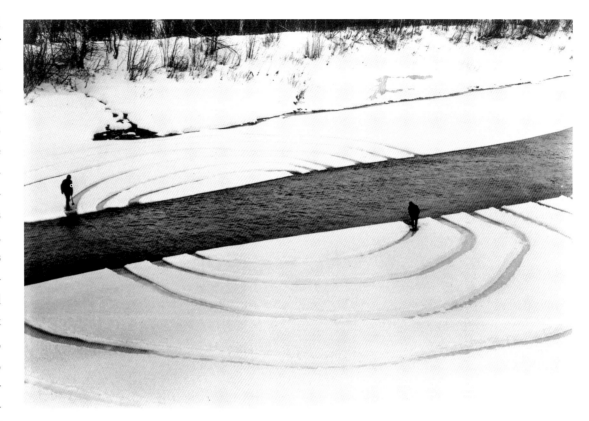

Dennis Oppenheim, *Annual Rings*, United States/Canada border at Fort Kent, Maine, and Clair, New Brunswick, 1968.
Diagram of tree age rings split by a political border. 150 x 200 feet. Time: United States 1:30 pm, Canada 2:30 pm. Courtesy of Dennis Oppenheim.

EVENT
Eternity

Past      Body      Future
(Object)               (Process)

Moment      THEORY
REPRESENTATION      FICTION

expressing his admiration for Carl Andre, Long illustrates his position through a comparison: "What distinguishes his work from mine is that he has made flat sculptures that can be walked on. It is a space for walking that can be taken away and put somewhere else, while my art is the act of walking itself. Carl Andre makes objects to walk on, my art is made by walking. That is the fundamental difference."[14] Long's art is an art of the moment experienced as purification, a "refinement" of time. The sensation of the passing of time, and its variations, is one of the most powerful effects of walking. In his walks, the artist is the work itself, he is both actor and spectator, creation and thing created, at his own limits and at the limits of the world. This art of the moment, an art that seeks to redefine its own boundaries, registers the *computation* of time, step by step. But for Long, two aspects of the work coexist. This art is in the process of being made at the moment in which it exists, articulated by the passage of time: but this is also art in representation, caught by the photograph, recorded on film, which could be situated on the vertical axis of our diagram. In this respect, Long's exhibitions function as compromise. The rocks displayed are *models*, equivalents, specially cut to size in quarries; they have not been brought back from visited and photographed sites. Nonetheless, they demand that the spectator walk around them to view them, and thus re-live the experience, the walk, and the process, at the basis of the artist's work itself.[15]

The dynamic relationship between space and time is one of the central themes in Long's walks, which is why he uses maps as "operators of transformation." In *A Walk of Four Hours and Four Circles* (England, 1972), the map does not represent the real route at all, since nothing indicates how and where one passes from one circle to the other. Instead, the map records

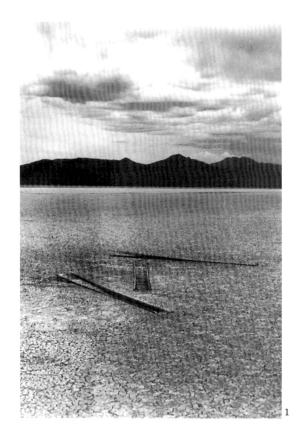

1

**1** Michael Heizer, *Dissipate*, (*Nine Nevada Depressions 8*), Black Rock Desert, Nevada, 1968.
Wood set into the flat bottom of a dried-up lake. 45 x 50 x 1 feet. Commissioned by Robert Scull. Photograph by Michael Heizer.
"There is no longer any photo that even loosely describes this work. Next year...it will probably be only the landscape. Climate has extended the process; it is being photographed throughout its disintegration. As the physical deteriorates, the abstract proliferates, exchanging points of view." (Michael Heizer, "The Art of Michael Heizer," *Artforum* [December 1969].)

**2** Michael Heizer, *Five Conic Displacements* (deteriorated, aerial view), Coyote Dry Lake, Mojave Desert, California, 1969.
136 tons of earth rearranged in the flat bottom of a dried-up lake, 800 x 15 x 4-1/2 feet. Photograph by Michael Heizer.

the speed of movement. From the first to the last circle, this speed increases considerably, since, while the time limit remains the same, the distance is further. In this case, since it is the time that is a fixed measure, the distance traveled can be infinitely large and become a line, or infinitely small and reduce to a point. In fact, this work uses the measurement of the artist's body, since he could stay immobile for one hour at a central spot, or in that hour could run around the largest circle allowed by his physical capacities. But Long was not interested in such performances; he is concerned only with the rhythm symbolized by his circles.

The cinema can capture this process, i.e. the experience of the body in Long's walk-creations, or of the reception of any sculptural work, but particularly it is Morris who has made this experience a constant theme of his work. Long did make a short film entitled *Walking a Straight 109 Miles Forward and Back Shooting Every Half-Mile* for Gerry Shum's Fernseh Gallery. After showing the route of the forthcoming walk on a map, the camera rotates 360 degrees, at the end of which we discover Long, almost ghostlike, walking away into the landscape. Following this, the camera zooms at regular half-mile intervals, giving us the impression of advancing into the landscape as if we were the walker, an impression reinforced by the soundtrack of the artist's breathing. With each zoom of the camera there is thus an effect of acceleration, and we feel a gap between the time of the image and the distance traveled. All this is not a simulation, but instead functions as a sensory equivalent.

Smithson filmed the conception and construction of *Spiral Jetty*. In an interview conducted after he completed the film, he recalls the relationships established between real time and cinematographic time: "Both the making and the filming of

LAND ART

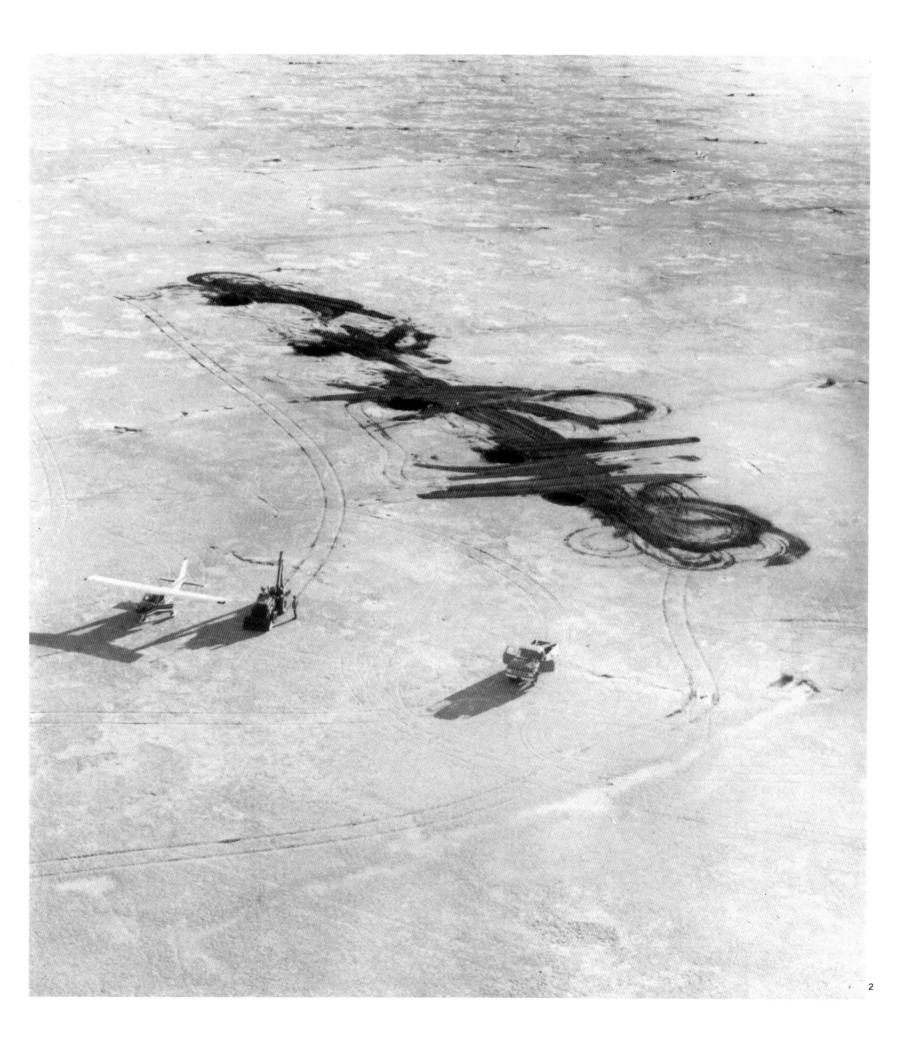

2

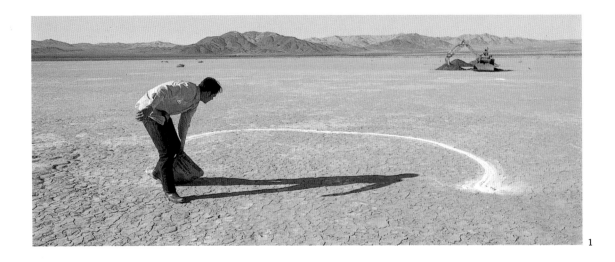

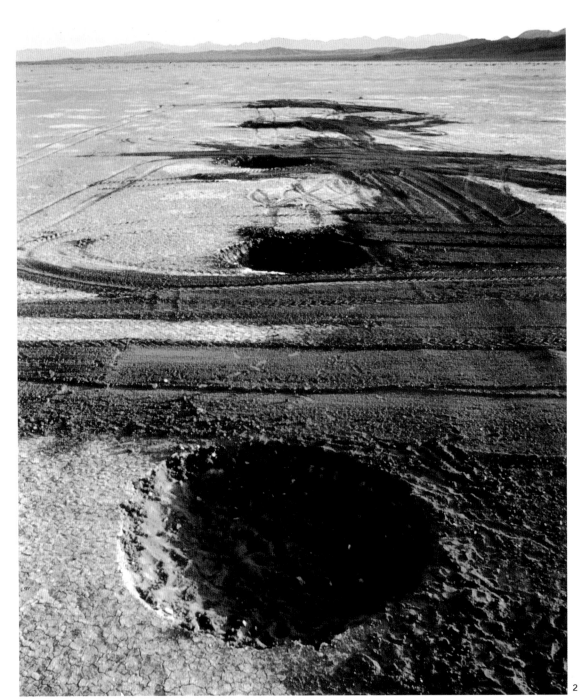

Michael Heizer, *Five Conic Displacements*, Coyote Dry Lake, Mojave Desert, California, 1969.

**1** During execution.
**2** Deteriorated.
**3** Filled with water.

"Man will never create anything really large in relation to the world—only in relation to himself and his size. The most formidable objects that man has touched are the earth and the moon. The greatest scale he understands is the distance between them, and this is nothing compared to what he suspects to exist. Five back-to-back storms from Japan flooded the West Coast. The five displacements were filled with rainwater—a transparent mass. This work might last 50 years. Colloidal matter fills the depressions at a rate of three to four inches annually. The final graphic image of this work will consist of many photographs taken as the spaces are filled and the surface is restored. The recent examples of Florence and Venice describe the same situation this work confronts." Michael Heizer, "The Art of Michael Heizer," *Artforum* (December 1969).

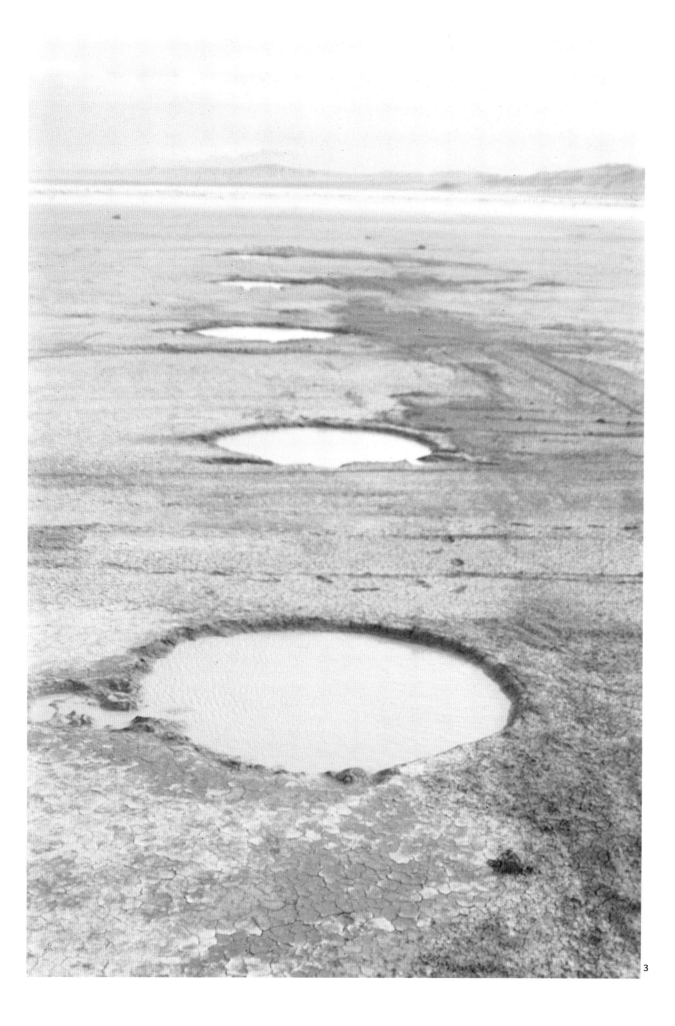

3

the work informed each other. Of course, the water rushing in the film is not rushing anymore, but there is a sense of parallel times—both temporal and atemporal." In the same interview, he discusses the changes undergone by the spiral: "When you are dealing with a great mass, you want something that will, in a sense, interact with the climate and its changes. The main objective is to make something massive and physical enough so that it can interact with those things and go through all kinds of modifications. If the work has sufficient physicality, any kind of natural change would tend to enhance the work."[16] In other words, for Smithson, the work should be at the same level as the physical, climatic, and seismic forces that can be exerted on it,[17] and it should have the capacity to attach itself to time so that time can complete it. Heizer admits that climatic conditions can modify some of his works. "I allow these possibilities if I encounter them but don't plan them. Many negative sculptures I built in the late sixties were inundated with water because they were built on dry lakes that flooded in the spring and winter or were eroded by wind. These works were photographed in this condition. They were extended and developed by natural forces, both physically and intellectually, beyond the 'completed' state I had left them."[18] But, if confronted, he does not rule out the idea of restoring the collapsed walls of *Double Negative*.

It is immediately evident how much this conception is once again dependent on Aristotelian logic. Nature is recognized as a plastic force to which the artist is in some sense auxiliary. For the Greeks, it was necessary to "follow nature," since nature holds absolute privilege, in the moral as well as the physical sense. It is the same for art, whose sole justification is to imitate nature: not its products—a crude version of *mimesis* as copy—but rather its

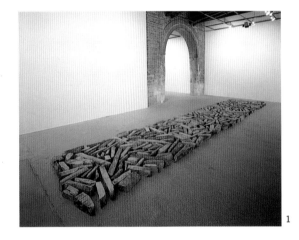

1

**1** Richard Long, *Cornwall Slate Line*, Capc, Musée d'Art contemporain, Bordeaux.
© Photo iso.

**2** Richard Long, *A Walk of Four Hours and Four Circles*, England, 1972.

production. Imitating nature is not reproducing its exterior, rather it is remaining a part of it to realize it completely. To use Pierre Aubenque's expression, art is an "active tautology" of nature.[19]

For the Land Art artists, art does nothing but channel natural forces by means of technical instruments, which are improved, certainly, but are not fundamentally more complex than the levers, pulleys, and winches used by the Greeks. Bulldozers, cranes, and lifting machines are instruments meant to multiply human force; in a certain sense, they are extensions of the human body.[20] The Greek word *mèkhanè* means a trap, stretched to the points where nature allows itself to be captured. Land Art artists are not fascinated by technology, and the ideology of progress that accompanies technology's most spectacular creations is fundamentally foreign to them. If they do dream of technical power, it is within the realm of the irrational, of chaos. For them, as for the Greeks, "the time of the technical operation is not a stable, unified, homogeneous reality, from which knowledge can be gained; it is the time of seized opportunity, of *kairos*, the point when human action meets a natural process that develops according to the rhythm of its own duration."(19) *Kairos* is the opportune moment, neither too early nor too late, when from a moral point of view, for example, virtue finds its fulfillment. This moment is a singular one, and cannot be the object of any science or art, since the judgement of art proceeds from the universal.[21] The art can, however, be the effect or the plastic expression of the result of natural and human forces. *Lightning Field*'s use of lightning elevates a natural phenomenon to the status of art, perfected by photography. The field of lightning rods is itself a work of art, but one which cannot be understood except through

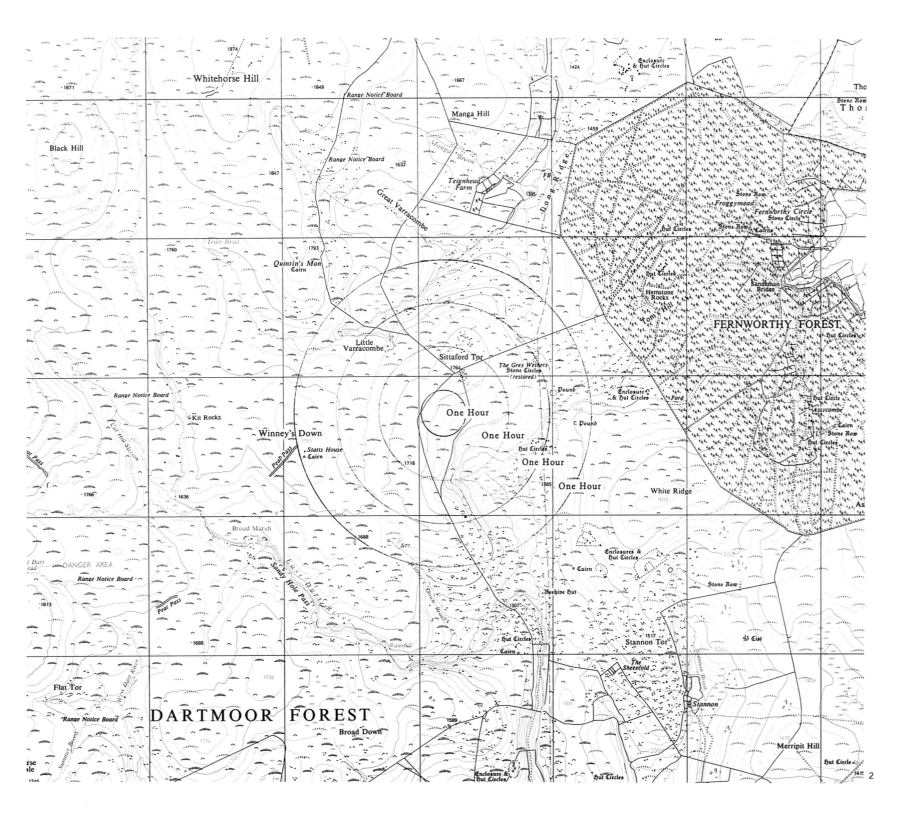

## A WALK OF FOUR HOURS AND FOUR CIRCLES

### ENGLAND 1972

a whole range of visibility that extends from an almost total eclipse, at the hour when the sun hits it from directly above, to a spectacular event, at the moment when lightning strikes it.

The Land Art artists have a sense of passage of time; their awareness of it leads them to search in the "depth" of the moment for the permanence that escapes them. To quote Aristotle, time, like movement, is a cancelling force; it is "ecstatic," from the Greek word *ekstatikon*. This is the basis of the artists' recourse to fiction. Fiction can be important as an experience of the body *through* time, or instead as an account of time that could just as easily take the form of

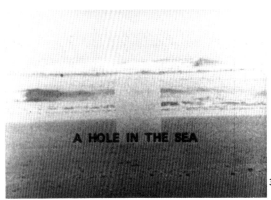

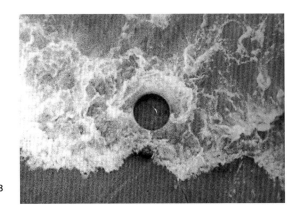

**1** Barry Flanagan, *Ring*, 1966.
120 pounds of sand, from which the artist removed a few shovelfuls, on the floor of the Rowan Gallery.

**2** Barry Flanagan, design in the author's notebook to explain how *Hole in the Sea* was constructed.
The plan shows the jetty and the fireman's ladder, at the end of which a camera was suspended. The same construction is also shown in section, with the pipe attached under the cylinder and connected to the suction pump of the truck.

**3** Barry Flanagan, frames from the film *A Hole in the Sea*, 1969.

history, of a poem, or of a film, as that of science-fiction. Fiction organizes experience in a scenario in which communication occurs by means of a number of markings or indicators, which then act as centers of meaning.

In 1975, Richard Long went on a six-day walk within an area of six miles around *The Giant of Cerne Abbas*, in Dorset. Through this work, Long revives an enigmatic figurative drawing, while simultaneously emptying it of its previous mythical power by giving it a sense of rhythm (the punctuation provided by the walk itself), thus registering the present within an ancient motif. This is one of the motivating forces of Richard Long's art. As Lucy

Lippard writes, "Long's outdoor work is moving precisely because of its evocation of the past within a highly specific present."[22] Long has also walked along the lines of Nazca, Peru, crossing immense territory, utilizing all the ancient sites whose existence and function have given rise to many interpretations, although none are truly convincing.[23]

In this sense, the most impressive work, because it is the simplest—from an aesthetic perspective where minimal means produce maximum effects—is *Hole in the Sea*, by the Englishman Barry Flanagan. Flanagan was a sculptor and a poet. He had already been showing his artwork for a number of years, and had participated in

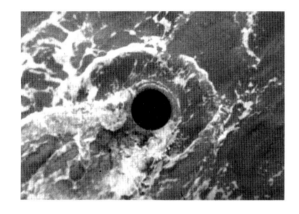

various "concrete poetry" events, such as the *Second International Exhibition of Experimental Poetry* at Saint Catherine's College in Oxford. His sculptures of that period were made in the shape of sacs stuffed with rags standing or piled up on the floor. At the Rowan Gallery in 1966 he showed *Ring*, a circular mound of sand weighing 120 pounds, at the center of which several shovelfuls of sand had been removed. Flanagan had been quite taken with the work of Alfred Jarry, whom he had discovered in 1964. Pataphysics, the "science of imaginary solutions," is also relevant to the idea of *Hole in the Sea*. Black holes were being widely discussed at the

### MOTIONLESS TIME

*Looking at her for this last moment, Ramson was aware of the unstated links between himself and this crippled young woman. The blanched features of her face, from which pain and memories alike had been washed away, as if all time had been drained from them, seemed to Ransom like an image from his own future. For Vanessa, like himself, the past no longer existed. From now on they would both have to create their own sense of time out of the landscape emerging around them...*

*Yet this stopping of the clock had gained them nothing. The beach was a zone without time, suspended in an endless interval as flaccid and enduring as the wet dunes themselves. Often Ransom remembered the painting by Tanguy which he had left behind in the houseboat. Its drained beaches, eroded of all associations, of all sense of time, in some ways seemed a photographic portrait of the salt world of the shore. But the similarity was misleading. On the beach, time was not absent but immobilized, what was new in their lives and relationships they could form only from the residues of the past, from the failures and omissions that persisted into the present like the wreckage and scrap metal from which they built their cabins.*

J.G. Ballard, *The Drought* (London: Jonathan Cape, 1965, reissued 1984), pp. 99, 161–162.

time, and Flanagan's work makes parodic reference to them. In Gerry Shum's short film of *Hole in the Sea*, the sea is filmed from above, as it rises above a plastic cylinder approximately thirty-one inches high and twenty-three inches in diameter, placed vertically in the sand. A fire truck ladder installed at the end of a pier allowed him to film directly above the cylinder. The hour of high tide is inserted between each sequence, for a total of thirteen times between 1:15 pm and 4:38 pm. When the sea finally submerges the cylinder, it appears to be almost swallowing it up. After this, Flanagan appears on the screen and carries away the cylinder, and the camera once again moves parallel to the ground. In absorbing time, space—through a characteristic inversion in which the "rising of the waters" symbolizes the engulfing of time—seems to show its vertical dimension. This idea is also found in Walter De Maria's buried kilometer (*Vertical Earth Kilometer*, 1977), a work visible only in section, and one that attempts to bring us back to the origin of time itself. This strongly suggestive image shows the dimension of artistic fiction, the particular way of "creating a world" of art, found within Land Art.

Entropy, which was introduced by Smithson in his discussion on art, belongs to the domain of thermodynamics, and has two essential principles: the conservation of energy, and the transformation of this energy into mechanical force. Applied to the entire universe, these two principles imply that, according to all probability, all surrounding energy deteriorates at a constant rate—this is called entropy—and that soon nothing will remain but a random agitation of molecules that will lead the universe to thermal death. Reading Smithson's "Entropy and the New Monuments," dating from 1966, the course of action that he took

Walter De Maria, *Olympic Mountain Project*, 1970.
Shaft four-hundred feet deep and three feet in diameter, bored into a pile of rubble in the form of a volcano and covered with earth and grass. The shaft was to be covered by a metal disk twelve feet in diameter. Project for the Olympic Games in Munich in 1972. Never constructed.

from this theory can be understood. According to him, many artists have created a "visible analogy" to the second principle of thermodynamics. This is true of the minimalists, Dan Flavin, Sol LeWitt, Donald Judd, and Robert Morris, for example, and it is also the case for others such as Paul Thek, Craig Kauffman, and Peter Hutchinson. In the same article, Smithson goes on to discuss artists' tastes in film, distinguishing those who love horror films and are thus seeking emotions from those who, through science fiction, aim to stimulate their perception. According to Smithson, more than the films, it is the movie theater itself that is a "mental conditioner," since "Time is compressed or stopped inside the movie house, and this in turn provides the viewer with an entropic condition. To spend time in a movie house is to make a 'hole' in one's life."[24]

For Smithson, entropy is a paradoxical model, characterized by inertia, solidification, and crystallization, as well as destruction and annihilation.[25] His idea of time is connected to entropy, perceived as an instantaneous crystallization and internal collapse. As a negation of time, entropy is distinguished by immobility. But above all, for Smithson it serves to designate the instantaneous objectification that freezes this "fraction," this infinitesimal "sequence" where the past and the future flow back into the present. This relates once again to the theory of black holes, which explains how certain stars collapse in on themselves, and which is also linked to thermodynamics.

The scientific theory thus plays a fictional role for artworks; the reality of these works is not questioned, but to be fully understood, they require that the viewer refer back to the principles that inspired them. In Smithson's work, these principles, culled from a mix of references both

Walter De Maria, *Vertical Earth Kilometer*, 1977.
This is a permanent, minimal, and conceptual earth sculpture adjoining the Friedriensplatz park in Kassel, Germany.
The boring of the shaft, which goes through six geological layers, took seventy-nine days. The continuous metal rod is made of 167 pieces, each almost 20 feet long, screwed tightly together. The sandstone square which surrounds the top of the shaft is at the center of the crossing of two paths which traverse the Friedriensplatz park. Principal coordinators: Dr. Manfred Schneekenburger, director of Documenta VI, and Dr. Hans Jurgen Picket, technical director. Dimensions: metal rod, .62 miles x 2 inches; sandstone plate: 6.6 feet square; weight 17 tons. Commissioned by the Dia Center for the Arts, New York. Photograph by Nic Tenwiggenhorn, © Dia Center for the Arts, 1977.

Robert Smithson, *Spiral Jetty Film Stills Photodocumentation.*
25 x 43-1/2 inches. Property of Robert Smithson. Courtesy of the
John Weber Gallery, New York.

concrete and ephemeral, are indissociable from the plastic creations they inspire.[26] It is this body of work, texts, and proposals, whose scientific relevance has been tested through precise procedures of experimentation, that the artist diverts from its original function to integrate with other constructions lacking such verification. This compendium functions as a mode of intellectual representation, indissociable from the objects whose creation it organizes on the linear axis of time. Concepts and objects mutually represent each other, in some sense, in an impossible coincidence in which the lived moment—the moment of experience itself—is the much sought-after yet elusive goal.

This imperceptible instant expands through history and acquires deeper meaning and new dimension through the passage of time. Myth, in the depth of the past, and science, in the extension of the future, provides final support. In the realm of myth, *Spiral Jetty* renews ties with ancient Indian legends, according to which deep whirlpools carry the lake water into the ocean. The *Spiral Jetty* film itself transports us to the

origins of the creation of the world and to the heart of the sun in fusion and shows us the cranes at work on the lake resembling prehistoric animals; it thus becomes the best vehicle for this myth.[27]

In her work, Nancy Holt maintains a poetic relationship with the scientific models that she utilizes. She discovered the deserts of the American West in 1968, in her travels with Smithson, whom she had married in the early 1960s. In 1969, she buried poems in carefully chosen sites. But it was not until 1973, in Amarillo, while looking for a site for the construction of *Amarillo Ramp*, that her idea for *Sun Tunnels* became fully developed.

*Sun Tunnels* is sited on land purchased by Holt, in northwest Utah. Four specially constructed enormous pipes, each eighteen feet long and nine feet high, face each other in pairs around an empty space, at the center of which is a cement circle flush with the level of the ground.[28] The pipes are oriented in the directions of the summer and winter solstices. "For about ten days around the winter solstice, the sun rises in the pipe facing southeast and can also be seen through the northwest pipe. At and around the summer solstice, the sunrise and sunset are aligned to the northeast/southwest and nortwest/ southeast pipes."[29]

Holes have been cut into the surface of the pipes, each according to the constellations. The size of these holes depends upon the importance of the stars, and the spots of light that penetrate to the interior of the pipes reproduce these moving figures, according to the movement of the sun during the day, and of the moon at night. Thus, writes Nancy Holt in her text on *Sun Tunnels*, "Day is transformed into night, and an inversion of the sky takes place: stars are cast down to Earth, spots of warmth in cool tunnels." Through

individual experience, this installation in the desert is intended to introduce the observer to the cosmic dimension of time: "'Time' is not just a mental concept or a mathematical abstraction in the desert. The rocks in the distance are ageless; they have been deposited in layers over hundreds of thousands of years. 'Time' takes on a physical presence. Only 10 miles south of *Sun Tunnels* are the Bonneville Salt Flats, one of the few areas in the world where you can actually see the curvature of the earth. Being part of that kind of landscape, and walking on earth that has surely never been walked on before, evokes a sense of being on this planet, rotating in space, in universal time."[30]

For Nancy Holt, *Sun Tunnels* is a way of placing the earth back onto its axis, of giving it a new direction in a place that is distinctly lacking direction, something no human convention can give. At the site, one has the feeling of being on the earth in the exact scale that the earth is understood in relation to the stars. One perceives the earth in its totality. It is certainly possible to section and frame the landscape through the pipes, but this landscape has no meaning except in relation to the axis of the sun and the movement of the planets. It is a stellar landscape, with the desert providing its image.

Although generally quite different, the work of Charles Ross is comparable to Nancy Holt's. Ross's work, however, is situated more within the realm of scientific fiction. On a plateau one hundred miles east of Albuquerque, Ross planned and began to construct a work whose central feature is a stainless-steel cylinder embedded into an enormous concavity on the southern edge of the plateau. The entire work measures 120 feet high and a tenth of a mile across. "The cylinder will be aligned with the axis of rotation of the earth, pointing to the north celestial pole. Its upper end will rise 50 to 60 feet above the mesa..."[31] A granite pyramid surrounds the cylinder; the pyramid's shadow will be delineated by a shallow depression in the surface of the mesa. The aim of *Star Axis* is to capture the relationship between the earth and the North Star, which changes periodically according to the precession of the equinoxes.

The earth wobbles unstably on its axis, causing the axis to point to different regions of the sky at different periods in history; the wobbling axis undergoes one complete revolution every 26,000 years. For example, during the construction of the Great Pyramid of Egypt in 2700 BC, the axis of the earth was almost exactly aligned not with the North Star Polaris, but with a different star, Thuban, in the constellation of Draco. Ross's cylinder frames the movement of Polaris, allowing the visitor to observe its changing orbit throughout history. The intention of *Star Axis* is to use this cylinder and the movement of the earth to make different kinds of time perceptible.

Nancy Holt, *Sun Tunnels*, Great Basin Desert, Utah, 1973–1976. Total length: 86 feet, length of tunnels: 18 feet. Courtesy of Nancy Holt.

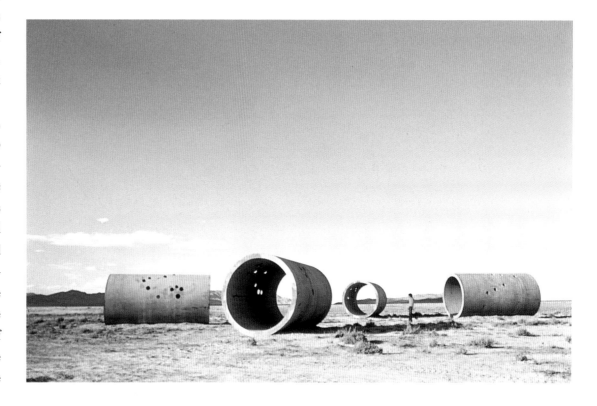

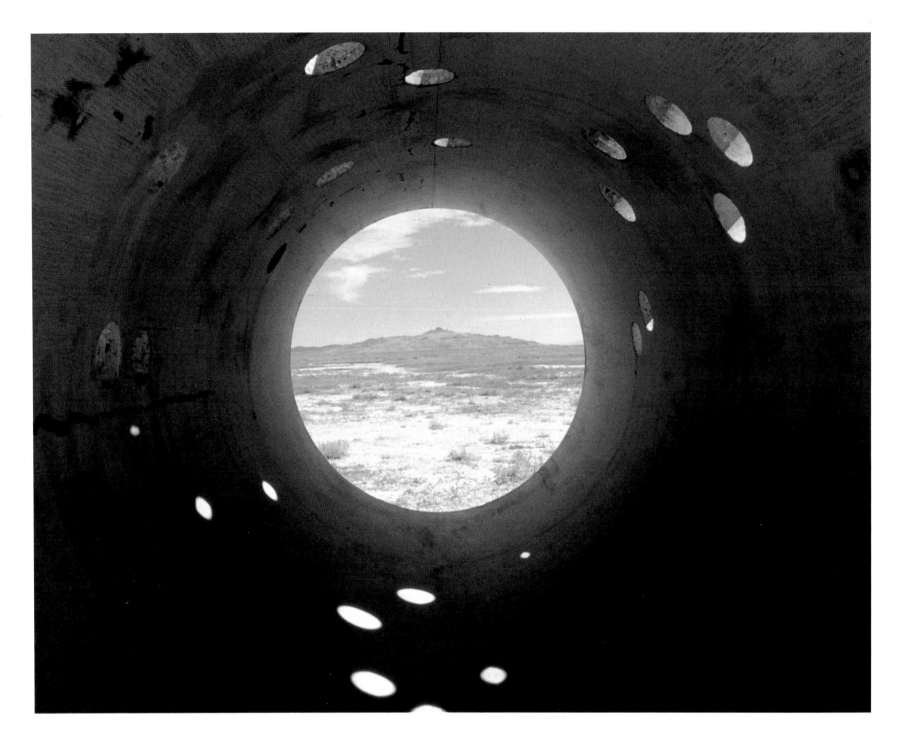

Nancy Holt, *Sun Tunnels*, Great Basin Desert, Utah, 1973–1976.
Detail. Courtesy of Nancy Holt.

Nancy Holt, *Sun Tunnels*, Great Basin Desert, Utah, 1973–1976.
Detail: sunset, summer solstice. Courtesy of Nancy Holt.

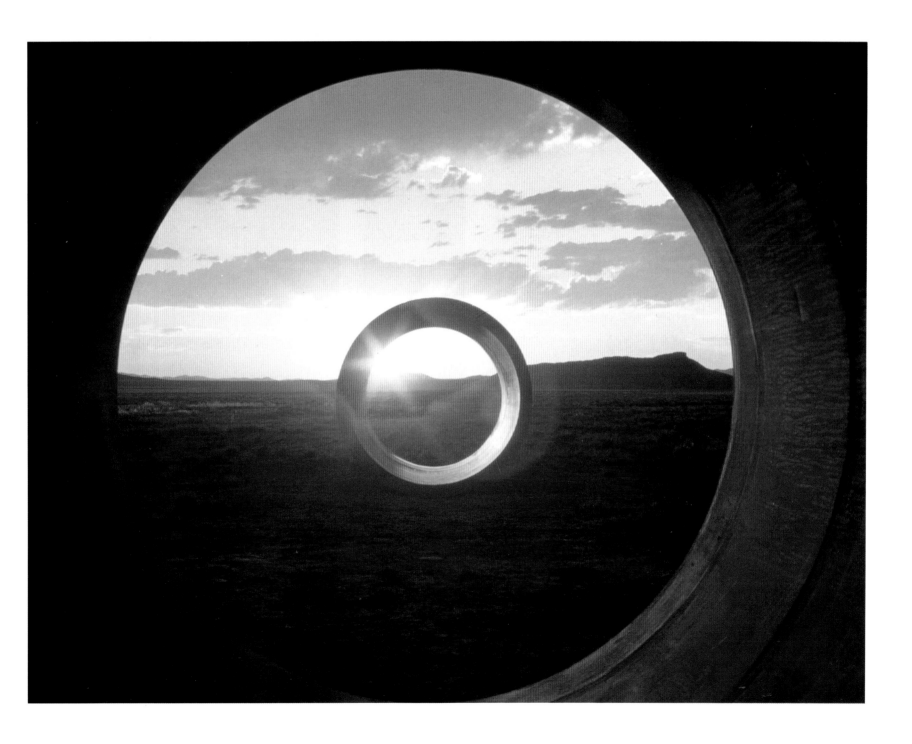

**1** Charles Ross, *Orbits of Time*, drawing for Star Axis.
© Charles Ross, 1977.

**2** Charles Ross, *Orbits of Polaris*.
© Charles Ross, 1977.

**3** Charles Ross, *Star Axis* (looking south).
© Charles Ross, 1990.

**4** Charles Ross, *Star Axis* (under construction, aerial view).
© Charles Ross, 1988.

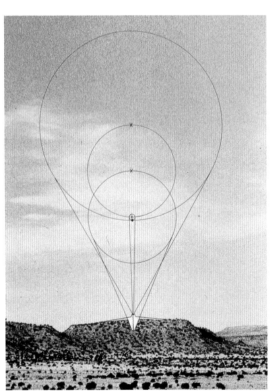

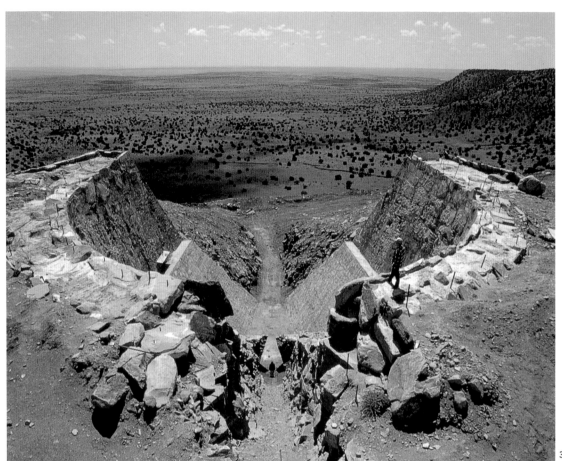

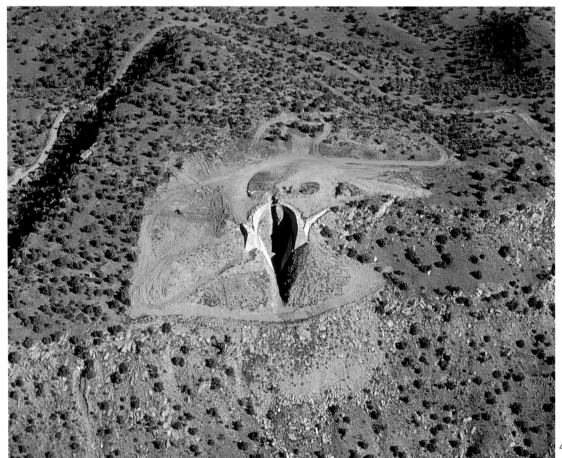

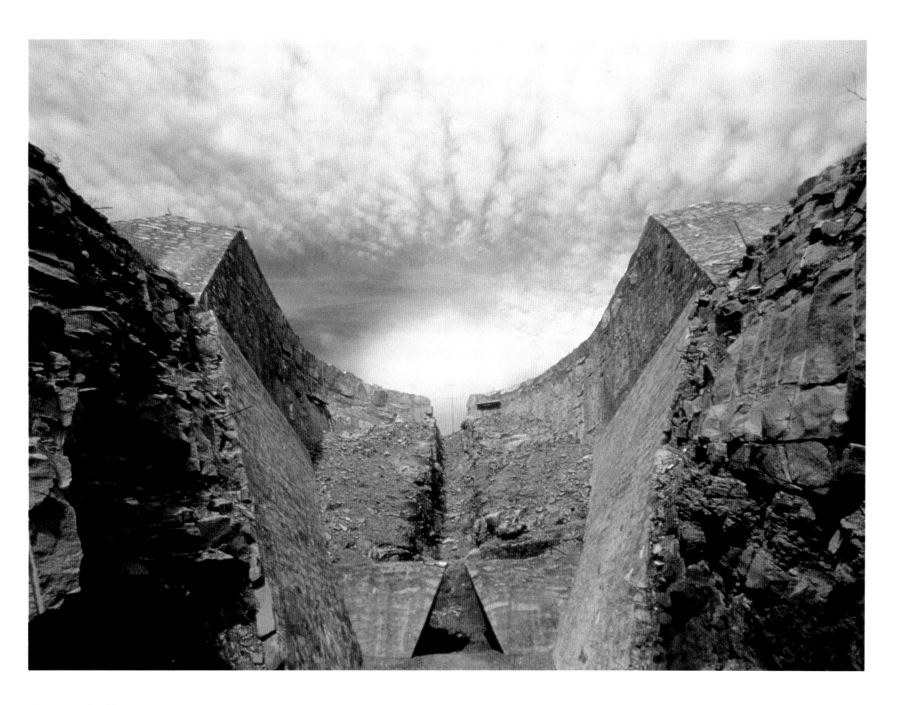

Charles Ross, *Star Axis* (under construction).
© Charles Ross, 1988.

"*Star Axis* places you in scale with the dramatic range of Polaris' circumpolar orbit. The smallest orbit, a one degree circle framed from the first stair of the tunnel, is about the size of a dime held at arm's length. Seen from the top stair, the largest orbit of Polaris encompasses the eye's entire field of view. The stairs will be dated to identify the present orbit as well as those of distant past and future times. Plato called precession the 'Great Year.' It is the largest cycle of astrophysical time to still retain a specific human measure. One 360th of the 26,000 year cycle, a 'Great Day,' is 72 years—approximately the human lifespan. By entering the earth to reach the stars, you can see and feel how the human form is scaled to fit the cosmos." Charles Ross, "Star Axis, When the Earth Meets the Sky," 1984.

"Days and years and ages so prolonged as to be normally indiscernable will all be inscribed in the work. Time will be rendered less anthropocentric, less automatic, as we see ourselves relative to cycles of a far greater duration and permanence than our own."[32]

Certain artists who have experienced the American desert have a temptation to suspend their art in the light between the earth and the sky, finding order and rhythm in the movement of the sky and the stars. This lure of the "eternal" corresponds to the contemplative pleasure we get from observatories, whether natural, such as James Turrell's *Roden Crater*, or constructed, such as Robert Morris's *Observatory*. This celestial voyage has as its opposite the descent into the depths of the earth and the consciousness symbolized by the labyrinth.

Jean-Marc Poinsot noted that for the two successive generations of Land Art artists, "the two original models are the labyrinth and the observatory."[33] These examples are complementary rather than truly opposed, as they can be considered representations of the interiority of the world and its enigma: time itself, the navel of existence, whose umbilical cord is symbolized by the labyrinth.[34] What is important in this use of this motif by the Land Art artists, is that, in addition to its references to prehistoric, Cretan, and Renaissance examples, it emphasizes the present moment. The center of the labyrinth is its complex expression, since it is the limit of the subject and the world, as well as the limit of the past and the present. This means that there is no center as such; as soon as a center is reached, it is surpassed, just like an instant of time, which disappears as soon as it is grasped. This is what Leibniz calls "the labyrinth of the continuum." He states that its contradictions are inextricable from its essence, and that they

characterize a philosophy similar to Aristotle's, who could only accept that the infinite existed in terms of potential. Without going further into this symbolism, it is important to note that the labyrinth is present in the work of Smithson,[35] Long,[36] Oppenheim,[37] and Morris, whose *Philadelphia Labyrinth*, shown in March of 1974 at the Institute of Contemporary Art, was subsequently destroyed.[38]

Morris intended the system of vertical openings supported by large stone slabs on the exterior circle of *Observatory* to correspond to the rising of the sun at the winter and summer solstices, and the openings in the interior wall indicate the positions of the sun at the equinox.

In addition to the specific relationship that it elicits with the spectator's body, and the way in which it challenges the spectator's global perception, *Observatory* transcribes solar time while making reference to certain neolithic monuments (Stonehenge being the most well-known) that are thought to have served as solar calendars. But this solar time is attained through the time necessary for the spectator to comprehend the work, and this aesthetic experience is also an experience of oneself as a physical, temporal being. Here one finds the same system of layering different concepts of time as in *Spiral Jetty*. The meaning of time for the observer expands through the reference to neolithic monuments and their function as calendars, which, as Morris himself has said, gives "a kind of 'time frame' or ever present context for the physical experience of the work."[39]

In fact, for these artists there are two conceptions of time, one inherited from modernism, the other fighting against it.

The former stems from a fascination with the moment, with the now, through which the work is supposed to offer itself to us, all at once—accompanied by an

**1** James Turrell, *Roden Crater Early Site, Plan and Section*, 1992. Drawing, 39-3/4 x 58-1/2 inches. Courtesy of the galerie Froment & Putman, Paris.

**2, 3** Richard Long, *Connemara Sculpture*, Ireland, 1971. Photograph and text, 26 x 32-3/4 inches. Courtesy of the Anthony d'Offay Gallery, London.

**4** Robert Morris, *Labyrinth (Philadelphia Labyrinth)*, 1974. Installation for the Institute of Contemporary Art, University of Pennsylvania, Philadelphia, March 1974. Chipboard and masonite painted gray. Height 8 feet; diameter approximately 30 feet. Collection of the Solomon R. Guggenheim Museum, New York, Panza Collection, 1991. Courtesy of the Guggenheim Museum, New York.

exploration of philosophic presuppositions implied by this relationship.[40] But here, the *ciel intelligible* is replaced by a group of hypotheses based in science as well as in fiction, whose coherence comes from the plastic creations which these hypotheses support. For some artists, behind these productions lies an ontological void that they see as the entrance to an almost religious dimension, for which art would provide the experience. Thus, for Heizer, this is through a group of historical or archaeological references, and for Long, within an empathic relationship with nature.

The second conception explores duration, and emphasizes the process of construction, reception, and deterioration of works of art. It focuses instead on the transformation of the materials and on the experience of space and the body, which Fried calls the "theater" of the world. Out of this exchange come discussions and works that attempt to appropriate this moment in time and to create a dialogue between this modernist *atemporality*—intended to characterize our relationship with art—and the artist's, as well as the spectator's, phenomenological exploration of the work. Both ideas about time are recognized as contradictory, yet both are inherent to much of the work on the Land Art movement.

Dennis Oppenheim, *Maze*, Whitewater, Wisconsin, 1970.
Materials: hay, straw, corn, and cattle, 600 x 1000 feet. A diagram of a maze for laboratory rats transposed onto an unseeded field. Food (corn) is deposited along the edges. The cattle run around the maze to find these deposits of food. Courtesy of Dennis Oppenheim.

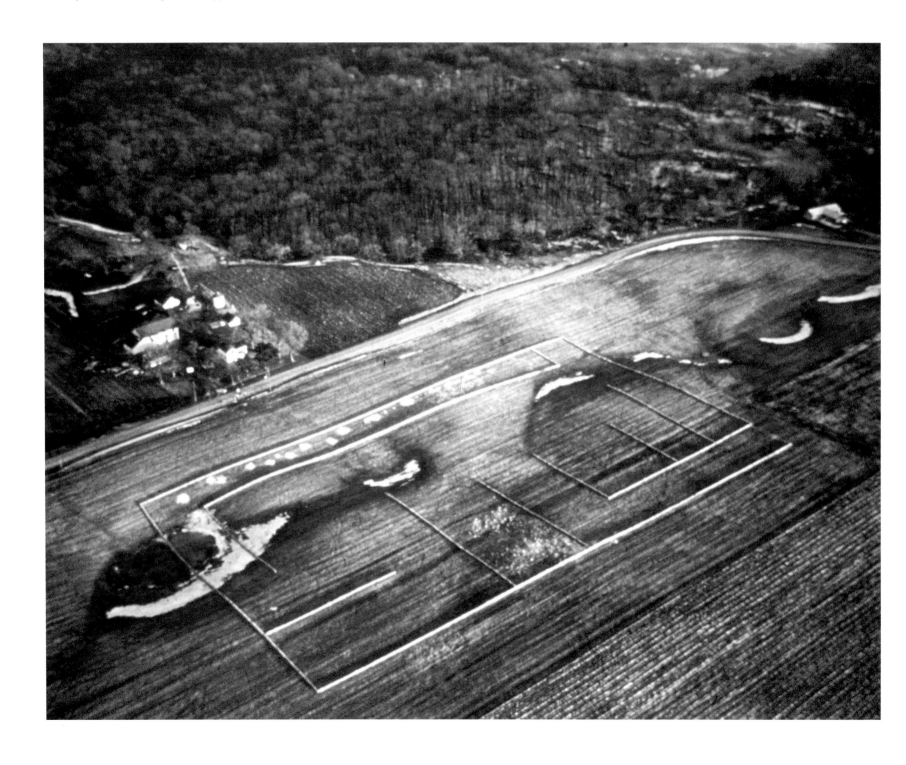

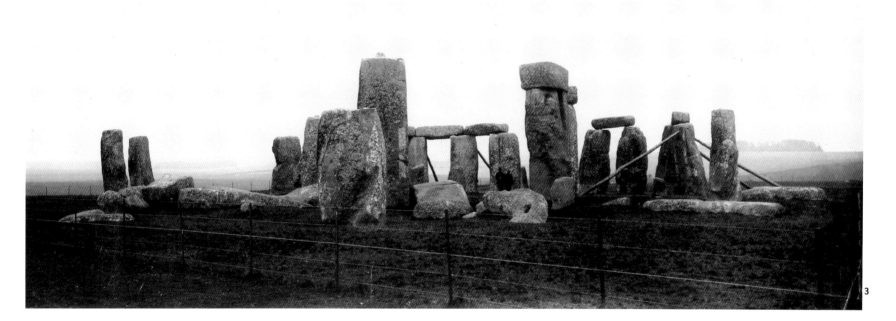

## MAYAN OBSERVATORY

*Excavations in group E revealed the first known Maya architectural assemblage aligned so as to function as an astronomical observatory. In the years since, a series of similar building alignments has been found at other Classic centers. These observatories seem to have been used primarily for determining the positions of equinoxes and solstices. A pyramid was built on the west side of a court, facing due east. On the opposite side, three temples were erected on a terrace, their facades running north and south, arranged so as to establish lines of sight when observed from the stairway of the pyramid on the west side. From this observation point, the sun on its way north, rose directly behind the middle temple (E-II in the figure) on March 21, the vernal equinox; behind the north front corner of the north temple (E-I) on June 21, the summer solstice; behind the middle temple again on its way back south on September 23, the autumnal equinox; and behind the south front corner of the south temple (E-III) on December 21, the winter solstice. This assemblage of buildings was a practical instrument for determining the longest and shortest days of the year, and the two intermediate positions when day and night are of equal length.*

Sylvanus G. Morley, George W. Brainerd, revised by Robert J. Sharer, "Uaxactun," excerpt, *The Ancient Maya*, 4th edition (Stanford: Stanford University Press, 1983), pp. 293–294.

1 Precolombian observatory, Mesa Verde National Park, Colorado, 1922.
Photograph by Roger-Viollet, Paris.

2 Uaxactun observatory, Guatemala.
Perspective drawing showing the alignments used to determine the dates of the solstices and the equinoxes. Drawing taken from *The Ancient Maya*, p. 294.

3 Stonehenge, prehistoric site.
Photograph by Roger-Viollet, Paris.

1 Robert Morris, *Model of Sonsbeek '71 Observatory*, 1971.
Lead hammered on wood, 8 x 120 x 96 inches. Collection of the
artist. Photograph by Rudolph Burckhardt. Courtesy of the
Guggenheim Museum, New York.

2, 3 Robert Morris, *Observatory*, 1971, temporary installation in
Ijmuiden, Netherlands, for the *Sonsbeek '71* exhibition.
Earth, wood, granite, metal, and water. Courtesy of the Guggenheim
Museum, New York.

Robert Morris, *Observatory*, 1971, temporary installation in Ijmuiden, Netherlands, for the *Sonsbeek '71* exhibition. Earth, wood, granite, metal, and water. Courtesy of the Guggenheim Museum, New York.

Robert Morris, *Observatory*, Oostelijk Flevoland, Netherlands, 1977.
Earth, wood, and granite, diameter: 299 feet. Courtesy of the Guggenheim Museum, New York.

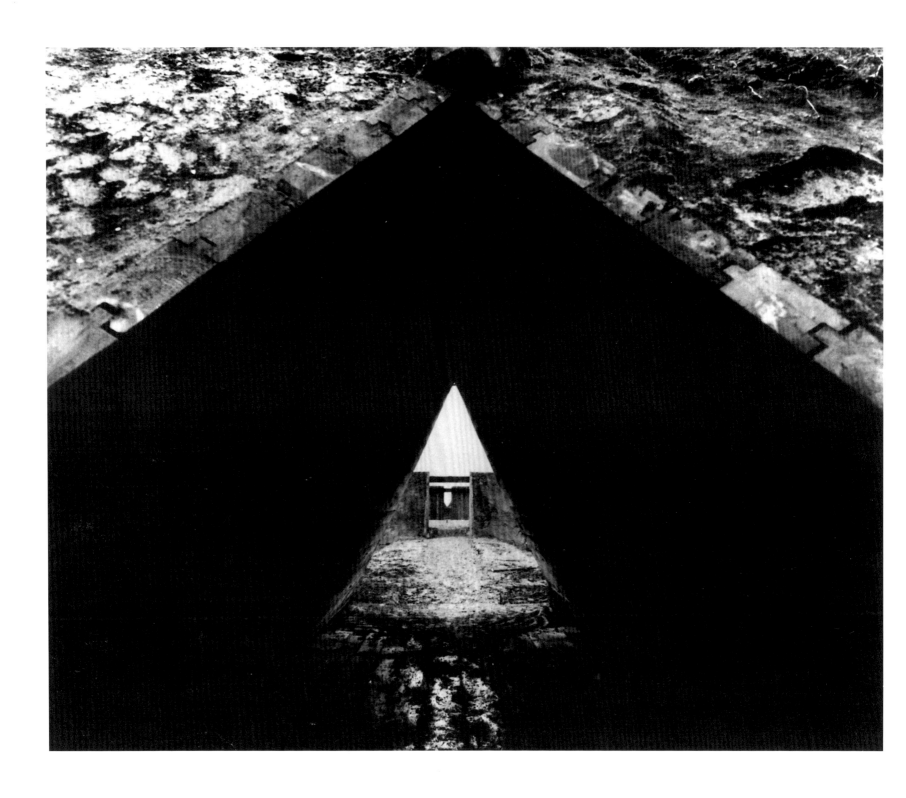

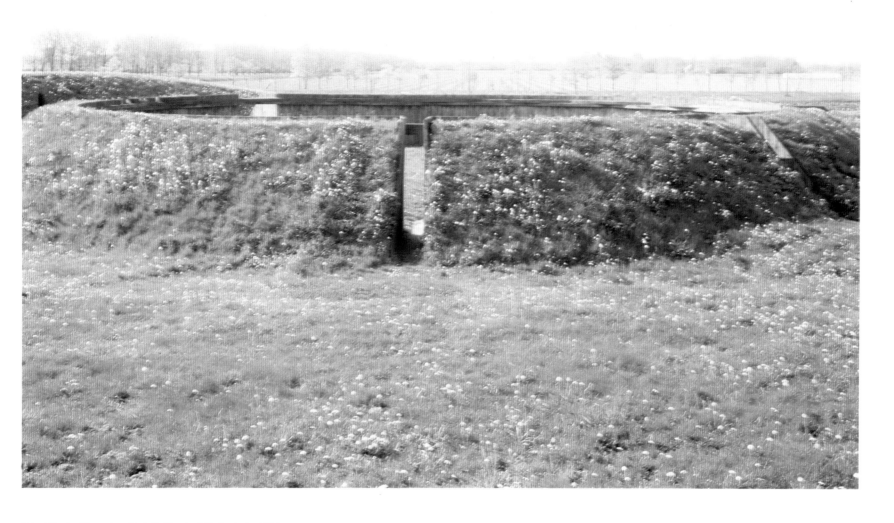

Robert Morris, *Observatory*, Oostelijk Flevoland, Netherlands, 1977.
Interior circle. Photograph by Gilles A. Tiberghien, 1992.

1. Michael Fried, "Art and Objecthood," *Artforum* (June 1967); reprinted in Gregory Battcock, ed., *Minimal Art, A Critical Anthology*, op. cit., p. 144.

2. Ibidem, pp. 25–26.

3. Titles such as *Systemics Paintings* or *Primary Structure* attest to this tendency.

4. This implicit reference to Lévi-Strauss is borne out by the theoretical context of the period.

5. Annette Michelson wrote that Morris's work is "Cognitive in its fullest effect, then, rather than 'meaningful,' its comprehension not only demands time; it elicits the acknowledgement of temporality as the condition or medium of human cognition and aesthetic experience." Annette Michelson, "Robert Morris: An Aesthetics of Transgres-sion," op. cit., p. 23.

6. Robert Smithson, "The Eliminator," op. cit., p. 207.

7. Robert Smithson, "Quasi-Infinities and the Waning of Space," *Arts Magazine* (November 1966); reprinted in *The Writings of Robert Smithson*, op. cit., p. 33. Like Kubler, Smithson denounces the organicist vision of art history that is based in biological metaphor, found from Vasari's time to the present and particularly in Hegel.

8. These questions regarding time in art were often debated by artists during this period. At the end of the 1960s, a group of artists with the name Pulsa were more specifically interested in the time of daily life in planning their exterior or interior environments, which, in playing with duration, were intended to better penetrate the space of the work. Among the members of this group were Michael Asher, Larry Bell, Dan Flavin, Robert Morris, and Carl Andre. At a meeting entitled "Time: A Panel Discussion" organized at the Shakespeare Theatre in New York, supporting a student committee fighting against the Vietnam War, Michael Cain, speaking on behalf of Pulsa, presented the activities of the group as such: "We're involved in considering the use of time and actually manipulating time as a material in works of art." (Cited in Lucy Lippard, *Six Years: The Dematerialization of the Art Object*, op. cit., p. 81.)

9. Robert Smithson, "A Sedimentation of the Mind: Earth Projects," op. cit., p. 90.

10. Robert Smithson, "Entropy and the New Monuments," op. cit., p. 10.

11. Translator's note: *ciel intelligible* is a term taken from Plato; it can also be found in Jean-Paul Sartre's *L'Existentialisme est un humanisme*. In his translation of Sartre's text, Philip Mairet has translated the relevant passage as follows: "Man is, indeed, a project which possesses a subjective life, instead of being a kind of moss, or a fungus or a cauliflower. Before that projection of the self nothing exists; not even in the heaven of intelligence..." (Jean-Paul Sartre, *Existentialism and Humanism*, translated by Philip Mairet [London: Methuen & Co., Ltd., 1948], p. 28.)

12. Robert Smithson cites Frank Kermode (*The Sense of Ending*): "Modern art, like modern science, can establish contemporary relations with discredited fictional systems; as Newtonian mechanics is to quantum mechanics, so *King Lear* is to *Endgame*." (*The Writings of Robert Smithson*, op. cit., p. 70.)

13. Peter Frank and Lisa Kahane, "Dennis Oppenheim: un art de la transition," *Dennis Oppenheim, rétrospective de l'oeuvre 1967–1977*, op. cit., p. 22.

*The Golden Spike Monument*, Utah, commemorative monument.
© Gilles A. Tiberghien, 1991.

14. Richard Long, "Entretien avec Claude Gintz," op. cit., p. 7.

15. "The sculptural dimension is part of the residual dimension allowed by the work's invasion of the exhibition space. It is impossible to walk in Long's muddy footsteps, to jump from one stone to another; we are not in the countryside, but in a museum or a gallery. The transplantation that changes the nature of a heap of stones or a jumbled bundle of sticks confirms something we never see in Long's books: the experience of displacement. What Long introduces into the museum is not nature or its fragments; rather, he makes us see the walk itself." Jean-Marc Poinsot, "Richard Long, construire le paysage," *Art Press* (November 1981), p. 11; reprinted in *L'Atelier sans mur* (1991), op. cit., pp. 98–99.

16. Robert Smithson, "...The Earth, Subject to Cataclysms, is a Cruel Master," op. cit., p. 179.

17. It has already been pointed out that when he bequeathed *Partially Buried Woodshed* to Kent State University, Smithson stipulated that the work should remain in the same physical state, and that the weather conditions to which it would be exposed were an integral part of the work (see chapter 2, note 30). After Smithson's death, this work was in fact threatened with destruction by university administrators; it was also partially damaged by fire, but it was finally kept in the same location. See Robert Hobbs, *Robert Smithson: Sculpture*, op. cit., p. 191.

18. Michael Heizer, "Interview: Julia Brown and Michael Heizer," op. cit., p. 26. He adds, "To me the climactic alterations were instructive and indicated a way to put more life into a sculpture. In making a sculpture outside, one can take two positions; reject and ignore climate and its effects by designing protections, or incorporate erosion through precipitation, wind, dust, and dirt. To modulate through weather is natural." And Heizer adds that this is how he learned to interest himself in the "phenomenological impact" of sculpture while remaining conscious that this taking into account of the destructive effect of time is not new, since "...the history of sculpture, as we know it, consists mostly of remains and fragments, damaged either by man or by natural phenomena." (Ibidem, p. 27.)

19. This is obvious in Oppenheim's work, for example. Alain Parent has written, "From this 'manipulation' at a distance, one witnesses a progressively stronger interrelation between the artist's body, initially conceived as a tool, and the terrain on which it exerts its action, the body forming an association with the terrain to the point of identifying with it. The body itself takes on the experience of the tool." Alain

*The Golden Spike Monument*, monument commemorating the first east-west joining of the transcontinental railroad.
© Gilles A. Tiberghien, 1991.

Parent, "Passages," *Dennis Oppenheim, Rétrospective de l'oeuvre 1967–1977*, op. cit., p. 10.

20. Jean-Pierre Vernant, "Remarque sur les formes et les limites de la pensée technique chez les Grecs," *Mythe et Pensée chez les Grecs* (Paris: Maspéro, "Petite Collection," 1971), vol. II, p. 59.

21. Aristotle, *Metaphysics*, Λ, 1, 981 a 5–7. See Pierre Aubenque, *La Prudence chez Aristote* (Paris: P.U.F., 1963), p. 102.

22. Lucy Lippard, *Overlay, Contemporary Art and the Art of Prehistory*, op. cit., p. 129.

23. Also see the article by Robert Morris, "Aligned with Nazca," op. cit.

24. Robert Smithson, "Entropy and the New Monuments," op. cit., p. 15. In discussing his work *Travel Mirror*, Smithson compares the image in the mirrors in the Yucatan to a "negative hole." ("Four Conversations Between Dennis Wheeler and R. Smithson, 1969–1790," in Eugenie Tsaï, *Robert Smithson Unearthed* [New York and Oxford: Columbia University Press, 1991], p. 121.)

25. For example, see the various types of entropy discussed by Jessica Prinz in her text, "Spiral Jetty," op. cit., pp. 112–113. On the concept of entropy in Smithson's work, see

*Dennis Oppenheim* exhibition, galerie Yvon Lambert, Paris.
© Yvon Lambert.

Eduardo Rubbio, "Robert Smithson, vers une archéologie de futurs lointans," *Canal* (November 1982), p. 4.

26. Peter Hutchinson, who also published numerous articles in art magazines during the 1960s, has written, "When an artist makes an object and uses scientific principles, he does the same thing that the science fiction writer does with science. That is, he is being quite purposeless. His work cannot prove anything scientifically. It has no scientific use. It has neither the objective approach of science nor the reason for being of science. Its accomplishments, in short, are aesthetic." Peter Hutchinson, "Science Fiction: An Aesthetic for Science," op. cit., p. 32. See also Eugenie Tsaï, "The Sci-fi Connections: The IG, J.G. Ballard, and Robert Smithson," *Modern Dreams: The Rise and Fall and Rise of Pop* (New York: Institute for Contemporary Art, and Cambridge, MA: MIT Press, 1988), pp. 71–74 and Adam Gopnik, "Basic Stuff: Robert Smithson, Myth, Science, and Primitivism," *Art Magazine* (March 1983), p. 13.

27. Robert Hobbs writes, "The *Spiral Jetty*, located in the lake called 'America's Dead Sea,' is an image of contracted time: the far distant past (the beginning of life in saline solutions symbolized by the lake) is absorbed in the remote past (symbolized by the destructive forces of the legendary whirlpools in the lake) and the no longer valid optimism of the recent past (symbolized by the Golden Spike Monument)." Robert Hobbs, *Robert Smithson: Sculpture*, op. cit., p. 193. Speaking of the story of his voyage in the Yucatan, and the Mayan gods whose image he evokes,

Smithson specifies that his text contains nothing mythological, since, "(a mythology is) a believed fiction. Now I am sticking to the integrity of the fiction, since I can't believe in objects and I can't believe in totems, what do I believe in? Fiction." ("Four Conversations Between Dennis Wheeler

Robert Smithson, *Towards the Development of a "Cinema cavern,"* 1971.
Pencil, photograph, adhesive, 12-5/8 x 15-5/8 inches. Photograph by Nathan Rabin.

and Robert Smithson 1969–1970," Eugenie Tsaï, *Robert Smithson Unearthed*, op. cit., p. 108). This distinction is meaningful only if one understands that myth is a fiction that one believes but without being aware that it is a fiction. See the reference to Frank Kermode, in Eugenie Tsaï, *Robert Smithson Unearthed*, op. cit., note 26, p. 125.

28. Nancy Holt made a thirty-five-minute film that shows the various stages of construction of this work, from the fabrication of the tunnels to their installation in the desert on cement blocks in the shape of half-circles, which are buried into the ground around an invisible cement axis.

29. Lucy R. Lippard, *Six Years: The Dematerialization of the Art Object*, op. cit., p. 106.

30. Nancy Holt, "Sun Tunnels," *Artforum* (April 1977), pp. 34–35.

31. John Beardsley, *Probing the Earth: Contemporary Land Projects* (Washington, DC: Hirshhor, USA, Smithsonian Institution, 1977), p. 71.

32. Ibidem, p. 74.

33. He adds, "The concept of the labyrinth comprises all the symbolic values of access to knowledge and its irreversible nature, while the simpler notion of the route or the road does not carry the same significations. The association of the labyrinth with the observatory, as an architectural device for organizing the surrounding space, opposes two ends of the same spectrum: at one end, the instrument that allows observation to those who already possess knowledge; at the other, the symbolic representation of the difficulties of access to this knowledge." Jean-Marc Poinsot, "Nature-Sculpture," op. cit., p. 73.

34. Hermann Kern, *Labyrinthe* (Munich: Prestel-Verlag, 1982).

35. The book by Matthews, *Mazes and Labyrinth, Their History and Development* (New York: Dover, 1975), which is the other classic work on this subject, conspicuously appears in the film *Spiral Jetty* and in certain montages of still photos taken from that film. See, for example, the catalog *Earth, Air, Fire, Water Elements of Art* (Boston: Museum of Fine Arts, 1971), p. 106. The positive and negative polarities of time are evident in the movement of a spiral, according to whether it turns in a clockwise or counterclockwise direction. In *Broken Circle* (positive movement) and *Spiral Hill* (negative movement), this symbolic opposition serves to intensify the obvious formal opposition. On the symbolism of the spiral, see, for example, *Spiralen & Progressen* (Lucerne: Kunstmuseum, 1975).

36. For example, Connemara Sculpture, Ireland, 1971.

37. In 1970 with a work titled *Maze*, Oppenheim reproduced the design of a labyrinth intended for laboratory rats onto a field, adapting the dimensions to the size of a cow: cattle were let out and searched for food, which they subsequently "redeposited" in the form of excrement, according to their movements in the maze.

38. Panza di Biurno holds the certificate of ownership and the plans for reconstruction.

39. Morris Archives, Gardiner, New York. As cited in a text from 1961 that was intended to be included in La Monte Young's anthology but which was never published (text cited in Maurice Berger, *Labyrinths, Robert Morris, Minimalism and the 1960s*, op. cit., p. 143), Morris sees minimalist objects as entropic structures; he wrote that sculpture in blank form "slowly waves a large grey flag and laughs about how close it got to the second law of thermodynamics." But when he is asked if his work *Observatory* relates to entropy, he replies, "I don't think so, although the first one did in fact [an allusion to the one which was constructed in 1971 and subsequently destroyed]...let's say entropy was victorious because it collapsed, and is now ruined. But that's not what it is about and I hope this one, the new one, will certainly not be about that. It's not concerned with entropy. It is concerned with time passing, it is concerned with acknowledging different seasons, but not about the decay of the thing or that it is going to be taken down. I did not intend that." ("Interview with Robert Morris," op. cit., also in John Beardsley, *Earthworks and Beyond, Contemporary Art in the Landscape*, op. cit., p. 27.)

40. Specifically, a metaphysics of presence and of the present moment that is found throughout the history of philosophy, from Aristotle to Husserl. On this issue, see Jacques Derrida, who wrote, for example, that "Despite all the complexity of its structures, temporality has a nondisplaceable center, an eye or living core, the punctuality of the real now." Jacques Derrida, *Speech and Phenomena*, translated by David B. Allison (Evanston, Illinois: Northwestern University Press, 1973), p. 62. Jean-Marie Schaeffer, who cites this work, sees in this tradition the origin of the conception of the "decisive moment" in photography. (Jean-Marie Schaeffer, *L'Image preecaire du dispositif photographique* [Paris: Seuil, 1987], p. 180.)

# CHAPTER 5

# MAPS AND INSCRIPTIONS

1  Robert Smithson, map game.
Courtesy of the John Weber Gallery, New York.

2  Robert Smithson, *Untitled* (folded map of Beaufort Inlet), c.1967.
36 x 31 inches. Courtesy of the John Weber Gallery, New York.

3  Robert Smithson, *Entropic Pole*, 1967.
Map, 24 x 18 inches. Courtesy of the John Weber Gallery, New York.

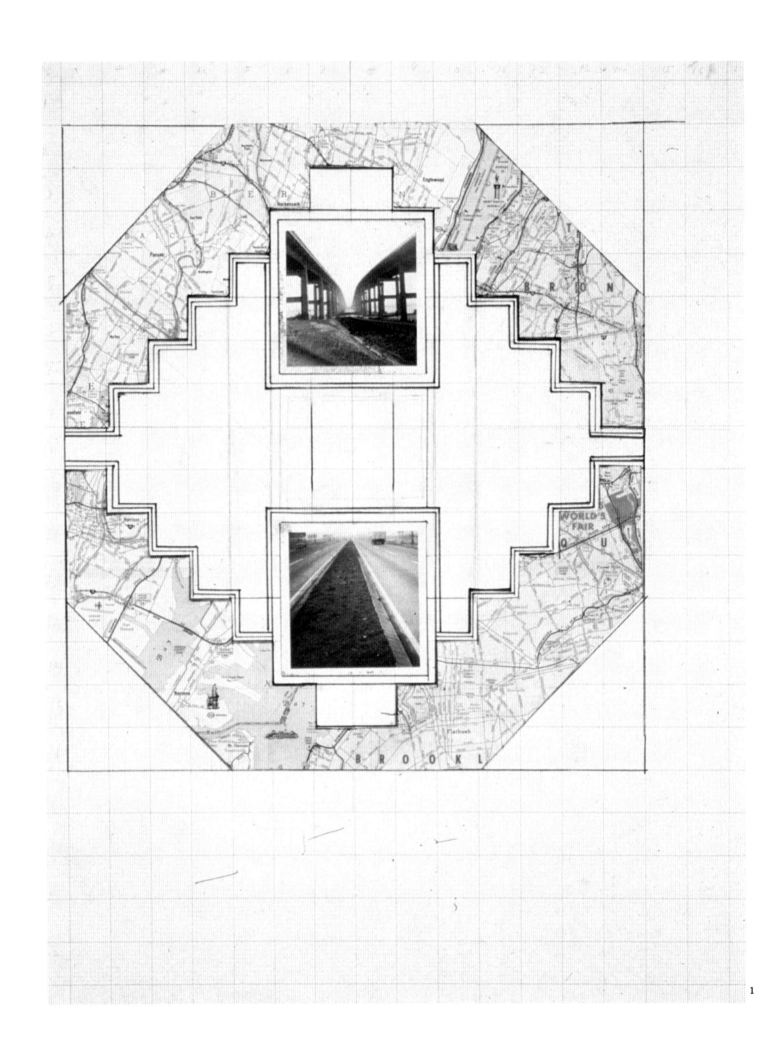

Maps, like encyclopedias, have always been "dreaming devices." This is not only because of the toponymic knowledge that they are able to impart, and the etymological inquiry that they can stimulate, but also because of the game of lexical cross-references inviting us to search between abscissas and ordinates for the location we seek, finally pinpointing its specific name. Deleuze and Guattari introduced the distinction between a map and a tracing: a map "does not reproduce an unconscious closed in upon itself," it is an operator of construction: "the map is open and connectable in all its dimensions; it is detachable, reversible, susceptible to constant modification. It can be torn, reversed, adapted to any kind of mounting, reworked by an individual, group, or social formation. It can be drawn on a wall, conceived of as a work of art, constructed as a political action or as a meditation."[1] In this view, a map is a generator of forms. It constructs the real, more than it represents it; it does not indicate a reality, rather it causes meanings to circulate, becoming each artist's medium for these meanings.

One of the most exhilarating effects of consulting an atlas is undoubtedly the constant change of scale, the possibility of gaining in expansion what one loses in comprehension, and vice versa. This is the principle of the "blow up" that one finds in Nancy Holt's *Buried Poems*, a little-known work created between 1969 and 1971. Five recipients (Michael Heizer, Philip Leider, Carl Andre, John Perrault, and Robert Smithson) received a packet of information that allowed them, if they desired, to find and dig up a poem. This poem had been buried in a location which, according to Nancy Holt, had been chosen based on the personality of the recipient: "Certain physical, spatial, and atmospheric qualities of a site would evoke a person who I knew."

**1** Robert Smithson, *New Jersey, New York*, 1967. Mixed media, 22 x 17-1/4 inches. Courtesy of the John Weber Gallery, New York.

**2, 3, 4** Maps belonging to the documentation for *Buried Poem #4 for Michael Heizer*, 1969. Courtesy of Nancy Holt.

## DOCUMENTATION FOR BURIED POEM #4

*1* *Take Route 160 to the entrance of Arches National Monument, preferably an hour before dawn. As the sun begins to rise, light is east at a slant and burns across the red-rock formations. At the entrance get a permit. (If you are there early enough you will not have to pay for one.) Then take the paved road that winds through such formations as Three Gossips, Sheep Rock, The Organ, The Tower of Babel, Balanced Rock, Fiery Furnace to a circular parking area by Tunnel Arch.*

*2* *Now you must walk for 2 miles, the last mile being rough and hazardous. (At one point you will have to walk on a narrow ridge with about a 1000 ft. drop on one side, and a 50 ft. drop on the other.) When you come to forks in the foot path, follow the direction of the arrow for Double-O-Arch on the signs (see slides). The path breaks down and becomes invisible around Landscape Arch, and then it becomes necessary to follow closely the remnants of painted footprints which appear from time to time on rock surfaces.*

*3* *When you arrive at Double-O-Arch (see slides), enter the smaller, lower arch. Stand in the center of the arch, facing 15° (N by NE). A few feet in front of you will be a small (about 20 ft. high) rose-colored hill with several evergreen trees growing from its sides. Gnarled deadwood lies scattered over it. (see specimens)*

*4* *Walk through the lower arch and look through it from the other side. In the distance, silhouetted against this sky, you will see the Dark Angel. (see slide, postcard)*

*5* *Now walk over the hill and climb to its highest point. On the left you will see a large, rose-colored boulder, and on your right you will see two bifurcated trees, one with a trunk which divides about 3 ft. above the ground, and the other with a trunk which divides about 1 ft. above the ground. 255° (W by SW) of the more upright tree, which divides at about 3 ft., and 4-1/2 ft. away from it, is buried 1-1/2 ft. down in the earth between 2 dead trees lying close to the ground, a 7-1/2" by 3-1/2" plastic vacuum thermos containing a poem for you. A rectangular rose-colored rock (10" by 5" by 5") marks the burial spot. However, if it is missing, you will have no trouble finding the poem with the other information given.*

*Equipment: Automobile, shovel, compass.*

Nancy Holt, *Buried Poem #4 for Michael Heizer*, excerpt, 1969.

### Entrada Sandstone

*Sand grains in the Entrada are small, faceted, frosted and well sorted, suggestive of desert deposition. It is arch-making sandstone because: 1. It is strong and uniformly deposited, able to support large arches. 2. It has been cracked and weakened along parallel joints. 3. Upper surfaces harden slightly, allowing accelerated erosion beneath.*

*Cracks in the rock are the first requisites in arch-making. They are attacked by wind, water, ice, and vegetation, which widen crevices and leave "fins" in which the arches form. Agents of weather begin eroding the rock. Erosion opens a small hole in the narrow fin. Rocks fall from the roof, enlarging the arch. Dark Angel is a pinnacle. Pinnacles remain from fin or wall erosion.*

Display information, Arches National Monument Museum.

**1, 2** Dark Angel and Double Arch, Arches National Park, Utah, part of the documentation for *Buried Poem #4 for Michael Heizer*. Courtesy of Nancy Holt.

**3** The last map used to locate *Buried Poem #4 for Michael Heizer*. Courtesy of Nancy Holt.

### Arches National Monument

*Here there are more natural stone arches, windows, spires and pinnacles than in any other known section of this country. Nearly 90 arches have been discovered, and others are probably hidden away in remote and rugged parts of the area. Spectacular towers, sweeping coves, shapes resembling figures of men and animals, balanced rocks, and other weird forms resulting from the combined action of running water, wind, rain, frost, and sun form a setting to which the arches are a majestic culmination. The rock in which the arches have formed was deposited as sand about 150 million years ago, during the Jurassic period. This 300-foot layer, called the Entrada Sandstone, is believed to have been laid down mainly by wind. Its characteristics suggest that it accumulated in a vast coastal desert. In time it was buried by new layers, and hardened into rock....Some arches, such as Delicate Arch, have been left isolated by erosion of surrounding fins. Of course, the continued thinning of arches by weathering will eventually result in their collapse. You can see all stages in their development and decay in the monument.*

Pamphlet from the Arches National Monument, National Park Service, U.S. Department of the Interior.

## BURIED POEMS

*My Buried Poems (1969/71) were private artworks. A concrete poem, made for a particular person, was buried in the earth in such places as an unnamed, uninhabited island in the Florida Keys, Arches National Monument desert in Utah and the bottom of the Highlands of Navesink near Sandy Hook, New Jersey.*

*Certain physical, spatial and atmospheric qualities of a site would evoke a person who I knew. I would then read about the history, geology, flora and fauna of the site and select certain passages from my readings for inclusion in a booklet, which also contained maps, photos, very detailed directions for finding the Buried Poem, along with either postcards, cut out images, and/or specimens of leaves and rocks.*

*After reading the booklet the recipient would begin to understand his connection with the chosen site. Since all the sites were remote, the poem was buried in a vacuum container which would protect the contents for at least a human lifetime, allowing the poem to be dug up whenever the person happened to be near the Buried Poem area.*

Nancy Holt, "Buried Poems," October 7, 1992.

## MAPSCAPES OR CARTOGRAPHIC SITES

*"There are approximately 50 Panama Canals to a cubic mile and there are 317 MILLION cubic miles of ocean."*

*R. Buckminster Fuller,* Nine Chains to the Moon

*R. Buckminster Fuller has developed a type of writing and original cartography, that not only is pragmatic and practical but also astonishing and teratological. His Dymaxion Projection and World Energy Map is a Cosmographia that proves Ptolemy's remark that, "no one presents it rightly unless he is an artist." Each dot in the World Energy Map refers to "1% of World's harnessed energy slave population (inanimate power serving man) in terms of human equivalents...", says Fuller. The use Fuller makes of the "dot" is in a sense a concentration or dilation of an infinite expanse of spheres of energy. The "dot" has its rim and middle, and could be related to Reinhardt's mandala, Judd's "device" of the specific and general, or Pascal's universe of center and circumference.*

*Yet, the dot evades our capacity to find its center. Where is the central point, axis, pole, dominant interest, fixed position, absolute structure, or decided goal? The mind is always being hurled towards the outer edge into intractable trajectories that lead to vertigo.*

Robert Smithson, "A Museum of Language in the Vicinity of Art," excerpt, *Art International* (March 1968), reprinted in *The Writings of Robert Smithson*, p. 78.

R. Buckminster Fuller's World Energy Map, represented in Dymaxion projection.
The people symbols represent the percentage of the world's population in each region. The black dots represent the percentage of "energy slaves" serving each region. First published in *Fortune* (February 1940).

The maps collected in the packet allowed the recipient to easily reach the chosen site. Thanks to the information thus presented, the poem could be approached mentally, it could be written at the same time that its location was designated. The artist stated that each text would be protected inside its container for the length of a human life.

Smithson remarked that, from the *Theatrum Orbis Terrarum of Orrelius* (1570) to the painted maps of Jasper Johns, cartography has always fascinated artists: "[Carl] Andre in a show in the Spring of '67 at Dwan Gallery in California covered an entire floor with a 'map' that people walked on—rectangular sunken 'islands' were arranged in a regular order. Maps are becoming immense, heavy quadrangles, topographic limits that are emblems of perpetuity, interminable grid coordinates without Equators and Tropic Zones."[2] Discussing various approaches to maps and territories, Smithson goes on to mention Lewis Carroll's abstract maps in *The Hunting of the Snark*, which he sees as the complete opposite of the map in Carroll's *Sylvie and Bruno*:

*He had bought a large map representing the sea,*
*Without least vestige of land:*
*And the crew were much pleased when they found it to be*
*A map they could all understand.*

*"What's the good of Mercator's North Poles and Equators,*
*Tropic Zones and Meridian Lines?"*
*So the Bellman would cry: and the crew would reply,*
*"They are merely conventional signs!*

*"Other maps are such shapes, with their islands and capes!*
*But we've got our brave Captain to thank"*
*(So the crew would protest) "that he's bought us the best—*
*A perfect and absolute blank!"*[3]

Jasper Johns, *Map*, 1966–1971.
Encaustic and collage on canvas, 15-1/2 x 33 feet. Ludwig
Museum, Cologne. Photograph by Rheinisches Bildarchiv.

*Sylvie and Bruno* is the story of a character named Mein Herr, in a country where maps became so perfected that their scale went from one centimeter equalling one kilometer, to one meter equalling one kilometer, and finally to one kilometer equalling one kilometer. It is Jorge Luis Borges, also cited by Smithson, who has most thoroughly explored this hypothesis of a map at 1:1 scale. In a short story supposedly written in Lerida in 1658 and inspired by a certain Suarez Miranda, *Viajes de Varones Prudentes* tells the story of an empire that pushed the art of cartography to such an extreme that its map covered an entire province, and eventually became the size of the entire empire. This map, ultimately useless, was abandoned by succeeding generations.[4]

These are the two true limits of cartography: an excess of application or an excess of abstraction, the distinctive feature of a map being that it is "schematic, selective, conventional, condensed, and uniform."

Such characteristics allow us a systematic approach, making facts visible which we would be unable to perceive otherwise. As Nelson Goodman says, "We may make larger and more complicated maps or even three-dimensional models in order to record more information; but this is not always to the good. For when our map becomes as large and in all other respects the same as the territory mapped—and indeed long before this stage is reached— the purposes of a map are no longer served. There is no such thing as a completely unabridged map; for abridgement is intrinsic to map making."[5] If maps hold interest for contemporary artists, it is primarily because of their *analytic* (as opposed to mimetic) connections to reality, and secondarily because of this discrepancy between representation and reality. It is undoubtedly also because maps are constructions as real as reality itself.

If we pinpoint a location on a map, we "see" where this location is. The fact that it

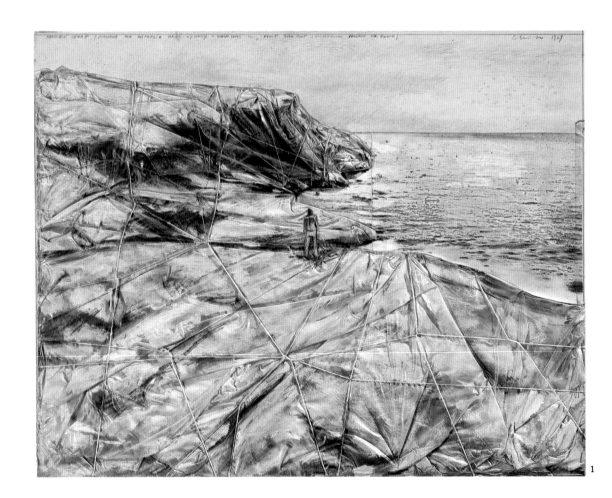

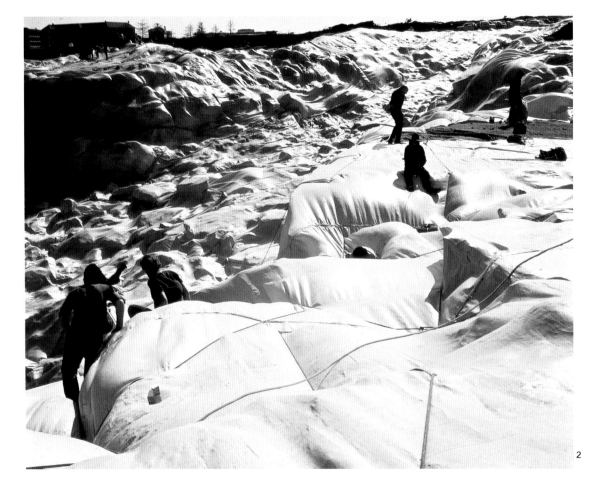

1  Christo, *Packed Coast, Project for Australia, Near Sydney*, 1969.
Collage, of pencil, polyethylene, string, rope, photocopies, charcoal,
paint, and cardboard, 22 x 28 inches. Collection of R.E. Curtis,
Sydney, Australia. Photograph by Harry Shunk. © Christo, 1969.

2  Christo and Jeanne-Claude, *Wrapped Coast, Little Bay, Australia*,
1969.
Erosion control fabric measuring one million square feet over a dis-
tance of thirty-five miles. Photograph by Harry Shunk. © Christo,
1969.

is on paper does not make it less real, simply different. In this sense, it is indeed a *fiction*, whose truth varies according to how strictly the rules are observed in the cartographic representation. But between an official state map and a painted map by Jasper Johns, there is no sense of continuity. Instead there is a whole range of possible worlds, making art into a simple actualization of the real, and reality into a vague *ensemble* of potential artistic worlds. Of course, these worlds never coincide. One of the fascinations in the concept of a map that covers the entire territory it represents comes precisely from this impossible synchronicity. If this exchange between reality and art, discussed by Harold Rosenberg in *The De-definition of Art*, is characteristic of the 1960s, an interest in maps is specific to the Land Art artists because for them, art is conceptual as well as real. In their case, art plays an operative role somewhat comparable to Kantian schematism, somewhere between the perceptible and the intelligible.[6]

Borges's fiction is situated within the realm of a tracing and not of a map. One would think that, through tracings, absolute accuracy would be obtained, but, in covering a territory point by point, this tracing makes the territory unrepresentable by making it disappear. If this tracing were to be considered as a territory itself, it could presumably be mapped— a map could be made of the map-territory. The logic of the trace would then be thwarted. Instead of copying a territory, the map creates a new reality which is another map, a map so concrete (territory-map) or so abstract (map-territory) that it cancels itself as such and suggests another map, a map to the second degree, itself referring to a third, and so on until infinity, as in the *third man* argument.[7]

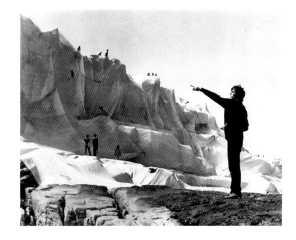

Christo and Jeanne-Claude, *Wrapped Coast, Little Bay, Australia*, 1969.
Photograph by Harry Shunk. © Christo, 1969.

In 1969, in Little Bay, near Sydney, Australia, using one million square feet of anti-erosion cloth and thirty-five miles of rope, Christo and Jeanne-Claude wrapped a one-mile strip of rocky coast, its height varying between one hundred fifty and eight hundred feet.[8] In this work, the territory was erased by being veiled. In the ten weeks during which the coast remained wrapped, it became a second relief, tacked over the original. The cliffs became a sort of decor, neither tracing nor map, but rather an intermediate reality; both a new geography and a system of coordinates (the ropes, necessary to restrain the cloth, formed lines of tension that recalled the grid of a map) referring only to itself. Although covered, the landscape was also "discovered," or "invented": simultaneously found, divulged, and created, since the Christos's work constructed a new landscape, one which was simply a new aspect of the one that he wrapped. A few years later, with *Ocean Front* (1974) in Rhode Island,[9] by covering the surface of the water of the bay of Kings Beach with a white cloth measuring fifteen thousand square feet, the Christos produced the effect of a giant tracing which was nothing but a moving line between the earth and the sea, the areas of transparence and opacity shifting with the tides.

Land Art artists work with quadrangle maps, maps which divide a vast territory into equal squares or quadrants, themselves divided into squares. The result is a checkerboard structure, comparable to that used during the Renaissance. These grids allow a measurement of the distance between objects in perspectival space, as well as a measurement of their increasing or decreasing size, according to the space that they occupy in relation to the spectator. As a result of Albrecht Dürer's drawing machine, on these maps the landscape

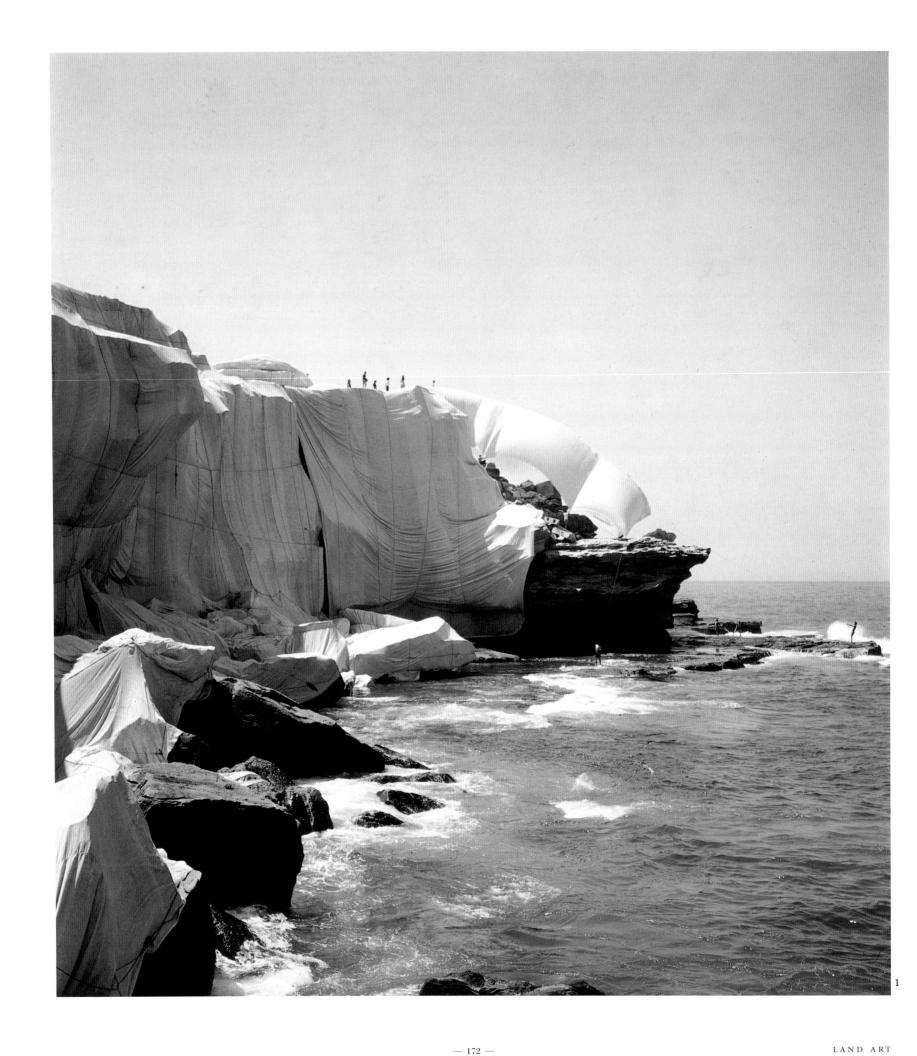

**1** Christo and Jeanne-Claude, *Wrapped Coast, Little Bay, Australia*, 1969.
Photograph by Harry Shunk. © Christo, 1969.

**2** Christo and Jeanne-Claude, *Ocean Front, Newport, Rhode Island*, 1974.
150,000 square feet of polypropylene, Width: 420 feet, length: 320 feet. Photograph by Gianfranco Gorgoni,
Sygma. © Christo, 1974.

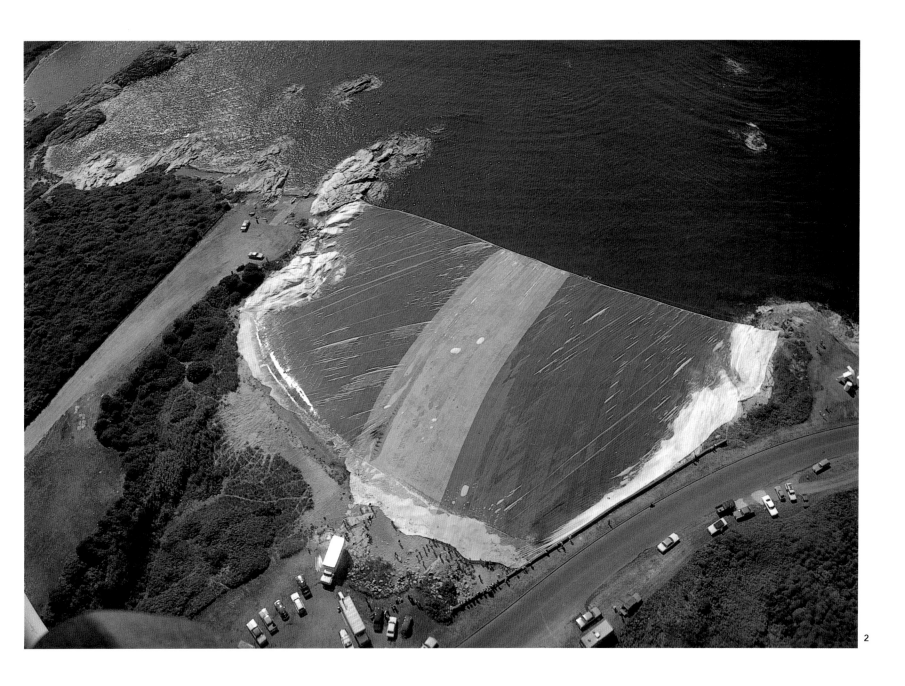

2

seems to be understood not from a "scenographic" aspect, but from the aspect of a floor plan. The map is thus a graphed landscape, a concrete geometry.

The conceptual aspect of a map is obvious. Maps, possessing no intrinsic value, modifiable based on systems of representation that relate only to other maps, could even be considered strictly conceptual entities. It is this type of approach that certain artists such as Douglas Huebler have taken. In November 1968, in Seth Siegelaub's apartment on Madison Avenue in New York City, Huebler organized an exhibition composed solely of documents, maps, photographs, drawings, and descriptive texts. The maps functioned as documentation for the projects and captured movement in time. Thus for *Site Sculpture Project 42nd Parallel Piece*, Huebler marked on a map of the United States fourteen cities and towns situated approximately along the forty-second parallel. From Truro, Massachusetts, he mailed fourteen letters to each one of these cities on the same day; the letters were subsequently mailed back. The map and the postal receipts constituted the exhibited work. The line of the forty-second parallel thus became a temporal vehicle, while the receipts, removed from their static administrative existence, acquired a dynamic and historic weight. The work, which took place over time and over distance, takes on the semblance of a story, yet one which it asks the viewer to recreate at one point in time and at one location.

Another work by Douglas Huebler, *Portland 2 Rectangles Proposal*, played with the immateriality of maps: the intervention consisted of removing a certain quantity of earth, stones, and water from the locations pinpointed by the four corners of two rectangles drawn on a map. Then all the materials were mixed with cement, and the mixture was hardened inside plastic

**1** Douglas Huebler, *Portland 2 Rectangles Proposal.* Portland, Maine. Seven transparent plastic tubes (8 inches x 1 inch).
"Seven sites (as indicated on map) describe two rectangles which meet at a common site near New Turkey Bridge. A small quantity of natural matter (sand, gravel, or water) is removed from each location. All collected material is mixed with cement and cured in a small clear plastic tube. Seven such tubes are returned and installed permanently to mark the sites." Document: drawing, ink on paper, 8 inches x 12 inches.

**2** Douglas Huebler, *42° Parallel,* 1968.
Eleven letters sent certified mail. Ten returned certified mail receipts. Approximately 4,900 km. Project of on-site sculpture.
"14 locations ('A' through 'N') are towns existing either exactly or approximately on the 42° parallel in the United States. Locations have been marked by the exchange of certified postal receipts sent from and returned to 'A'—Truro, Massachusetts, August–September 1968." Documents: drawing, ink on paper, 9 inches x 17 inches.

**3** Douglas Huebler, *42° Parallel,* 1968.
Three letters sent certified mail, each one 2-3/8 inches x 4-7/8 inches. Three certified mail receipts, each one 3 inches x 4-3/8 inches. Photographs 1–3 from the musée national d'Art moderne, Centre Georges-Pompidou, Paris.

tubes which themselves were then placed at the corners of the rectangles as markers. This process essentially unified locations which are spatially scattered, making them as homogeneous as the points drawn on the paper. This type of work recalls Smithson and his site/nonsite dialectic. Lucy Lippard writes, "Huebler's early map pieces and site 'sculptures' (titled ironically, since the overlay of geometric shapes or points on a mapped area results in nothing sculptural whatsoever) probably owe their initial impetus to Robert Smithson's introduction into the art vocabulary of maps and earth as sculptural materials, and the 'site' as a focal point. But Smithson is adamant about the necessity for some physical residue to provide a dialectic between the idea and its manifestation, while Huebler, naively perhaps, saw his works as not really existing at all. 'Both the site selected and the shape they describe are 'neutral,' and only function to 'form' the work,' he said; at the same time, the documents 'prove nothing. They make the piece exist and I am interested in having that existence occur in as simple a way as possible.'"[10]

Smithson, fascinated by the possibilities of cartography, tended to make much use of maps, radically altering their form as well as their function. In 1969, for the Long Beach Island Foundation of Arts and Sciences, he created a map made of glass debris entitled *Map of Broken Clear Glass (Atlantis)*. The work was subsequently destroyed and then reconstructed in 1975 for the Museum of Contemporary Art in Chicago. Atlantis is a mythical continent—as is Lemuria, whose form Smithson had sculpted in shells and sand on a Florida beach. The photograph of the latter work is accompanied by a map of the supposed location of the continent of Lemuria, as well as a section of a map of Florida indicating the location of Smithson's intervention. In

the film *Spiral Jetty*, Smithson included a jurassic map, on which mythical continents (including Gondwana and Atlantis) were visible. In *Atlantis*, the map is created with pieces of broken glass. Smithson's note in "Incidents of Mirror-Travel in the Yucatan," published in *Artforum*, shows that the people who claim to know where *Atlantis* is found all have different theories. He himself agrees with the opinion of one of these speculative geographers, Scott-Eliot. The greatness of a map like *Atlantis* exists in its transparence as well as in its power of reflection. It filters the rays of the sun, much as the gases which encircle the planet do: "Like the glass, the rays are shattered, broken bits of energy, no stronger than moonbeams....The sheets of glass leaning against each other allow the sunny flickers to slide down into hidden fractures of splintered shadow. The map is a series of 'upheavals' and 'collapses'—a strata of unstable fragments is arrested by the friction of stability."[11] In fact, *Atlantis* exists only because of the light of the sun outlining the contours of the work—a pure luminous essence, that the material absorbs in the shadow, in a wholly neo-Platonic manner, reminiscent of Charles Ross's sky maps. Beginning in the late 1960s, Ross became interested in the artistic possibilities of the sun's trace on the earth, its diffraction through prisms, and its effect on materials altered by its heat. In 1968 at the Dwan Gallery, he showed a series of four pieces entitled *Prism*, inspired by minimalism. In 1972 at the John Weber Gallery, he exhibited *Sunlight Convergence Solar Burn*; each day for a year, a different wooden plank was left in the sun under an enormous magnifying glass. When the 365 planks were laid end to end, the sun's markings on them formed an inverse double spiral.[12] For Ross, this double spiral, which is also the symbol for infinity, can be explained from a

Robert Smithson, *The Hypothetical Continent of Lemuria*, 1969. Ink, pencil, paper, 22 x 17 inches. Courtesy of the John Weber Gallery, New York.

scientific point of view if one understands the relationship that exists between the movement of the sun and the earth. He adds that the marking results from "a combination of terrestrial and celestial forces acting in different dimensions of time."[13] With this work, there is an attempt, albeit a futile one, to map time in space using light through abandoning all conventional reference points with which we are familiar (in this case, those which allow us to locate ourselves on a map). In 1974, Ross began his series of *Star Maps*, representations of the celestial sphere that have been flattened according to cutting methods varying from one map to another. Thus, in *Point Source/Star Space*, *Sun Center/Degree Cut*, 1975, each cut corresponds to 10° terrestrial latitude so that "the earth," as the map key indicates, "becomes the measurement of the universe."

In an article that appeared in 1979 in the magazine *October*, Rosalind Krauss wrote that she saw the grid as an emblem of modernity, "ubiquitous in the art of *our* century, while appearing nowhere, nowhere at all, in the art of the last one."[14] Through its total flatness, the grid is able to suppress the real and, simultaneously, to affirm the autonomy of art. According to Krauss, it is necessary to go back to the fifteenth and sixteenth centuries to find previous examples of grids that predetermine the relationships between objects. But, as opposed to the system of perspective, whose function is knowledge of reality, not abstraction from it, "the grid does not project the space of a room, of a landscape, or a group of people on the surface of a painting. It if projects something, it is the surface of the painting itself."[15] Without discussing this theory, we will simply observe that a map is exactly the type of grid which "suppresses" the dimensions of reality, and also submits to it. However, in certain respects this ambiguity

1

2

## THE STAR MAPS OF CHARLES ROSS

*All of Ross's art is a disguise of, a frame for, an effort to soften the impact of this dramatic experience of the stars—this experience of becoming lost in the stars, consumed by and converted into light. It is this terrible experience that has been called "mythical." Ross's maps do not guarantee this experience, but we can talk a little more about them as art. They are at once open and closed constructions. They are constituted by 428 photographic negatives from the Falkau astronomical atlas (begun in the 1950s) by Hans Vehrenberg. The atlas shows stars to the thirteenth magnitude, considerably beyond our boundary of vision at the sixth magnitude (the dimmest stars visible to the naked eye). The negatives from the atlas have been arranged to cover the entire celestial sphere from pole to pole; the viewpoint is that of an observer at the center of the earth. The maps are cuts of the sphere, necessary in transferring it to a flat surface. One cut breaks up the sphere into intervals that correspond to ten degrees of earth latitude on star space (Ross calls this the earth-space cut); another cut is determined by the boundaries of the same constellations, as established by an international meeting of astronomers in the 1920s (mind-space cut); and a third cut breaks the sphere into long points like triangles, each of which represents the stars that would pass a fixed point in the period of an hour (earth-time cut). In each case the earth becomes in a sense the measure of the universe.*

Donald B. Kuspit, "Charles Ross: Light's Measure," excerpt, *Art in America* (March–April 1978).

1  Charles Ross, *Point Source/Star Space*, Sun Center by Earth Degree.
8 feet 10 inches x 24 feet 9 inches. © Charles Ross, 1975–1986.

2  Charles Ross, *Point Source/Star Space*, Milky Way Center By Earth Hour.
8 feet 10 inches x 23 feet 6 inches. © Charles Ross, 1975–1986.

3  Charles Ross, *Solar Burn Year Shape*.
36 x 96 inches. © Charles Ross, 1971–1972.

*following pages:*
1  Richard Long, *Dartmoor Riverbeds, A Four Day Walk Along all the Riverbeds Within a Circle on Dartmoor*, Devon, England, 1978.
Collection of the Rijksmuseum Kröller-Müller, Oterlo. Rights reserved.

2  Richard Long, *Wind Line, A Straight Ten Mile Northward Walk on Dartmoor, 1985*.
Printed text, 61-1/2 x 41-1/2 inches. Rights reserved.

3  Richard Long, *A Walk by all Roads and Lanes Touching or Crossing an Imaginary Circle*, Somerset, England, 1977.
Map and text, 34-1/2 x 48-1/2 inches. © Courtesy of the Anthony d'Offay Gallery, London.

4  Richard Long, *One Hour, A Sixty Minute Circle Walk on Dartmoor*, 1984.
Black and red text, 62-1/2 x 41-1/2 inches. © Courtesy of the Anthony d'Offay Gallery, London.

3

# DARTMOOR RIVERBEDS

## A FOUR DAY WALK ALONG ALL THE RIVERBEDS WITHIN A CIRCLE ON DARTMOOR

## DEVON ENGLAND 1978

WIND LINE

A STRAIGHT TEN MILE NORTHWARD WALK ON DARTMOOR

1985

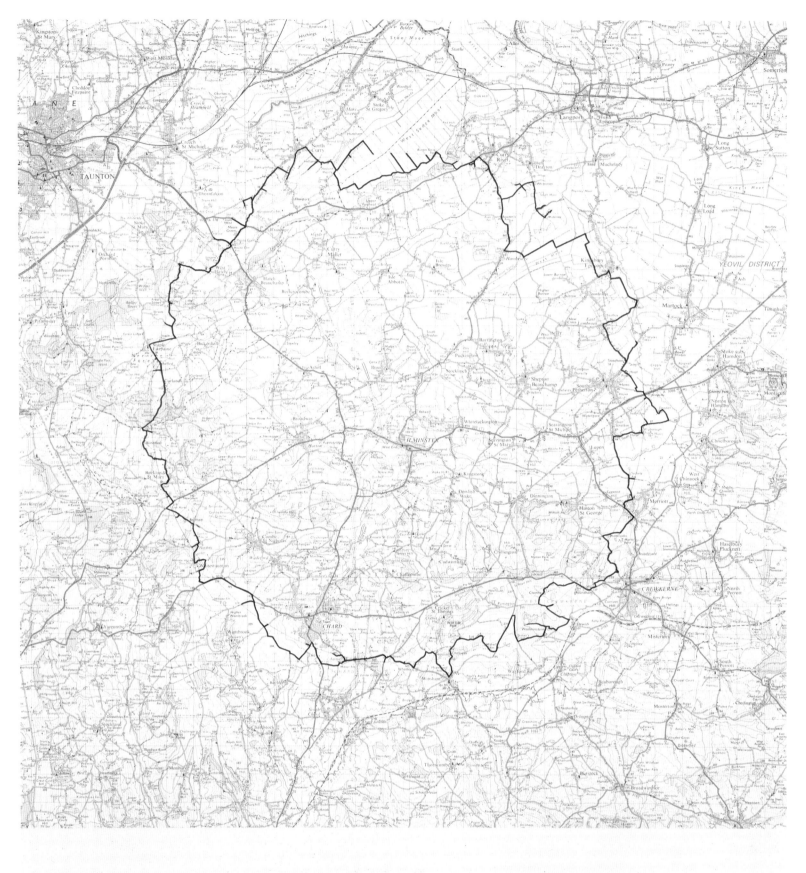

A WALK BY ALL ROADS AND LANES TOUCHING OR CROSSING AN IMAGINARY CIRCLE

SOMERSET ENGLAND 1977

3

SPIDER ALIGNED SLABS CAWING STUB CAW SKULL BROWNISH MOSS LARK HAZE MOTH WARM SPLASH WATCHED GURGLING SLOPE CLITTER KICK SHEEP SQUINT SLANT SNIFF FLOODLINE BUBBLING SQUELCH TWIST HEATHER TUSSOCKS CRUNCHING SUNLIGHT ROCK LOPING DOWNHILL WIND TOR BELCH SKYLINE REFLECTION SWISH GURGLE REEDS POOL RED BANK HOLLOW BREATHE BLUE SOFT SQUELCH SCUFF ICE GRASS SHADOW JUMP YELLOWISH PANTING SLITHER DROPPINGS SCRUNCH

ONE HOUR

A SIXTY MINUTE CIRCLE WALK ON DARTMOOR   1984   4

1

is an apt characterization of the use that the Land Artists make of it. But the functional methods of this cartographic schematism vary according to the artist.

In Long's work, maps and photographs are always accompanied by captions. The work, as it is conveyed and made known to us through the photograph, thus indicates an identifiable reality. The reality exists, as evidenced by the photograph, but an indeterminate reality is frozen by the snapshot, and frozen through the image, without a connection in space. These landscapes could just as easily be in Nepal, Ireland, or South America; generally nothing allows us to situate them, other than the titles given by Long. It is these titles that "fix" the image, that give meaning to the photographed work and incorporate it into a system of signs in which each name evokes a particular place from where the image was taken. The titles given by Long merely situate the work in time and space.

These photographs make up a system in that they supposedly cover the total surface of the earth (which Long claims to have entirely traveled, even if he says he has not been everywhere). But these names of places, regions, and countries are necessarily dependent upon the map. No longer only their linguistic signification but their true meaning comes from it. "Dorset" signifies nothing other than its reference to a location on the map of England. For Fuchs, the words are like stones, in that they are found along the way, but words have more suggestive power than maps. Words have specific trajectories within our mental universe; they are subject to forces of association and to poetic disturbances, which a map remedies by restoring the figurative distance sought by the artist, a distance that results from its relationship to space. In this system, words have the function of making the

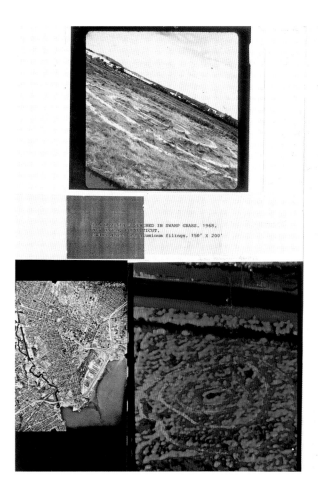

1

map readable, as the map exists to make them visible.

The information that words provide is like the imagined line that follows the visible curved and straight lines on maps. These lines embody both distances and speeds, and in spite of their appearance, they do not have the *same length*. The geometry of the maps' shapes and the abstract nature of the maps' grids represent varying movements and shapes, which in *reality* are not symmetrical. But this reality is an abstraction; the movements of motion transcend what we see.

Beginning in 1967 with his first *Gallery Transplants*, Oppenheim transposes interior spaces (galleries) to the exterior, through means of maps that play the role of transformers. In these works he erases the physical peculiarities of a space to emphasize only its cartographic coordinates, thus endowing it with an abstract reality.

1, 2 Dennis Oppenheim, *Contour Lines Scribed in Swamp Grass (New Haven Project)*, 1968.
Aluminum filings on swamp grass forming concentric circles, 150 x 200 feet. The contour lines of a neighboring mountain were enlarged and projected onto this terrain. The entire project is under water at noon. Courtesy of Dennis Oppenheim.

GROUND MUTATIONS— SHOE PRINTS, NOVEMBER, 1969.
KEARNEY, NEW JERSEY AND NEW YORK, NEW YORK.
SHOES WITH ¾" DIAGONAL GROOVES DOWN THE SOLES
AND HEELS WERE WORN FOR THREE WINTER MONTHS.
I WAS CONNECTING THE PATTERNS OF THOUSANDS OF
INDIVIDUALS... MY THOUGHTS WERE FILLED WITH
MARCHING DIAGRAMS.

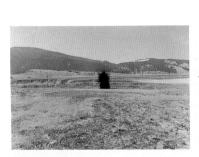
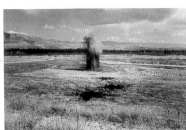
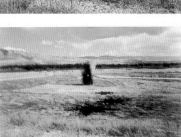

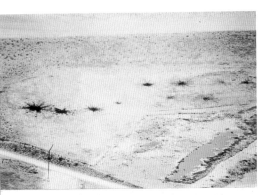

THREE DOWNWARD BLOWS (KNUCKLE MARKS). 1977
PROCEDURE: UNDERGROUND EXPLOSIONS, AT FIVE TO SIX FEET BELOW THE GROUND.
APPROXIMATE DIAMETER OF CRATERS: FOUR FEET, SIX FEET, EIGHT FEET, TEN FEET
AND TWELVE FEET.
LOCATION: LOLO, MONTANA

**1** Dennis Oppenheim, *Ground Mutations—Shoe Prints*, Kearney, New Jersey, and New York, New York.
Document: black and white photographs, color photographs, 40 x 169 inches. Courtesy of Dennis
Oppenheim.

**2** Dennis Oppenheim, *Three Downward Blows (Knuckle Marks)*, Lolo, Montana, 1977.
Procedure: Underground explosions, five to six feet deep. Approximate diameter of craters: four feet, six
feet, eight feet, ten feet and twelve feet. Document: topographic map, color photographs, collage, 47 x 130
inches. Courtesy of Dennis Oppenheim.

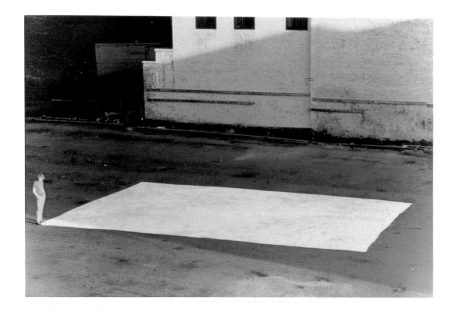

SALT FLAT. 1969. 1000 pounds of baker's salt placed on asphalt surface and spread into a rectangle, 50' X 100'. Sixth Ave., New York, New York. Identical dimensions to be transferred in 1' X 1' X 2' salt-lick blocks to ocean floor off the Bahama Coast. Identical dimensions to be excavated to a depth of 1' in Salt Lake Desert, Utah.

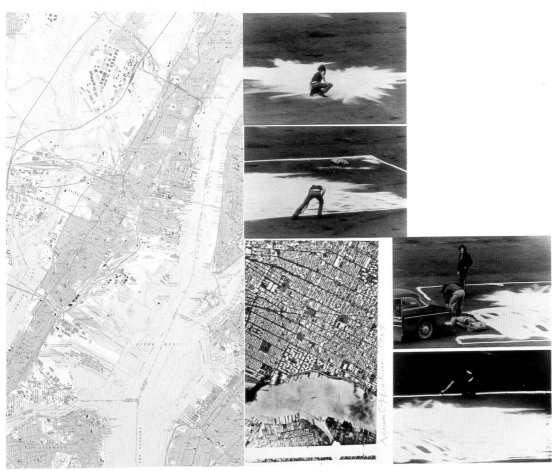

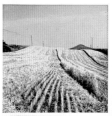

DIRECTED HARVEST. 1969.
Hamburg, Pennsylvania.
Harris Harvester was directed to break down the surface, 1000' in length, in linear patterns. Stage #1 through stage #4.

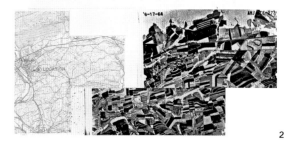

**1** Dennis Oppenheim, *Salt Flat*, Sixth Avenue, New York, 1969.
"1000 pounds of baker's salt placed on asphalt surface and spread into a rectangle, 50' x 100'. Sixth Ave., New York, New York. Identical dimensions to be transferred in 1' x 1' x 2' salt-lick blocks to ocean floor off the Bahama Coast. Identical dimensions to be excavated to a depth of 1' in Salt Lake Desert, Utah." Document: black and white and color photographs, topographic map. Courtesy of Dennis Oppenheim.

**2** Dennis Oppenheim, *Directed Harvest*, Hamburg, Pennsylvania, 1969.
"Harris Harvester was directed to break down the surface, 1000' in length, in linear patterns." Courtesy of Dennis Oppenheim.

*New Haven Project* (1968) uses this process, but in this case it is two exterior spaces, a mountain and a swamp, that are transposed by projecting the contours of one onto the surface of the other. Discussing this project, Oppenheim declared, "Altitude lines on contour maps serve to translate measurement of existing topography to a two-dimensional surface....I create contours which oppose the reality of the existing land, and impose their measurements onto the actual site, thus creating a kind of conceptual mountainous structure on a swamp grid."[16]

At the end of the 1960s, Oppenheim also uses maps to question the arbitrariness of conventions that he sees as controlling the measurement of time. In "Discussions with Heizer, Oppenheim, Smithson," he characterizes his method of procedure: "A good deal of my preliminary thinking is done by viewing topographical maps and aerial maps and then collecting various data on weather information. Then I carry this with me to the terrestrial studio....So this is an application of a theoretical framework to a concrete situation..."[17] In the same interview, Smithson says about Oppenheimer, "I think that what Dennis is doing is taking a site from one part of the world and transferring the data about it to another site, which I would call a dis-location. This is a very specific activity concerned with the transference of information, not at all a glib expressive gesture. He's in a sense transforming a terrestrial site into a map."[18]

Transforming a site into a map makes it purely a medium for existing conventions. Such an abstraction requires a system of symbols to allow it to be understood and interpreted; it is enough to read the map to know the terrain. The map graphs, but it also produces a system of coordinates which removes all relief, all matter, all roughness from the terrain.[19]

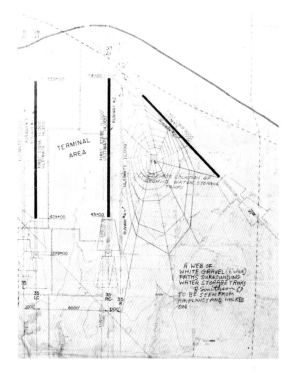

Robert Smithson, *Aerial Map Proposal for Dallas-Fort Worth Regional Airport*, 1967.
Courtesy of the John Weber Gallery, New York.

Smithson's interest in maps can be traced back to his childhood (a period of his life that influenced much of his art). His idea of integrating maps into his work, both as an element of information and as a plastic element, dates from the period of his work on the Dallas-Fort Worth Regional Airport site. "The old landscape of naturalism and realism is being replaced by the new landscape of abstraction and artifice," Smithson writes at the beginning of his article entitled "*Aerial Art*."[20] He explains that at first he thought about the way in which the lines of runways at an airport appear when viewed from the sky, how they produce a kind of de-naturalization of the landscape by incorporating it into a perspectival world in which the site becomes completely non-objective. Smithson continues in the same text, "The landscape begins to look more like a three-dimensional map rather than a rustic garden."

The difference in scale produced by the changes in altitude is striking and the world, viewed from above, appears totally abstract. This was the origin of Smithson's idea to create an Aerial Art that would be viewed from an airplane—earthworks located around airport runways, or constructions in the form of grids at ground level. Through this project, Smithson emphasizes the problem of our distance from artworks and how we view them within the daily limits of our perception: "Visibility is often marked by both mental and atmospheric turbidity." "The camera obscura of our mind...takes a picture but does not see it." He then asked himself, why not also see art through a telescope, since we do not always see what we think we see? "Simply looking at art at eye-level is no solution. If we consider the aerial map as 'a thing in itself,' we will notice the effects of scattered light and weak tone-reproduction. High-altitude aerial photography

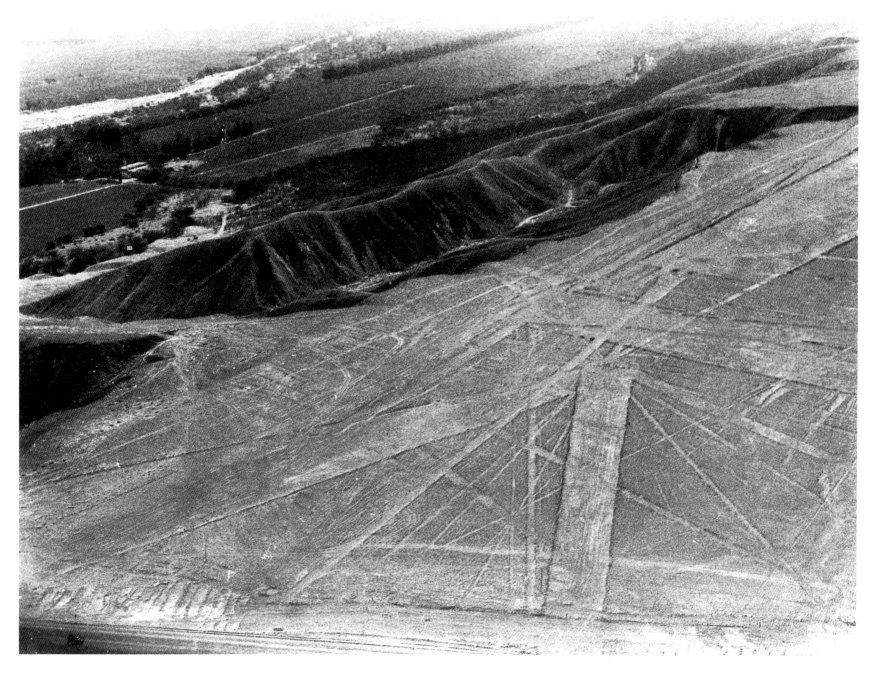

Lines in the Nazca desert.
Photograph by Roger-Viollet, Paris.

Robert Smithson, *After Thought Enantiomorphic Chambers*, c.1965.
Photographic collage, 11 x 8-1/2 inches. Courtesy of the John Weber Gallery, New York.

shows us how little there is to see, and seems to prove what Lewis Carroll once said, 'They say that we Photographers are a blind race at best…'"[21]

Robert Morris felt the Nazca lines held a formal relationship to contemporary art: "Much recent Western history of the plastic arts can be read only within the context of the confining rectilinear room, where space is either an illusion or limited to a few feet, and where the details of the work are never out of focus. The Cartesian grid of rectilinear room space involves a mental as well as a perceptual focus which implies simultaneous presentness of all parts."[22] The Nazca lines are forms which were made to be seen horizontally as well as vertically. We do not know for what purpose these lines were created, but they share with certain recent works "an obsession with space as a palpable emptiness." Morris explains that the physical world is divided between surface (the domain of information and signs) and depth. Aside from architecture, minimalism is "the only art of objects" which belongs to an intermediate zone between surface and depth. It requires a knowledge of the workings of time, and its results come back to us in the form of sketches, diagrams, and perceptual experiences of dimensional space. "There is now little relation to the stylistic look or systematic rationales of Minimalism. However, certain environmental concerns such as relation to site, negative spaces, and shaped enclosures are to be found in Earthworks and interior spaces fashioned in the '60s."[23]

The Nazca lines also simultaneously reconstruct "the flat and the spatial, line and mountain, the abstract figure and the concrete object, the notational abstraction and the concrete existent." In sum, we are in an intermediary space comparable to that of maps;[24] the landscape is reduced to two dimensions and we are aware that the

third is missing—the place of the observer, who himself is absent. As Smithson said about Heizer and De Maria, "The desert is less 'nature' than a concept, a place that swallows up boundaries. When the artist goes to the desert he enriches his absence and burns off the water (paint) on his brain.…Heizer's 'dry lakes' become mental maps that contain the vacancy of Thanatos."[25] For Smithson, the system of cartography used by surveyors is similar to crystallography. The telescope mounted on a stand with which the surveyor measures the terrain permits him to draw lines of equal distance, which he then uses to mark out the territory that he measures. He thus obtains a network resembling a system of crystals. "Mapping the Earth, the Moon, or other planets is similar to the mapping of crystals. Because the world is round, grid coordinates are shown to be spherical, rather than rectangular. Yet, the rectangular grid fits within the spherical grid. Latitude and longitude lines are a terrestrial system much like our city system of avenues and streets. In short, all air and land is locked into a vast lattice. This lattice may take the shape of any of the six Crystal Systems."[26]

As it did for Tony Smith, Donald Judd, and other artists of the era, crystallography played an important role in Smithson's art. In Smithson's library, one finds D'Arcy Thompson's *On Growth and Form*, as well as a number of technical writings on the subject.[27] From these books Smithson borrowed a terminology and a mode of thought; he did not delve into scientific issues. Thus the notion of enantiomorphy[28] served not only for the conception of his work *Enantiomorphic Chamber*, but also more generally in his art and his writings to characterize the relationship of signs to things, and of maps to their referents. In the story of his voyage in the Yucatan, in a passage

1 Robert Smithson, *Gyrostasis*, 1968. Metal, 73 x 57 x 40 inches. Property of Robert Smithson. Courtesy of the John Weber Gallery, New York.

2 Robert Smithson, drawing of a detail of *Gyrostasis*, 1968. Pencil, 9-1/2 x 14 inches. Property of Robert Smithson. Courtesy of the John Weber Gallery, New York.

about his ninth mirror displacement, he describes his *enantiomorphic* trip through Villahermosa: "Two asymmetrical trails that mirror each other could be called enantiomorphic after those two common enantiomorphs—the right and left hands. Eyes are enantiomorphs. Writing the reflection is supposed to match the physical reality, yet somehow the enantiomorphs don't quite fit together. The right hand is always at variance with the left. Villahermosa on the map is an irregular yellow shape with a star in it. Villahermosa on the earth is an irregular yellow shape with no star in it. Frontera and Cd. del Carmen are white circles with black rings around them. Frontera and Cd. del Carmen on the earth are white circles with no black rings around them. You say nobody was looking when they passed through those cities. You may be right, but then you may be wrong. You are caught in your own enantiomorph."[29]

One of the characteristics of crystals which is metaphorically valuable for Smithson is that they grow, yet are not actually living things, thus uniting the properties of the organic and the inorganic. Representing the solidification of gas and liquids, a crystal also has the advantage of giving a powerful and immediately suggestive image of entropy.[30] Finally, in offering the equivalent of a space with multiple vanishing points, crystals permit Smithson to use a mode of representation capable of corrupting a standard system—a map—by tracing it directly from crystallography. A map linked with crystallography forms a crystalline structure and thus demultiplies its own referential space.

In 1968, Smithson created *Gyrostasis*, a three-dimensional replica of the map that he had drawn for the Dallas-Fort Worth Regional Airport project. As was *Mono Lake Nonsite* (1968), on a more explicit level, *Gyrostasis* was inspired by Lewis

Carroll's idea of a map containing nothing but the uninterrupted expanse of the sea. As Hobbs has said, here Smithson uses a system that obeys only its own laws to measure distance and scale. "The title *GYROSTASIS* refers to a branch of physics that deals with rotating bodies, and their tendency to maintain their equilibrium. The work is a standing triangulated spiral. When I made the sculpture I was thinking of mapping procedures that refer to the planet Earth. One could consider it as a crystallized fragment of a gyroscopic rotation, or as an abstract three-dimensional map that points to the *SPIRAL JETTY*, 1970 in the Great Salt Lake, Utah. *GYROSTASIS* is relational, and should not be considered as an isolated object."[31]

The sculpture is constructed using twelve hexagonal forms; the joining of their sides and angles alternates as they progressively decrease in size, creating a movement of rotation, twelve triangles that unfold tangentially around an empty space corresponding to Lewis Carroll's map. The sculpture represents "abstract cartographic grids"[32] but it energizes movement in that it creates a narrowing curve around an empty space, which also suggests an entropic movement. It is as if this work were a crystallographic creation of frozen time. *Entropic Pole* (1967) uses the cartographic system in a similar fashion, as well as using the system of perspectival construction, playing with the idea of pole, yet situating it in a swamp, which is both the materialization of the vanishing point and its disappearance, its becoming mired in the mud. These two systems of representation cancel each other out, eliminating any possible center.[33] This idea in Smithson's work corresponds to his obvious long-term interest in non-centered spaces.

Hobbs has written, "[Smithson] looked for a geography that could serve as a

Ad Reinhardt, *A Portend of the Artist as a Yhung Mandala*, 1955. Collage, 26 x 19 inches. Part of a series of drawings commissioned by *Art News*, this appeared in May 1956.

metaphor for the present state of humankind and found it in New Jersey suburbs (such as Passaic), in industrial parks, and in Western deserts."[34] This interest finds an echo, for example, in the article "A Museum of Language in the Vicinity of Art," in which Smithson comments on Ad Reinhardt's *Portend*, writing that this work is the exact opposite of the Pascalian concept according to which the center is everywhere and the circumference is nowhere: "Instead with Reinhardt we get an Art World that is an infinite sphere, whose circumference is everywhere but whose center is nowhere."[35] In 1968, Smithson, Heizer, and Nancy Holt went on a trip to Mono Lake, a dried-up salt lake near Las Vegas, where they shot a short film (which was never shown). Smithson was fascinated by the type of landscape that he saw there, a sort of "recessive" landscape. "Maps are very elusive things. This map of Mono Lake is a map that tells you how to get nowhere."[36] This map is a copy of Lewis Carroll's map at the beginning of *The Hunting of the Snark*, and it constitutes a non-site, while also being filled with volcanic deposits, pumice stone, and cold ashes. Here Smithson is emphasizing the site/nonsite opposition, the nonsite attracting attention by the empty space that it displays, and the site existing at the borders where "your mind loses its boundaries and a sense of the oceanic pervades."[37] Mono Lake is in northern California, and Smithson explains that the volcanic material there interested him because of its granular nature, its mix with salt deposits. "If you look at the map, you'll see it is in the shape of a margin—it has no center. It's a frame, actually."[38] And he adds that the location particularly interested him because it tends to evaporate entirely—the more one approaches, the more it evaporates. "It becomes like a mirage and it just

disappears. The site is a place where a piece should be but isn't. The piece that should be there is now somewhere else, usually in a room."[39] Discussing Mono Lake, Smithson resumes the dialectic of site and nonsite: "The interesting thing about the site is that, unlike the nonsite, it throws you out to the fringes. In other words, there's nothing to grasp onto except the cinders and there's no way of focusing on a particular place. One might even say that the place has absconded or been lost. This is a map that will take you somewhere, but when you get there you won't really know where you are. In a sense the non-site is the center of the system, and the site itself is the fringe or the edge."[40]

Here as well, the center disappears, the map is non-centered; it does not begin at a particular point, or it begins at all of them at once. A map always brings us back to its circumference, and, if one believes to have grasped the secret of the map behind the map, there is always another map that is also a territory. This de-centering is a method of voluntarily siting oneself at the boundaries of known worlds, like the maps from antiquity showing *terra incognita*, a vast, unknown territory subject only to the imagination. But here the difference is that the earth is not at the center of the system. It is illogical to represent our world using a central perspective system, and Smithson experiments with the spatial order of classical perspective to attempt to best circumvent it. But whether we are discussing Richard Long, Dennis Oppenheim, or Robert Smithson, for all of them the "cartographic schematism," by its nature, is a *model* of time. The *ichnographic* point of view allows a single glance to encompass that which the perspective system forces an observer to see in a successive fashion only. With a map, human time is no longer the measurement of the visible world, and it is this which strengthens the contrast between

Map by Lewis Carroll from *The Hunting of the Snark*, 1876.

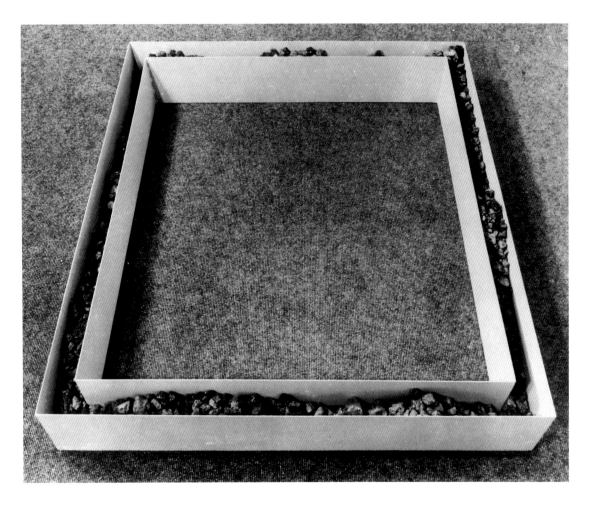

Robert Smithson, documentation for *Mono Lake Nonsite*, 1968.
Courtesy of the John Weber Gallery, New York.

Richard Long's photos, his maps, and the experience (inaccessible as such) to which they supposedly refer.

These artists' maps do not exist to allow us to find ourselves in them, quite the opposite; their aim is to lose us, to isolate us within the *singular experience* of the art. In the consumer culture of the 1960s, these artists attempted to re-instill in art the sense of true aesthetic adventure. Cartography shifts art's geography, which is never where one believes it to be; one must reconstruct, based on available information—maps, in this case—what these do not provide. In creating a new conceptual space, these artists attempt to restore to works of art a space of their own.

Robert Smithson, documentation for *Mono Lake Nonsite*, 1968.
Courtesy of the John Weber Gallery, New York.

1. Gilles Deleuze and Félix Guattari, *A Thousand Plateaus: Capitalism and Schizophrenia* (Minneapolis: University of Minnesota Press, 1987), p. 12.

2. Robert Smithson, "A Museum of Language in the Vicinity of Art," *Art International* (March 1968); reprinted in *The Writings of Robert Smithson*, op. cit., p. 76. Svetlana Alpers, emphasizing art historians' and scientists' common interest in maps, which tends to unite their respective fields of research, writes, "Cartographers and geographers, for their part, in keeping with a related intellectual revolution of our time, are newly conscious of the structure of maps and of their cognitive basis. A distinguished geographer put the change this way: while once it was said that 'that it is not geography which cannot be mapped,' now it is thought that 'the geography of the land is in the last resort the geography of the mind.' Jasper Johns's *Map* is a painter's version of this thought." (Svetlana Alpers, *The Art of Describing: Dutch Art in the Seventeenth Century* [Chicago: University of Chicago Press, 1983], p. 125.)

3. Lewis Carroll, "The Hunting of the Snark," *The Collected Verse of Lewis Carroll* (New York: E.P. Dutton & Co., Inc., 1929), p. 35.

4. Jorge Luis Borges, *L'Auteur et Autres Textes*, translated from the Argentinian by Roger Caillois (Paris: Gallimard, 1960), p. 199.

5. Nelson Goodman, *Problems and Projects* (Indianapolis: Hackett Publishing Co., 1972), p. 15. "Not only is it easy to lie with maps, it's essential," writes Marc Monmonnier in the first sentence of the introduction to his book *How to Lie with Maps* (Chicago: University of Chicago Press, 1991), p. 1.

6. Emmanuel Kant, *Critique de la Raison pure*, translated from the German by A. Tremesaygues and B. Pacaud (Paris: P.U.F., 7th edition, 1971), p. 151. The schemas described by Kant as "monograms of the imagination" allow us to comprehend the phenomenon's form by making the images of the perceptible world possible. To venture an analysis, just as the schema cannot be reduced to any image or concept, the map as such can be neither a painting by Johns nor the idea of a walk by Long.

7. This is a classic argument, used by Aristotle to refute the Platonic theory of ideas. J. Tricot, in his edition of *La Métaphysique*, summarizes it well: "If any element common to many things is elevated to the rank of separate substance, whatever the perceptible man and the man himself have in common will produce a third man; what this third man, the man himself, and the perceptible man have in common will produce a fourth man, and so on to infinity." (Aristotle, *La Métaphysique* [Paris: Vrin, 1953], vol. I, note 2, pp. 82–83.) On the logical paradoxes created by the hypothesis of the map at 1:1 scale, see Umberto Eco, "Dell'impossibilità di costruire la carta dell'Impero 1 a 1," in Omar Calabrese, Renato Givannoli, Isabella Pezzini (ed.), *Hic Sunt leones. Geografia fantastica e viaggi straordinari* (Milan: Electa, 1983).

8. The technical information given by the Christos is always very precise; from it, one learns that "17,000 man power hours, over a period of 4 weeks, were executed by: 15 professional Mountain Climbers, 110 Labourers, Students from

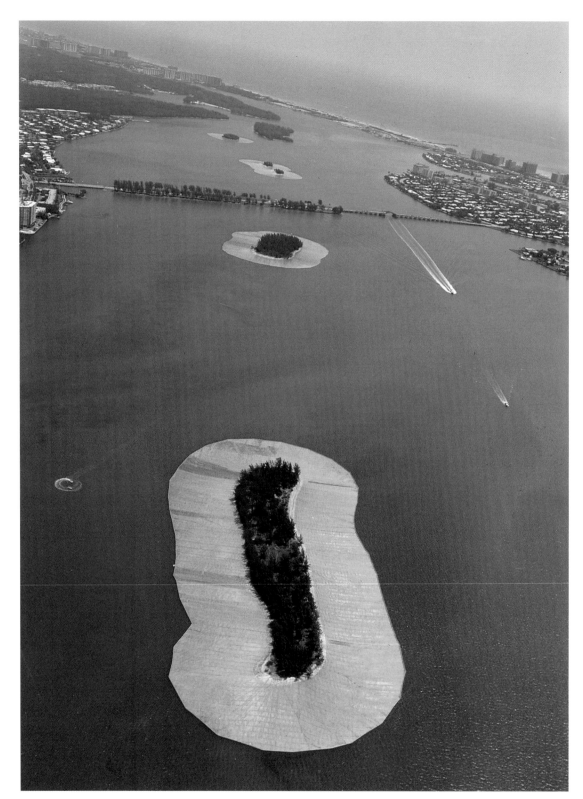

Christo and Jeanne-Claude, *Surrounded Islands*, Biscayne Bay, Greater Miami, Florida, 1983.
Photograph by Jeanne-Claude Christo. © Christo, 1983.

Robert Smithson, *Sunken Island*, Summerland, Key, Florida, 1971. Rocks grouped in a lagoon, approximately five feet.

Sydney University and East Sydney Technical College, as well as some Australian Artists and Teachers." See Marina Vaizey, *Christo* (New York: Rizzoli, 1990), in which this information is recorded.

9. *Ocean Front*, Newport, Rhode Island, 1974.

10. Lucy R. Lippard, "Douglas Huebler; Everything About Everything," *Art News* (December 1972), p. 30; reprinted in *Douglas Huebler* (Eindhoven: Van Abbemuseum, 1979).

11. Robert Smithson, "Incidents of Mirror-Travel in the Yucatan," *Artforum* (September 1968); reprinted in *The Writings of Robert Smithson*, op. cit., p. 103.

12. Charles Ross, *Sunlight Convergence Solar Burn* (Salt Lake City: University of Utah Press, 1976), 38 pages.

13. Charles Ross as cited in Donald B. Kuspit, "Charles Ross: Light's Measure," *Art in America* (March–April 1978); reprinted in *Art in the Land, a Critical Anthology of Environmental Art*, Alan Sonfist ed., op. cit., p. 164.

14. Rosalind E. Krauss, *The Originality of the Avant-Garde and Other Modernist Myths*, op. cit., p. 10.

15. Ibidem.

16. Cited in Lucy R. Lippard, *Six Years: The Dematerialization of the Art Object*, op. cit., p. 184.

17. "Discussions with Heizer, Oppenheim, Smithson," op. cit., p. 171.

18. Ibidem, p. 171.

19. "Clearly, maps are not traditionally read as space. Sixth-grade geography teachers, Rand McNally, and the AAA, by telling us to read them for data, not experience, hinder us from seeing them visually. But art like Oppenheim's can help. By introducing the map to the context of a piece, he and others invite and coax us to experience its implied space, a space so vast it exceeds even that of Baroque panoply-of-heaven ceiling paintings, Christianity's best effort to date. Maps suggest another space, even larger than the landscape-scale space discussed above, that Oppenheim has helped make accessible to art." (Jean-Louis Bourgeois, "Dennis Oppenheim, a Presence in the Countryside," op. cit., p. 36).

20. Robert Smithson, "Aerial Art," op. cit., p. 92.

21. Ibidem.

22. Robert Morris, "Aligned with Nazca," op. cit., p. 37.

23. Ibidem.

24. For Smithson, these lines are interesting only when photographed from an airplane: "For me, a photograph acts as a kind of map that tells you where the piece is and I don't see anything wrong with that. The Nazca lines have meaning only because they were photographed from airplanes, at least for our eyes conditioned by the 20th century." (Robert Smithson, "The Earth, Subject to Cataclysms, is a Cruel Master," op. cit., p. 180.)

Charles Ross, *Star Axis*, 1988–1989 (under construction). © Charles Ross, 1989.

25. Robert Smithson, "A Sedimentation of the Mind: Earth Projects," op. cit., p. 89.

26. Robert Smithson, "Toward the Development of an Air Terminal Site," op. cit., p. 43.

27. For example, Charles Bunn, *Crystals, Their Role in Nature and Science* (London: Academic Press, 1964); Harold Hilton, *Mathematical Crystallography and the Theory of Groups of Movements* (New York: Dover, 1963); Alan Holden & Phylis Singer, *Crystals and Crystal Growing* (Doubleday Anchor, 1960). The group of books, edited by Georgy Kepes, on the relationships between art and science—and, more specifically, *The New Landscape in Art and Science* (1956)—certainly influenced Smithson as well, since in 1972 he published his text "Spiral Jetty" in another of these books, *Arts of the Environment*.

28. In his classic work, *Leçons de cristallographie*, Georges Friedel classifies a figure and an object as symmetrical as long as they show "operations of symmetry." These operations are defined "by the condition that they do not modify the mutual distances of the points of the figure." There are two types of symmetry. Here we are only interested in "the operations said to be of the second type, in which F and F' have the same relation to each other that an object and its image in the mirror have; for example, a left and right hand, a left and a right screw. F and F' are said to be enantiomorphs of each other, and are not generally superimposable by a simple movement." (Georges Friedel, *Leçons de cristallographie* [Paris: Berger-Levrault, 1926], pp. 26–27.) See also Kurt Mislow, *Introduction to Stereochemistry* (New York: W.A. Benjamin, 1966). Smithson's interest in this explanation is evident.

29. Robert Smithson, "Incidents of Mirror-Travel in the Yucatan," op. cit., p. 102.

30. Robert Hobbs, *Robert Smithson: Sculpture*, op. cit., p. 21.

31. Robert Smithson, *The Writings of Robert Smithson*, op. cit., p. 37.

32. Robert Hobbs, *Robert Smithson: Sculpture*, op. cit., p. 96.

33. This principle is similar to *A Nonsite, Franklin New Jersey*, 1968. See chapter seven of this book.

34. Robert Hobbs, *Robert Smithson: Sculpture*, op. cit., p. 98.

35. Robert Smithson, *The Writings of Robert Smithson*, op. cit., p. 73.

36. "Discussions with Oppenheim, Heizer, Smithson," op. cit., p. 176.

37. Ibidem.

38. Ibidem.

39. Ibidem, p. 177.

40. Ibidem.

## CHAPTER 6

# NEAR AND DISTANT LANDSCAPES

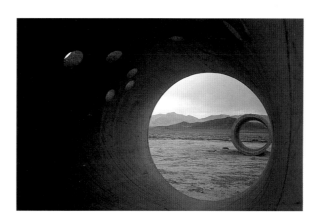

Nancy Holt, *Sun Tunnels*, Great Basin Desert, Utah, 1973–1976.
Detail. Photograph by Gilles A. Tiberghien, 1992.

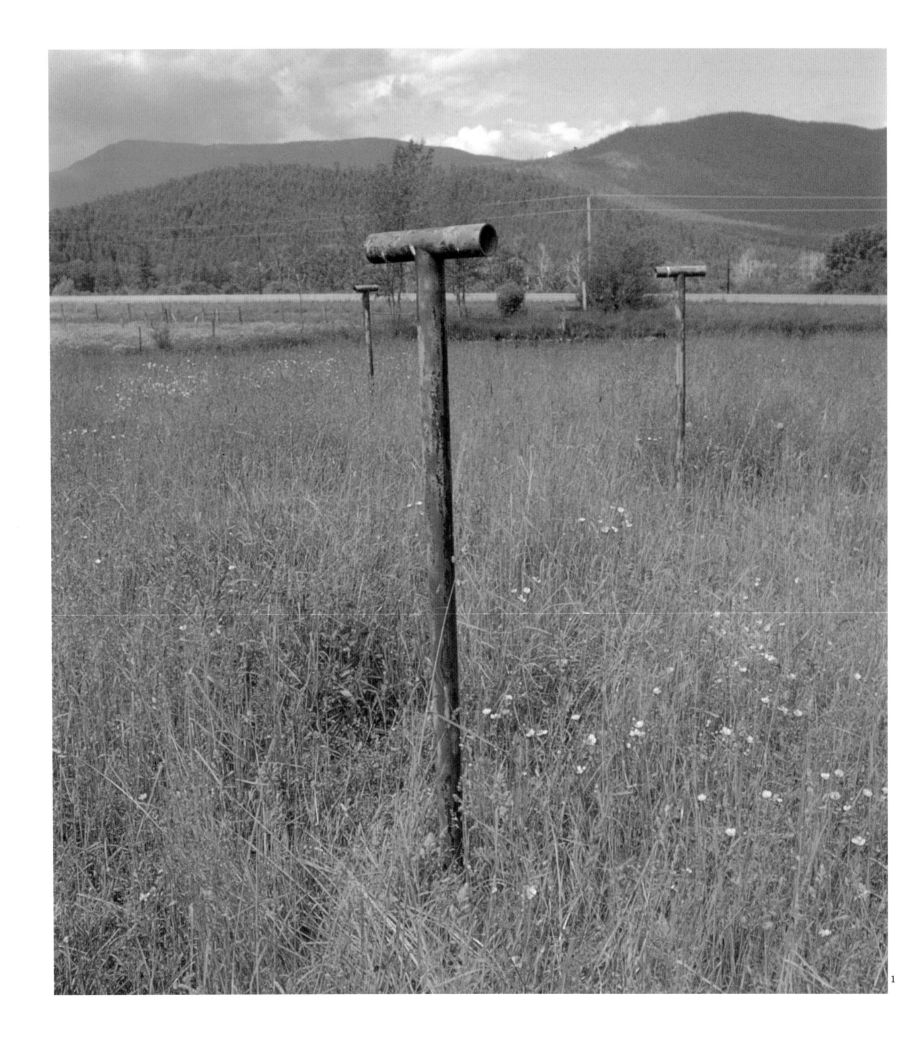

1

The relationship between Land Art artists and the landscape is complex.

For Michael Heizer, for example, "it's not landscape art," and he adds, speaking of *Complex City*: "The only thing you can see is the sky. It stops the idea that this is a form of landscape art..."[1] Yet for Long, the landscape takes precedence. Regardless, whether negative or positive, this relationship to the landscape is privileged in that these artists intervene in a natural environment, modifying it in a deliberate fashion.

In art, the earliest landscapes are viewed through a window, bordered by a frame, and thus removed from the land. One such example is the *veduta* visible in the background of the Annunciations of the quattrocento. The whole history of Western painting since the Renaissance has been marked by this analogy to the window, discussed by Alberti in *De pictura*. Our present *"vision"* of the landscape, which is essentially dependent on painting, is still based on this concept of the window, especially as the system of perspective creates an even stricter frame. How do the Land Art artists, even before modifying this vision, relate to the landscape itself? One of the essential functions of art was to "schematize"[2] our glance, to give it a form of representation of nature, varying according to the time period and the culture, which determines our aesthetic judgement. From this point of view, gardens could be considered as an "application" of these schemes, which a certain number of Land Art artists have renewed under other forms, yet still within a wholly classical

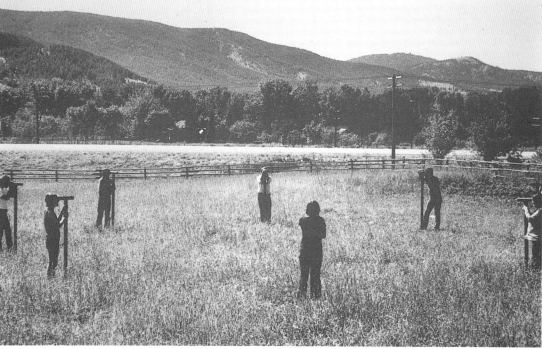

**1, 2, 3** Nancy Holt, *Missoula Ranch Locators*, Missoula, Missouri, 1972.
Courtesy of Nancy Holt.
Any number of people standing in a field can observe the same landscape through wooden viewers, which allows each individual to have the singular experience of his own perception. Looking through these devices, one notices that the locators face each other, and that the work is thus "self-referential," to use Nancy Holt's description.

perspective. This is somewhat true of the work of Nancy Holt, Christo, Walter De Maria, the first ephemeral works by Heizer and Jan Dibbets, and photographs by Richard Long. Long has been referred to as a "landscapist, that is, an artist who constructs a vision of the landscape."[3] His works can be defined as constructed, since the photographs of the locations of his circles and lines are accompanied by a wealth of information, place names, and measurements indicating altitude or distance—all of which constitute in some sense the instruments of construction, while still allowing a "reading" of the work.

Nancy Holt's interest in light and its transformations is often emphasized when discussing her work. While recognizing this interest, however, she refuses to reduce her art solely to light: "My work is about perception and space. Light is something I got into because I was thinking about sight."[4] Her first "locators" such as *Views Through a Sand Dune* (Narragansett Beach, Rhode Island, 1972) and *Missoula Ranch Locators* (Montana, 1972) have the function of directing the spectator's view so that each person sees *exactly* the same thing while having the singular experience of his own perception. It was to follow the different positions of the sun, which contribute largely to these variations in vision, that Nancy Holt envisioned the creation of *Sun Tunnels*. This work maintains an explicit relationship not only with time, but also with the landscape, since the enormous tunnels are also "locators" in which one can stand to take shelter from the wind or the sun, as if at the bottom of a gigantic oculus. Similar to Walter De Maria's *Lightning Field*, this work gives an initial impression of a landscape that stretches on endlessly, since the immensity of the terrain, bordered in the distance by mountain ridges, offers no reference points to orient the

1

1  Nancy Holt, *Sun Tunnels*, Great Basin Desert, Utah, 1973–1976.
Detail: sunset at summer solstice. Courtesy of Nancy Holt.

*following pages:*
**2, 3, 4**  Nancy Holt, *Views Through a Sand Dune*, Narragansett Beach, Rhode Island, 1972.
Courtesy of Nancy Holt.

## SUN TUNNELS

*I wanted to bring the vast space of the desert back to human scale. I had no desire to make a megalithic monument. The panoramic view of the landscape is too overwhelming to take in without visual reference points. The view blurs out rather than sharpens. Through the tunnels, parts of the landscape are framed and come into focus. I chose the diameter, length, and distance between the tunnels based on the proportions of what could be seen of the sky and land, and how long the sun could be seen rising and setting on the solstices.*

*In the desert, scale is hard to discern from a distance. Mountains that are 5 or 10 miles away look deceptively close. When Sun Tunnels is seen from 4 miles away, it seems very large. Closer in, a mile or so away, the relational balance changes and is hard to read. The work is seen from several angles on the road in, at times two of the tunnels line up exactly head on and seem to disappear. Seen from a side angle, the two tunnels in front can totally overlap and cancel out the ones in the back.*

*From the center of the work, the tunnels extend the viewer visually into the landscape, opening up the perceived space. But once inside the tunnels, the work encloses, surrounds—and there is a framing of the landscape through the ends of the tunnels and through the holes.*

*The color and substance of the tunnels is the same as the land that they are a part of, and the inner matter of the concrete, the solidified sand and stone, can be seen on the insides of the holes, where the "core-drill" cut through and exposed it. In that kind of space the work had to have a substantial thickness and weight, which was only possible with concrete. The rims are wide enough to frame the space from long distance, and the weight (22 tons per tunnel) gives the work a feeling of permanence.*

Nancy Holt, "Sun Tunnels," excerpt, *Artforum* (April 1977).

2

3

4

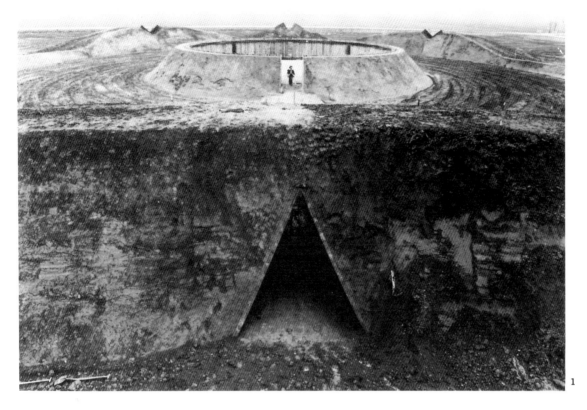

**1, 2** Robert Morris, *Observatory*, Oostelijk Flevoland, Netherlands, 1977.
Earth, wood, and granite, diameter: 299 feet. Photographs by Pieter Boersma. Courtesy of the Guggenheim Museum, New York.

with the earth taking the measure of the sky, and vice-versa. This work could be thought of as Earth Art rather than Land Art, as the former term has the advantage of emphasizing its "planetary" nature. As opposed to *Sun Tunnels*, the observatory works do not frame the landscape; they open up the horizon, making notches in it resembling castle embrasures, cutting into the sky, as if into atmospheric matter, to create the reference points which move with the observer. The observer *knows* that the surveyors' staffs indicate precise or "absolute" positions in space, he *knows* that the large axis of the observatory is aligned with the direction of the sun at the summer solstice, and yet at the same time, this work gives him the experience of the wholly relative nature of these indications, as if the only truly important direction, contrary to Morris's intentions, were the vertical.

Something comparable can be found in Christo and Jeanne-Claude's *Running Fence, Sonoma and Marin Counties, California, 1972–1976.* [7] *Running Fence* is undoubtedly the most famous of their works. It took four years to be completed, and the legal and technical problems which accompanied its installation are an integral part of the work. An artistic reflection on the arbitrary nature of borders, *Running Fence* is considered to be a parody of "the iron curtain," on the other side of which Christo, of Bulgarian origin, lived until he emigrated to the West in 1957. In 1962 Christo and Jeanne-Claude had completed an earlier work on the same theme, *Le Rideau de Fer, Mur de Tonneaux, rue Visconti, Paris*. But the political dimension of this gesture was not simply in its reference. The work mobilized hundreds of workers, engineers, advisers, students, and farmers who worked on its installation; this contributed to its strong "social"

observer, nothing upon which to focus the eye. [5] However, upon reaching the center of the sculpture, space becomes hierarchical, and the landscape becomes organized around the four large tubular axes. Instead of trying to instill in us a mystical passion for nature, or a feeling of dissolution recalling Rousseau's *Rêveries* du promeneur solitaire, in a completely *calculated* manner Nancy Holt attempts to give us the feeling of belonging within the order of the cosmos. She explains that she tries to place herself in the center of cyclical time so as to put us at the "center of the world." Her basic motivation is to "bring the vast space of the desert back to human scale. I had no desire to make a megalithic monument. The panoramic view of the landscape is too overwhelming to take in without visual reference points." [6] The work is an articulation between the sky and the earth, and through this the landscape takes on a new dimension.

Similarly, Morris's *Observatory* is both a multidirectional vector and a hinge,

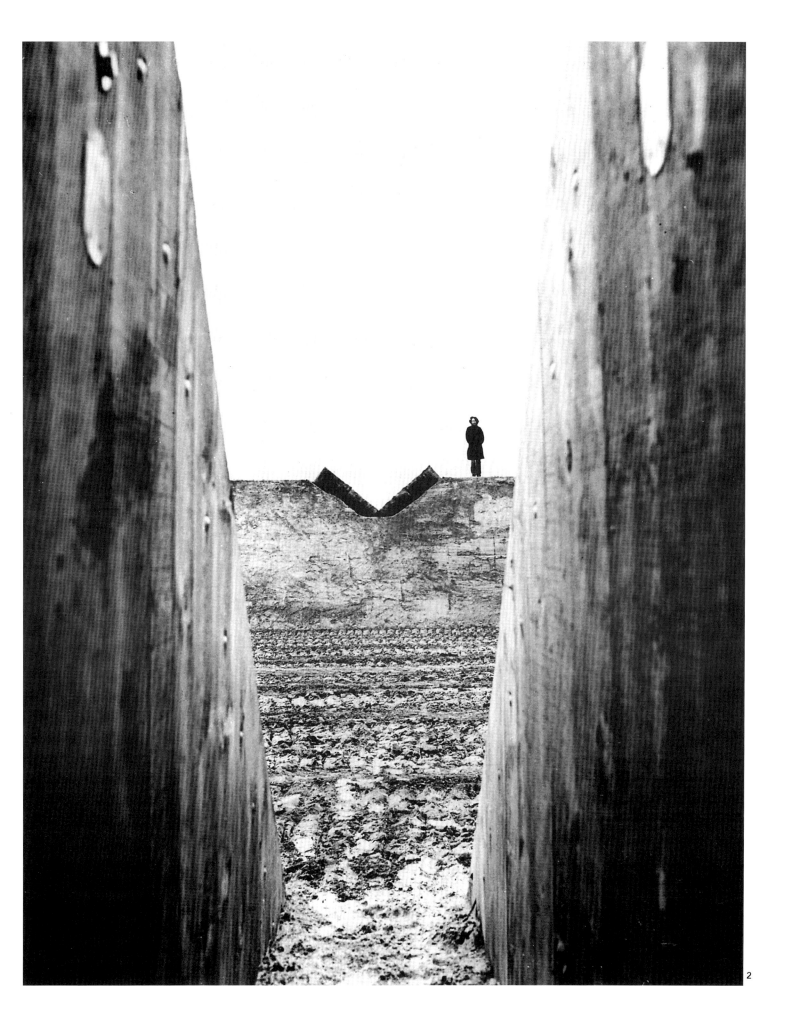

2

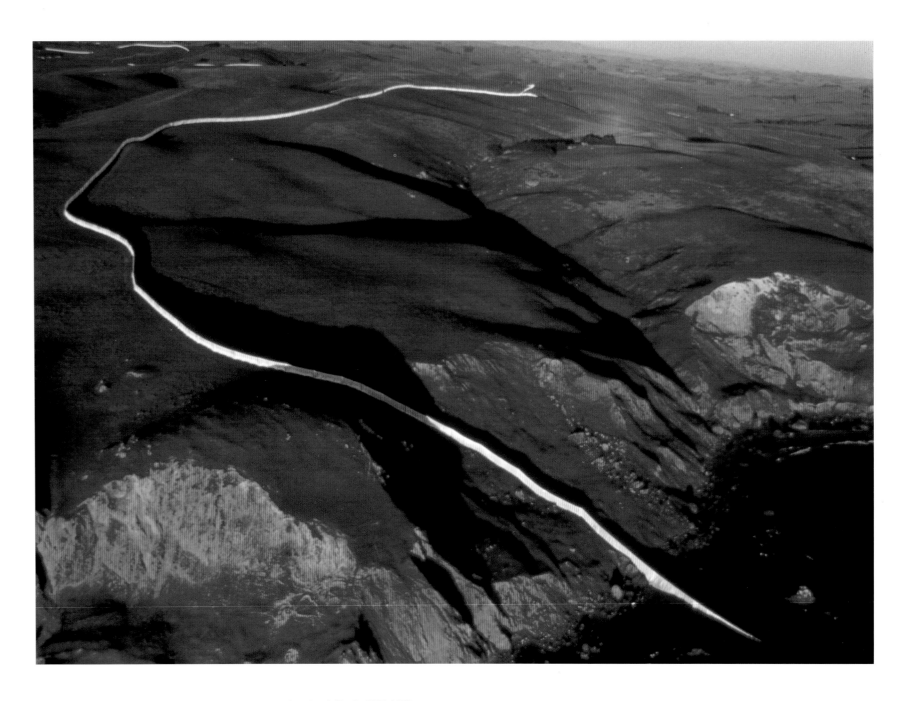

Christo and Jeanne-Claude, *Running Fence, Sonoma and Marin Counties, California, 1972–1976.*
Height: 18 feet, length: 24-1/4 miles. Photograph by Gianfranco Gorgoni. © Christo, 1976.

Christo and Jeanne-Claude, *Running Fence, Sonoma and Marin Counties, California, 1972–1976.*
Photograph by Jeanne-Claude Christo. © Christo, 1976.

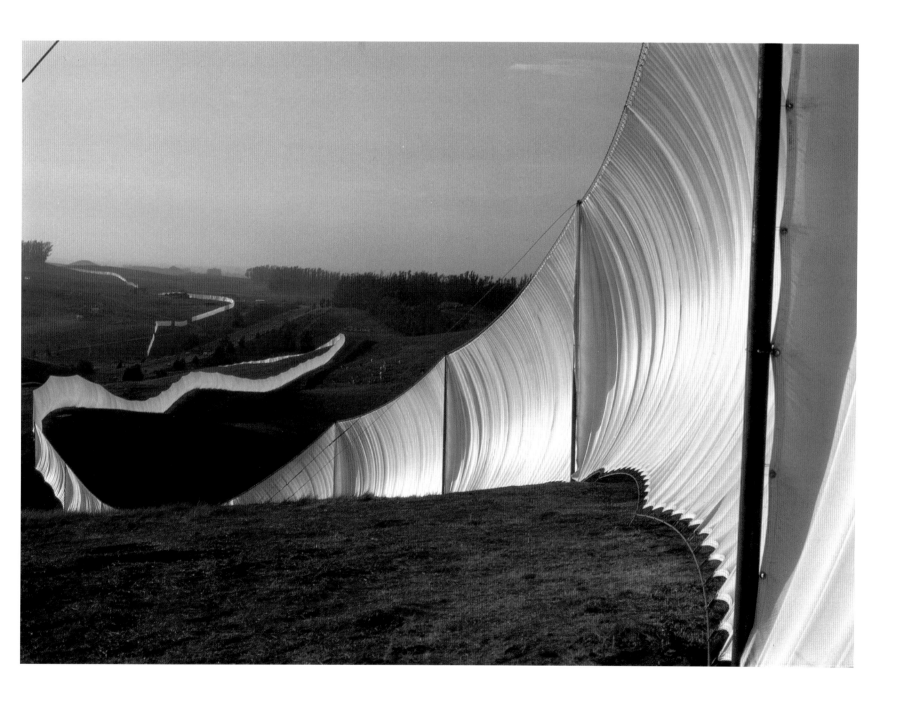

dimension, especially because of the maximal visibility it acquired. *Running Fence*, more than twenty-four miles long, eighteen feet high, and made of nylon material, was visible for fourteen days along the roads of Sonoma and Marin counties, California.

As well as its political aspect, which is admittedly central, it is important not to forget this work's specific relationship to the landscape: surrounded by this "barrier" which expands the landscape and opens up new spaces, *Running Fence* also indissolubly connects the landscape to its

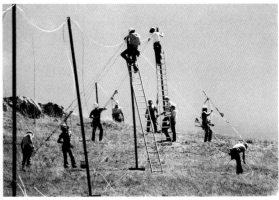

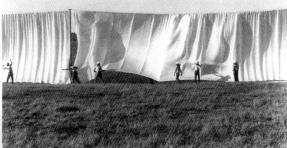

1  Mural, Valley Ford, California.
Last existing evidence of *Running Fence*. Photograph by Gilles A. Tiberghien, 1991.

**2, 3**  Christo and Jeanne-Claude, *Running Fence, Sonoma and Marin Counties, California, 1972–1976.*
Installation. Height: 18 feet, length: 24-1/4 miles. Photograph by Wolfgang Volz. © Christo, 1976.

borders, to the sea which surrounds it and extends it like a fold in the flow of a wave, and to the sky, making the horizon mobile. *Running Fence* "runs," and, through this movement, ignores all boundaries. Thus the land reclaims its rights to these territories, and the landscape does not coincide with artificially created borders, but instead extends to the dimensions of the globe, not really visible as such except from outer space. Here the picture frame becomes mobile, emphasizing the contours of the hills, dividing the land as a means of uniting it, softening or breaking up the land's sharp contours.

*Running Fence* is a kind of giant paintbrush, and a simple movement of the spectator, or a shift of the angle of the camera (upon which we are now all dependent), produces new rhythms, new tensions. The

landscape seems to construct itself at each moment, constantly redrawn by the eye of the person viewing it. This work, also, belongs in the category of Earth Art, as it brings into play the geographical and political totality of the earth, becoming the artistic expression of this totality. *Running Fence* was possibly the second monument (the first being the Great Wall of China), visible from the moon.

The approach of the Land Art artists could be considered as the sign of a renewed interest in the picturesque, as well as in the setting, which had already been cultivated by minimalism.[8] Richard Serra, when asked if a sculptural object in a landscape plays the role of frame or pedestal for that landscape, responds that it becomes an element of definition of the landscape, but not a frame: "If you use the word 'frame' in referring to the landscape, you imply a notion of the picturesque," which, he adds, never interested him. He continues, "Smithson was interested in the picturesque. His *Spiral Jetty* (1969–1970) not only spirals you out into the landscape, framing vistas of the landscape, but as it dovetails back on itself, it also leads you to concentrate on its internal structure."[9] Christo and Jeanne-Claude's *Valley Curtain, Rifle Colorado, 1970–1972* reacts to the same interest in the picturesque. The curtain, installed on August 10, 1972, was 1313 feet long. It blocked the valley at its

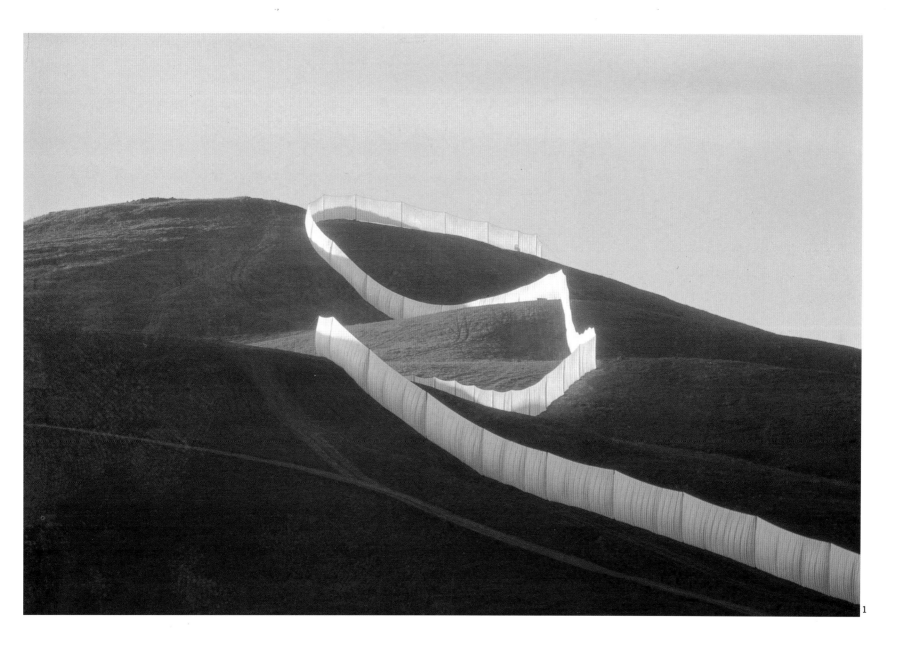

**1**  Christo and Jeanne-Claude, *Running Fence, Sonoma and Marin Counties, California, 1972–1976.*
Height: 18 feet, length: 24-1/4 miles. Photograph by Wolfgang Volz.
© Christo, 1976.

**2**  Great Wall of China.
Photograph courtesy of Magnum, Paris.

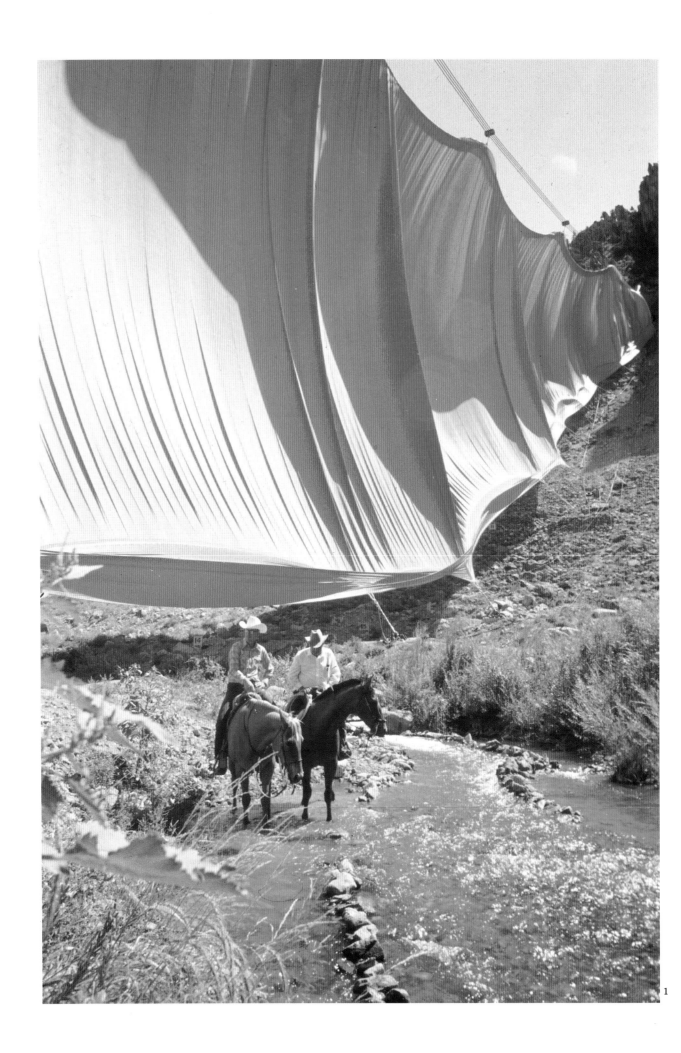

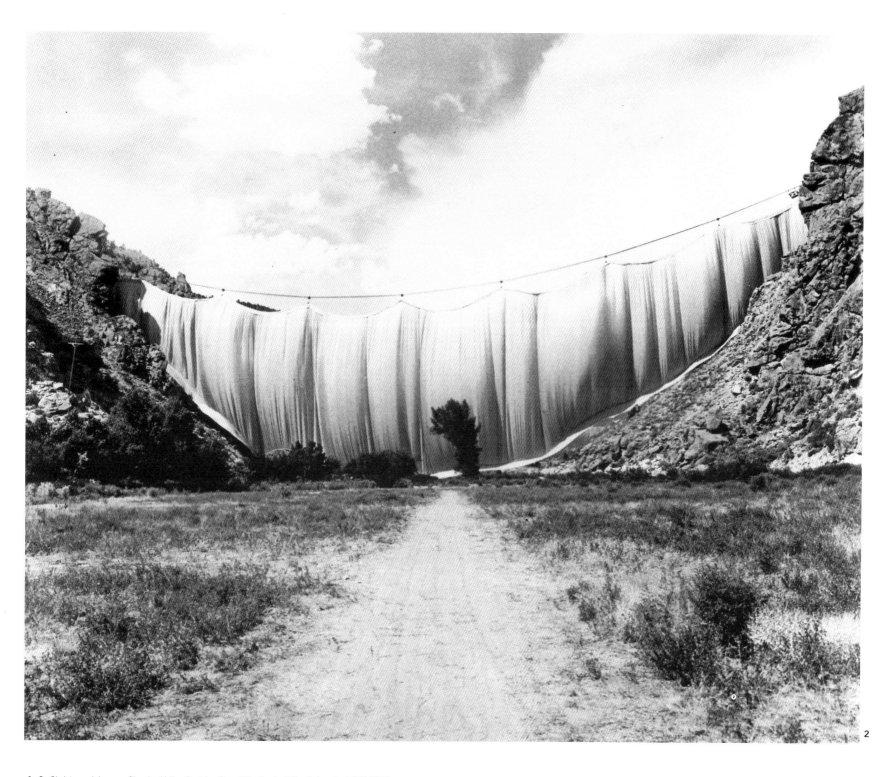

**1, 2** Christo and Jeanne-Claude, *Valley Curtain, Grand Hogback, Rifle, Colorado*, 1970–1972. Span: 1250 feet, height: between 185 and 365 feet; 200,000 square feet of nylon polyamide, 50 tons of steel cable. Photograph by Harry Shunk. © Christo, 1972.

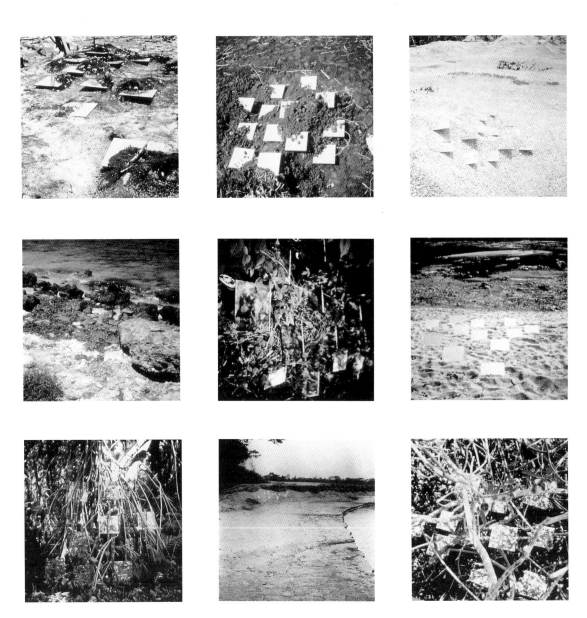

Robert Smithson, *9 Mirror Displacements* ("Incidents of Mirror-Travel in the Yucatan"), 1969.
Photographs by Robert Smithson. Courtesy of the John Weber Gallery, New York.
*First Mirror Displacement, Second Mirror Displacement, Third Mirror Displacement, Fourth Mirror Displacement, Fifth Mirror Displacement, Sixth Mirror Displacement, Seventh Mirror Displacement, Eighth Mirror Displacement, Ninth Mirror Displacement.*

widest point, and its height varied between 185 and 365 feet. Here the importance of the setting is at its most evident, as the orange curtain simultaneously masks and uncovers the theater of nature (of which we are a part, and which photography generally allows us to occupy): a rocky valley where two roads border a thin band of green.

Sidney Tillim's essay on the "New Picturesque"[10] aimed to show that Land Art was a reaction to "great art," pure and noble art whose arrival had been announced by modernism. However, certain characteristics that interested the Land Art artists, such as the emphasis on the process of the work and the impact of time, paralleled the concerns that had been of great importance in eighteenth- and nineteenth-century art,[11] particularly the implicit relationship to movement and to the passing of time.[12] For Price and Gilpin, the two most noted theorists on the subject, the picturesque is defined by intricacy and variety, as opposed to the beautiful, which is characterized by simplicity, symmetricality, clarity, and smoothness. A garden that is beautiful, harmonious, and symmetrical in its paths and green spaces, while "well placed in nature," would not necessarily be pleasing in a painting. Thus the preference for the "rough" object over the plain object, which is seen as incompatible with the aesthetics of picturesque composition.

Gilpin provided a number of examples to illustrate this conception. He said that from the point of view of painting, a work horse was worth more than a purebred stallion admired for its force and its elegance; an old nag provides a better effect. Roughness allows for variety, contrast, and effects of light and shadow. In reading Gilpin, Smithson, "the great rediscoverer of the picturesque,"[13] was struck by two examples: Palladio, whose architecture

could not be considered beautiful from a picturesque point of view, except as transformed into a "rustic ruin," and the marble-mirror, evoked to illustrate that variety must exist for the work to be considered picturesque. "Let the marble be perfectly white, and the effect vanishes. Thus also a mirror may have picturesque beauty; but it is only from its reflections."[14]

Smithson is fascinated by mirrors, by their ability to double and redouble, mimicking the dialectic of site and non-site. But water can also take on the properties of a mirror, as is the case in *Spiral Jetty* and *Broken Circle*, developing and explaining what the work envelopes and implies. Thus the sky is reflected on the earth, and the earth, whose internal dynamic seems to be shown by the spiral, coils up (in certain photographs of *Spiral Jetty*) around the sun, which is like the spiral's beginning and end. The picturesque quality here is not only that of the images or points of view taken of the world, it is in the relationship of reciprocal transformation between the act of observation and the thing that is observed. To see the landscape, one must go through the window, one must explore and even re-form the land.

When he traveled in England and Scotland, Gilpin tended to draw, making sketches and notes. He began to expand upon this habit with *On Sketching Landscape*, the last of his three essays on the picturesque, advising travelers who also liked to take notes either to keep visual records of what they had observed or to graphically annotate the narratives of their journeys. This tradition resurfaces slightly differently in the American "drifters" (as symbolized by Kerouac in the 1950s), which the Land Art artists, exploring the deserts of the American West, can be said to have inherited. At varying degrees, these artists are animated by a "narrative" urge.[15]

Smithson's mirror displacements, although at a higher level of complexity, are direct descendants of the Stendhalian proposition according to which a story is a mirror that advances at the edge of a road. With the difference that, in "A Tour of the Monuments of Passaic, New Jersey," "the mirror kept changing places with the reflection. One never knew what side of the mirror one was on."

Smithson experiments with this particular type of motion in his "mirror displacements." The most important of these, discussed in the September 1969 issue of *Artforum*, was entitled "Incidents of Mirror-Travel in the Yucatan," in reference to the travelogue by John L. Stevens, *Incident of Travel in Yucatan*. The mirror not only visually echoes the site/nonsite dialectic, it also has a "critical" function, in the sense that it allows a breakdown of the representation on its surface. But, as Hobbs has noted, Smithson's text itself functions as a mirror of his artistic activity, since it utilizes the mechanisms of writing to reflect the complexity of art, as well as to

Robert Smithson, *Spiral Jetty*, Great Salt Lake, Utah, April 1970. Black rocks, salt crystals, earth, red water (algae), 1500 feet long by 15 feet wide. Photograph by Gianfranco Gorgoni, Sygma.

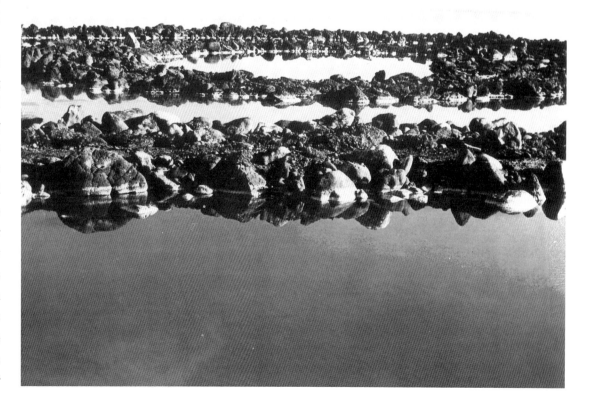

weaken the certainties of reality. In doing so, Douglas Crimp writes, Smithson has reintroduced allegory to art.[16]

Hobbs also compares Smithson's text and his mirror displacements in the Yucatan with *Enantiomorphic Chambers* (1965), in which the spectator, placed at the point from which all the lines diverge, finds himself no longer at the center, but at the periphery of the process. This interpretation is justified by the citation in the epigraph of Smithson's essay, taken from *The Savage Mind* by Levi-Strauss: "The characteristic feature of the savage mind is its timelessness; its object is to grasp the world as both a synchronic and a diachronic totality and the knowledge which it draws therefrom is like that afforded of a room by mirrors fixed on opposite walls, which reflect each other (as well as objects in the intervening space) although without being strictly parallel."[17] This de-centering is also a way of visualizing the original meaning of the word *yucatan*, "I do not understand," uttered by the Indians in response to the Spanish who asked them where they were.[18]

The road, as it appears during Smithson's voyage in the Yucatan, is simultaneously a non-space—an emptiness which separates the sites from the non-sites—and a crack in the mirror. About the road, Smithson wrote, "Through the windshield the road stabbed the horizon, causing it to be bleed a sunny incandescence. One couldn't help feeling that this was a ride on a knife covered with solar blood....The tranquil drive became a sacrifice of matter."[19] The mirrors, placed in groups of twelve, are partially covered with earth, reflecting the sky, the movements of the clouds, and the path of insects. Mirrors blur representation, at least in their popular or realist version, whose function is only to reproduce reality. This simplified version of *mimesis* is nonetheless a common conception that

1 Alan Sonfist, *Time Landscape of New York*, 1965. 45 by 200 feet. © Alan Sonfist 1965.

2 Richard Long, *Mud Hand Circle*, New York, 1989. Mud from the Avon River, diameter: 12 feet. Installation: Sloan-Kettering Memorial Cancer Center, New York, 1989. Courtesy of the Anthony d'Offay Gallery, London.

Smithson's text attempts to ruin. Smithson may also be making reference to Brunelleschi's device that established the technical rules of perspective, which had been systematized on the theoretical level by Alberti in *De pictura*. In this optical *montage*—a veritable "pictorial manifesto," as John White has said—the sky takes the place of the mirror. It is actually the sky which appears in the upper portion of the painting, covered with polished silver, such that the image offered to us is not a figurative representation but rather a reflection of a reflection.[20] Robert Smithson's text of his journey seems to produce exactly the same effect: "One must remember that writing on art replaces presence by absence by substituting the abstraction of language for the real thing. There was a friction between the mirrors and the tree, now there is a friction between language and memory. A memory of reflections becomes an absence of absences."[21] The picturesque unveils itself to the traveler; it is not only a pure projection of the mind, but it is also already a part of nature. Uvedale Price, who wrote, "...and after all, we should never forget that the beautiful is no more the immediate result of smoothness, undulation, and serpentine lines, than the picturesque is of roughness, abruptness, and sudden variation..."[22] shows that the picturesque is a fundamental quality inherent in objects. In Smithson's article on Olmsted (who designed Central Park), an essay that works just as well as his stories or prose poems as a means of expressing his reflections—in accordance with his customary mixing of genres—he contrasts Price and Gilpin with "timid academics," people, such as ecologists, who maintain idealist visions of nature.

"Inherent in the theories of Price and Gilpin, and in Olmsted's response to them, are the beginnings of a dialectic of the

2

RIVER AVON MUD HAND CIRCLES

ROSC DUBLIN 1984

Central Park, 1885.
Looking northwest from Park Avenue, probably at about 94th or
95th Street.

landscape," writes Smithson. He continues, to assert that if one considers the relationship that Burke established between the "beautiful" and the "sublime," linked to "smoothness, gentle curves, and delicacy of nature, as opposed to the feeling of terror and solitude, the one playing the role of thesis, the other of antithesis, one can conclude that "Price and Gilpin provide a *synthesis* with their formulation of the 'picturesque,' which is on close examination related to chance and change in the material order of nature."[23] Consider the increased value of ruins or of sites upon which time has left its mark.

For Smithson, the value of these authors lies in their materialist or "dialectic" conception. "The picturesque, far from being an inner movement of the mind, is based on real land; it precedes the mind in its material external existence. We cannot take a one-sided view of the landscape within this dialectic. A park can no longer be seen as 'a thing-in-itself,' but rather as a process of ongoing relationships existing in a physical region—the park becomes a 'thing-for-us.'"[24] To Smithson, Olmsted was the inheritor of this conception. He considered nature, in its relationship with humankind, as well as in its dynamic relationship to itself, as a constant and uncertain process of transformation. In creating his gardens, Olmsted took this process into account, so that his parks "exist before they are finished, which means in fact they are never finished." To construct Central Park, Olmsted did not hesitate to move ten million horse-carts of earth, and he constantly had to contend with the city's negligence and misappropriation of funds. His heroic and "Promethean" nature seduced Smithson, who saw in Olmsted an ancestor of the Land Artists, someone who knew how to compose with the hazards of nature, taking into account the result of fate to which nature had been subject, the destructions that it had suffered, and the industrial and urban environment by which it had been transformed. The nature recreated in Central Park is not a static and nostalgic image of paradise lost, an image especially prevalent during the nineteenth century, that "...leaves one without a solid dialectic, and causes one to suffer an ecological despair." The artist Alan Sonfist was able to make use of a similar image in his *Time Landscapes* (1965–1978), urban compositions he created in the Bronx, Brooklyn, and Manhattan. The principle was to recreate the general feeling of a forest, with its various trees and plants, on urban sites that had been wooded during the pre-Columbian era. In these wooded enclaves, the past is visible in the present and recalls to the citizens their early origins.[25]

Smithson's essay on Olmsted concludes with the story of his walk through the park, and describes the spillway from the ice rink, transformed into a "muddy slough" in which tin cans float and supermarket carts are stuck. Smithson says that the mud should be dredged and made into a "mud extraction sculpture," and a documentary would follow the transport from the place of

extraction to the site of deposition. "A consciousness of mud and the realms of sedimentation is necessary in order to understand the landscape as it exists."[26]

This love of mud, soft and malleable earth, is also evident in Richard Long's work, and some of his art is made of clay thrown onto walls. "Mud is a fantastic material, halfway between stone and water, which are two constant themes in my work."[27] For an artist, mud can be a favored material in rendering the process of gestation of a work. Mud is formation without form, or, to paraphrase Aristotle (referring to movement), "the actuality of the potential *qua* potential." But this "ideal" state of pure matter has no reality other than the trace, the mark, the scar. Mud is the dream of a formless matter as well as the plastic embryo of all form.

Smithson's *Asphalt Rundown* (Rome, 1969), an homage to Pollock's drippings, is a flow of asphalt which, poured from a truck, follows the slope of a hill created by the erosion of an abandoned dump of rubble. The tar is a kind of "trap for energy," as Robert Hobbs says, a trap that captures time by congealing the speed evoked by the highway, using petroleum residue, the product of an ancient process of sedimentation.[28] This fascination with mass and the force of weight drove Smithson to other similar experiments, such as the burying of a shed at Kent State University in Ohio (*Partially Buried Woodshed*, 1970).[29] The picturesque quality of this work is found in its dynamic relationship to time and to the environment it modifies through its presence, as well as in the reactions that it provokes. It is therefore not a simple way of regarding things, nor even of considering them as worthy of being painted. It breaks away from harmony, order, and symmetry; as opposed to the Kantian sublime that results from a subjective feeling

1 Central Park, Vista Rock Tunnel, 1862.

2 Central Park, Vista Rock Tunnel, 1972.

produced in us by certain natural spectacles, attached to the object itself. Although an object can be picturesque, it can not be sublime. The picturesque quality associated with Long's photography concerns the *image* of nature. What interests Smithson concerns the *object* itself in its dialectical relationship with natural forces.

In the 1960s, the attitude of the Land Art artists aroused much controversy, which was generally directed at the brutal and antiecological nature of Land Art. A common interpretation held that their processes partook of the return to nature, characteristic of the ideology of the period, but that they had betrayed it by violating the virgin soil of the deserts of the American West with cranes and other heavy machinery. Michael Heizer, although in truth concerned about his natural environment, embodied the image of the savage brute, the unscrupulous cowboy who bulldozes the ground. The artists certainly contested these accusations, refusing the ideological naïveté of seeing nature as the last refuge against the evils of civilization.

The Land Art artists did not consider the deserts of the West to be lacking connections with the world of museums and galleries. In interviews with Dennis Oppenheim and Michael Heizer that were published in 1970 in *Avalanche* magazine, Smithson said, "I think we all see the landscape as coextensive with the gallery. I don't think we're dealing with matter in terms of a back-to-nature movement. For me the world is a museum."[30] The vast expanses of land, as well as the possibility of moving huge masses, of drawing gigantic figures on the ground, and of building megalithic sculptures satisfied their artistic requirements, while also responding to concerns of an ideological and political order. The motivations of these artists were never identical, even if, in the euphoria of the early years, the distinctions were not yet

James Turrell, *Roden Crater*, Arizona.
Photograph by Gilles A. Tiberghien, 1991.

evident. Nature was not really used for itself; it was a compelling part of the work, offering a new medium for their various practices. Some of these practices were ancient, but nonetheless they did not contain any more mythical or religious content, and from this point of view they lacked any relationship to the society from which they had come. The revitalization of this content, as an attempt to rediscover a lost or hidden meaning, was the affirmed objective of Long and Fulton, and they contributed to spread the idea of the desecration of nature. For the others, the landscape became the place for intellectual, perceptible, and palpable experience. Rather than an object of contemplation, the landscape was simply an aesthetic partner. The more lasting these artists' works are, the less their inscription in the landscape matters. This does not mean that they are not harmoniously integrated with nature; on the contrary, everything contributes to give them value: the road leading to the works, the horizon that they stand out against, the color of the earth or the water, and the position of the sun in the sky. In a sort of exchange, they define these spaces, which cease being mere traversed expanses and become worked landscapes. But these are landscapes of memory, if they can be called such, which becomes apparent not so much from the work itself as from whoever looks at it. To view Morris's *Observatory* or Smithson's *Spiral Hill/Broken Circle*, one must cross vast, almost completely flat expanses. The impression evoked by these spaces is especially startling in Flevoland, since, even if one does not know that these lands were recently submerged under the sea, one has the feeling of being exposed by the tide, as if the water could spill over at any moment. The site disappears before the work, and yet the work would not be viewed in the same way had it been

constructed or installed elsewhere. Our perception seems tied to the landscape that we have just seen, immersed in it, in the same way that our eyes, viewing the work of James Turrell, are still filled with the darkness that we have just passed through to reach the space where the work is found. Little by little, we acclimate to the blackness, everything becomes progressively clearer, and the monochrome work floats in space more and more visibly. But this is at the price of a fragile equilibrium, such that the shadow is as important as the light. It is generally the same with any Land Art site. The force of these works—which they share with temples or various pre-Columbian cult sites, for example—may be in the activation of this area of obscurity, through arousing an overpowering feeling in the spectator who wanders unguided. This effect is even stronger when one is alone in these places; there is little chance of finding a crowd when one goes to see *Double Negative*, even though the Museum of Contemporary Art of Los Angeles provides a brief set of directions upon request. This is completely different from a sculpture in a garden that passing, half-interested visitors casually stop to admire. The remarkable determination that guides the traveler, the relatively dangerous nature of the undertaking, and the empty immensity of the arid landscape all contribute to prepare him for a powerful aesthetic emotion, one which cannot be reduced to a simple tale of adventure.

Before the immensity of these spaces, the grandeur of these works, one begins to dream of the sublime. The picturesque, intermediary between the beautiful and the sublime, can be associated with both, such that one can just as easily talk of the beautiful picturesque as the sublime picturesque.[31] However, this feeling of the sublime arises not from the objects, but from the ideas that they evoke. Our judgement of

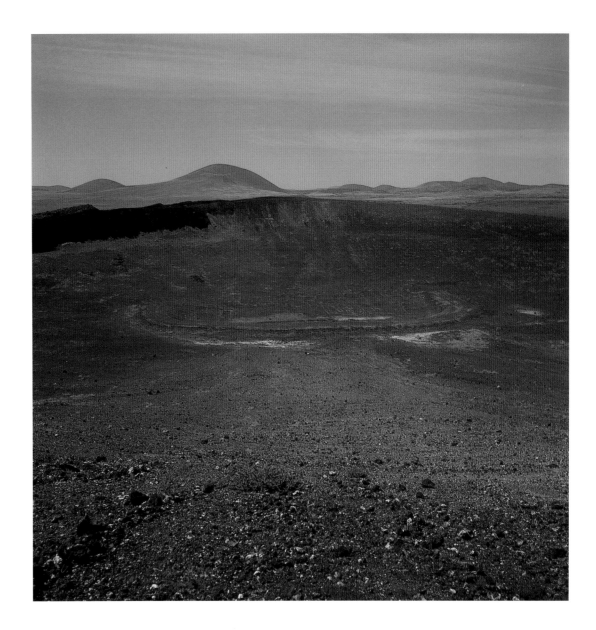

James Turrell, *Roden Crater*, Arizona.
Photograph by Gilles A. Tiberghien, 1991.
In 1977, James Turrell acquired Roden Crater, part of a chain of volcanic mountains northeast of Flagstaff, Arizona. Turrell began excavation work using bulldozers to give the larger of the two craters (which together make up the volcano) the form of a perfect circle. Its interior was given a slightly concave form, like the bottom of a sphere. This work was financed by the Dia Art Foundation and by the collector Panza di Biumo.
The view from the edge of the volcano shows the geologic disruption of the region, which dates back to prehistoric times. The Arizona sky is one of the clearest in the world, and this crater serves as a celestial observatory. Rooms linked by passageways are to be dug into the crater following precise calculations, to allow the light of the rising sun to penetrate during the solstices and the equinoxes.
The layout of these rooms and tunnels also follows other complex rules which allow for various effects of light such as the observation of eclipses and similar astrological phenomena. For example, in one of these rooms, the full moon will be visible, as if through a telescope, every "18.61 years." On those days, its image will be projected onto a wall at the rear of the room.

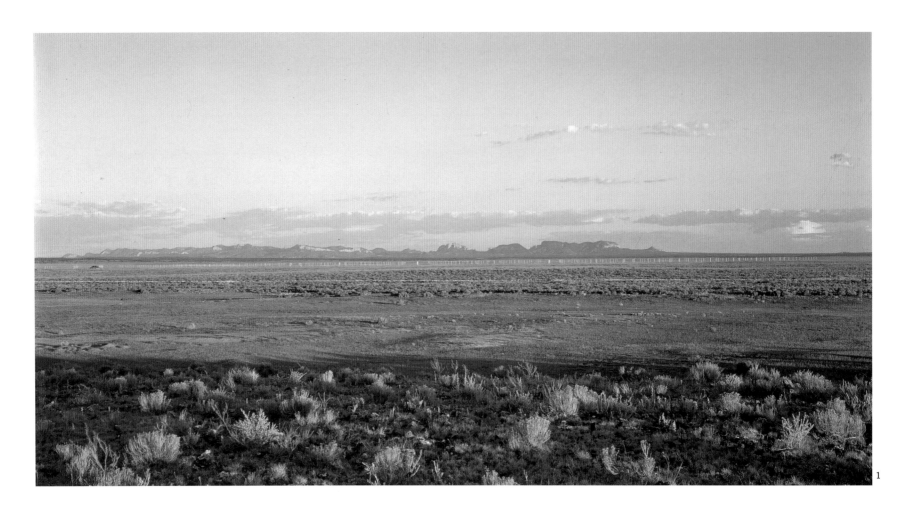

**1–4** Walter De Maria, *The Lightning Field*, New Mexico, 1977.
Four-hundred pointed steel rods, custom made, one mile by one kilometer. Collection of the Dia Art
Foundation, New York. © Dia Art Foundation, 1977. Photographs by John Cliett.

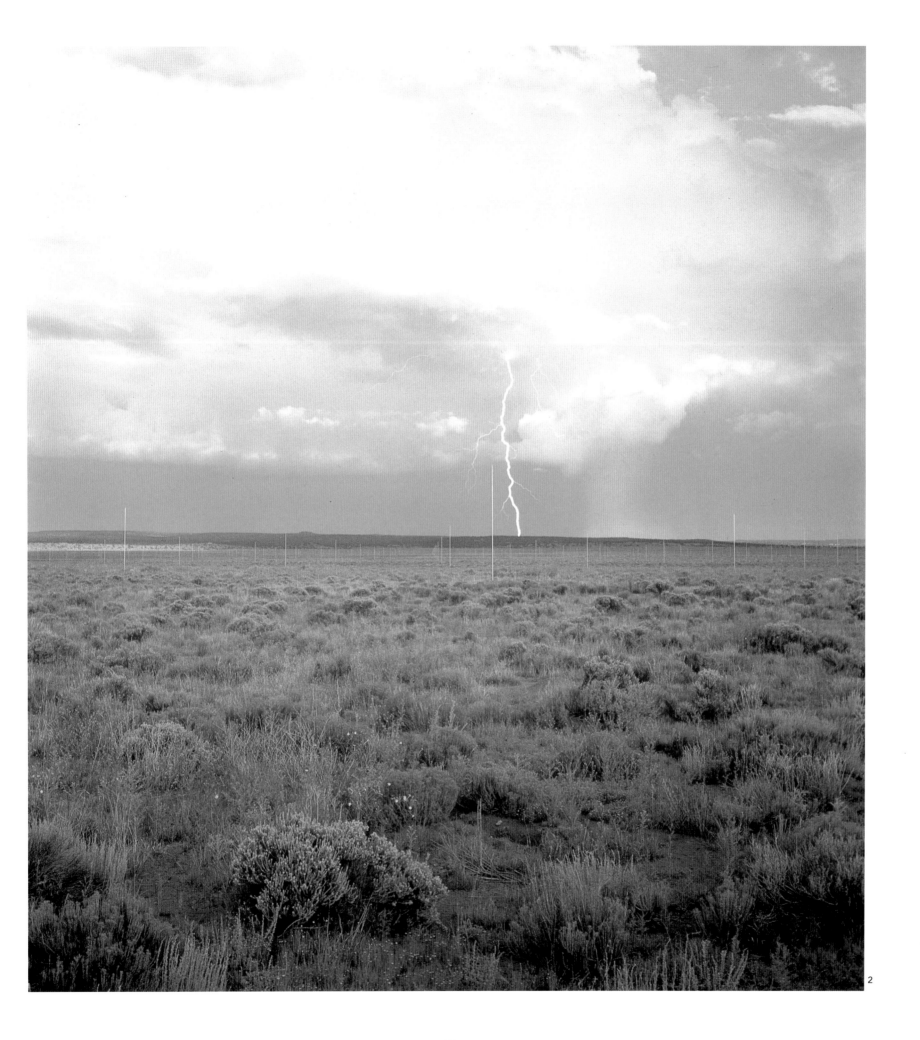

2

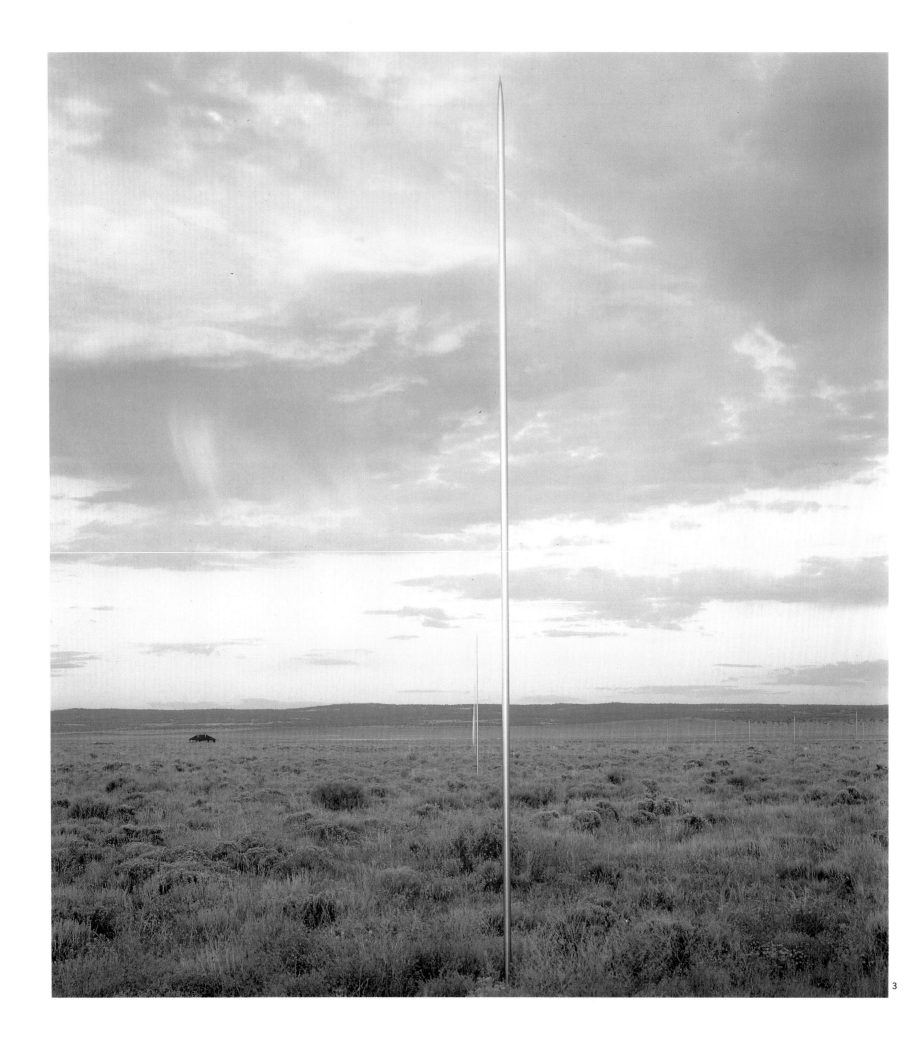

3

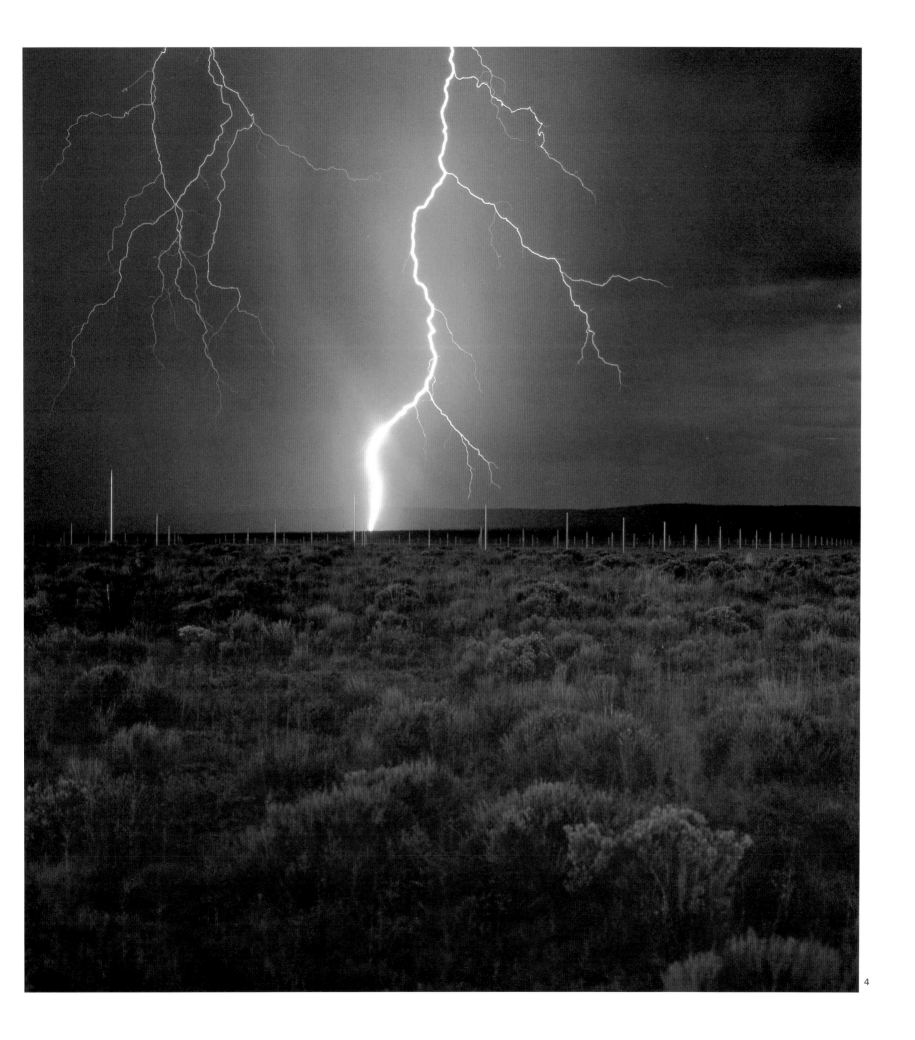

4

Serpent Mound, Adams County, Ohio, 10th century A.D.

a landscape as sublime constitutes a manner of *thinking* and not of perception. This recalls Hegel, who says that there is no *artistic* representation of the sublime, since "the work of art thus becomes the outpouring of the pure Being as the meaning of all things," which considerably limits its content, if not completely prohibiting it outright. What is obvious in this interpretation is the (infinite) abyss that exists between the Divine and any finite representation of it. Thus, that which defines "the art of the sublime" can be found "especially in the outlook of the Jews and in their sacred poetry." Hegel adds, "For visual art cannot appear here, where it is impossible to sketch any adequate picture of God; only the poetry of ideas, expressed in words, can."[32]

John Beardsley[33] sees in artists such as Heizer and De Maria a contemporary expression of the sublime as characterized by Burke, that is, resulting from the effect of terror that a vast and desolate landscape, exposed to the forces of nature, can produce. In his book *The Picturesque*, published in 1927, the art historian Christopher Hussey attributed seven characteristics to the sublime: obscurity, power, deprivation, immensity, infinity, succession, and uniformity—each one of these applicable to De Maria's *Lightning Field*. On a more general level, the scale and immensity of American landscapes, in which one finds the works of Heizer, Smithson, De Maria, and Holt, immediately associates these works with the sublime because of the relationship that exists between the work and the landscape, whose size gives us the feeling of something "absolutely great," to quote Kant.[34] It is when nature is transformed into theater that the sublime is evident, suddenly disrupting the delicate equilibrium that art had succeeded in stabilizing. Between the form and that which produces it, there is an inadequacy which greatly affects the representation itself. It is through this representation—and therefore through the distance that it always requires in shielding us from the violence of natural elements—that we experience this feeling of the sublime. Thus, the raging ocean can be qualified by horrible or by "hideous," as Kant says, but not by sublime.

A "spectacle," to use Kant's term, can be calmly contemplated only when intellectual enjoyment outweighs fear or unease. Whoever walks in the midst of the gigantic rods of *Lightning Field* is in this frame of mind, especially if a storm threatens in the distance. One can then admire the turbulent sky from the porch of the Log Cabin, and, if lucky, can see the lightning strike in forked ribbons. Art—the photographic image—will create the memory of the work.[35] This is why the feeling of

the sublime in regard to *Lightning Field* must be understood in a metaphoric sense, essentially through the story that we can create about it, much as in the poetry discussed by Hegel. This is the reason why photographs of lightning striking this work may be analogically the closest thing to "this outward shaping which is itself annihilated in turn by what it reveals,' so that the revelation of the content is at the same time a supersession of the revelation."

The relationship of the Land Art artists to the primitive arts is primarily plastic. The size and mass of primitive works strongly imfluenced them, more through their brutality than their formal vocabulary. While Heizer's and De Maria's forms on the ground are probably inspired by the Nazca lines, their interest in these ancient lines is primarily visual and aesthetic. Merely objects of historical inquiry, or of simple curiosity, they are now used as a design schema. The intellectual context of the 1960s was also valuable: the importance of Kubler's thought, founded in part on his work as a specialist on pre-Columbian art. The wave of structuralism, exemplified by Lévi-Strauss, also sensitized these cultured artists to primitive societies and their art. As Kirk Varnedoe notes, primitive thought is no longer considered to be within the realm of magic, discussed by Levy-Bruhl and exalted by the surrealists, but rather "...as the seat of powerful forms of logic, separate from but comparable to scientific thought."[36]

The focus here is not to confront contemporary art with primitive art. The classic text by Lucy Lippard, *Overlay*, whose aim is "to recall the function of art by looking back to times and places where art was inseparable from life,"[37] has already covered the essential analysis. Of importance here is the borrowing of primitive art's forms. We have already discussed the Land

Michael Heizer, *Effigy Tumuli*, 1983 (model).
Photograph by Ivan Dalla Tanoi.

Art artists' interest in observatories and labyrinths. Morris never claimed to be knowledgeable about the pre-Columbian civilizations from which he borrowed the form for *Observatory* (which recalls the interior plan of Caracol at Chichen Itza), but he admits that the observatory has connections to neolithic architecture. "I think that certainly neolithic structures like Stonehenge and others have had to do with...have been concerned about marking seasons, being big clocks in some way, that's an obvious connection..." Yet he adds, "I don't know much about the architecture of Mexico. I know very little about the Mexican astronomical observatories; I've seen the one in Oaxaca, Monte Alban. That is a very interesting structure, but I could tell nothing about it when I was there."[38] These references to primitive civilizations simply allow the artists to create their art within an atemporal realm, between humanity's most distant past and the sophisticated scientific world, the control of the sky being its symbol. Also, as Edward Fry justly writes, "[*Observatory*'s] real function is the symbolic negation of cumulative knowledge, historical and scientific, through Morris's choice of a model that we recognize as prehistoric..."[39] Such a remark is also true for all the works that function as celestial observatories, those by Holt and Turrell as well as those by Ross. Ross explains that *Star Axis* is "naked eye astronomy." For him this is a "direct physical, emotional, and sensory experience of our earth to star connection."[40] We are at the outer limits of science, and scientific procedures of verification or experimentation do not really interest these artists. Their objective is the return to perception and the search for a "naive realism" on which Aristotelian science is founded. The aesthetic linked to it, which stresses daily perceptive experience, does not have

recourse to any conceptual or theoretical instrument other than ordinary reasoning. Just as Aristotelian science always returns to perceptible experience, whatever the mathematical reasonings and the calculations that it has utilized, this art uses scientific knowledge to enrich our sensory experience and to provide new aesthetic satisfaction.

The importance of archaic forms for the Land Art artists stems from the desire to revive, through art, another type of knowledge, one which would be based on our perceptible experience, but at the same time would permit it to be raised to an *impure* aesthetic experience (to use Greenberg's terminology), which claims a *"regard hybride"*[41] at the intersection of the cognitive, the religious, and the perceptible. On an abandoned mining site not far from Chicago, Michael Heizer created a series of colossal sculptures which, instead of using his typically abstract vocabulary, are inspired by animal forms comparable to the tumuli constructed by the ancient Indian civilizations of Mississippi, called the Mound Builders. These zoomorphic sculptures, which were initially planned to *represent* insects, have the form of five stylized animals: a water strider, a frog, a turtle, a catfish, and a snake. In truth, it is difficult to identify them as such, and it is only from an airplane that Heizer's formal synthesis recalls animal shapes. The artist also had difficulty accepting the idea of creating sculptures which represent something. He explains that it was only because he wanted to incorporate these monumental sculptures into the history of the region that the issue was resolved in this manner. Similarly, because the Indians represented animals belonging to the local fauna, Heizer abandoned his idea of depicting insects to study the animals living in the river and the surrounding area. In constructing these

Michael Heizer, *Effigy Tumuli*, Buffalo Rocks, Illinois, 1985.
**1** *Frog.*
**2** *Turtle.*
**3** *Cat Fish.*

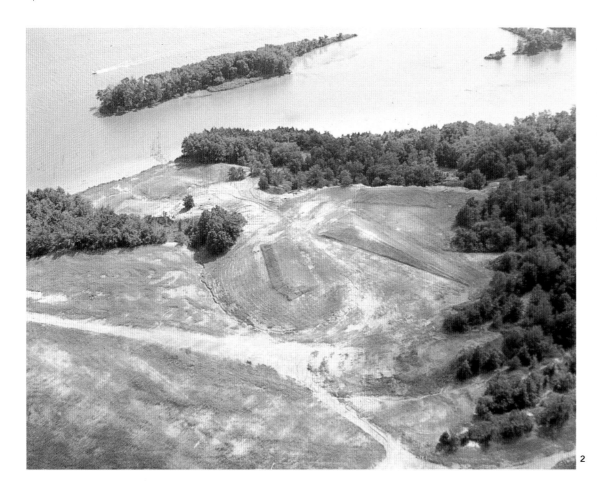

2

sculptures, not only does he integrate historical and geographical constraints, but he also takes into account the topography of the site, while incorporating the already existing earth mounds and forms.[42] Heizer's work thus pays homage to an extinct civilization, to a people who have disappeared. This political gesture is a truly commemorative one, restoring to these monuments their primitive function.

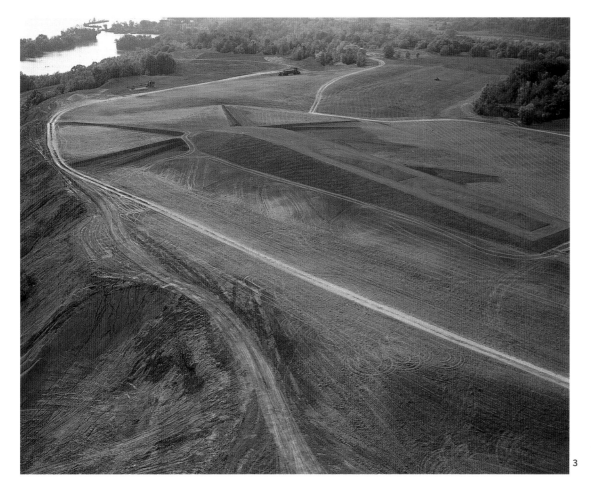

3

*Effigy Tumuli* was constructed on the site of an old open-air carbon mine at the Illinois border. The land measures approximately one mile by one-half mile. It had been completely destroyed and polluted by acids, to the point where, even forty years after its exploitation, no vegetation was able to grow. The project to rehabilitate the site had been given to Noguchi initially but it was discontinued. In 1983 the project was given to Heizer; he began work the following year and it was finished in 1985. Klauss Kertess wrote, "That Heizer could successfully negotiate the bureaucratic maze he was confronted with, for the duration of construction, is itself a noteworthy achievement." (Klauss Kertess, "Earth Angels," *Artforum* [February 1986], p. 77.) Heizer moved approximately 460,000 cubic meters of earth and added 6000 tons of limestone to reduce the acidity of the soil and to allow vegetation to grow. To minimize the costs of the operation, he used the previously existing forms as much as possible in the creation of his sculptures.

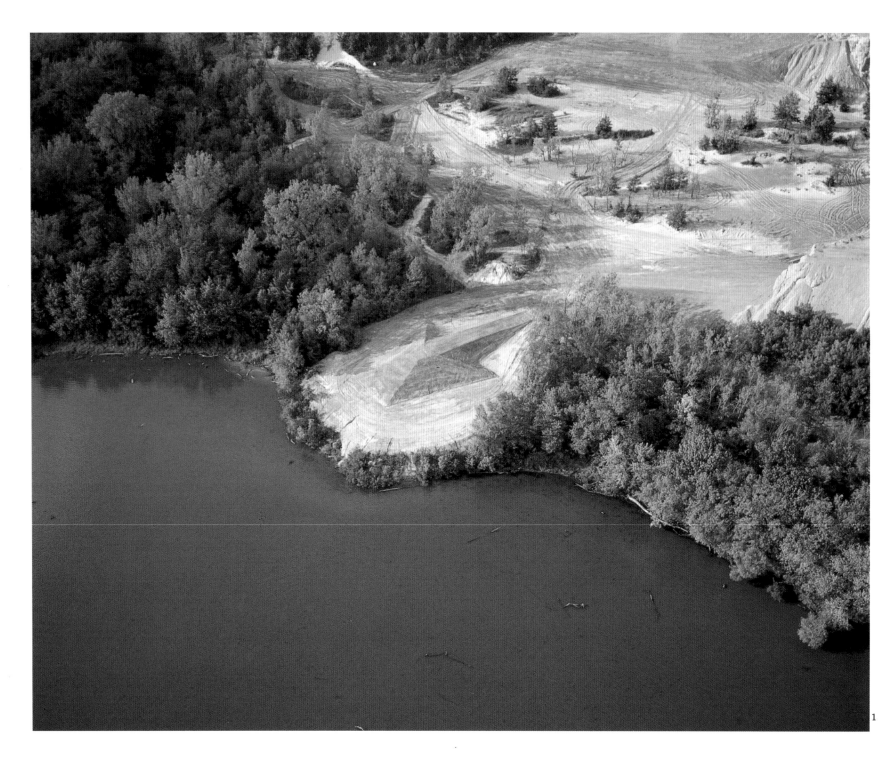

Michael Heizer, *Effigy Tumuli*, Buffalo Rocks, Illinois, 1985.
**1** *Snake.*
**2** *Water Strider, Frog, Catfish.*

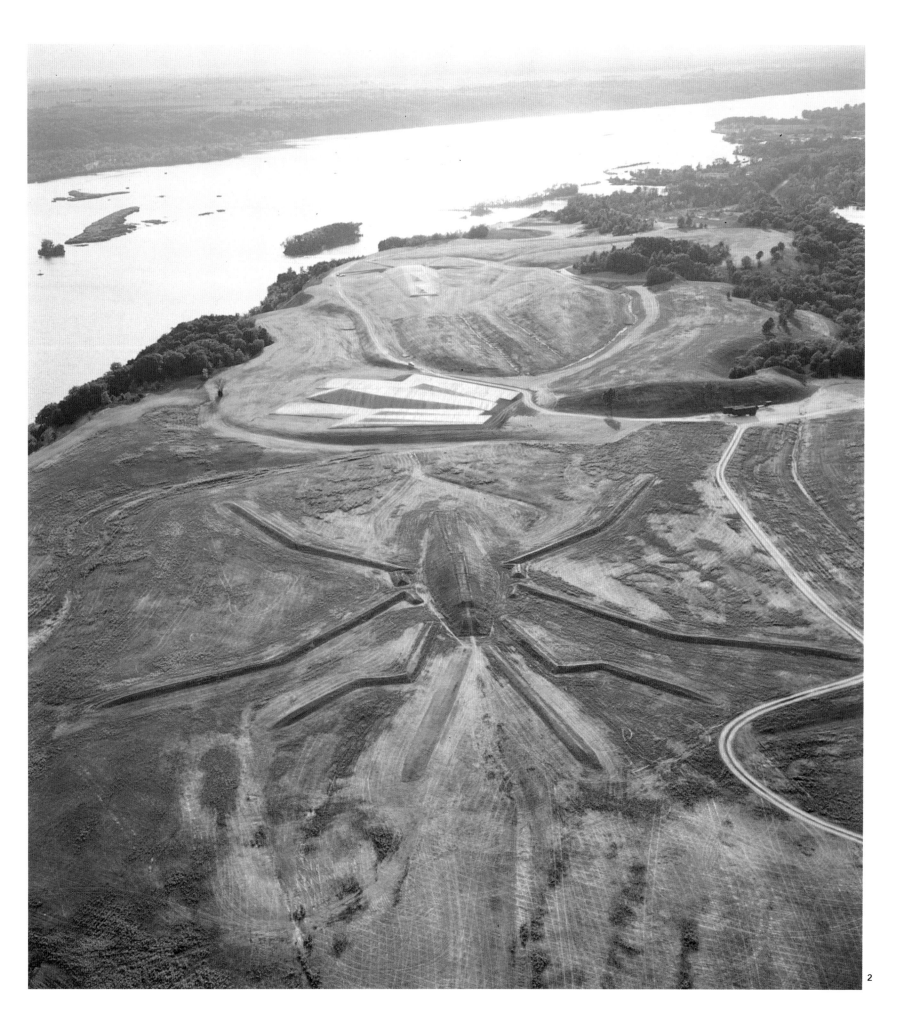

1. Michael Heizer, "Interview, Julia Brown and Michael Heizer," op. cit., p. 18.

2. At the beginning of his book, *Nus et Paysages*, Alain Roger defines his use of this term, inherited from Kant, as follows: he intends it neither in the epistemological sense of modelization, nor in the sociological sense of "un vague patterning à la mode." "One theory of schematism allows these two equally indispensable moments to play against each other, but when separated, they are only concepts without conceptualization. Thus to schematize is neither to modelize nor to model, it is rather their dynamic truth in the element of the scheme." (Alain Roger, *Nus et Paysages, Essai sur la fonction de l'art* [Paris: Aubier, 1978], p. 23.)

Alan Sonfist, *Rock Monument of Rocky Mountain*, 1971.
© Alan Sonfist, 1971.

3. Jean-Marc Poinsot ("Richard Long, construire le paysage," *L'Atelier sans mur*, op. cit., p. 73) specifies the meaning that he intends: "An artist who constructs a vision of the landscape."

4. Nancy Holt, cited in Ted Castle, "Nancy Holt, Siteseer," *Art in America* (March 1982), p. 87.

5. Similarly, in regard to *Rock Rings*, constructed between 1977 and 1979 in Bellingham on the grounds of Washington University, Nancy Holt said, "I would like people to think about what they're seeing. Say you go to see *Rock Rings*. You look through a set of holes in thick stone walls. That does something to the landscape you're seeing. It's about making structures to focus our perceptions, channeling them and giving them a depth, and also a visual disorientation in space, that we don't normally have an opportunity to experience. I'm setting up structures that give us a chance to experience our own perceptions. The structures exist to turn

experience inside out. To bring perception into consciousness." (Nancy Holt, cited in Ted Castle, "Nancy Holt, Siteseer," op. cit., p. 90.)

6. Nancy Holt, "Sun Tunnels," op. cit., p. 35.

7. This is the complete title, as Jeanne-Claude Christo emphasized after I had written the title in abbreviated form in an article which appeared in the magazine *Traverses*, number 1 (spring 1992); I have here borrowed two paragraphs, adding, "The author may think that the titles chosen by the artist are not too important; however, he would never write, 'The first breakfast' in describing 'The last supper.'"

8. "It [minimalism] does not present objects with art on them but useless artifacts that create a setting rather than a space." (Sidney Tillim, "Earthworks and the New Picturesque," op. cit., p. 43.) This prompted Michael Fried to speak of "theatricality" in discussing minimalism.

9. Richard Serra, "Interview with Peter Eisenman," *Skyline, The Architecture and Design Review* (April 1983), pp. 16–17.

10. Sidney Tillim, "Earthworks and the New Picturesque," op. cit., p. 43. "Yet Smithson objected to the European or 'pictorial' emphasis in Tillim's essay," writes Ron Graziani in "Robert Smithson's Picturable Situation: Blasted Landscapes from the 1960s" (*Critical Inquiry*, XX, 3 [Spring 1994], p. 419–451). Graziani is referring to unpublished correspondence between Smithson and Philippe Leider, from the Archives of American Art, Smithsonian Institution. For a detailed study on Smithson and the picturesque, see Graziani's text.

11. The picturesque is a concept inherited from painting and which, at the beginning of the sixteenth century in Italy, designated by the word *pittoresco*, represented "the way in which Giorgione, and later, Titian, reproduce the effects of light and shadow to give the feeling of unity of the landscape." (E. Conan, postscript to William Gilpin, *Trois Essais sur le beau pittoresque*, translated from the English by the baron of Blumenstein in 1799 [Paris: Le Moniteur, 1982], p. 121.) The picturesque in England during the eighteenth century was basically anything worthy of being painted, that which "would not be out of place in a painting." The category was finally narrowed in the nineteenth century to mean "a way of representing nature which is exclusive to painters; for the connoisseur of natural landscape, a form of attention which allows him to directly discover what a painter has represented." (Ibidem.)

12. "Firstly, so much is clear, that common speech denotes every total form as picturesque which, even when it is at rest, yields an impression of movement." (Heinrich

Wölfflin, *Principles of Art History* [New York: Dover Publications, 1950], p. 26.)

13. "He looked for ways to understand devastated industrial areas, to take hold of them in aesthetic terms, and he found a ready-made concept in the picturesque, which deals primarily with change, and which assumes an aesthetic distance between viewer and landscape." (Robert Hobbs, *Robert Smithson: Sculpture*, op. cit., p. 29.)

14. William Gilpin, *Three Essays on Picturesque Beauty* (London: printed for R. Blamire, 1792), p. 24.

15. In any case, those artists to whom the category of picturesque applies. This is how the picturesque gardener organizes his parks, in a series of *tableaux* which are revealed during the course of the walk. This idea, which can affect an artist such as Smithson, is completely foreign to Richard Serra. Thus Yve-Alain Bois writes, "It is to this narrative conception of discontinuity that Serra opposes himself, and it is this, more than anything else, that separates him from the picturesque." (Yve-Alain Bois, "Promenade autour de Clara Clara," op. cit., p. 22.)

16. "This blatant disregard for aesthetic categories is nowhere more apparent than in the reciprocity which allegory proposes between the visual and the verbal: words are often treated as purely visual phenomena, while visual images are offered as script to be deciphered." (Craig Owens, "The Allegorical Impulse: Toward a Theory of Postmodernism," *October* #12 [spring 1980], p. 74.)

Robert Smithson, *Meandering Island*, Little Fort Island, Maine, 1971.
Pencil, 18-5/8 x 23-5/8 inches. Estate of Robert Smithson.
Photograph by Nathan Rabin. Earthwork project on two tiny islands purchased by Smithson in 1971 which recalls the Indian serpent-shaped tumuli found in Ohio. Courtesy of the John Weber Gallery.

17. Claude Lévi-Strauss, *The Savage Mind*, op. cit., p. 263; also cited in Robert Smithson, "Incidents of Mirror-Travel in the Yucatan," *The Writings of Robert Smithson*, op. cit., p. 94. For Lévi-Strauss, the resulting images give different views of the same room each time, but they constitute a

whole characterized by "unvarying properties forming a truth." All things considered, it is unclear whether Smithson's work represents an appropriation of this concept of Lévi-Strauss's as well.

18. "Although Smithson refers to the first meeting of Mayans and Spaniards in 1517, he does not mention that the word 'yucatan' is a variation of Mayan for 'I don't understand.' When asked by the Spanish the name of the place, the

*The Turtle at Waukesha* with detail of *Turtle Mound*, in *The Antiquities of Wisconsin* (*Smithsonian Contribution of Knowledge*, VII, 1855).

Mayans responded that they didn't understand the question. Their response, misunderstood by the Spaniards, became the name for the land, and this mutual noncomprehension provides an underlying meaning of Smithson's mirror displacements that are reflections of incomprehensibility." (Robert Hobbs, *Robert Smithson: Sculpture*, op. cit., p. 153.)

19. Robert Smithson, "Incidents of Mirror-Travel in the Yucatan," op. cit., p. 95.

20. On this, see John White, *The Birth and Rebirth of Pictorial Space* (London: Faber and Faber, 1959); Hubert Damisch, *La Théorie du nuage* (Paris: Seuil, 1972), pp. 166–171; *L'Origine de la perspective* (Paris: Flammarion, 1987); Giulio Carlo Argan, *L'Architecture de Brunelleschi et les origines de la théorie perspective au XVe siècle*; and Rudolf Wittkower, *Perspective et Histoire au Quattrocento*, translated from the Italian by Jean-Jacques Le Quilleuc, Marc Perelman, and Fra Marcello (Paris: édition de la

Passion, 1990), pp. 24–26, in which Argan shows that this system of representation belongs to an architect's reasoning.

21. Robert Smithson, "Incidents of Mirror-Travel in the Yucatan," op. cit., p. 100.

22. Uvedale Price, *Essays on the Picturesque* (London: printed for J. Mawman, 1810), p. 84.

*Ancient Works at Pike Lake*, woodcut in *The Antiquities of Wisconsin*, op. cit. This book, discovered in an antique bookshop by Michael Heizer's wife, contains a series of fifty-five woodcuts from the nineteenth century by the author, I.A. Lapham, an engineer who completed a systematic study of the ancient Indian tumuli in Wisconsin, which by now have disappeared. The discovery and study of this book was of considerable importance to Michael Heizer in his creation of *Effigy Tumuli*.

23. Robert Smithson, "Frederick Law Olmsted and the Dialectical Landscape," op. cit., p. 119.

24. Ibidem.

25. There is an interesting comparison between Smithson and Sonfist in Marc Rosenthal, "Some Attitudes of Earth Art: From Competition to Adoration," *Art in the Land, a Critical Anthology of Environmental Art*, Alan Sonfist ed., op. cit., pp. 68–72.

26. Robert Smithson, *The Writings of Robert Smithson*, op. cit., p. 127.

27. Richard Long, "Entretien avec Claude Gintz," op. cit., p. 7.

28. See Robert Hobbs, *Robert Smithson: Sculpture*, op. cit., p. 176.

29. *Partially Buried Woodshed*, June 1970. See chapter 2.

30. Robert Smithson, *The Writings of Robert Smithson*, op. cit., p. 174.

31. See Yve-Alain Bois, "Promenade autour de Clara-Clara," op. cit., p. 26, which assimilates Serra's work into

the category of the sublime picturesque in discussing these distinctions.

32. G.W.F. Hegel, *Aesthetics*, vol. I, op. cit., pp. 372–373.

33. John Beardsley, *Earthworks and Beyond, Contemporary Art in the Landscape*, op. cit., p. 62.

34. Immanuel Kant, *Critique of Judgement*, translation by J.H. Bernard (New York: Hafner Press, and London: Collier MacMillan, 1951), p. 86. See, for example, how Louis Marin uses this category to discuss Poussin's painting: "The classic sublime: the 'tempests' in several Poussin landscapes" (Louis Marin, *Lire le paysage, Lire les paysages* [C.I.E.R.C.: Saint-Etienne, 1984], p. 201.) According to Jean-François Lyotard, the irrepresentable or unpresentable characterizes all of "postmodernism." Thus, writes Lyotard, "the postmodern would be that which, in the modern, puts the unpresentable in the presentation itself; that which rejects the comfort of formal conventions; that which researches new presentations, not to possess them, but to better show that something unpresentable is there." (Jean-François Lyotard, *Le Postmoderne expliqué aux enfants* [Paris: éditions Galilée, 1986], p. 33.)

35. Rather than the image of the sublime, one can speak of a sublime image, defined by Jean-Marie Schaeffer as erratic and floating, "undecidable under our gaze, keeping our gaze at a distance because the sublime image shows itself to be resistant to all introspection." (Jean-Marie Schaeffer, *L'Image précaire*, op. cit., pp. 169–170.)

36. Kirk Varnadoe, "Contemporary Explorations," *Primitivism in 20th Century Art*, edited by William Rubin (New York: The Museum of Modern Art), vol. II, p. 662.

37. Lucy R. Lippard, *Overlay, Contemporary Art and the Art of Prehistory*, op. cit., p. 4. Also see the well-known work by Anton Ehrenzweig, *The Hidden Order of Art*, which Smithson cites.

38. Robert Morris, "Interview with Robert Morris," op. cit.

39. Edward Fry, "Introduction," *Robert Morris/Projects* (Philadelphia: Philadelphia Institute of Contemporary Art, 1974), not paginated.

40. Janet Saad-Cook, "Touching the Sky: Conversations with Four Contemporary Artists," *Archeoastronomy* (January 1987), p. 122.

41. The expression belongs to Carlo Severi.

42. On the specifics, see Michael Heizer, *Effigy Tumuli, the Reemergence of Ancient Mound Building*, with an essay by Douglas C. McGill (New York: Harry N. Abrams, 1990).

# THE LIMITS OF REPRESENTATION

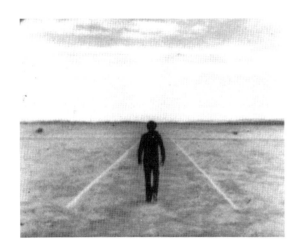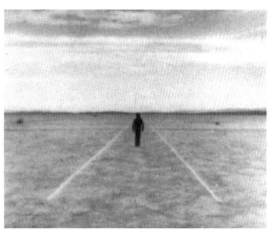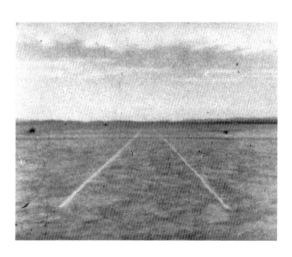

Walter De Maria, frames from the film *Two Lines, Three Circles in the Desert*, Mojave Desert, California, March 1969.
4 minutes 46 seconds. Rights reserved.

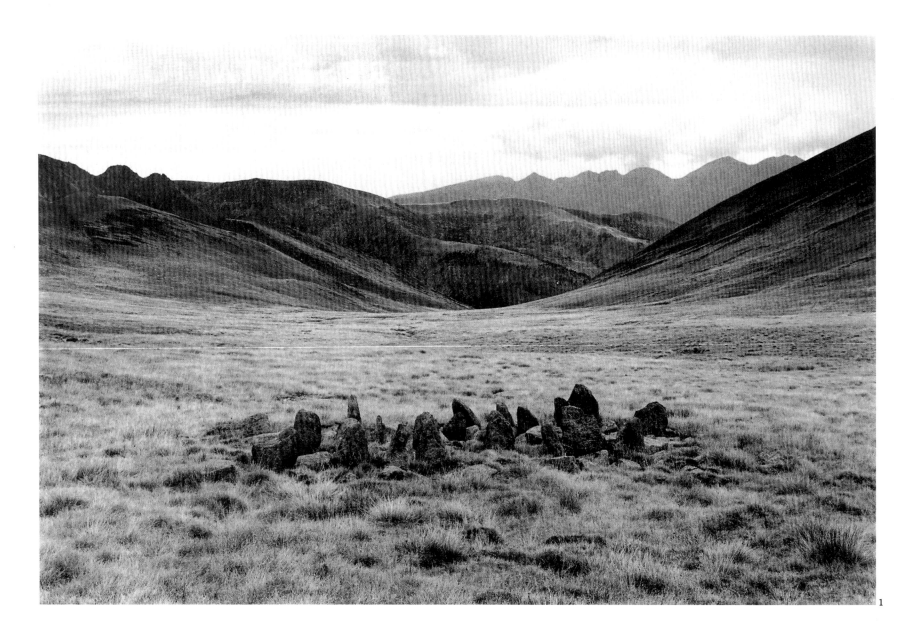

STONES IN PYRENEES

FRANCE 1986

Land Art works demonstrate what André Breton calls a *"discours sur le peu de réalité,"* or what critics such as Lucy Lippard have called the dematerialization of art. Even if these works can be considered conceptual—which they are in the general sense, but without actually making reference to so-called "conceptual art"—they nonetheless possess a physical reality, often an extremely imposing one. For this reason, critics see Land Art works as art of contradiction. Although at first, the Land Art artists fled the museums and galleries, claiming a desire to escape from the market system, this was only to return to these spaces—albeit through another door—to exhibit photographs and various other documentation related to their works.[1] Furthermore, their enormous "sculptures," which require a real experience of space, have been reduced to two-dimensional images because of their remote locations. The works of Richard Long are slightly more logical; he creates works based on easily manipulable materials found on the site, rather than constructing gigantic monuments that require extremely heavy equipment and means disproportionate to the results—or to the effects finally obtained.

Those who follow this reasoning display a traditional view of sculpture. They believe they do not have to alter their aesthetic habits in order to perceive these works, whose originality they do recognize. They thus transfer their own artistic prejudices onto these objects, whose mode of existence they feel should contradict the basic conditions that actually governed their creation. In truth, for those Land Art works that still exist, it is important to remember the words of Michael Heizer, who once said, "Many people complain that no one will see these works because they are too far away, but somehow people manage

1 Richard Long, *Stones in the Pyrenees*, France, 1986. Rights reserved.

2 Richard Long, *A Line Made by Walking*, England, 1967. Courtesy of the Anthony d'Offay Gallery, London.

to get to Europe every year....You don't complain that you'll never see the Gizeh pyramid because it's half way around the world in the middle of Egypt, you just go and look at it."[2] Heizer's work is certainly as worthy of such a journey. According to Heizer, more people have gone to see *Double Negative* than one might think; in general, it is not difficult to visit the various Land Art sites throughout the United States.

Having said this, it is important to stress that the photographic images of these works do not have a uniquely documentary function. Although they may be used by default—by Heizer, Morris, and Nancy Holt in particular—this does not mean these artists consider them only as such, nor that others will not put them to quite different uses. Nancy Holt clearly explains at the end of her text on *Sun Tunnels* that the photograph is not only a substitute for the work, but also an enticement to visit the site,[3] and Heizer has said that for him, photography has the function of a memory aid and that it is thus only a "residue" whose use he must control, for fear of seeing magazines making it into an "exotic"[4] material, both artists have made varied use of photography (in fact, Nancy Holt was initially a photographer).[5] For other artists, such as Richard Long, photographs constitute the bulk of what is exhibited. As Nancy Foote says of Long and Fulton, "With both artists, the act of photography is as much a part of the work as the resulting images. In Long's case, it determines the conceptual structure of the piece; with Fulton, it enables him to 'charge' the landscape aesthetically."[6] In the figurative divide between the photographs of the installation of Christo's ephemeral *Running Fence*, and the photographs of Heizer's *Complex 1*, there lies a wide range of images conveying varying attitudes toward photography,

**1, 2** Richard Long, *Hilltop Stones*, Bolivia, 1981.
Diptych, 34-3/4 x 99-1/4 inches. Capc, musée d'Art contemporain, Bordeaux.

2

from "primary information," which reduces the work purely to its photographic image (and thus a catalog can constitute the art itself), to "secondary information," which implies the physical presence of the object in one manner or another, to use Seth Siglaub's distinction as quoted by Nancy Foote.[7] Regardless, the significant use of photography allowed Rosalind Krauss, making reference to the art situation during the 1960s, to speak of a "logic of the index."[8] According to Krauss, although Duchamp was the originator of this logic, its name is borrowed from Pierce. Krauss writes, "By index, I mean that type of sign which arises as the physical manifestation of a cause, of which traces, imprints, and clues are examples."[9] This conception goes against the idea that photographic representation is exclusively within the category of resemblance (icon) or of simple convention (symbol), since, as an index, it demonstrates a relationship of physical contiguity between the sign and its referent.[10] Philippe Dubois, elaborating on Krauss's argument, shows the importance of photography not only as a way to remember works of art, but also as an integral part of a project. This is true for the images of Richard Long's work, as Long "is careful to photograph his constructions according to the principle of a rigorously perspectival and axial view."[11] This is also the case for Walter De Maria, whose work *Lightning Field* reaches its artistic apogee at the moment when lightning strikes it; only photography can testify to this event.

The use of photography also has to do with these artists' fascination with the instant, conceived as both the ultimate expression of movement and as a possible jump outside of time, as if it were an opening through which atemporality could be attained. Yet the contrary is also true; photography is presented as a privileged medium that allows artists an experience of the temporal dimension of art, something which artists like to explore. There is certainly no limitation constraining them to use photography; it is even used thematically in more conceptual works, such as those by Smithson and Dibbets.

For these artists, photography has served as an instrument to question reality and the conventions we use to represent it: that is to say, simultaneously its indicatory dimension and its status as an icon. As Pierre Bordieu writes, "…photography is a conventional system which expresses space in terms of the laws of perspective (or rather of one perspective) and volumes and colors in terms of variations between black and white….And if [photography] has immediately presented itself with all the appearance of a 'symbolic communication without syntax,' in short a 'natural

Richard Long, *Stones in Nepal*, 1975.

STONES IN NEPAL

1975

language,' this is especially so because the selection which it makes from the visible world is logically perfectly in keeping with the representation of the world which has dominated Europe since the quattrocento."[12] Thus photography merely renews the perspectival illusionism of the Renaissance.

But if perspective produces an illusory space in which all lines converge to a point, ordering volumes according to their size and their degree of distance on the visual pyramid, this is not to create belief in a real presence, but to show the rationality of the world thus depicted using new, mathematically calculated rules. All of space should obey the laws of Euclidean geometry: continuous and homogeneous, infinite in theory, yet practically enclosed in the interior of the imaginary cube that the eye visualizes. If the concept of spatial realism has meaning, this meaning is neither unique nor identical throughout all periods of history; what one saw as real in the Renaissance, in retrospect is nothing but an abstract schema conveying a certain conception of the universe. As Francastel has shown, at that moment in history, "the new plastic space was real insofar as the people in the quattrocento associated fragments of the imaginary universe in which they lived with a new operative vision."[13] But the artists of Smithson's generation have a different conception of the universe, and the spaces explored by cubism, as well as the spaces deduced from non-Euclidean geometries, are not less "natural" to us than those proposed by the Albertian system of perspective.

The traditional space of sculpture is also a Euclidean space, as the object depends on the architectural setting in which it is found. Outdoor sculptures do exist, but they are placed in sites whose order they create or determine, sites which are organized based on them. As we have

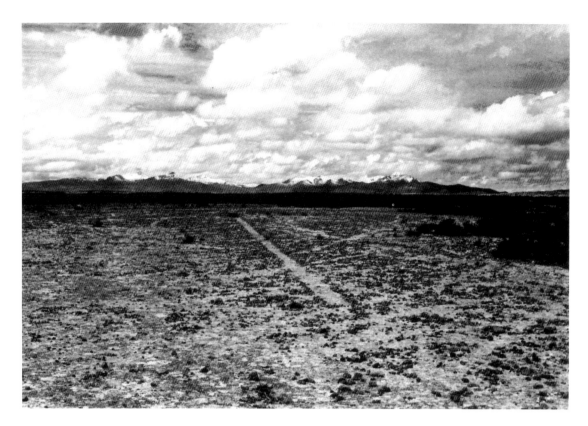

# A LINE AND TRACKS IN BOLIVIA
## 1981

Richard Long, *A Line and Tracks in Bolivia*, 1981.
34-5/8 x 48-4/8 inches. Courtesy of the Anthony d'Offay Gallery, London.

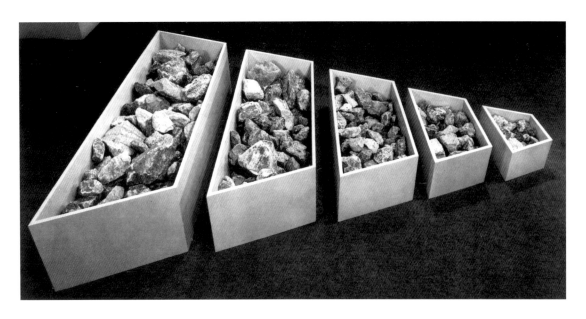

Robert Smithson, *A Nonsite, Franklin, New Jersey*, 1968.
Wood, limestone, 16-1/2 x 82 x 110 inches. Courtesy of the John
Weber Gallery, New York.

seen, modern sculpture radically diverges from this situation; the monument has become a pure signifier referring only to itself. In his text on "specific objects" dating from 1965, Donald Judd declared that all painting was "spatial," or rather, illusionistic, "except for a complete and unvaried [visual] field of color or marks," that is, when the field is lacking depth. For example, Judd states, "Pollock's paint is obviously on the canvas, and the space is mainly that made by any marks on a surface, so that it is not very descriptive and illusionistic." He continues, "Three dimensions are real space. That gets rid of the problem of illusionism and of literal space...which is riddance of one of the salient and most objectional relics of European art."[14] As Jean-Marc Poinsot has remarked, this may have rather quickly identified real space with the space of galleries and museums, whose spaces are typically based on the rules of classical linear perspective.[15]

It is within the context of these theories that the ideas and works of the American Land Art artists developed; for them, minimalism was the dominant artistic context. Ultimately, they completely dissociated the space of a work's reception from its "axiomatic space." In Smithson's text, "A

Tour of the Monuments of Passaic, New Jersey," the site appears as a sort of mirage, and we do not know if it is a pure projection of the mind or if it is the opposite: if it is we who are transformed by it. The past and the future come together, in an evanescent place that disrupts the spatial reference points we use to measure time. The site is no longer intelligible as such; it has become an illusory space insofar as its form is reversible, which is why Smithson attempts to make this "mirror" movement perceptible, by splitting up one space into two places that he calls "sites" and "nonsites."

But the question remains, what does one see? Typically, one sees a nonsite whose entire function seems to be to designate the site, to signify it in some sense. Yet the sites, composed of earth and organic material, are not unchangeable. While there are the *abschattungen*—the contours or the outlines —of what seems to be an inalterable essence, a work in itself, there is also the sedimentation of a process whose completion is a part of its own deterioration. And while there are glimpses of a *ciel*, or in any case, an *espace*, intelligible, there is still matter destined to undergo change. If time "works for the artist," this is not because time begins to erode the work, but because time decomposes the work at the same moment that the artist creates it. Its space of visibility is entirely within this distortion, within this discrepancy; the illusion is to believe that it constitutes a real place. When one visits *Spiral Jetty* today, one sees nothing—except from a helicopter, where its dark mass appears to be sleeping under the waters of the lake. Traces remain which themselves become nonsites. But one can also imagine the traces of these traces, such that step by step, a chain of signifiers is constructed whose signified can no longer be found. Artists like Smithson attempt to explore this paradox inherent on all of Land Art.

The issue in question is the limits of representation, or rather, the conditions that make representation possible. The nonsite does not represent the site, nor does it truly signify the site; instead it refers back to a multiform, evanescent reality, one which in return, contaminates the nature itself of the nonsite. It is as if, in a vertically cut space, art had no other possibilities than to channel the ebb and flow of time, creating sites where there was nothing, transforming places and landscapes as a simple sign of the supposed presence of these sites. In fact, as we have seen, it is the concept of the site itself which is transformed. The issue is no longer the space of reception for a work of sculpture (as in the traditional space of representation), or an uncertain space recomposed around an autonomous work (as in the realm of modern sculpture); it is how the site itself constitutes the work.

For Smithson, prior to the construction of his first earthwork in 1970,[16] photography is a manner of questioning reality. In other words, photography's iconic characteristics as well as its function as an index are called into question, since it is the status of the referent itself that is examined. In "A Tour of the Monuments of Passaic," Smithson photographed remains of industrial installations that he parodied by calling monuments. But since their monumentality is only evident through the text and, especially the photographs, it is the latter that become "monumental." The site that Smithson explores becomes a gigantic photograph: "Photographing it with my Instamatic 400 was like photographing a photograph."[17] Commenting on this passage, Craig Owens writes, "If reality itself appears to be already constituted as image, then the hierarchy of object and representation—the first being the source of the authority and prestige of the second—

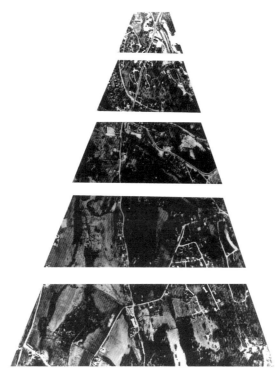

Robert Smithson, *A Nonsite, Franklin, New Jersey*, 1968 (aerial map).
Courtesy of the John Weber Gallery, New York.

is collapsed. The representation can no longer be grounded, as Husserl wanted, in presence. For Smithson, the real assumes the contingency traditionally ascribed to the copy; the landscape appeared to him, not as Nature, but as a 'particular kind of heliotypy.'"[18] Photography plays the same role for the nonsites as maps, containers, texts, or any other type of document do. It also questions perspective space. In *A Nonsite, Franklin, New Jersey*, for example, the aerial photographs that reproduce the trapezoidal structure of the five containers are organized in such a way that the lines extending from their edges converge towards an invisible vanishing point. For the vanishing point to be perceived, one must visit the site, the place from which the ore samples originate. In addition, two systems of representation (zenith and perspectival) are superimposed, and their point of convergence designates an elsewhere—reality itself—which is not actually ever there.[19] Alberto Velasco, who described and analyzed this work in detail, writes that "the indexical truth of photography is here very cleverly smashed to pieces,"[20] as is its iconic structure (which he neglects to mention).

All the Land Art artists play with conventions governing perspective vision, even if they do not all question it as radically as Smithson does. In 1968, Heizer photographed his early works, *Rift, Dissipate*, and *Compression Line*, in such a way as to considerably increase the depth of field (he reduced the portion of sky to take up only one-fifth of the image). In these photographs, scale is entirely lost. It is impossible to determine the true size of what is shown, as the angle of the shot suggests an unlimited expanse. Heizer found this style of composition to be indispensable in emphasizing the importance of these spaces and how they had been marked by art. During this period, he was unable to

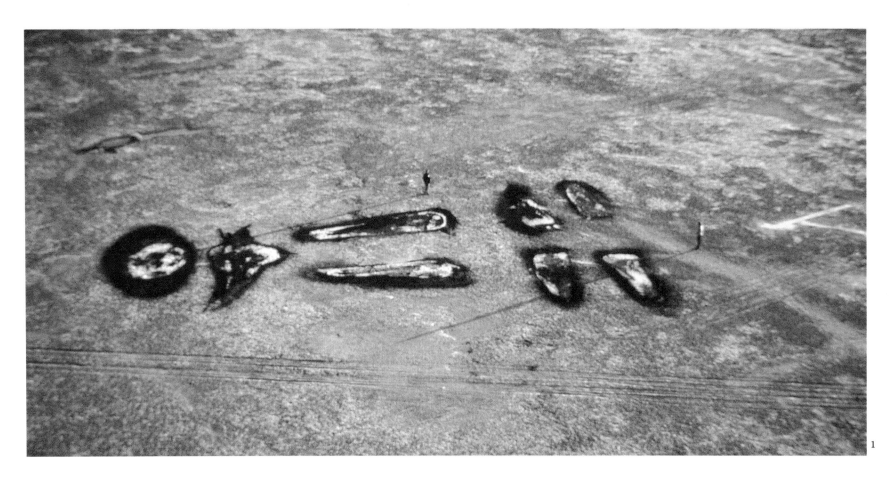

1

1 Michael Heizer, *Primitive Dye Painting 1*, Coyote Dry Lake, Mojave Desert, California, 1969 (deteriorated).
Aniline dye and lime powder on the bottom of a dried-up lake, area of 45 x 75 feet. Photograph by Michael Heizer.

2, 3, 4 Michael Heizer, *Primitive Dye Painting 1*, 1969 (detail).
Photographs by Michael Heizer.

construct most of the works he had conceived, and therefore he compensated by creating photographic equivalents. Long is content to use photography as an imaging device, since, unlike Heizer,[21] he never cuts into or marks the ground with instruments or machines. The traces that he leaves on the landscape are always those of his body, as in one of his first works (*A Line Made by Walking*, 1967) in which he walked back and forth along an imaginary line until he left the mark of his footsteps, or his moving of stones, assembling them in a line or a circle. From this point of view, Long is more of a classic artist, who shares his contemporaries' similar sensibilities to time, to obsolescence, and to the simple beauty of natural materials. During the same period, Heizer took photographs from a helicopter of some of his drawings on the ground, such as *Primitive Dye Painting* (1969), *Isolated Mass/Circumflex* (1968), and later, *Circular Surface Planar Displacement Drawing*

(1970), drawings that were created by two motorcycles turning like compasses around a central point to which they were attached by a rope. Heizer created a model of this work in 1972, etching it into the sidewalk in front of Sam Wagstaff's house in New York. For Heizer, photography is also a construction technique, similar to drawings or sketches. Thus the photographs of the site published in *Effigy Tumuli* show "mounted" panoramas—a series of photographs assembled side by side so as to follow the contours of the landscape. This technique gives the work the appearance of a book of photographic sketches, and relativizes the majestic effects of the panorama while emphasizing the analytic nature of the resulting image. Heizer used this same technique to photograph *Double Negative* and the interior of *Munich Depression: Munich Rotary Interior*.

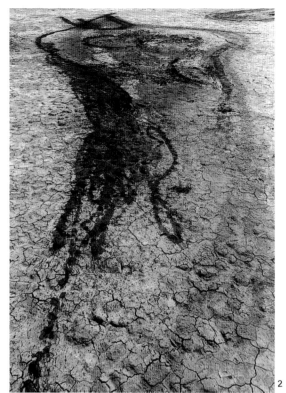

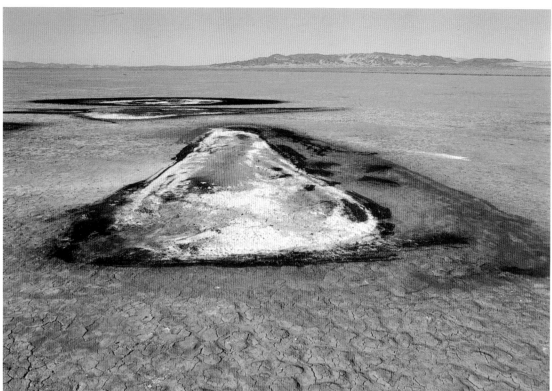

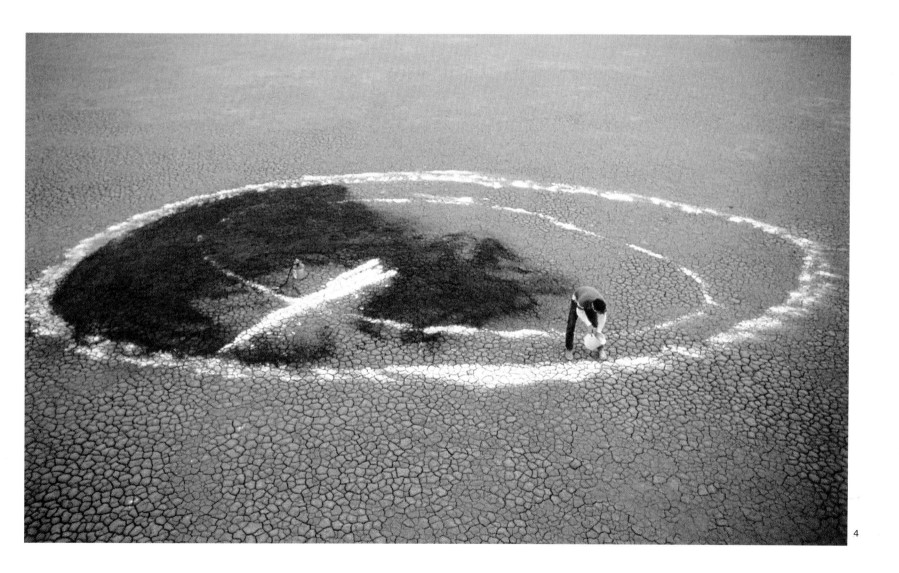

**1** Michael Heizer, *Isolated Mass/Circumflex*, Massacre Dry Lake, Vyo, Nevada, 1968 (deteriorated; *Nine Nevada Depressions 9*).
Six-ton displacement on the bottom of a dried-up lake, 120 x 12 x 1 feet. Commissioned by Robert Scull.
Photograph by Michael Heizer.

**2** Michael Heizer, *Rift*, Jean Dry Lake, Nevada (deteriorated; *Nine Nevada Depressions 1*).
One-and-one-half-ton displacement on the bottom of a dried-up lake, 52 x 1.5 x 1 feet. Commissioned by
Robert Scull. Photograph by Michael Heizer.

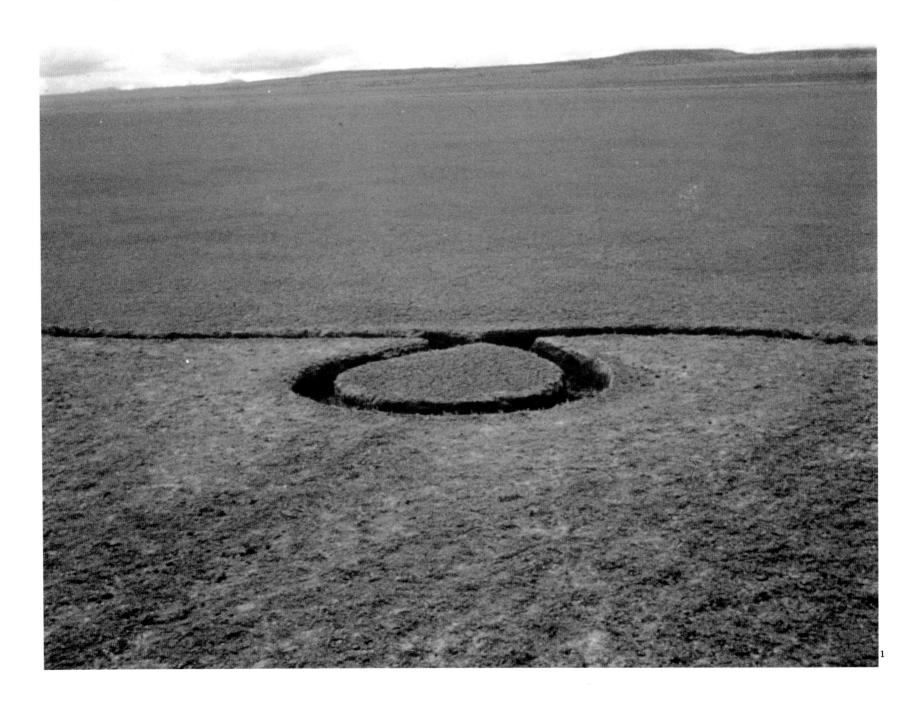

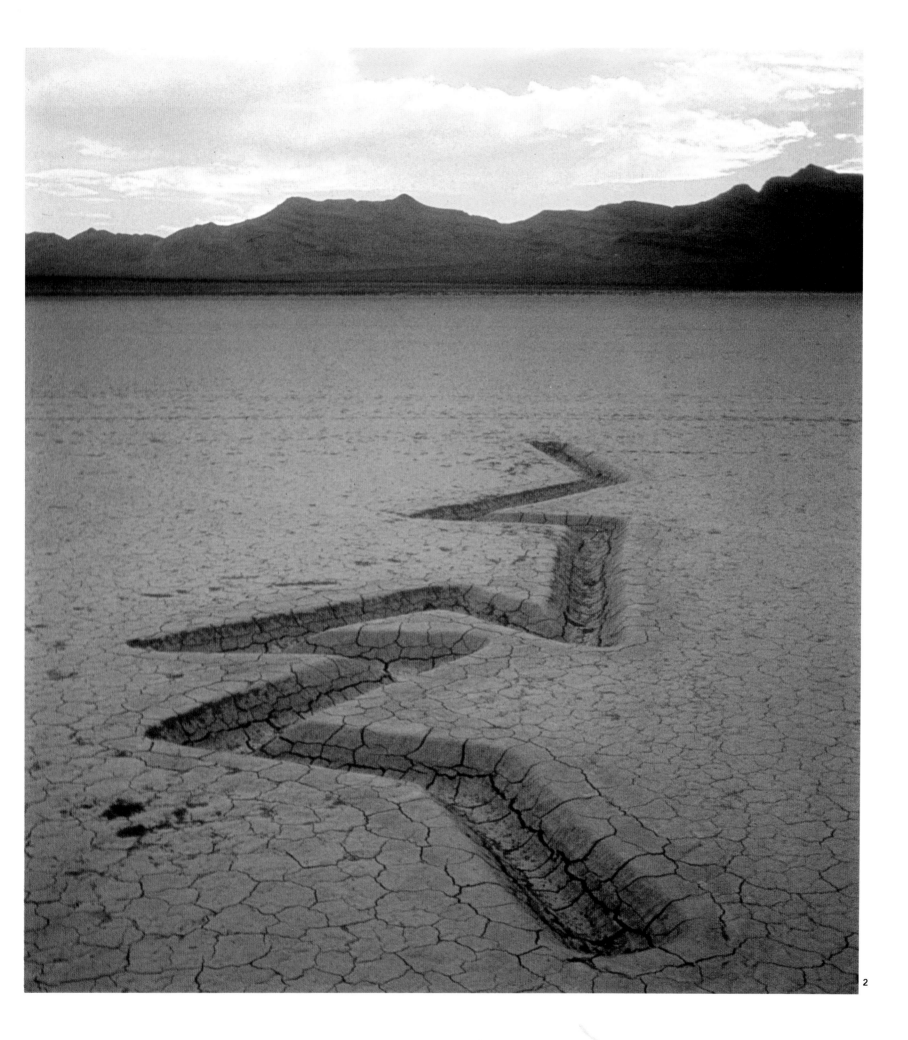

2

1 Michael Heizer, *Circular Surface Displacement Etching*, 1972.
Etching in a basalt block on a New York sidewalk.

2 Michael Heizer, *Circular Surface Planar Displacement Drawing*,
Jean Dry Lake, Nevada, 1970 (during creation).
Photograph by Michael Heizer.

3 Michael Heizer, *Circular Surface Planar Displacement Drawing*,
Jean Dry Lake, Nevada, 1970 (detail).
Earth, area of 900 x 500 feet. Photograph by Gianfranco Gorgoni.

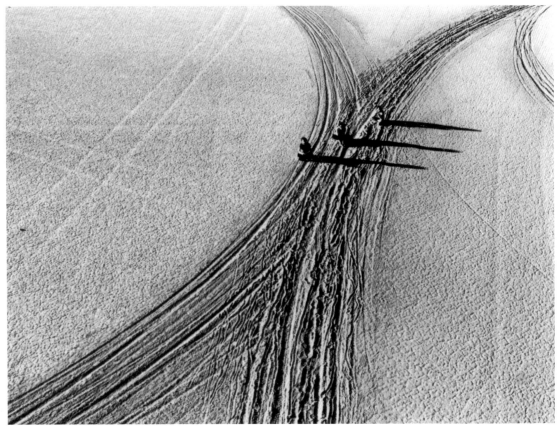

Michael Heizer, *Circular Surface Planar Displacement Drawing*, Jean Dry Lake, Nevada, 1970 (deteriorated).
Tire tracks on the flat surface of a dried-up lake, 900 x 500 feet. Collection of Sam Wagstaff. Photograph by Gianfranco Gorgoni.

**1** Michael Heizer, *Double Negative*, Mormon Mesa, Overton, Nevada, 1969–1970.
Suspended from a crane by a cable, Michael Heizer took a series of photographs of the bottom and the interior walls of *Double Negative*. By lining up these photographs end to end, he created a topographic representation—almost an x-ray—of the work. Its abstracted contours are outlined by the surrounding landscape.
**1, 2** Photographs by Michael Heizer.
**3** Photograph by Gianfranco Gorgoni.

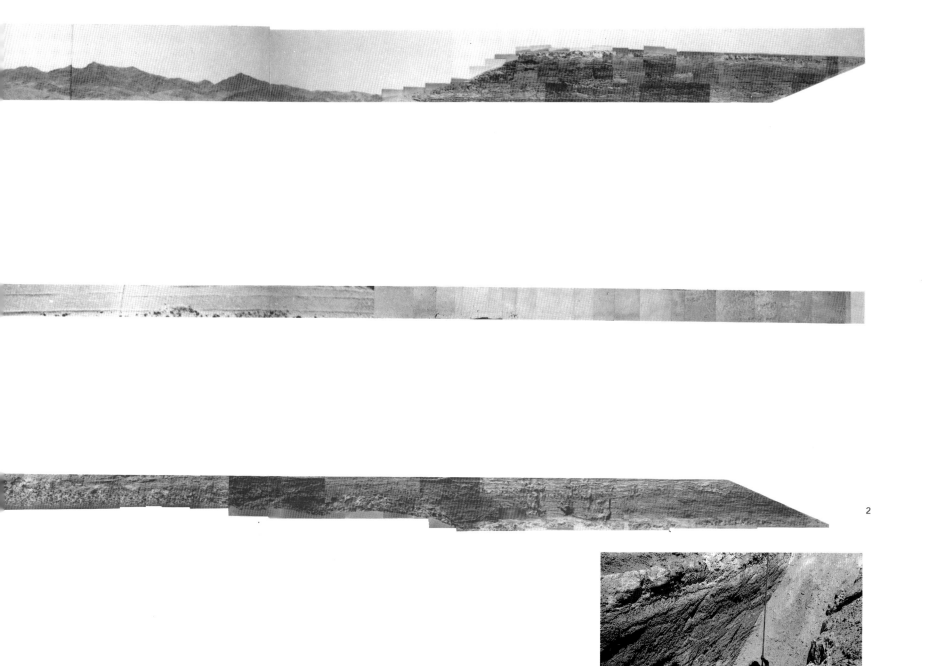

2

3

**1** Jan Dibbets, *Perspective Correction, Horizontal Vertical Cross,* 1968.
Black and white photographs and pencil on paper, 19-5/8 x 25-5/8 inches. Private collection. Courtesy of Jan Dibbets.

**2** Jan Dibbets, *Construction of a Wood*, 1969.
Courtesy of Jan Dibbets.

**3** Paolo Uccello, *The Hunt*, c.1470.
Oxford, Ashmolean Museum.

## AN ESSAY ON LANDSCAPE

*I should now indicate some methods by which you may execute the same design in your grounds, and ascertain the possibility of producing the same effect there: making allowance for the local disposition of the objects, their distance, their respective proportions, and the use of the manual labour. You must place yourself in the same spot where the drawing was made in order to realize it. From thence the principal objects to be arranged will be:*

*1st, The masses of wood, whether forest-trees, or copse, which are to form the* side scenes *in the perspective of your picture. In order to mark the place of these* side scenes, *you need only set up a few stakes, with a piece of white cloth affixed, at each projecting point, the height of which should be in proportion to the general perspective.*

*2dly, As it is very difficult to copy in nature the effect expressed by the picture, the forms and angles, the different superficies and projections of the buildings, instead of puzzling yourself with*

*mathematical plans, which mere workmen would not comprehend, because this sort of building is to be picturesque; instead of employing your carpenters to trace, with much labour, the ground plan of the work; it would be much better that they should represent the elevation with laths or rods; describing the angles, the strait lines, and projecting parts of the roof. This operation will make it much more easy for you to rectify and fix the lengths, and heights, and principal lines, essential to the effect of the construction; if it is to be seen from a distance, you would do well, for greater security, to spread over this scaffolding some cloth of the same colour as the building in the picture: by this means, long before you begin to build, you may combine your buildings, and assure yourself of their success relative to the different points where they are to be seen, with regard to their elevation, angles, their different fronts, and projection of their roofs. You will by this means be able to judge whether they accord with the surrounding objects, and what are the proper materials to make use of, in order to give the effect that you may wish; and finally, this method will make the construction much more easy to all the workmen, because they will have before their eyes a model of the intended building, which will determine every part of the work.*

*3dly, Nothing being more uncertain than the theory of perspective with regard to level surfaces; whenever you have the least doubt whether you shall be able to see from your house a piece of water, for example, after it is brought into the situation ascribed to it in the picture, do not hesitate to spread some white cloth on the ground, of the same form and extent that is expressed in the plan, and in the same spot where the water is to be conducted; for it is of importance that you should succeed in so costly an undertaking as altering the course of water.*

René Louis de Girardin, *An Essay on Landscape* (London: J. Dodsley, 1783), reprinted in *The English Landscape Garden* (New York and London: Garland Publishing, Inc., 1982), pp. 29–33.

Jan Dibbets's first "perspective corrections" date from 1967, when he was attending St. Martin's School of Art in London. Until that time he had completed only a few works and was still seeking direction. According to Rudi Fuchs, he created about forty of these corrections, both inside and outside his studio. The principle of the perspective corrections is simple: it consists of invalidating the illusion of perspective created by the photographic construction, while creating another illusion which suggests that the square visible in the photograph is not *in* the image but superimposed on it. One must look closely to understand that the sides of the square are parallel to the edges of the photograph because of lines created on the ground (generally with white string) which, seen from above, would take on the shape of a trapezoid whose longest side is actually the farthest away from the camera. The correction of one illusion produces another illusion (since one quickly perceives that these lines are not drawn on top of the photograph), so that one is led to deconstruct the conventions which lead us to believe in an absence of depth. This recalls the work of Piero della Francesca, whose fresco series, *The Legend of the Cross*, obliges us to examine it closely, in order to understand how he has constructed the space within it.[22] "The illusionistic space, which is the natural space of photography, is thus eliminated: it is as if space is being pushed forward, almost out of the image," writes Rudi Fuchs.[23] Between 1968 and 1971, Jan Dibbets participated in many of Gerry Schum's films for the Fernseh Gallery, including *12 Hours Tide Objects With Correction of Perspective*. In this film, the beach and the sea are initially viewed from the height of a dune. There is the sound of the waves and the cries of birds. Then a tractor enters the frame from the left. The sound of the motor can be

ENGLAND
1967

2

**1** Richard Long, *England*, 1967.
Photograph, 48-3/4 x 34-5/8 inches. Rights reserved.

**2** Jan Dibbets, *Perspective Correction*, 1968 (square with two diagonals).
Black and white photograph on canvas, 47-1/4 x 47-1/4 inches. Collection of Gian Enzo Sperone, Rome.
Courtesy of Jan Dibbets.
Jan Dibbets's perspective corrections experiment with the optical construction of space inherited from
the Renaissance. These interior and exterior works were created between 1967 and 1969, usually using
string stretched over the ground to form squares or rectangles.

heard clearly. The tractor continues on a course parallel to the edge of the screen, constructing a corrected perspective, which slowly materializes on the beach in front of our eyes. The rising tide at the end of the film erases the lines in the sand, as if nature itself helped reconstruct the optical conventions that the camera lens forces us to see, those which the artist worked at destroying. The simplicity and the efficacity of the demonstration (as well as its humorous tone) make this—along with the films of De Maria and Flanagan—the most radical film of the series. De Maria's *Two Lines Three Circles in the Desert*, also filmed by Gerry Schum, plays with perspective to show it as moving away from representation.[24] At the beginning of the film, the camera is fixed in one spot; the deserted landscape is framed in such a way that the horizon line divides the screen in half. Two parallel lines drawn in chalk converge towards the horizon. In the center of the lines, a man (De Maria) walks, filmed from the back. When he has gone a few steps, the camera slowly turns in a circle on its axis. When it has revolved 360 degrees and we return to the same image, the man is already far away; by the second camera revolution, he is only a point on the horizon, and when the camera completes its third revolution he has disappeared completely. The walk itself has lasted the length of the film. The man is merely the subject of a fiction, and as if reinforcing the illusory nature of fiction, even the man—the subject itself—disappears, ceases to exist. The art of the 1960s is an art that evolves within an "antihumanist" context.[25] In using the device of perspective, which was contemporaneous with the beginnings of renascent humanism, De Maria somehow turns it against itself. In this type of construction where the point of view corresponds to the vanishing point, De Maria's film shows us how, in passing from one of

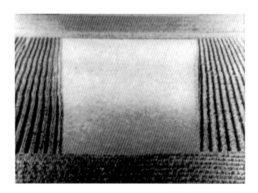

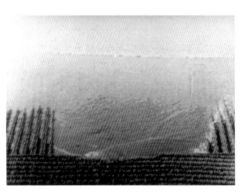

Jan Dibbets, frames from the film *12 Hours Tide Objects with Correction of Perspective*, Dutch coast, February 1969. Seven minutes, thirty-three seconds.

these points to the other, humanity has exited from the art scene by the same door through which it made its triumphant entry. This process echoes the interest these artists have in cartography. As one scholar has noted, "the mapped view suggests an encompassing of the world, without, however, asserting the order based on human measure that is offered by perspective pictures."[26]

The space claimed by Smithson, Morris, Oppenheim, and the other Land Art artists is no longer a homogeneous and continuous space, which is what we had become accustomed to after four centuries of perspective. In spite of its cubist "deconstruction," the Renaissance model of perspective is still dominant, and it makes us accept this particular type of representation for the realistic image of what we are seeing. Through this model, perspective is a pseudo-truth that these artists attempt to destroy. Photography has weakened this "truth" within the domain of art only in proportion to its capacity to infinitely multiply the points of view that we can have of reality. Thus Smithson wrote that "Cézanne and his contemporaries were forced out of their studio by the photograph.... Photography does make Nature an impossible concept."[27] The illusionistic frame nonetheless remains, even if one multiplies it endlessly, as in his work (*400 Seattle Horizons*, 1969), exhibited in Seattle and subsequently destroyed, which showed four hundred photographs of the coast aligned into a huge rectangle, completely indecipherable.

Smithson does not abandon all formal convention, however—as the reading of certain texts by Rosalind Krauss suggest.[28] With works such as *Untitled* (1963–1964 and 1964–1965), inspired by crystalline structures, he multiplies the vanishing points using a faceted structure:

"*Double Vanishing Point* exists as a solid reversal of traditional illusionistic perspective. Infinite without space." In other words, a point infinitely divisible in itself, which evokes the title of another sculpture, *Pointless Vanishing Point* (1968). This work, like *Leaning Strata* (1968), is apparently inspired by minimalism, but in actuality it breaks with the perceptive evidence that it attempts to impose. Commenting on *Pointless Vanishing Point*, Smithson explains that the "centrifugal theory of vision seems to have returned to modern times in the guise of 'kinesthetic space' or what is sometimes called 'surveyor's space.'" Through this type of space, which is completely unnatural and entirely constructed, one has the illusion of infinity. Smithson adds, "Natural visual space is not infinite. The surveyor imposes his artificial spaces on the landscape he is surveying, and in effect produces perspective projections along the elevations he is mapping. In a very non-illusionistic sense, he is constructing an illusion around himself..." The result could be called a "phenomenotechnique," which turns the so-called reality of a visible landscape into merely an illusion. But this illusion is specific in that it follows the rules of Albertian scenography. Smithson's intention is to negate these rules using purely plastic means, yet without foregoing the commentary of those same means.

Thus, just as a prism analyses light by diffracting it, a mirror structure, in reflecting space, reflects itself and introduces its own power of reflection. Smithson does not use mirrors to give the illusion of an anisotropic space, but rather to show the process of production of this space by means of a "critical reflection," in both the optical and intellectual sense. This type of sculpture is not simply placed in space; it is the pure product of the differentiation of space's internal limits. It becomes the limit of one space by another space.

Walter De Maria, frame from the film *Two Lines, Three Circles on the Desert*, Mojave Desert, California, March 1969. Four minutes, forty-six seconds. Rights reserved.

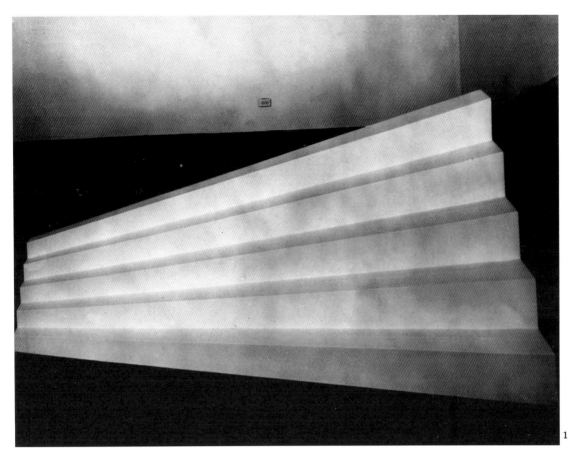

In *Enantiomorphic Chambers*, Robert Smithson uses the same deconstruction, but reverses the point of view, in a sense. This time the spectator moves to the other side— to the center of the device—and sees only reflections of reflections, which are dispersed and thus prohibit stereoscopic vision. That is to say, they prevent the formation of a single image. Smithson writes, "It is as though one were being imprisoned by the actual structure of two alien eyes. It is an illusion without an illusion."[29] And, in effect, this illusion is produced by the spectator himself, as if he could not accept what he really saw and instead had to preserve the illusion of something he did not see. Thus, Smithson writes, "to see one's own sight means visible blindness."

Maps, photographs, films for television and cinema, and three-dimensional objects are ways in which these artists explore the conventions of perspective space as a means to better subvert them. In deconstructing space, they modify the temporal dimension of the work. As we have seen, the awareness of time as such (which is one of the characteristics of what can be called postmodernism) is constitutive of Land Art, whether it deals with the process of creation or reception, and the (artistic) existence of ephemeral Land Art works relies on photography. Here the logic of the index is evident. Challenging the limits of representation imposed by the rules of Albertian perspective is not new; these rules have been transgressed repeatedly. An artist such as Piero della Francesca even played with them in a "demonstrative" fashion, as Hubert Damisch shows, seeking less "to understand the appearance of things as they allow themselves to be seen, than to show the limits of the validity of a representative device produced by perspective."[30] If Piero della Francesca chose to use

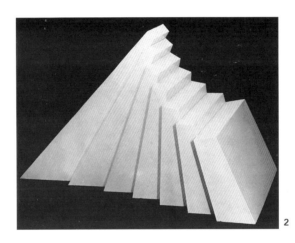

**1** Robert Smithson, *Pointless Vanishing Point*, 1968. Fiberglass, 40 x 40 x 96 inches. Courtesy of the John Weber Gallery, New York.

**2** Robert Smithson, *Leaning Strata*, 1968. Bent metal, flat surface painted white, 49-1/2 x 103 x 30 inches. Courtesy of the John Weber Gallery.

the construction of a central vanishing point, this was to better *"make visible the work of perspective."* The reality of the representation and the distortions imposed by the rules it obeys (distortions which can be understood mathematically) nonetheless correspond to a projective illusion, since it is not easy in the perceptive order to maintain the distinction "between the two languages, that of reality and that of appearance, of truth and of what seems to be true. And in fact this is the paradox of perspective," writes Damisch, "that between the perceptible and the understood the positions can reverse, and that what appears to be a factor of uncertainty in regard to geometry can still be believed, not because of the eye, but because of the intellect."[31] Situating works inside this new conceptual system nonetheless takes the position of the artist and the place of the spectator into account. Time is an integral part of the art, in the cosmic, historical, and geological sense, but also as the amount of time necessary to experience the work. It is only through the latter that the spectator can incorporate all the other forms of time as variations which are conceptually intelligible, yet only their traces, their deposits, their solidified states are actually perceptible. Similarly, the earthworks in the deserts are only generally accessible through what Smithson calls nonsites or through photography.

Let us return once more to photography. Here the problem lies in what can be called the *"mise en tableau"* of the image which reintroduces illusionism, in a certain sense, through forcing the representation back behind the photograph itself, reducing the material surface of the image to the "picture plane [upon which] is projected the spatial continuum which is seen through it and which is understood to contain all the various individual objects."[32] Certainly the

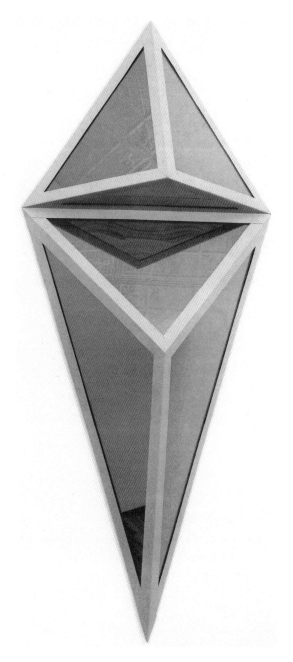

Robert Smithson, *Untitled*, 1964–1965.
Steel, plexiglas, mirror, 78-3/4 x 10 inches. Courtesy of the John Weber Gallery.

distortions are not the same as in painting, nor does photography obey any rules of transformation. But the latter, like the former, imposes a point of view, constructs a frame, and determines an axis that gives it *meaning*. In fact, our relationship to these seemingly inaccessible works of art can be compared to the relationship of the Renaissance elite (who liked to take promenades) to their gardens of that period, organized so as to bring about the best angles of visibility, like a succession of paintings whose effect is to reduce nature to a two-dimensional space.[33] And it is true that the photographic images we have—of works still visible today, as well as for those which can no longer be seen—and which are reproduced in magazines or books are almost always the same, so that there exists what one could call "standards," which eventually become substitutes for the works themselves. Artists are fairly familiar with this phenomenon, and are thus concerned that these images be disseminated under optimal conditions. Smithson, for example—as a number of his drawings testify—gave very specific instructions on how to photograph his earthworks, and Heizer forbade visitors at *Complex City* to photograph his work in any other fashion.[34]

Our relationship to these works could be qualified as an "aesthetic relation of incertitude." When one attempts to experience the (photographic) point of view of one of these works, one loses the perception of space, light, and volume which constitute it. When one attempts to understand the work's internal development through its spatial exploration, one misses what has perhaps become its true localization, which depends either on the optimal point of view determined by the camera lens (which transforms concrete space into "other" space) or, more often, on an optical construction giving a view of the work from

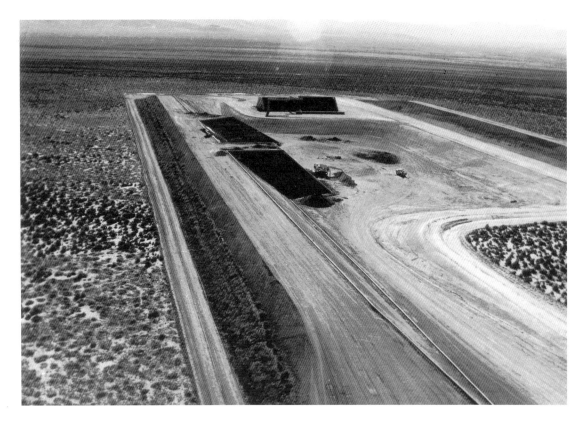

Michael Heizer, *Complex City* (eastern half), Garden Valley, Nevada, 1989 (*Complex I* in background; *Complex II* at left).
Reinforced concrete and compacted earth. Photograph by Michael Heizer. Collection of the artist and of Virginia Dwan.
Dimensions of the elements of the monumental sculpture-city (length x width x height):
*Complex I*: 140 x 110 x 23.5 feet.
*Complex II*: 1087 x 90 x 23.5 feet.
*Complex III*: 680 x 90 x 20 feet.
—Pit, including roads: 942 x 331 x 15.5 feet; baseline: 398 x 243 feet maximum; crestline: 493 x 331 feet maximum.
—Maximum elevation rise from the base of the pit to the top of *Complex II*: 35.5 feet.
—Maximum slope from the base of the pit to the top of *Complex II*: 60.75 feet.

above and thus portraying it as site-sculpture. The reason for this—and this is a complementary aspect of the problem—is that the effect produced by views from an airplane or a helicopter differs radically from the experience that we have walking around these works. These aerial photographs, though they may be few in number, contribute to the creation of the visual standards we are discussing; the images of *Spiral Jetty*—which, as Serra says, is much more *graphic* than volumetric, while appearing, thanks to the film, within the realm of *fiction*—are the best example of this.

Photographs taken from airplanes give us a feeling of floating in space, which can be attributed to the absence of any known reference points familiar to our perception of our place in the world. Malevich illustrated the text of his book *The Non-Objective World* (1927) with aerial photographs, as he was interested in the sensation that could come from speed and flight in the air; Smithson often referred to this

text. Man Ray's *Elevage de poussière*, a photograph taken of Duchamp's *Large Glass*, proposed a landscape aesthetic in which there was obvious loss of scale; this work seduced Smithson, fascinated by what he called "the surd."[35]

Thus the resulting illusion is one which affects our judgements, as Leibniz had already determined. He wrote: "So when we are deceived by a painting our judgements are doubly in error. First, we substitute the cause for the effect, and believe that we immediately see the thing that causes the image, rather like a dog barking at a mirror. For strictly we see only the image, and are affected only by rays of light. Since rays of light need time—however little—to reach us, it is possible that the object should be destroyed during the interval and no longer exist when the light reaches the eye..."[36] This describes perfectly the index-ical nature of photography, while emphasizing the dimension of the past, "l'avoir été," on which Roland Barthes had written.[37] Thus the presence of these works seems as illusory to us as that of a star dead for millennia, whose light still reaches us. *Isolated Mass/Circumflex* (Nevada, 1968) is one of Heizer's most beautiful works; it has long since disappeared but its image is often reproduced. The same is true of Smithson's *Spiral Jetty*, presently submerged under water. This fate, brutally illuminated by the nature itself of Land Art works, is the inescapable eventuality of all works of art, though typically by a much slower process. This aspect is rarely taken into account in the appreciation of artistic phenomena, and it is emphasized by the art historian George Kubler in his book *The Shape of Time*: "However fragmentary its condition, any work of art is actually a portion of arrested happening, or an emanation of past time. It is a graph of an activity, now stilled, but a graph made visible like an astronomical

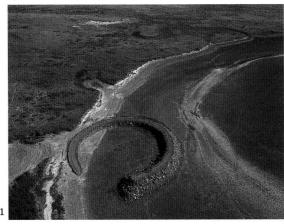

body, by a light that originated with the activity. When an important work of art has utterly disappeared by demolition and dispersal, we still can detect its perturbations upon other bodies in the field of influence."[38]

A second cause of error, says Leibniz, comes from the fact that we "believe that what comes merely from a flat painting actually comes from a body. In such cases our judgements involve both metonymy and metaphor...." Metonymy in that we take the effect for the cause, and metaphor in that "we substitute one cause for another." This shift of understanding is necessary to sort out this visual *sophistry*. Without a map, without a plan, without a caption, the Land Art constructions are completely insignificant. It would be folly to believe in the emptiness of what one sees, without having a frame or a point of view, since, to quote Leibniz, "This picture whose parts one sees distinctly, without seeing what they result in until one looks at them in a certain way, is like the idea of a heap of stones, which is truly confused..." He adds, "It is sometimes hard to find the key to the confusion—the way of viewing the object which shows one its intelligible properties; rather like those pictures...which must be viewed from a special position or by means of a special mirror if one is to see what the artist was aiming at,"[39] various means for decoding distorted

images or for seeing the monumental Land Art works *in situ* through the optical means of photography. In other words, one finds oneself in a critical space actually within perspective, which has the effect of showing its limits, privileging one point of view as clear and distinct while dooming the others to confusion or to a sort of monadological wandering on the part of the spectator.

However, these works exist, or existed, and all the art of Robert Smithson (on this subject, possibly the most lucid of the Land Art artists) may have been a means of reflecting on this dichotemy and of rethinking the true nature of representation, of which the illusion is to believe that it is found elsewhere than in this elusive movement. There is probably a "romantic"

1  Robert Smithson, *Amarillo Ramp*, Amarillo, Texas, 1973 (aerial view).
Photograph by Gianfranco Gorgoni.

2  Robert Morris, *Observatory*, Oostelijk Flevoland, Netherlands, 1977 (aerial view).

3  Nevada desert (aerial view).
Photograph by Gilles A. Tiberghien.

dimension to Land Art in that, through this "aesthetic relation of incertitude," it shows the impossibility of contact with of the work itself. At the same time, its radical *transcendence* forces one to recall the *Sehnsucht*, the infinite nostalgia of the Romantics. It may be that Land Art demonstrates the conditions necessary for the existence of art itself, which is the subject of a constantly renewed quest. Art is always elsewhere; it is neither in the work, nor in the one-dimensionality of the representation, nor in the mind of the artist or the spectators. It is present among us in the form of absence. This concept has an almost

religious dimension, and the crossing of the deserts provides tangible experience of this dimension, in some sense. "Only appearances are fertile," Smithson says in "Incidents of Mirror-Travel in the Yucatan." He adds, "They are gateways to the primordial. Every artist owes his existence to such mirages. The ponderous illusions of solidity, the non-existence of things, is what the artist takes for 'materials.' It is this absence of matter that weighs so heavy on him, causing him to invoke gravity....It is the dimension of absence that remains to be found."[40]

Michael Heizer, *Isolated Mass/Circumflex*, Massacre Dry Lake, Vyo, Nevada (deteriorated; *Nine Nevada Depressions 9*).
Six-ton displacement on the bottom of a dried-up lake, 120 x 12 x 1 feet. Commissioned by Robert Scull.
Photograph by D. Gorton.
"The intrusive, opaque object refers to itself. It has little exterior reference. It is rigid and blocks space. It is a target. An incorporative work is aerated, part of the material of its place and refers beyond itself." Michael Heizer, "The Art of Michael Heizer," *Artforum* (December 1969).

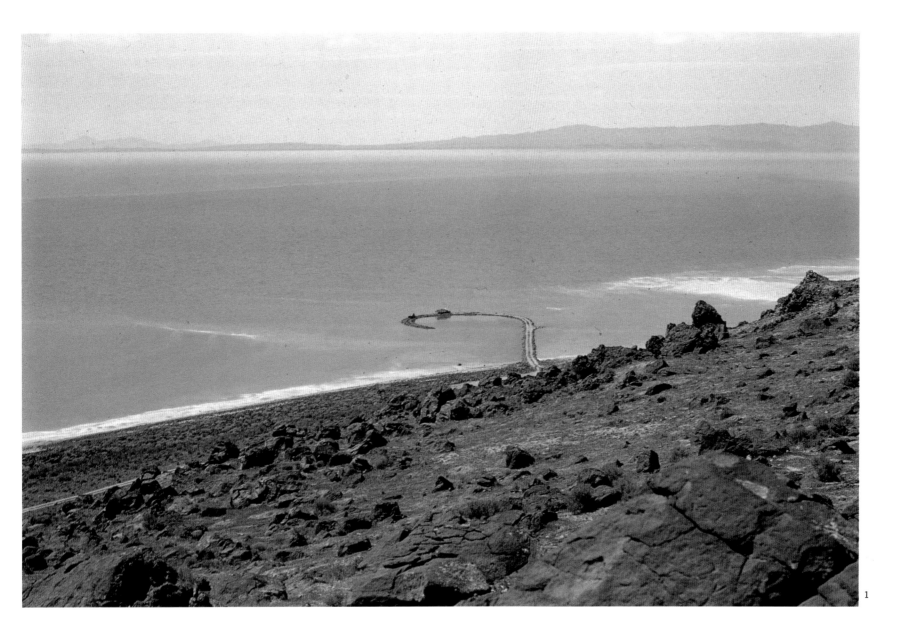

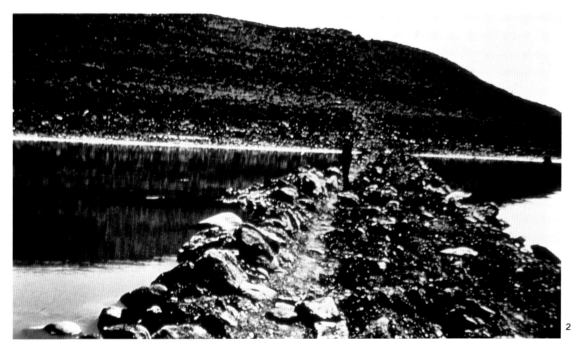

**1** Robert Smithson, *Spiral Jetty*, Great Salt Lake, Utah, 1970.
Photograph by Gianfranco Gorgoni. Property of Robert Smithson.

**2** The shore of the Great Salt Lake as seen from the *Spiral Jetty*.
Courtesy of the John Weber Gallery, New York.

**3** Robert Smithson, drawing (instructions given by the artist on
how to photograph *Spiral Jetty*).
Courtesy of the John Weber Gallery, New York.

1  Robert Smithson, *Spiral Jetty*, 1970
(aerial view).
Property of Robert Smithson. Photograph
by Gianfranco Gorgoni.

2  Robert Smithson, *Spiral Jetty*
(submerged).
Recent photograph by Atsushi Fujie.
Courtesy of Nancy Holt.

1

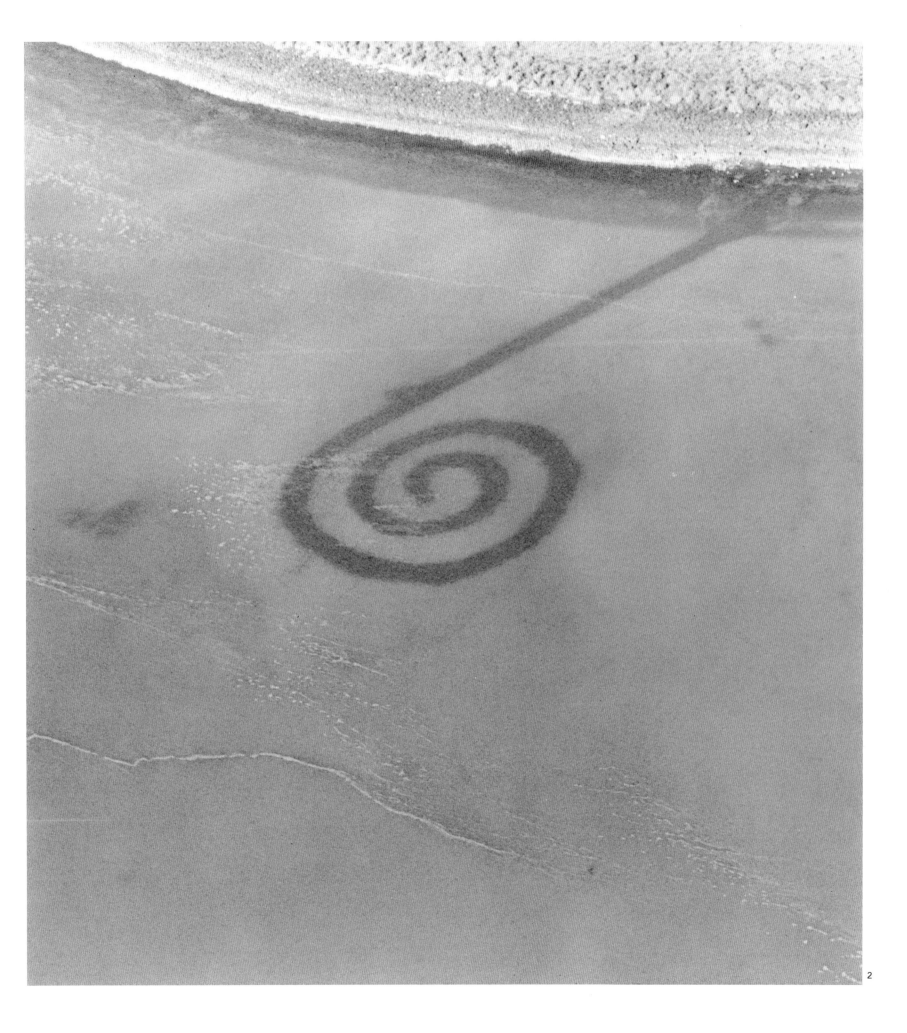

2

1. This is something Richard Serra, who is very close to the Land Art artists (he completed *Amarillo Ramp* with Nancy Holt and Tony Shafrazi) also believes: "Works in remote landscapes involve a contradiction that I have never been able to resolve. What most people know of Smithson's *Spiral Jetty*, for example, is an image shot from a helicopter. When you actually see the work, it has none of that purely graphic character, but then almost no one has really seen it. In fact, it has been submerged since shortly after its completion." (Richard Serra, "Interview with Douglas Crimp," *Arts Magazine* [November 1980].)

2. Michael Heizer, "Interview, Julia Brown and Michael Heizer," op. cit., p. 42.

3. "Words and photographs of the work are memory traces, not art. At best, they are inducements for people to go and see the actual work." (Nancy Holt, "Sun Tunnels," op. cit., p. 37.)

4. Michael Heizer, "Interview, Julia Brown and Michael Heizer," op. cit., p. 42.

5. In 1980 Holt published a small book of photographs enti-

Robert Smithson, instructions for a film project (never completed) on *Broken Circle/Spiral Hill*, 1971.
Property of Robert Smithson. Courtesy of the John Weber Gallery, New York.

tled *Ransacked*, which shows the destroyed interior of her aunt's house. The images are accompanied by a text, which is the aunt's story of the last moments of her life before she died of cancer, tyrannized by her nurse whom she believed wanted to kill her. The second part of the book reproduces letters, old family photos, a check, a birth certificate, a copy of an inquest, and burial photos, which constitute the "documentation" of the first part of the book. *Ransacked, Aunt Ethel: An Ending* (New York: Printed Matter, Inc., in association with Lapp Princess Press, Inc., 1980), 38 pages.

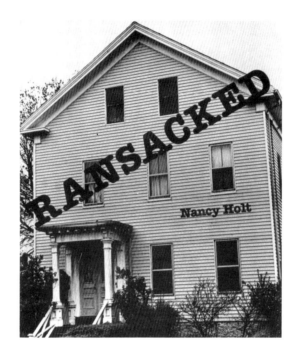

Cover of a book of photographs by Nancy Holt, accompanied by a story by the author. *Ransacked*, 1980.

6. Nancy Foote, "The Anti-Photographers," *Artforum* (September 1976), p. 50.

7. Ursula Meyer, *Conceptual Art* (E.P. Dutton, 1972), p. 14, cited in Nancy Foote, "The Anti-Photographers," op. cit., p. 49.

8. See Rosalind E. Krauss, "Notes on the Index, Part 1," *October* (spring 1977); "Notes on the Index, Part 2," *October* (fall 1977), reprinted in *The Originality of the Avant-Garde and Other Modernist Myths*, op. cit., p. 219.

9. Ibidem, p. 211.

10. For example, see Philippe Dubois, *L'Acte photographique et autres essais* (Paris: Nathan, 1990), chapters 1 and 2. The English language has one word, *index*, whereas the French language has two: in this case, the French would use *indice* (which implies a causal relationship) rather than *index* (which assumes a spatial relationship). As a method of creating a visual mark, photography is *indicielle* because it is also the result of what it shows. Daniel Soutif discusses how "the photographic image, being the result of what it is also the icon of (because it is an *indice* of a particular type—smoke is not the icon of fire), is, conversely, an *index* (or rather, as will be seen, a 'quasi-index') because it is an icon....Since only an object itself, in flesh and blood, can be considered as the cause of the photograph, it is therefore the combination of the object's real absence and its iconic quasi-presence which allows photography to be considered as both *indicielle* and *quasi-indexicale*." (Daniel Soutif, "De l'indice à l'index, ou de la photographie au musée," *Cahiers du Musée national d'Art moderne* [spring 1991], p. 77.)

11. Philippe Dubois, *L'Acte photographique*, op. cit., p. 246.

12. Pierre Bourdieu, *Photography, a Middle-Brow Art*, trans. by Shaun Whiteside (Cambridge, England: Polity Press, 1990), pp. 73–74. See also Pierre Francastel, *Peinture et Société* (Paris: Gallimard, 1951), which cites Bourdieu.

13. Pierre Francastel, *Etudes de sociologie de l'art* (Paris: Denoël, collection "Méditations," 1970), pp. 187–188. On this notion of spatial realism and its subordination to art, see Joel Snyder, "Fenêtres, miroirs et transparence picturale," *Les Cahiers du musée nationale d'Art moderne, no. 41: Nelson Goodman et les langages de l'art*, trans. from English by Daniel Soutif and Gilles A. Tiberghien (fall 1992).

14. Donald Judd, "Specific Objects," *Arts Yearbook* 8 (1965); reprinted in Donald Judd, *Complete Writings 1959–1975* (Halifax: The Press of the Nova Scotia College of Art and Design, and New York: New York University Press, 1975), pp. 182, 184.

15. Jean-Marc Poinsot, "In situ, lieux et espaces de la sculpture contemporaine," op. cit., p. 322.

16. *Partially Buried Woodshed*. Smithson's site/nonsite dialectic is as valid for the much more conceptual works dating from 1968 and 1969 as it is for his *earthworks* period dating from 1970. The text describing this dialectic is published in a footnote at the end of the text on *Spiral Jetty*, which first appeared in 1972 in *Arts of the Environment*. The site is therefore not only a "mental space." Nothing prohibits one from visiting it, as Smithson himself says.

17. Robert Smithson, *The Writings of Robert Smithson*, op. cit., pp. 52–53. On the importance of photography in this text, see Jean-Pierre Criqui, "Ruines à l'envers, introduction à la visite des monuments de Robert Smithson," *Cahiers du Musée national d'Art moderne*, no. 43 (spring 1993).

18. Craig Owens, "Photography en abyme," *October*, no. 5 (1978), p. 86.

19. Smithson ends his text of *A Nonsite, Franklin, New Jersey* with the following: "An unexhibited aerial photo of this point is deposited in a bank-vault. This photo can be seen—a key is available." (Robert Hobbs, *Robert Smithson: Sculpture*, op. cit., p. 106.)

20. Alberto Velasco, "Robert Smithson, une critique en acte de la photographie," *Histoire de l'art*, no. 13–14 (1991), p. 83.

21. Who also made the mark of his body on the ground; see *Foot Kick Gesture*, Coyote Dry Lake, California, 1968.

22. It is this "*trompe l'intelligence*" system which consists of deceiving us as to the depth of the space, and which obliges us to cut into it "intellectually" in reconstructing the painter's process for ourselves, in understanding "how it's done" which Thomas Martone has demonstrated in various writings. For example, see Thomas Martone, "Piero della Francesca e la prospettiva dell'inteletto," *Piero Teorico dell'arte*, edited by Omar Calabrese (Rome: Gangemi editore, 1985), pp. 173–204.

23. Rudi Fuchs, "The Eye Framed and Unframed," *Jan Dibbets* (Minneapolis: Walker Art Center, 1987), p. 51.

Isamu Noguchi, *Sculpture to be Seen from Mars*, 1947. Sand model, destroyed. Photograph by Soichi Sunami.

24. In 1969, De Maria made another color film (16 mm) entitled *Hard Core* and described as a Minimal-Land-Mystery-Historical-Western. The basic principle is the same since this film also takes place in the desert, with a series of panoramas filmed from different places each time. After several minutes a pair of cowboy boots appears for a few seconds. Then the camera rotates 360 degrees and another pair of boots appears. A second rotation occurs, and the camera shows us a revolver loaded and replaced in its holster. After yet another rotation a rifle is loaded. Then, following the same procedure, after every 360-degree turn the viewer successively sees the expressions of each of the two protagonists up until the final scene when we see the two men, one young, the other older, shooting for a bit more than a minute at target that we assume to be the other man, without ever seeing it. During the whole film, we hear the sound of waves from which the sound of drumming progressively emerges. De Maria himself composed the music "for ocean and drums," and he himself plays the drums (he was the drummer for the Velvet Underground in 1965 for six months). Then, after about twenty seconds, we see the face of a young Asian girl, which may be an allusion to the Vietnam War.

25. This period is one of dominant structuralism, in the United States as well as in France. In his book *La Pensée Sauvage*, Lévi-Strauss declared, "So I accept the characterization of aesthete in so far as I believe the ultimate goal of the human sciences to be not to constitute, but to dissolve man." (Claude Lévi-Strauss, *The Savage Mind*, op. cit., p. 247.) And if one remembers the end of Foucault's *Les Mots et les Choses*: "As the archeology of our thought easily shows, man is an invention of recent date. And one perhaps nearing its end. If those arrangements [there was a "change in the fundamental arrangements of knowledge" which began "a century and a half ago" for Foucault] were to disappear as they have appeared…then one can certainly wager that man would be erased, like a face drawn in sand at the edge of the sea." (Michel Foucault, *The Order of Things* [New York: Pantheon Books, 1970], p. 387.)

26. Svetlana Alpers, *The Art of Describing*, op. cit., p. 144.

27. Robert Smithson, *The Writings of Robert Smithson*, op. cit., p. 168. Jean-François Chevrier and Catherine David, who cite this text, add, "It is through infinitely multiplying the points of view and the possible framings of the image, more than through the calculated effects of fragmentation, that photography has definitively ruined Nature's tableau. Smithson is correct in suggesting that the relativization of points of view, conditioned by the uniform rigor of the frame, radically differs from the single, exemplary alternative found in the tableau." ("Actualité de l'image," *Passage de l'image* [Paris: Musée national d'Art moderne, Centre Georges-Pompidou, 1990], p. 19.)

28. In her text "Echelle/Monumentalité, Modernisme/Postmodernisme, La ruse de Brancusi," op. cit., pp. 246–253.

29. Robert Smithson, *The Writings of Robert Smithson*, op. cit., p. 209.

30. Hubert Damisch, "La perspective au sens strict du terme," *Piero teorico dell'arte*, op. cit., p. 25.

31. Ibidem, p. 23.

32. Erwin Panofksy, *Perspective as Symbolic Form*, translated by Christopher S. Wood (New York: Zone Books, 1991), p. 27.

33. See William Howard Adams, *The French Garden, 1500–1800* (New York: Braziller, 1979).

34. Which is justified, in that the elements which constitute the complex are made to be seen head-on, and in that a complete study of all of the constructions requires a fairly large number of images to alleviate the reduction we are discussing, among other reasons.

35. For a rapid yet suggestive history of the views of the sky in painting and photography, see chapter five of Kirk Varnedoe, *A Fine Disregard: What Makes Modern Art Modern* (New York: Abrams, 1990). Interestingly, Smithson does not discuss Malevich in his article on "Aerial Art" while mentioning him twice in "A Sedimentation of the Mind: Earth Projects." He writes, "Aristotle believed that heat combined with dryness resulted in fire: where else could this feeling take place than in a desert or in Malevich's head? 'No more 'likenesses of reality,' no idealistic images, nothing but a desert,' says Malevich in The Non-Objective World." (Robert Smithson, *The Writings of Robert Smithson*, op. cit., p. 89.) There is an English-language version of Malevich's text, translated from the German, not the original Russian: *The Non-Objective World*, translated by Howard Dearstyne (Chicago: Paul Theobald and Co., 1959). Smithson was probably familiar with this edition.

36. G.W. Leibniz, *New Essays on Human Understanding*, translated by Peter Remnant and Jonathan Bennett (Cambridge: Cambridge University Press, 1981), p. 135.

37. Roland Barthes, "Rhétorique de l'image," *Communication* (1964).

38. George Kubler, *The Shape of Time* (New Haven and London: Yale University Press, 1962), p. 19. He adds, "By the same token works of art resemble gravitational fields, in their clustering by 'schools.' And if we admit that works of art can be arranged in a temporal series as connected expressions, their sequence will soon resemble an orbit in the fewness, the regularity, and the necessity of the 'motions' involved." (Ibidem, p. 19.)

39. G.W. Leibniz, *New Essays on Human Understanding*, op. cit., p. 258.

40. Robert Smithson, *The Writings of Robert Smithson*, op. cit., p. 103.

# MAPS

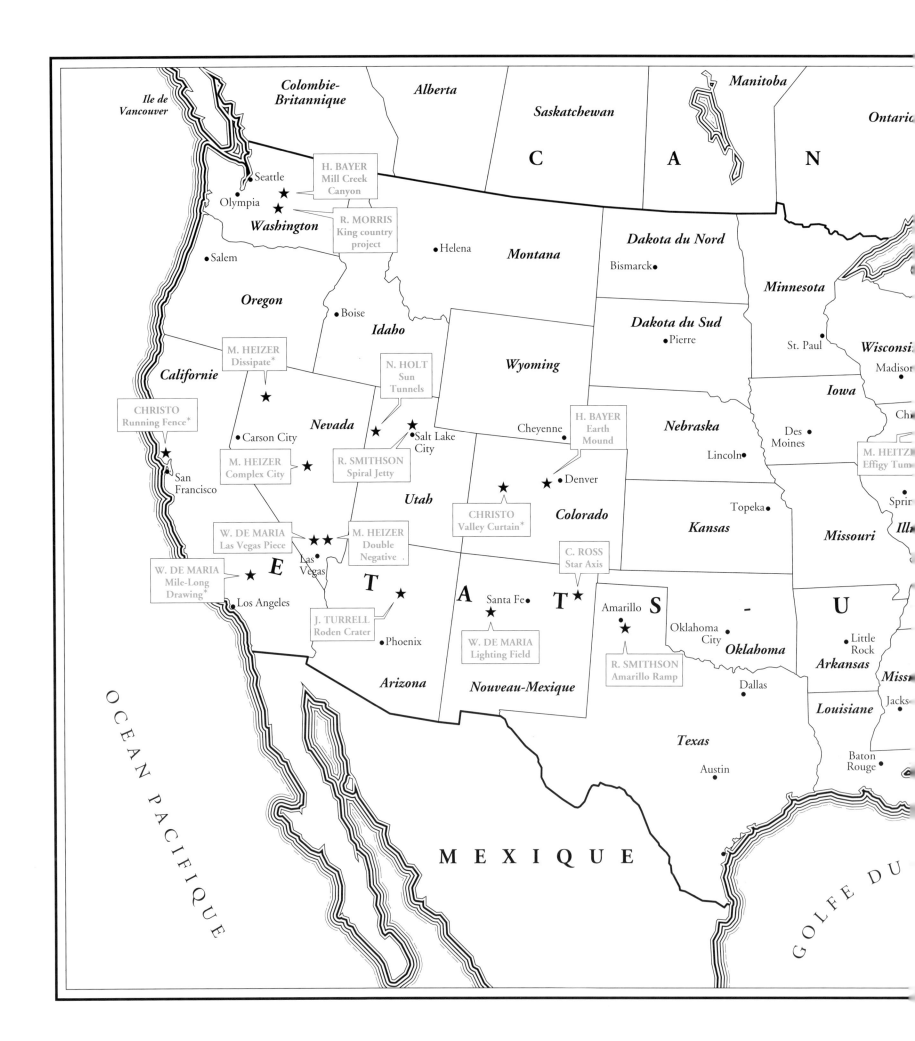

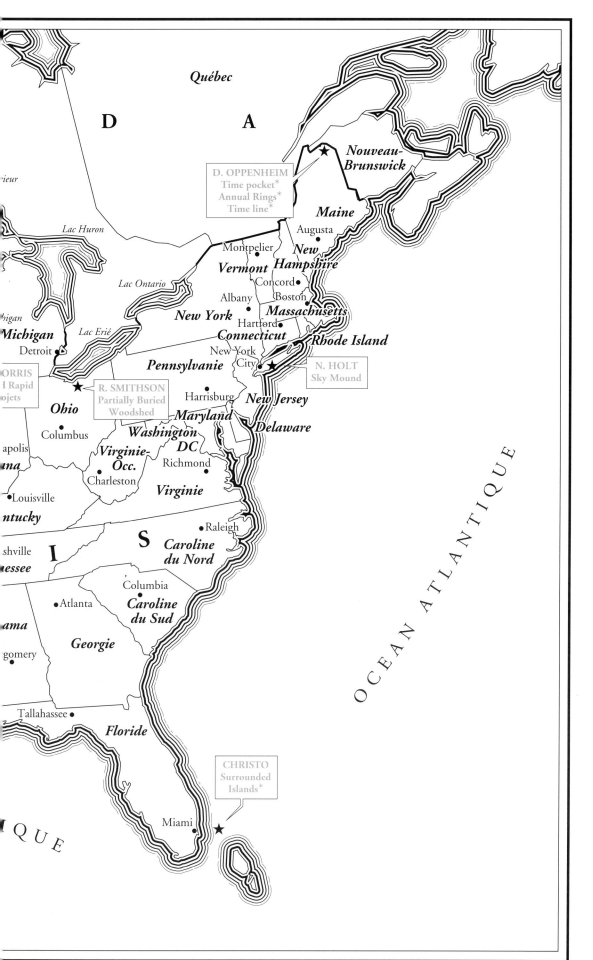

Map of the United States locating the Land Art works presented in this book. Those works on the map marked with an asterisk no longer exist.

—*Complex City* (Michael Heizer).
Under construction. Cannot be visited.

—*Lightning Field* (Walter De Maria).
To visit *Lightning Field*, you must make an appointment by telephoning or writing the Dia Art Foundation, Dia Center for the Arts, 2 Wind Northwest, Albuquerque, New Mexico 87120.
Tel (505) 898-5602.
At 3:00 pm, a car from the Dia Center takes you from Quemado to the Cabin Lodge. The trip takes about 40 minutes. At 11:00 the next morning, the same car picks you up and brings you back. Food for preparing dinner and breakfast is provided in the cabin. The distance by car is approximately 3 hours from Albuquerque, New Mexico, 4 1/2 hours from Phoenix, Arizona, and 5 hours from Flagstaff, Arizona.

—*Roden Crater* (James Turrell).
Under construction. For information, write to Skystone Foundation, Box 725, Flagstaff, Arizona 86002.

—*Spiral Jetty* (Robert Smithson).
The spiral, which is immersed under several feet of water, is visible only from a plane. For information, contact the John Weber Gallery, 142 Greene Street, New York, New York 10012.

—*Star Axis* (Charles Ross).
Under construction. For information, contact Charles Ross, 383 West Broadway, New York, New York 10012.

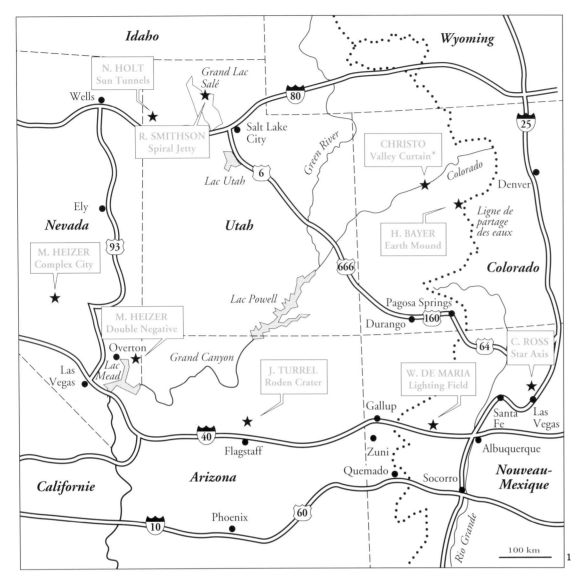

**1** Map showing the principal Land Art sites found in the western part of the United States.

—*Double Negative* (Michael Heizer).
"Take Route 15 north from Las Vegas to Route 169 (exit 393) to Overton. Once in Overton, turn left onto Cooper Street which leads to the Overton Airport. This will be a sharp left shortly after the Moapa Valley Community Center and Las Vegas Met. Police Station (on left) and the post office (on right). Continue on Cooper Street to Airport Road. Turn right on Airport Road." Once you arrive at the airport, you must sign in with the airport operator (for security reasons), and sign out when you leave. "After signing in at the airport, proceed up the road to the top of the western edge of the mesa. As you pass the dump, it will turn into a dirt road. When you reach the top of the mesa, note mileage and continue straight across the mesa (do not go onto immediate right or left road). After traveling 2.6 miles, keep your eyes to the left and make your first possible left (at 2.8 miles) onto a small dirt road which is easy to miss. Note mileage again. The road runs to the north, parallel to the eastern edge of the mesa where *Double Negative* is located (and which overlooks the Virgin River). Proceed carefully. Road has many rocks and is hard to follow. Pass the first two notches in the mesa and a small U.S. Dept. of the Interior marker (3 wood poles) at right. *Double Negative* is located in the third notch. After traveling 1.3 miles, you will come to a fork which leads to each cut of *Double Negative*. Bear right to the south cut. The left fork leads to the north cut."
These are the directions provided by the Museum of Contemporary Art of Los Angeles, the present owner of *Double Negative*. Bring plenty of water and do not forget to sign out at airport on your return.

**2** Nancy Holt's directions to reach *Sun Tunnels*, near the town of Lucin, Utah:

"SOUTHERN ROUTE—200 miles (recommended)
Take Route 80 West from Salt Lake City through Wendover to Oasis, Nevada. At Oasis take Route 30 NE through Montello, Nevada (last gas, water, food, motel) back into Utah. About 10 miles past the border is a sign on the right saying "to Lucin." Turn right onto the gravel road for 5 miles to Lucin (pop. 10). Continue on the same road south of Lucin (you may be able to see *Sun Tunnels* in the distance to your lower left—SE) for about 2-1/2 miles. Turn left for 2 miles and then right 3/4 miles to *Sun Tunnels*. Since the earth is soft and/or mud, keep the car on the gravel roads at all times. There is a gravelled parking area at the end of the road to *Sun Tunnels*.
NORTHERN ROUTE—also 200 miles, but a little slower
Take Route 15 North from Salt Lake City to Route 80. Take Route 80 to Snowville where you turn onto Route 30 going southwest. After about 100 miles on Route 30 you will see a sign on the left saying "to Lucin." Turn left to Lucin and follow directions above. You may camp on my land, but please leave everything the way you found it."

**3** Topographic map of Overton, Nevada (detail) marking the site of Michael Heizer's *Double Negative*.
From the U.S. Geological Survey, 1958.

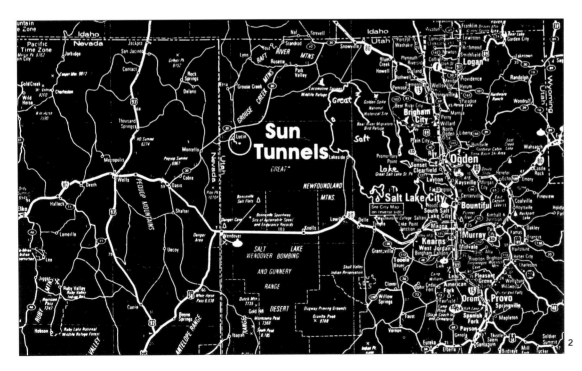

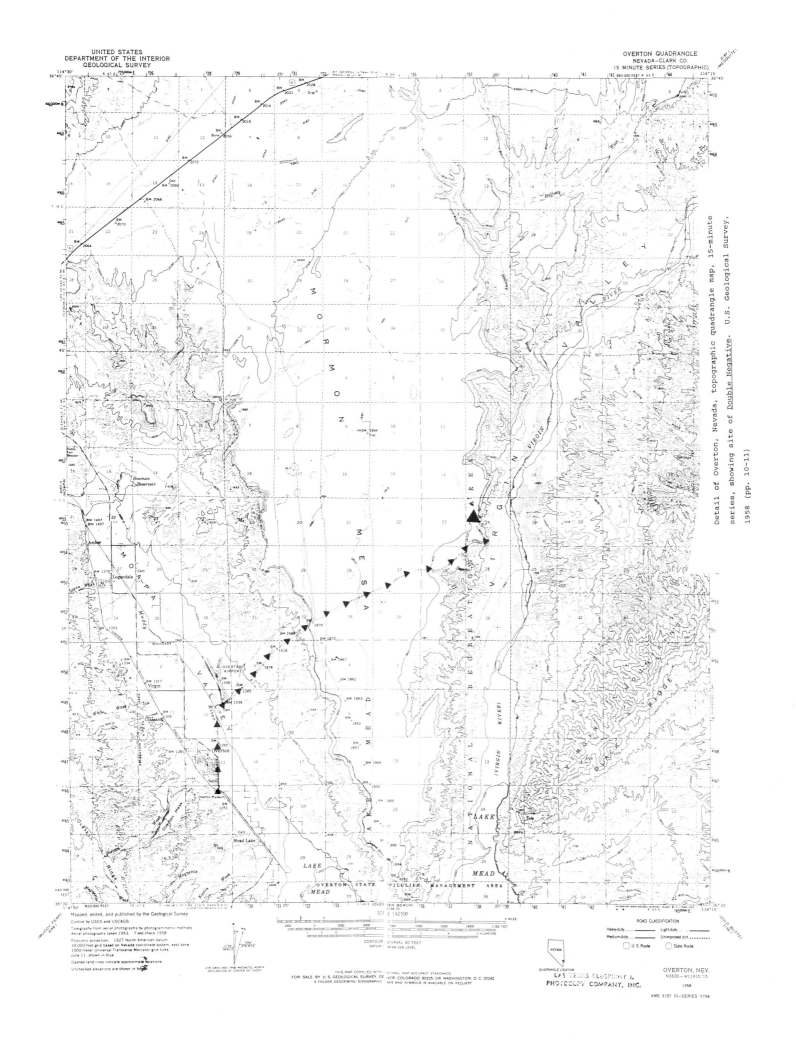

Detail of Overton, Nevada, topographic quadrangle map, 15-minute series, showing site of Double Negative. U.S. Geological Survey, 1958 (pp. 10-11)

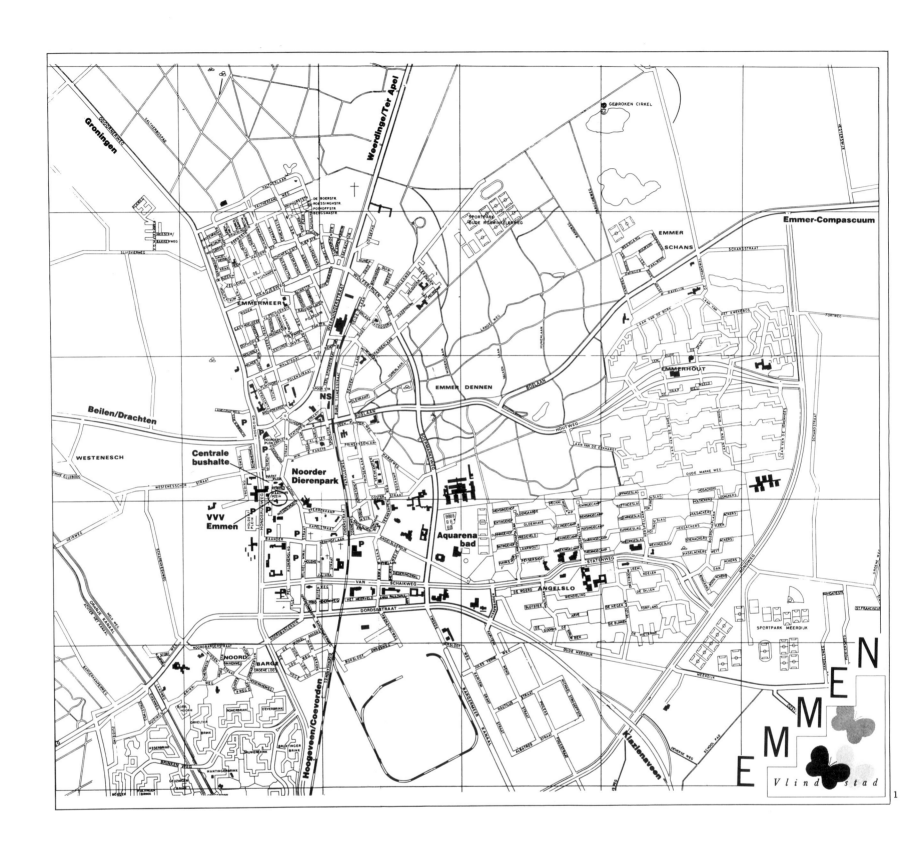

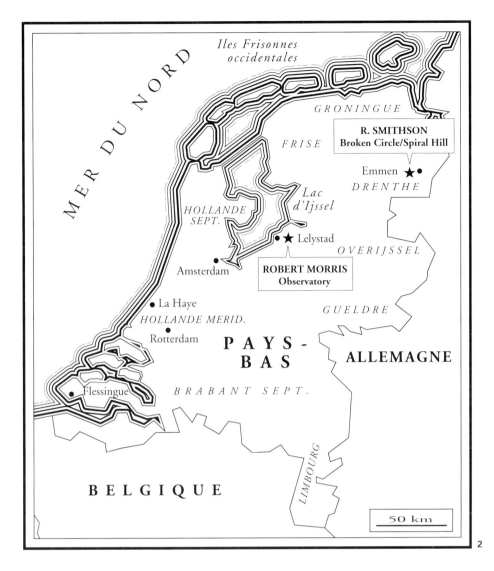

1 Map of the city of Emmen showing the location of *Broken Circle/Spiral Hill* (Gebroken Cirkel, at top right).
City of Emmen.

2 Map of the Netherlands showing the cities of Emmen and Lelystad, where Robert Smithson's *Broken Circle/Spiral Hill* and Robert Morris's *Observatory* are located, respectively.
—*Observatory* (Robert Morris).
Approximately 55 minutes from Amsterdam. Follow the directions indicated on the map.
It is best to visit the site at sunrise or sunset during the time of either the summer or winter solstice.
—*Spiral Hill/Broken Circle* (Robert Smithson).
Emmen is located approximately two hours from Amsterdam. Exit the city on the road indicated on the map and ask for directions to the sand quarries.

3 Map showing the location of Robert Morris's *Observatory*, in *Het Observatorium van Robert Morris*, Amsterdam, Stedelijk Museum, 1977.

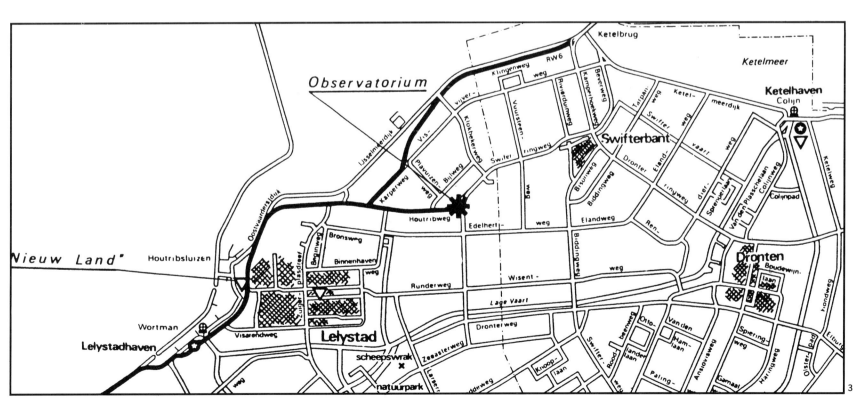

# DOCUMENTS

# DISCUSSION BETWEEN MICHAEL HEIZER, DENNIS OPPENHEIM, AND ROBERT SMITHSON

These discussions were held in New York from December 1968 to January 1969.
The transcript was edited in collaboration with the artists.

*"The work is not put in a place, it is that place."*
Michael Heizer

*Dennis, how did you first come to use earth as sculptural material?*

D.O.: Well, it didn't occur to me at first that this was what I was doing. Then gradually I found myself trying to get below ground level.

*Why?*

D.O.: Because I wasn't very excited about objects which protrude from the ground. I felt this implied an embellishment of external space. To me a piece of sculpture inside a room is a disruption of interior space. It's a protrusion, an unnecessary addition to what could be a sufficient space in itself. My transition to earth materials took place in Oakland a few summers ago, when I cut a wedge from the side of a mountain. I was more concerned with the negative process of excavating that shape from the mountainside than with making an earthwork as such. It was just a coincidence that I did this with earth.

*You didn't think of this as an earthwork?*

D.O.: No, not then. But at that point I began to think very seriously about place, the physical terrain. And this led me to question the confines of the gallery space and to start working things like bleacher systems, mostly in an outdoor context but still referring back to the gallery site and taking some stimulus from that outside again. Some of what I learn outside I bring back to use in a gallery context.

*Would you agree with Smithson that you, Dennis, and Mike are involved in a dialectic between the outdoors and the gallery?*

D.O.: I think that the outdoor/indoor relationship in my work is more subtle. I don't really carry a gallery disturbance concept around with me; I leave that behind in the gallery. Occasionally I consider the gallery site as though it were some kind of hunting-ground.

*Then for you the two activities are quite separate?*

D.O.: Yes, on the whole. There are areas where they begin to fuse, but generally when I'm outside I'm completely outside.

R.S.: I've thought in this way too, Dennis. I've designed works for the outdoors only. But what I want to emphasize is that if you

want to concentrate exclusively on the exterior, that's fine, but you're probably always going to come back to the interior in some manner.

*So what may really be the difference between you is the attitude you have to the site. Dennis, how would you describe your attitude to a specific site that you've worked with?*

D.O.: A good deal of my preliminary thinking is done by viewing topographical maps and aerial maps and then collecting various data on weather information. Then I carry this with me to the terrestrial studio. For instance, my frozen lake project in Maine involves plotting an enlarged version of the International Date Line onto a frozen lake and truncating an island in the middle. I call this island a time-pocket because I'm stopping the IDL there. So this is an application of a theoretical framework to a physical situation—I'm actually cutting this strip out with chain saws. Some interesting things happen during this process: you tend to get grandiose ideas when you look at large areas on maps, then you find they're difficult to reach so you develop a strenuous relationship with the land. If I were asked by a gallery to show my Maine piece, obviously I wouldn't be able to. So I would make a model of it.

*What about a photograph?*

D.O.: Ok, or a photograph. I'm not really that attuned to photos to the extent to which Mike is. I don't really show photos as such. At the moment I'm quite lackadaisical about the presentation of my work; it's almost like a scientific convention. Now Bob's doing something very different. His non-site is an intrinsic part of his activity on the site, whereas my model is just an abstract of what happens outside and I just can't get that excited about it.

*Could you say something, Bob, about the way in which you choose your sites?*

R.S.: I very often travel to a particular area; that's the primary phase. I began in a very primitive way by going from one point to another. I started taking trips to specific sites in 1965: certain sites would appeal to me more—sites that had been in some way disrupted or pulverized. I was really looking for a denaturalization rather than built up scenic beauty. And when you take a trip you need a lot of precise data, so often I would use quadrangle maps; the mapping followed the traveling. The first non-site that I did was at the Pine Barrens in southern New Jersey. This place

was in a state of equilibrium, it had a kind of tranquillity and it was discontinuous from the surrounding area because of its stunted pine trees. There was a hexagon airfield there which lent itself very well to the application of certain crystalline structures which had preoccupied me in my earlier work. A crystal can be mapped out, and in fact I think it was crystallography which led me to map-making. Initially I went to the Pine Barrens to set up a system of outdoor pavements but in the process I became interested in the abstract aspects of mapping. At the same time I was working with maps and aerial photography for an architectural company. I had great access to them. So I decided to use the Pine Barrens site as a piece of paper and draw a crystalline structure over the landmass rather than on a 20 x 30 sheet of paper. In this way I was applying my conceptual thinking directly to the disruption of the site over an area of several miles. So you might say my non-site was a three-dimensional map of the site.

D.O.: At one point in the process you've just described, Bob, you take a quadrangle map of an airport. In my recent piece at the Dwan Gallery, I took the contour lines from a contour map of Ecuador, which is very close to the Equator and I then transferred this two-dimensional data onto a real location. I think there's a genuine similarity here. In this particular case I blew up the information to full size and transferred it to Smith County, Kansas, which is the exact centre of the United States.

R.S.: I think that what Dennis is doing is taking a site from one part of the world and transferring the data about it to another site, which I would call a dis-location. This is a very specific activity concerned with the transference of information, not at all a glib expressive gesture. He's in a sense transforming a terrestrial site into a map. Where I differ from Dennis is that I'm dealing with an exterior and an interior situation as opposed to two exterior situations.

*Why do you still find it necessary to exhibit in a gallery?*

R.S.: I like the artificial limits that the gallery presents. I would say my art exists in two realms—in my outdoor sites which can be visited only and which have no objects imposed on them, and indoors, where objects do exist...

*Isn't that a rather artificial dichotomy?*

R.S.: Yes, because I think art is concerned with limits and I'm interested in making art. You can call this traditional if you like.

But I have also thought about purely outdoor pieces. My first earth proposals were for sinks of pulverized materials. But then I got interested in the indoor-outdoor dialectic. I don't think you're freer artistically in the desert than you are inside a room.

*Do you agree with that, Mike?*

M.H.: I think you have just as many limitations, if not more, in a fresh air situation.

*But I don't see how you can equate the four walls of a gallery, say, with the Nevada mudflats. Aren't there more spatial restrictions in a gallery?*

M.H.: I don't particularly want to pursue the analogy between the gallery and the mudflats. I think the only important limitations on art are the ones imposed or accepted by the artist himself.

*Then why do you choose to work outdoors?*

M.H.: I work outside because it's the only place where I can displace mass. I like the scale—that's certainly one difference between working in a gallery and working outdoors. I'm not trying to compete in size with any natural phenomena, because it's technically impossible.

*When Yves Klein signed the world, would you say that was a way of overcoming limits?*

R.S.: No, because then he still has the limits of the world...

*Dennis, recently you have been doing really large-scale outdoor pieces. What propels you to work outdoors rather than in an already structured situation?*

D.O.: I'm following a fairly free path at present so I'm not exclusively outdoors in that sense. In fact I'm tending to refer back to the gallery.

*Why do you find that necessary?*

D.O.: It's a kind of nostalgia, I think. It seems to me that a lot of problems are concerned mainly with presentation. For some people the gallery issue is very important now but I think that in time it will mellow. Recently I have been taking galleries apart, slowly. I have a proposal that involves removing the floorboards and eventually taking the entire floor out. I feel this is a creeping back to the home site.

*Bob, how would you describe the relation between the gallery exhibit and nature?*

R.S.: I think we all see the landscape as coextensive with the gallery. I don't think we're dealing with matter in terms of a back to nature movement. For me the world is a museum. Photography makes nature obsolete. My thinking in terms of the site and the non-site makes me feel there's no need to refer to nature anymore. I'm totally concerned with making art and this is mainly an act of viewing, a mental activity that zeroes in on discrete sites. I'm not interested in presenting the medium for its own sake. I think that's a weakness of a lot of contemporary work.

*Dennis, how do you see the work of other New York sculptors, specifically Morris, Judd Lewitt and Andre?*

D.O.: Andre at one point began to question very seriously the validity of the object. He began to talk about sculpture as place. And Sol Lewitt's concern with systems, as opposed to the manual making and placement of object art can also be seen as a move against the object. These two artists have made an impact on me. They built such damn good stuff that I realized an impasse had been reached. Morris also got to the point where if he'd made his pieces a little better, he wouldn't have had to make them at all. I felt that very strongly and I knew there must be another direction in which to work.

*Are you referring to Morris' minimal work?*

D.O.: Yes, his polyhedrons. The earth movement has derived some stimulus from minimal art, but I think that now it's moved away from their main preoccupations.

M.H.: I don't think that you're going to be able to say what the source of this kind of art is. But one aspect of earth orientation is that the works circumvent the galleries and the artist has no sense of the commercial or the utilitarian. But it's easy to be hyperesthetic, and not so easy to maintain it.

R.S.: If you're interested in making art then you can't take a kind of facile cop-out. Art isn't made that way. It's a lot more rigorous.

M.H.: Eventually you develop some sense of responsibility about transmitting your art by whatever means are available.

*What do you have to say about that, Dennis?*

D.O.: I think we should discuss what's going to happen to earth art, because the cultural reverberations stimulated by some of our outdoor pieces are going to be very different from those produced by a piece of rigid indoor sculpture.
For one thing, I think a lot of artists will begin to see the enormous possibilities inherent in working outdoors.

M.H.: Do you mean something ought to be said about the IMPORTANCE of what's being done with earth????

D.O.: Yes.

M.H.: Well, look at it this way. Art usually becomes another commodity. One of the implications of earth art might be to remove completely the commodity-status of a work of art and to allow a return to the idea of art as…

*Art as activity?*

M.H.: No, if you consider art as activity then it becomes like recreation. I guess I'd like to see art become more of a religion.

*In what sense?*

M.H.: In the sense that it wouldn't have a utilitarian function any more. It's okay for the artist to say he doesn't have any mercenary intentions, knowing full well that his art is used avariciously.

*So the artist's responsibility extends beyond the creative act?*

M.H.: The artist is responsible for everything, for the work and for how it's used. Enough attacks have been made on my work for me to have considered protecting it, like a dog burying a bone in the ground.

D.O.: Don't you see art as involved with weather or perhaps redirecting traffic?

M.H.: I like your idea, Dennis, but it sounds as though you want to make a rain machine, which I don't think is what you mean at all.

D.O.: Aren't you indicating possibilities here that other artists haven't really explored? It seems to me that one of the principal

functions of artistic involvement is to stretch the limits of what can be done and to show others that art isn't just making objects to put in galleries, but that there can be an artistic relationship with things outside the gallery that is valuable to explore. Mike, what are you trying to achieve by working in nature?

M.H.: Well, the reason I go there is because it satisfies my feeling for space. I like that space. That's why I choose to do my art there.

*Has your knowledge of archaeological excavations had any bearing on your work?*

M.H.: It might have affected my imagination because I've spent some time recording technical excavations. My work is closely tied up with my own experiences; for instance, my personal associations with dirt are very real. I really like it, I really like to lie in the dirt. I don't feel close to it in the farmer's sense…And I've transcended the mechanical, which was difficult. It wasn't a legitimate art transition but it was psychologically important because the work I'm doing now with earth satisfies some very basic desires.

*So you're really happy doing it.*

M.H.: Right. I'm not a purist in any sense and if I'm at all interested in Bob's or Dennis's work, it's because I sense in it the same kind of divergence from a single ideal as in my own. That's why I said earlier that earth art is a very private thing. And of course I'm not at all concerned about style.

R.S.: I think most of use are very aware of time on a geological scale, of the great extent of time which has gone into the sculpting of matter. Take an Anthony Caro: that expresses a certain nostalgia for a Garden of Eden view of the world, whereas I think in terms of millions of years, including times when humans weren't around. Anthony Caro never thought about the ground his work stands on. In fact, I see his work as anthropocentric cubism. He has yet to discover the dreadful object. And then to leave it. He has a long way to go.

D.O.: It seems to me that this consciousness of geological process, of very gradual physical change, is a positive feature, even an aesthetic characteristic of some of the more significant earth works.

R.S.: It's an art of uncertainty because instability in general has

become very important. So the return to Mother Earth is a revival of a very archaic sentiment. Any kind of comprehension beyond this is essentially artificial.

*Geological thinking seems to play an important role in your esthetic.*

R.S.: I don't think we're making an appeal to science at all. There's no reason why science should have any priority.

M.H.: Scientific theories could just as well be magic as far as I'm concerned. I don't agree with any of them.

*Do you see them as fiction?*

R.S.: Yes.

M.H.: Yes. I think that if we have any objective in mind it's to supplant science.

R.S.: I wrote an article recently entitled "Strata" covering the Precambrian to the Cretaceous periods. I dealt with that as a fiction. Science works, yes, but to what purpose? Disturbing the grit on the moon with the help of billions of dollars. I'm more interested in all aspects of time. And also in the experience you get at the site, when you're confronted by the physicality of actual duration. Take the Palisades non-site: you find trolley tracks embedded in the ground, vestiges of something else. All technology is matter built up into ideal structures. Science is a shack in the lava flow of ideas. It must all return to dust. Moondust, perhaps.

*Why don't we talk about one of your pieces, Bob, the one on the Mono Lake, for example.*

R.S.: The Mono Lake non-site, yes. Maps are very elusive things. This map of Mono Lake is a map that tells you how to get nowhere. Mono Lake is in northern California and I chose this site because it had a great abundance of cinders and pumice, a fine granular material. The lake itself is a salt lake. If you look at the map, you'll see it is in the shape of a margin—it has no centre. It's a frame, actually. The non-site itself is a square channel that contains the pumice and the cinders that collected around the shores of the lake at a place called Black Point. This type of pumice is indigenous to the whole area.

*What exactly is your concept of a non-site?*

R.S.: There's a central focus point which is the non-site; the site is the unfocused fringe where your mind loses its boundaries and a sense of the oceanic pervades, as it were. I like the idea of quiet catastrophes taking place....The interesting thing about the site is that, unlike the non-site, it throws you out to the fringes. In other words, there's nothing to grasp onto except the cinders and there's no way of focusing on a particular place. One might even say that the place has absconded or been lost. This is a map that will take you somewhere, but when you get there you won't really know where you are. In a sense the non-site is the centre of the system, and the site itself is the fringe or the edge. As I look around the margin of this map, I see a ranch, a place called the sulphur pond; falls, and a water tank; the word pumice. But it's all very elusive. The shorelines tell you nothing about the cinders on the shore. You're always caught between two worlds, one that is and one that isn't. I could give you a few facts about Mono Lake. Actually, I made a movie about it with Mike Heizer. It's in a state of chaos, it's one of those things that I wouldn't want to show to more than a few people. But Mono Lake itself is fascinating. Geologists have found evidence of five periods of glaciation in the Sierra. The first began about half a million years ago, the last ended less than fifteen thousand years ago. The glaciers left prominent marks upon the landscape, they gouged out canyons, broadening and deepening them into U-shaped valleys with steep headwalls and then advanced onto the plain. They built up high parallel ridges of stony debris called moraines. There are all sorts of things like that. The Mono craters are a chain of volcanic cones. Most of them were formed after Lake Russell evaporated. That's why I like it, because in a sense the whole site tends to evaporate. The closer you think you're getting to it and the more you circumscribe it, the more it evaporates. It becomes like a mirage and it just disappears. The site is a place where a piece should be but isn't. The piece that should be there is now somewhere else, usually in a room. Actually everything that's of any importance takes place outside the room. But the room reminds us of the limitations of our condition.

D.O: Why do you bother with non-site at all?

R.S.: Why do I?

D.O.: Why don't you just designate a site?

R.S.: Because I like the ponderousness of the material. I like the idea of shipping back the rocks across the country. It gives me more of a weighty sensation. If I just thought about it and held it

in my mind it would be a manifestation of idealistic reduction and I'm not really interested in that. You spoke about evil: actually for a long time people thought mountains were evil because they were so proud compared to the humble valleys. It's true! Something called the mountain controversy. It started in the eighteenth century.

*How would you characterize your attitude to nature?*

R.S.: Well, I developed a dialectic between the mind-matter aspects of nature. My view became dualistic, moving back and forth between the two areas. It's not involved with nature, in the classical sense. There's no anthropomorphic reference to environment. But I do have a stronger tendency towards the inorganic than to the organic. The organic is closer to the idea of nature: I'm more interested in denaturalization or in artifice than I am in any kind of naturalism.

*Are there any elements of destruction in your work?*

R.S.: It's already destroyed. It's a slow process of destruction. The world is slowly destroying itself. The catastrophe comes suddenly, but slowly.

*Big Bang.*

R.S.: Well, that's for some. That's exciting. I prefer the lava, the cinders that are completely cold and entropically cooled off. They've been resting in a state of delayed motion. It takes something like a millennium to move them. That's enough action for me. Actually that's enough to knock me out.

*A millennium of gradual flow...*

R.S.: You know, one pebble moving one foot in two million years is enough action to keep me really excited. But some of us have to simulate upheaval, step up the action. Sometimes we have to call on Bacchus. Excess. Madness. The End of the World. Mass Carnage. Falling Empires.

*Mmmm...What would you say about the relationship between your work and photographs of it?*

R.S.: Photographs steal away the spirit of the work...

D.O.: One day the photograph is going to become even more important than it is now—there'll be a heightened respect for photographers. Let's assume that art has moved away from its manual phase and now it's more concerned with the location of material and with speculation. So the work of art now has to be visited or abstracted from a photograph, rather than made. I don't think the photograph could have had the same richness of meaning in the past as it has now. But I'm not particularly an advocate of the photograph.

*It's sometimes claimed that the photo is a distortion of sensory perception.*

M.H.: Well, the experience of looking is constantly altered by physical factors. I think certain photographs offer a precise way of seeing works. You can take a photograph into a clean white room, with no sound, no noise. You can wait until you feel so inclined before you look at it and possibly experience at greater depth whatever view you have been presented with.

*What are your primary concerns, Mike, in carrying out one of your Depressions?*

M.H.: I'm mainly concerned with physical properties, with density, volume, mass and space. For instance, I find an 18 foot square granite boulder. That's mass. It's already a piece of sculpture. But as an artist it's not enough for me to say that, so I mess with it. I defile...if you're a naturalist you'd say I defiled it, otherwise you'd say I responded in my own manner. And that was by putting some space under the boulder. My work is in opposition to the kind of sculpture which involves rigidly forming, welding, sealing, perfecting the surface of a piece of material. I also want my work to complete its life-span during my lifetime. Say the work lasts for ten minutes or even six months, which isn't really very long, it still satisfies the basic requirements of fact....Everything is beautiful, but not everything is art.

*What makes it art?*

M.H.: I guess when you insist on it long enough, when you can convince someone else that it is. I think that the look of art is broadening. The idea of sculpture has been destroyed, subverted, put down. And the idea of painting has also been subverted. This has happened in a very strange way, through a process of logical questioning by artists. It hasn't been like these various looks which appear every twenty years or so; they're just minor phenomena within the larger one that will be remembered.

*Do you approve of this undermining of existing art forms?*

M.H.: Of course I do, because then the artist will realize that only a real primitive would make something as icon-like, as obviously pagan as a painting. I worked all those years painting and now I'm critical of the fact that I won't allow myself to do those mindless things any more. It looks as though the whole spirit of painting and sculpture could be shrugged off, in two years' time perhaps. It's almost totally inconsequential. Of course it'll never happen, but it's conceivable, it could happen.

"Discussion with Heizer, Oppenheim, Smithson" *Avalanche* (Autumn 1970), reprinted in *The Writings of Robert Smithson*, Nancy Holt ed. (New York: New York University Press, 1979).

# ALIGNED WITH NAZCA

*"I am not of the big world, I am of the little world,"* was an old *refrain with Murphy, and a conviction, two convictions, the negative first."*
Samuel Beckett, *Murphy*

## PROLOGUE–DIARY

Peru. Coastal desert, mountains, jungle. West to east in that order. Military junta of the left. Communized haciendas, nationalized utilities. Attempting to avoid Allende's unworkable democracy. In six years Pizarro got it all with 200 men and 80 horses. Half the population still Indian. Languages dying out unrecorded. One road, the Panamerican highway, south from Lima through the sand. Here and there an oasis. Where the culture began. Paracas weaving. How many knots to the square inch? Six million under the Incas at the height of the empire. But only three inventions: the foot plow, the plumb bob, and mortarless masonry. Administrators who knew of, but forbade writing. Sand blows across the road constantly. South from Lima. Glasslike sea on the right. Andes to the left. White and black mountains. Unstable glaciers hanging off the Cordillera Blanca. Six thousand obliterated when the glacier fell on Huascaran in

1962. Spaniards "liberated" Nazca leaving no one to speak of the "lines." Lowlanders made the inventions. Empires came from the mountains. The cold heights of stubbornness. The Urus of Lake Titicaca, thinking themselves subhuman, refused to assimilate. Last Uru dead in 1955. Here it is hot. Sensuality of the first oasis, Canete (km 147 south of Lima). Erotic pottery. Ripe and rotting fruit. Bought avocados. Skeleton water pots with erections in the Rafael Larco Herrera Museum. The desert slides down from the mountains to the sea. Or is it a huge beach going the other direction? Wind blows constantly, drifting sand over the road, rocking the car, opening up patches of sun in the glaring coastal fog. Eyes fatigued, taste of sand in the mouth. Highlanders different. Incas with barrel chests, two more quarts of blood. For the altitude. The cold heights of administration where walls were built, order recorded in quipu knots, Quechua imposed. Here below, mud and the oasis. Soft wet earth for growing, making pots, adobe houses. Glistening brown nude boys in the irrigation ditches. Remembering the female mummy in the Herrera Museum. Still beautiful, full set of perfect teeth and the fine eyebrows still intact. Twinges of necrophilia in the groin. Mud pots with erections. She was from Paracas. The mummy. About three thousand years ago. The road leaves the turn off to Paracas at km 234 and veers inland south from Lima, only sand. The dunes become larger. Miles to the right two small

whirlwinds chase one another leaving a whitish wake in the dark desert surface. Eyes ache from the glare. Just past Ica (km 306) the tiny figure of a woman carrying a large bundle and moving through unmarked sand toward the mountains. Her red scarf the only dot of color in the landscape. A desiccated Corot. On across the desolate Pampa de Huayuri eating dust behind a tank truck for eight kilometers. Finally the oasis of Palpa. Hand cut peeling an avocado. Ripe and dark fruit. Women staring. Different standards of beauty before. Heads bound into long, round shapes, short or high in Chavin times. Herrera female mummy. Perfect set of teeth. Hand sticky with blood and soft avocado. Trepanned skulls in the archeology museum. Sixty percent survived the operations. Gold plate replaced the removed bone. Long climb up to the Pampa Colorado. Five hundred square kilometers of tablelands where they drew the lines. Bounded by Palpa and Nazca. Two oases. Mud and ripe fruit. Wet earth equals life. Water pots with erections for spouts. Impregnating the desert. Long lines of irrigation slits and trenches. Glistening nude boys bathing. Brown erections in the muddy water. Ditches moving off in lines. Searching for different lines here. Artificial, dry and on an uninhabitable plateau. The Nazca lines somewhere on the Pampa. Light fading now. Sand still blowing over the road. Five p.m. six kilometers outside Nazca. No lines. Missed them completely in the fading light. Try tomorrow.

## LOG

At 7:30 the next morning I returned to the Pampa Colorado in search of the lines I had missed the day before. I drove northwest from the town of Nazca through the ever-present morning fog. A pale Panamerican road moves across the plain within a few miles of the first ranges of mountains to the northeast. Further to the north are other ranges. The desert stretches away uninterrupted to the southwest where it eventually drops into a valley.

In the early morning light, about 20 kilometers out of Nazca, I saw to the left a faint geometric rectangle stretching along an east-west axis. It was barely distinguishable in the flat, pebbly desert surface. I got out of the car and walked toward this shape for about a quarter of an hour. I seemed to approach no closer and realized the deceptiveness of distances in the immense space stretching away to the southwest. It was possible, however, to see that the shape was trapezoidal, its narrowing in the western direction seemed too extreme to be a result of perspective. It

was one of the types of markings I had expected to find, the others being the narrower straight lines and the figures of animals and geometric forms.

About two-thirds of the way back to Palpa two yellow signs I had completely missed the day before announced the site as an archeological area and cautioned against disturbing it. From these signs a secondary service road ran perpendicular to the highway in a southwestern direction. The surface of this road was a fine, light ocher sand approaching dust. On both sides of the road was darker, nearly sienna with black mixed into it. The surface of the desert was covered with small stones of this color. The land was not absolutely flat but undulated out in all directions and rose slightly in elevation to the southwest. I began to see "lines" which the road cut through. Some of these were no more than a foot wide. Others varied from two to six feet in width. The lines had been made by removing the stones along a straight axis and placing these along the desired width of the line as a kind of irregular curbing. The ground itself appeared to have been excavated slightly. That is, the lines were not just drawn by clearing a path through the stones, but were actual depressions or shallow incisions in the surface of the earth.

Maria Reiche speculates that the lines were made with brooms, the small stones and the darker oxidized top layer of sand being swept from side to side along the line's axis. Dr. Reich also has an explanation for the durability of the markings:

"It seems almost incredible that ground-drawings made by superficially scratching the surface could have withstood the ravages of time and weather over such long periods. The climate is one of the driest of the globe. One could say that it rains for half an hour every two years. And although strong winds carry great quantities of sand, not encountering any obstacles on the vast tablelands open towards north and south, they take it further north, where at seventy miles' distance one can see huge dunes on both sides of the highway. Moreover close to the ground the air is becalmed considerably. Owing to their dark color, the surface stones absorb much heat, causing a cushion of warm air to protect the surface from strong winds. An additional factor contributing to the ground remaining undisturbed for hundreds of years is that the soil contains a certain amount of gypsum which, moistened by daily morning dew, slightly affixes every stone to its base."[1]

After an hour or so of walking and observing, one becomes very aware of how one's behavior as an observer affects the visibility and definition of the lines. Greatest definition is obtained not only by the body's positioning itself so that the line stretches out 90° to the horizon, but by focusing on the line at some

distance. For this definition, one looks out, away, across, not close up or at. When one stands on a flat plane that stretches away as far as one can see, the horizon line is always at eye level. This is true at Nazca in every direction except the northeast where the mountains rise. One looks out over a relatively featureless landscape of desert and realizes that exactly half of what is within one's vision is land and half sky.

Unlike urban spaces, the ground plane is not confined to a brief flatness constantly interrupted by verticals. In a landscape like that of Nazca the ground plane does not remain merely horizontal, for it extends up into one's vision to the height of one's eyes at the distant horizon. The opposition of street and building, floor and wall, of close-up urban seeing, is nonexistent. One sees instead always at a distance, the known flatness of the ground also becomes visible "elevation" at the horizon. The lines inscribed on the plain become visible only by virtue of the extension of that plain—literally from under one's feet up to the level of one's eyesight. The horizontal becomes vertical through extension. The lines become visible by the "tilt" of the ground plane and subsequent compression of foreshortening. The further down the line one looks the greater its definition. Yet the greater the distance the less definition of detail. The lines are both more general and more distinct as lines in direct proportion to the distance focused by the eye. The gestalt becomes stronger as the detail becomes weaker.

It is no wonder that everyone I spoke to in Peru advised me to contact the nearby naval air field and see the lines from the air. Comments such as "there is nothing to see from the ground," or "you are going to fly over them, aren't you?" were common from people in the U.S. who had seen them as well as the Peruvians. And various books speak of the "near invisibility" of the lines from the ground. Aerial photography returns us to our expected viewpoint. Looking down, the earth becomes a wall at 90° to our vision. We see them in that familiar elevation which reveals to us every cultural artifact from buildings to artworks to photographs to the print on this page.
Generally, the wider the line, the greater build-up of an "edge." Where the secondary road crossed the larger plains or trapezoidal shapes the edges were quite pronounced. Some of these areas were so wide that if one were not at a great distance from them the two edges could not be seen at once—one saw only a single ridge or curbing stretching away into the distance.

I have described the two different colors of the top and under layer of desert earth. Yet the lines do not contrast greatly in color from their surroundings. It is more the absence of stones on the pathways and the slight alignment of stones along the edges that give, at close range, the suggestion of regularity. Standing within a line and looking down at one's feet, the line hardly "reads." There are seldom enough stones at the edge to mark a distinct curb or defining edge, and the cleared area is never flat and free of stones. At close range the lines simply do not reveal themselves. It is only by positioning oneself within a line so that it stretches away to the horizon that they have any clarity. And their definition or emergence as distinct geometric figures occurs only with a mid- or long-range view, where the effect of perspective then compresses the length and foreshortening reinforces the edges. Since the lines are seldom perfectly straight within any local segment, it is only by looking out rather than down that, by virtue of their great length, the irregularities fade away and the gestalt of linearity emerges. All this happens when one stands within a line and sees it meet the horizon perpendicularly. At that vantage point, the greatest foreshortening and compression occurs and the line is revealed with the greatest clarity.

Yet walking across the desert the lines come into view at various diagonals before one actually reaches them. As one approaches the line it swings more into a 90° relation to the horizon, reaching maximum definition as one crosses it. As one leaves it and this definition fades, its relation to the horizon becomes more acute. Lines of all widths, some forming trapezoids, cross one another constantly and move toward all points on the compass. The crossings have a particular character. The curbings have been carefully removed at all intersections so that no one line interrupts the linearity of another. When one looks down a line it is never blocked, even though it may be crossed by innumerable others. This would seem to imply either that the lines were all made at the same time (unlikely) or that previous lines were always respected.

<center>II</center>

*"And he wondered what the artist had intended to represent (Watt knew nothing about painting), a circle and its centre in search of each other, or a circle and its centre in search of a center and a circle respectively, or a circle and its centre in search of its centre and a circle respectively, or a circle and its centre in search of a centre and its circle respectively, or a circle and a centre not its centre in search of its centre and its circle respectively, or a circle and a centre not its centre in search of a centre and a circle respectively, or a circle and a centre not its*

*centre in search of its centre and a circle respectively, or a circle and a centre not its centre in search of a centre and its circle respectively, in boundless space, in endless time (Watt knew nothing about physics)...."*
Samuel Beckett, *Watt*

What one sees on the ground at Nazca has little to do with seeing objects. For if in the urban context space is merely the absence of objects, at Nazca space as distance is rendered visible by the lines and, conversely, the lines become visible only as a function of distance. If one sees here by looking down, across, through, do the lines perhaps also point to something in that distance?

There have been various speculations as to the purposes or intentions of these lines. All assume that the lines pointed to something. The Nazca culture, equally famous for its intricate polychrome ceramics and textiles, flourished between 800 and 300 B.C. By the mid-16th century, the Spaniards had "liberated" the Nazca area at the cost of killing every last Indian. None survived to report on what purposes the lines may have served. The Spanish chronicler Cieza de Leon reported in 1548 that in the desert north of Nazca were "signs pointing the way" to travelers. But after experiencing the multi-directionality of the lines one wonders which way. The lines were "rediscovered" in 1927 by Toribio Mexia Xesspe who suggested in 1939 that the lines were of a ceremonial nature. One wonders what he thought about for 12 years before coming to that astonishing conclusion. Paul Kosok studied the area in 1941 on foot and with the aid of aerial photography. He theorized an astronomical-calendrical function for the markings. By 1947, Dr. Hans Horkheimer had suggested that the markings represented kinship lines connecting graves of members of various local clans. Since 1941, Dr. Maria Reiche has been studying the lines and figures. She accepts the theory of their functioning as astronomical sight lines for sun, moon, and perhaps particular stars or constellations. Subsequent computerized correlations have thrown doubt on the speculations. The resemblance of some of the trapezoidal areas to landing strips has fired the imaginations of those who believe spaceships visited the planet centuries ago.

The ancient ceramic work of the region reveals that the early oasis cultures had an interest in depicting all forms of everyday life. On these polychrome pots, various diseases are catalogued, as are manners and costumes of all classes. Architectural forms, all possible sexual attitudes and combinations, modes of war and dance, musical instruments, ways of hunting, etc., are to be seen. The oasis cultures built with adobe. Unlike the highland Incas they erected no stone fortifications or monuments. Mud was their forte, whether it was fashioned into a pot or a house. Water was their life source, existing as they did by careful irrigation of the oasis. No doubt that is the reason for their obsession with the ithyphallic water pots which pour by ejecting a stream of water from the erect penis. Some of these pottery figures take the form of a dead man or skeleton with an erection. Water was life, its absence death. With water the desert is made fertile, moistened for molding artifacts as well as for growing food. For the Nazcans, all things concerning life were to be found at the surface of the earth or just below it: the irrigation ditch, the crop, the adobe for building, the clay for utensils.

One can speculate that the lines in the desert were spiritual irrigation systems connecting certain places of power in the surrounding sierra to the lower plains. Many of the lines point to peaks along the northeast border of the Pampa Colorado and many of the trapezoidal ways converge on notches between peaks. It is possible to imagine that the Nazcans, with their specially devised long-handled brooms (good for sighting as well as sweeping),[2] made a trek into the crystalline highlands to attempt a record long line toward one of the peaks invested with special powers.

Whatever the intentions of these forms on the desert, they are morphically related to certain arts we see today. If Nazcan purposes were los in the past, they can nevertheless throw our present art context into a helpful relief. Western art is an art of objects requiring different spatial settings as well as perceptions. Impressionism, for example, had no more to do with seeing into deep space than, say, the *sfumato* technique of Da Vinci. Both were concerned with representing space on a vertical plane which was seen at close range. All twentieth-century art seems compelled by a type of Cartesian projection which will net every visual experience by a vertical plane interposed between the viewer and the world. We expect to encounter objects which will block our vision at a relatively close range. Seeing is directed straight out, 90° to the wall or at an object never far from a wall. The pervasive spatial context is one of room space with its strongly accentuated divisions between vertical and horizontal and the subsequent emphasis on orientations of plumb and level. Within such a context for vision, the seemingly phenomenological dichotomy between flat and three-dimensional, marking and making, painting and sculpture, has been nurtured. Recalling for a moment the nature of the lines and their context, these sharp distinctions cannot be made.

The lines are both markings and constructed excavations which nominally occupy the horizontal but are located within a perceptual vertical as well. Much recent Western history of the plastic arts can be read only within the context of the confining rectilinear room, where space is either an illusion or limited to a few feet, and where the details of the work are never out of focus. The Cartesian grid of rectilinear room space involves a mental as well as a perceptual focus which implies simultaneous presentness of all parts.

The lines of Nazca were created for as yet unknown reasons by a culture unacquainted with the enclosing visual grid of urban space. Long before the cyclopean stone walls of the Incan Cuzco or the adobe enclosures of Chan Chan, with their high walls and gridded plan, the oasis Indians around Nazca were sighting and sweeping lines across the Pampa Colorado. Yet common to this ancient drawing and certain recent work is an obsession with space as a palpable emptiness: for the Indians an indeterminate exterior, and in the 1970s, an interior, a bounded void, a recaptured absence.

For nearly a decade work succeeding Minimalism has been built around one form or another of rationalistic information as content. This has been a basically analytic strategy for art-making. Analysis as strategy was present in earlier Minimal work in its reliance on simple systems. But if that work was an art of wholes with underlying, understated structures of information, later object art became an art of parts which visible, underlined structures of information bound together. Such work, while object-bound, moved toward diminishing the density of the physical until a point was reached where physical manifestations merely illustrated the information structure. Hanging art on order structures, algebraic classifications, topological geometries, etc., became a faintly academic exercise. But the internal analytic mode of such work mirrored the external analytic modes of general art strategy throughout the last ten years. The rationalization of art which began with Johns in the mid-'50s has continued to broaden to become a kind of episteme for the object-type of our time. If early '70s object-type art located itself within that space of basic, rationalized information systems, another type of art has been emerging more recently whose mode is not that of the logical icon. Rather, it is the space of the self which the latter work explores.

Roughly two types of basically noninformational, non object work can be located. On the one hand a cool, environmental work engages both interior and exterior space, sometimes articulated by sound or light as well as physical enclosures. Such work, always attentive to thee contingencies of its setting, appears rigidly formal in comparison to the second type which is also environmental by morphology, but much more focused on psychological phenomena. These are polarities rather than categories and one can locate many works now being done on an axis running between these poles where spaces for the physical or psychological self are marked out. Both modes have in common an environmental approach, a strong relation to their site or place. Both frequently have a temporal as well as a spatial dimension. Both are concerned with creating allusive contexts which refer to the self rather than generating sets of homeless objects.

The art in question substitutes the solipsistic, even autistic, discovery in its construction of either a psychological landscape or a physical enclosure for the self. One sees in the latter category a number of works being constructed outdoors. Usually on an intimate scale and often making use of small enclosures, these are works that can be, if not handmade, at least free of the kind of bankrolling required by earlier monumental-Minimal desert Earthworks. Again these are spaces for the self—the self in relation to an enclosure and the expanse of the surrounding site.

The obsession with the self as subject is as old as self-portraiture. Previous explorations in this area, however, assumed that self's space as continuous with the world. The glooms Beckett hollowed out for himself in the post-World War II years are spaces discontinuous with the rest of the world. In those spaces a Murphy, a Malone, or a Watt endlessly and precisely permuted his limited store of ideas and meager belongings. Here counting and farting inside a greatcoat stuffed with the *Times Literary Supplement* was a world in itself. Beckett must surely be seen as the first instance of the artist fashioning out space *itself* as an extension of the self. But the spaces of and for the self now being built in the plastic arts have little to do with the dust, the grimness, or even the humor of Beckett. For if these spaces imply aloneness they indicate none of the anxieties of isolation. An undefiant separateness and even a kind of self-confidence in the autistic permeates them.

Orders and logics are basically operations. As such they exist in time, not space. As communicated, they exist in one of two ways: written or spoken. The only "space" in which they can exist is aural. In both cases the communication is a function of time, of tracing or working through the operation. It is not surprising that the epistemological side of early '70s work finds its home in flat art where all operations can be "held" in sequences of one form or another. Work which projects complex operations and information systems is invariably flat, surface-bound. Whether it is on the wall or floor it is basically "plan view," diagrammatic. The "objects" employed in such work are reduced

and function as markers or slightly thickened symbols. The most abstract mental operations are best represented on flat surfaces. Logic does not exist in the physical world but within notational systems. Flatness is the domain of order. Space is basically incomprehensible, an absence of things, a nothingness which obliterates order.

The insistence on the rational placement of units in Minimal art as linear or grid extensions was borrowed from painting's ordering. Minimal art's diagrammatic aspect was derived from plans generated by drawings on flat pages. Most Minimal art was an art of flat surfaces in space. At best an object can be permuted in its positions or parts and as such it can be rotated on its own dense axis.

It makes sense that the type of spatial work under consideration here dispenses with systems and orders derived from notations whose home is flatness. Such work ventures into the irrationality of actual space, limiting it by enclosures, not systematic marker-notations. Our encounter with objects in space forces us to reflect on our selves, which can never become "other," which can never become objects for our external examination. In the domain of real space the subject-object dilemma can never be resolved. The problems of solipsism and autism hang in the air. Here the labyrinth form is perhaps a metonym of the search for self, for it demands a continuous wandering, a relinquishing of the knowledge of where one is. A labyrinth is comprehensible only when seen from above, in plan view, when it has been reduced to flatness and we are outside its spatial coil. But such reductions are as foreign to the spatial experience as photographs of ourselves are to our experience of ourselves.

The perception of things in depth returns us to our consciousness of our own subjectivity, which, like space itself, has no clear demarcation, no visible bounding limit. Yet neither space nor consciousness is a medium in which objects or thought are constituted. For we know space by the objects in it as we know consciousness by the relationships of our thoughts. The illusion of space as a medium of physical absence, or consciousness as an endless mental space, is engendered by the continuousness of experience itself. Memory is a kind of temporal metonym of depth, as ever-present as it is ever-changing in a way similar to an object's appearance. An object has no stable perceptual place or size or relation to other objects. For these are a function of our own positions as perceivers. Fixity is a function of notational systems and notational systems exist in the flat world of surfaces. Systems of notation are used by us at the distance which makes them intelligible; they are extra-spatial. At a point in time the highway sign for a curve is "seen." The subsequent curve is negotiated; lived through from beginning to end. The physical world divides for us between the flat, where notational information exists perceptually outside of space, and the spatial, where perceptual relativity is the constant.

If the physical world divides for us between surfaces and depth, it is not a natural but a cultural division, the origins of which are bound up with those of writing. If Marshak's theory is correct, the origins of writing arose from the impulse to fix the periodicity of nature—that is, to objectify particular memories as artifacts, as tools for predictability. The past had to become object in order that the future might be controlled. The act of counting invented time. The periodic recurrences of an object in space (the moon) were fixed by marks on a surface. Thus notation began its long march through the history of humankind, functioning not only to record and control but to shut out the physical world. A second world was invented: the world of flat surfaces where notations reigned. The differences between art that is flat and that which exists in space begin to take on more than a formal distinction, more than a convenient descriptive value. The very selection of one or the other is bound up with orientations which are as deep as culture itself.

Perhaps the most compelling aspect of Minimalism was that it was the only art of objects (aside from the obvious example of architecture) which ever attempted to mediate between the notational knowledge of flat concerns (systems, the diagrammatic, the logically constructed and placed, the preconceived) and the concerns of objects (the relativity of perception in depth). But mediation is a delicate and frequently brief state of affairs. Work succeeding the Minimal which had an increased involvement with information and logical orderings moved ever more into the flat modes—whether on the wall or floor. It seems that the physical density and autonomy of objects becomes compromised when ordered by more than the simplest of systems.

The tendency of later work involved with enclosed spaces for the self has a complex relation to Minimalist esthetics in that it accentuates certain attitudes about reflexiveness and the conditions of perception which were only acknowledged by the earlier work. There is now little relation to the stylistic look or systematic rationales of Minimalism. However, certain environmental concerns such as relation to site, negative spaces, and shaped enclosures are to be found in Earthworks and interior spaces fashioned in the '60s.

In the light of these remarks on the nature of the surface and the spatial, the lines of Nazca take on a deeper meaning. For here, as in Minimalism, the flat and spatial are mediated. At least in relation to my proposed theory of their functions, the

lines work toward this mediation. This implies that we are will-
ing to include in the perception of the enterprise the totality of
the landscape. The mountains as well as the lines must be con-
sidered. Assuming that the lines point to power points in the
Sierra (as well as the literal sources of water) we then have both
terms: the flat and the spatial, line and mountain, the abstract
figure and the concrete object, the notational abstraction and
the concrete existent. Here the artifact-symbol functions to
channel the powers of nature into human design. Nature's power
flows through the artist's marks. His linear symbol acts as a con-
duit of spiritual power, it flows down to him along the lines.
Analogically the actual life-giving substance, water, flows
through the erect penis of the Checan water pot which has fur-
ther analogy to the biological function of the life force of male-
conceived sexuality. The site at Nazca can be seen as an instance
of large-scale public art, whose claim to monumentality has to do
with a unique cooperation with its site. This makes it different
from other ancient monumental art which confronted and domi-
nated people by one form or another of gigantic verticality
imposed on the flatness of the earth. In spite of the distances
involved in the lines at Nazca, there is something intimate and
unimposing, even off-hand, about the work. The lines were con-
structed by a process of removal. They do not impress by indi-
cating superhuman efforts or staggering feats of engineering.
Rather it is the maker's care and economy and insight into the
nature of a particular landscape that impresses.

The art of the '60s was, by and large, open and had an
impulse for public scale, was informed by a logic in its structure,
sustained by a faith in the significance of abstract art and a belief
in an historical unfolding of formal modes which was very close to
a belief in progress. The art of that decade was one of dialogue:
the power of the individual artist to contribute to public, rela-
tively stable formats which critical strategies, until late in the
decade, did not crumble. Mid-way into the '70s one energetic part
of the art horizon has a completely different profile. Here the pri-
vate replaces the public impulse. Space itself has come to have
another meaning. Before it was centrifugal and tough, capable of
absorbing monumental impulses. Today it is centripetal and inti-
mate, demanding demarcation and enclosure. Deeply skeptical of
experiences beyond the reach of the body, the more formal aspect
of the work in question provides a place in which the perceiving
self might take measure of certain aspects of its own physical exis-
tence. Equally skeptical of participating in any public art enter-
prise, its other side exposes a singe individual's limit in examin-
ing, testing, and ultimately shaping the interior space of the self.

Robert Morris, "Aligned with Nazca" *Artforum* (October 1975).

1. Maria Reiche, *Mystery on the Desert* (Stuttgart-Vailhingen: 1968), p. 44.
2. None has been found.

# HYDRA'S HEAD

SITE: Along the Niagara River.

EARTH AREA: 28' x 62'

ELEVATIONS: 200' above the river. A 15' precipice runs the length of the site. The work can be seen from above and at ground level.

CONCRETE PIPES: Diameters (2)4' (3)3' (1)2' Depth 3'

WATER VOLUME: 1340 gallons. Configuration of pools is based on the positions of the 6 stars in the head of the constellation Hydra. Diameters of pools differ relative to the light magnitude of each star.

The Seneca Indians of New York have a saying—"pools of water are the eyes of the earth." At night the pools of Hydra's Head "see" the stars brought down into their circumferences, by day they catch in their "view" sky, clouds, sun, and a bird or two. The moon is seen moving from pool to pool as I walk—a continuous recurrence of light encircled. Eddies and whirlpools in the river below, fed by the mad waters of Niagara Falls seven miles upstream, keep up a loud rhythm—there's always the sound of water. Hearing and seeing come together in a vaporous fusion. The sky has suddenly fallen and is circled at my feet. Clouds drift through the earth. the sun gleams off the wind blown ripples. A bottomless hole is there to engulf me. A sinking feeling begins to pervade. Nature's mirrors absorb. The color of the concrete pipe seen rimming the pools echoes in the color of the rocks nearby. The concrete separating water from earth is itself made of these elements—sand, stones, water combined. From time to time the air moves and waves the water. Then reflections waver, breaking up on the surface, becoming whole again in stillness. Changes in sunlight cause the color of entire pools to change or vanish in a silvery glimmer. Shades of green, aquamarine, blue, and silver come and go as I move around the pools. The depth and diameter of the sunken pipes, causing shadows to be continuously cast; the green-gray color of wet concrete; and the slight haze of river water all come together to bring about the surface color and the endlessness of the pools. The bottoms are invisible, the depths unknown. Evaporation and rain interact in an emptying and replenishing cycle. Each drop of rain causes circular ripples to multiply—circles within circles within circles. Water cascades down a tiny waterfall nearby. Falling water, rushing water, swirling water, still water, sound of water, color of water coalesce here in this place of water, not far from the Falls—their proximity always felt, producing a constant flow of liquid meditations.

Nancy Holt, "Hydra's Head" *Revue Arts* (January 1975).

# FREDERICK LAW OLMSTED
# AND THE DIALECTICAL LANDSCAPE

*The landscape-architect André formerly in charge of the subur-*
*ban plantations of Paris, was walking with me through the*
*Buttes-Chaumont park, of which he was the designer, when I*
*said of a certain passage of it, "That, to my mind, is the best*
*piece of artificial planting of its age, I have ever seen." He*
*smiled and said, "Shall I confess that it is the result of neglect?"*
Frederick Law Olmsted, *The Spoils of the Park*

Imagine yourself in Central Park one million years ago.
You would be standing on a vast ice sheet, a 4,000-mile glacial
wall, as much as 2,000 feet thick. Alone on the vast glacier, you
would not sense its slow crushing, scraping, ripping movement as
it advanced south, leaving great masses of rock debris in its
wake. Under the frozen depths, where the carousel now stands,
you would not notice the effect on the bedrock as the glacier
dragged itself along.

Back in the 1850s, Frederick Law Olmsted and Calvert
Vaux considered that glacial aftermath along its geological pro-
files. The building of New York City had interrupted the pon-
derous results of those Pleistocene ice sheets. Olmsted and Vaux
studied the site topography for their proposed park called
"Greensward." In Greensward Presentation Sketch No. 5 we see

a "before" photograph in terms of earth sculpture. It reminds
me of the strip-mining regions I was last year in southeastern
Ohio. This faded photograph reveals that Manhattan Island
once had a desert on it—a man-made wasteland. Treeless and
barren, it evokes the observations of "the valley of ashes" in F.
Scott Fitzgerald's *The Great Gatsby* (1925), "where ashes grow
like wheat into ridges and hills and grotesque gardens…"

Olmsted, "the sylvan artist," yearned for the color green as
"Nature's universal robe" (see James Thomson, *The Seasons*,
1728) and the "Sharawaggi" parks of England.[1] He wanted the
asymmetrical landscapes of Uvedale Price in the middle of urban
flux. Into Brooklyn he would bring "the luxuriance of tropical
scenery…gay with flowers and intricate with vines and creepers,
ferns, rushes, and broad leaved plants." This is like having an
orchid garden in a steel mill, or a factory where palm trees would
be lit by the fire of blast furnaces. In comparison to Thoreau's
mental contrasts ("Walden Pond became a small ocean"),
Olmsted's physical contrasts brought a Jeffersonian rural reali-
ty into the metropolis. Olmsted made ponds, he didn't just con-
ceptualize about them.

The origins of Olmsted's view of landscape are to be found
in 18-century England, particularly in the theories of Uvedale
Price and William Gilpin. Price extended Edmund Burke's
*Inquiry into the Origin of our ideas of the Sublime and the*

*Beautiful* (1757) to a point that tried to free landscaping from the "picture" gardens of Italy into a more physical sense of the temporal landscape. A tree, for example, struck by lightning was something other than merely beautiful or sublime—it was "picturesque." This word in its own way has been struck by lightning over the centuries. Words, like trees, can be suddenly deformed or wrecked, but such deformation or wreckage cannot be dismissed by timid academics. Price seems to have accepted a side of nature that the "formalists" of his times would rather have excluded.

Some of our present-day ecologists, who still see nature through eyes conditioned by a one-sided idealism, should consider the following quote from Price.

"The side of a smooth green hill, torn by floods, may at first very properly be called deformed; and on the same principle, though not with the same impression, as a gash on a living animal. When a rawness of such a gash in the ground is softened, and in part concealed and ornamented by the effects of time, and the progress of vegetation, deformity, by this usual process, is converted into picturesqueness; and this is the case with quarries, gravel pits, etc., which at first are deformities, and which in their most picturesque state, are often considered as such by a levelling improver." (*Three Essays on the Picturesque* [1810].)

And from William Gilpin's *Observations Relative to Picturesque Beauty* (1789): "A piece of Palladian architecture may be elegant in the last degree, but if we introduce it in a picture it immediately becomes a formal object and ceases to please."

Price and Gilpin were, for Olmsted, "professional touchstones," whose views he esteemed "so much more than any published since, as stimulating the exercise of judgement in matters of my art, that I put them into the hands of my pupils as soon as they come into our office, saying, "You are to read these seriously, as a student of law would read Blackstone."

Inherent in the theories of Price and Gilpin, and in Olmsted's response to them, are the beginnings of a dialectic of the landscape. Burke's notion of "beautiful" and "sublime" functions as a thesis of smoothness, gentle curves, and delicacy of nature, and as an antithesis of terror, solitude, and vastness of nature, both of which are rooted in the real world, rather than in a Hegelian Ideal.[2] Price and Gilpin provide a synthesis with their formulation of the "picturesque," which is on close examination related to chance and change in the material order of nature. The contradictions of the "picturesque" depart from a static formalistic view of nature. The picturesque, far from being an inner movement of the mind, is based on real land; it precedes the mind in its material external existence. We cannot take a one-sided view of the landscape within this dialectic. A park can no longer be seen as "a thing-in-itself," but rather as a process of ongoing relationships existing in a physical region—the park becomes a "thing-for-us." As a result we are not hurled into the spiritualism of Thoreauian transcendentalism, or its present day offspring of "modernist formalism" rooted in Kant, Hegel, and Fichte. Price, Gilpin, and Olmsted are forerunners of a dialectical materialism applied to the physical landscape. Dialectics of this type are a way of seeing things in a manifold of relations, not as isolated objects. Nature for the dialectician is indifferent to any formal ideal.

This ideal does not mean one is helpless before nature, but rather that nature's conditions are unexpected, like Price's hill torn by the flood. In another sense Olmsted's parks exist before they are finished; they remain carriers of the unexpected and of contradiction on all levels of human activity, be it social, political, or natural. An example of this can be found in Paul Shepard's excellent book, *Man in the Landscape*:

"His [Olmsted's] report proceeded to note that Europe could not be our model. We must have something better because it was for all "phases of society." The opulent, he continued, should be induced to surround the park with villas, which were to be enjoyed as well as the trees by the humble folk, since they "delight in viewing magnificent and imposing structures." A kind of American doubletalk reconciling villas with democracy and privilege with society in general had begun."

The maps, photographs, and documents in catalogue form and recently on exhibition at the Whitney Museum of American Art are as much a part of Olmsted's art as the art itself. The catalogue's illustrative portfolio by William Alex, and an informative text by Elizabeth Barlow make one aware of the ongoing development of Central Park as a dialectical landscape.[3] Here the documentary power of the photograph discloses a succession of changing land masses within the park's limits. The notion of the park as a static entity is questioned by the camera's eye. The portfolio brings to mind Dziga Vertov's documentary montages, and suggests that certain still photographs are related to the dialectics of film. For example, a photograph on page 78, *Tunnel carved out through Vista Rock for Transverse Road No. 2 at 79th Street* could be a still from a hypothetical film by Vertov on the building process of Central Park. In the photograph there is no evidence of the trees that would in the future screen the sunken roadway from the park proper. The photograph has the rawness of an instant out of the continuous growth and construction of the park, and indicates a break in continuity that

serves to reinforce a sense of transformation, rather than any isolated formation. We notice in this photograph that nature's development is grounded in the dialectical, and not the metaphysical.

An example of a metaphysical rendering of a "tunnel" may be seen in John Martin's mezzo-tint, *At the Brink of Chaos* (1825). Born into England's industrial revolution, Martin translated engineering efforts into visions of cosmic doom. He substituted a tunnel for Milton's bridge in *Paradise Lost*, and in so doing retreated into the metaphysical.[4] In this instance the more dialectical aspect of the picturesque is shrouded in a sentimental gloom that has its origins in the Puritan religion. Modern day ecologists with a metaphysical turn of mind still see the operations of industry as Satan's work. The image of the lost paradise garden leaves one without a solid dialectic, and causes one to suffer an ecological despair. Nature, like a person, is not one-sided. Another factor to note is that Olmsted's tunnel is in the real world, whereas Martin's is a pictorial representation derived only from the mind.

Olmsted's view of the landscape was lost sight of around the first part of this century, what with the rise of the "antidemocratic intelligentsia" that included Wyndham Lewis, Ezra Pound, T.S. Eliot, and T.E. Hulme.[5] Although Pound and Eliot did maintain traces of the picturesque in their poetry, they theoretically scorned it. "Over the tumbled graves, about the chapel," wrote Eliot in *The Waste Land*, "There is the empty chapel, only the wind's home." But Eliot's picturesque was a nostalgia for church authority, it ceased to be the democratic dialectic between the sylvan and the industrial that Price and Olmsted worked toward. Instead they stressed a neoclassical formalism, and T.E. Hulme, who exerted great influence on all three, was drawn to the "abstract" philosophy of Wilhelm Worringer. After World War II, when fascistic motives were revealed, various liberal critics moved in to pick up the pieces— among them Clement Greenberg. He tried to graft a lame formalism to a fuzzy Marxist outlook. Here is Greenberg upstaging both Lewis and Eliot:

"Eliot has called Wyndham Lewis 'the greatest prose stylist of my generation—perhaps the only one to have invented a new style.' I find this exaggerated, but even if it were not, Lewis would still have paid too dearly for the distinction." (Clement Greenberg, "Wyndham Lewis Against Abstract Art," *Art and Culture* [Boston: 1961].)

This is a smart way to subsume authority, but the rest of the article sheds no light on "abstraction." My feeling is that they all missed the boat.[6]

Turning to France, a sense of the picturesque results in Paul Cézanne's *Bibémus Quarry* (1895), but his direct encounters with the landscape were soon to be replaced by a studio-based formalism and cubistic reductionism which would lead to our present day insipid notions of "flatness" and "lyrical abstraction." The general direction of this tendency begins in 1914 when T.E. Hulme, lecturing on "Modern Art and Philosophy," talks about reducing trees to cones.[7] Representations of "stripes" became the logical outcome.

Any discussion concerning nature and art is bound to be shot through with moral implications. Once a student told me that "nature is anything that is not man-made." For that student man was outside the natural order of things. In Wilhelm Worringer's *Abstraction and Empathy* (1908), we are told that Byzantine and Egyptian art were created out of a psychological need tó escape nature, and that since the Renaissance our understanding of such art has been clouded by an undue confidence in nature. Worringer locates his "concept" of abstraction outside the sensuous anthropomorphic pantheism of Renaissance humanism. "The primal artistic impulse," says Worringer, "has nothing to do with the renderings of nature." Yet, throughout his book he refers to "crystalline forms of inanimate matter." Geometry strikes me as a "rendering" of inanimate matter. What are the lattices and grids of pure abstraction, if not renderings and representations of a reduced order of nature? Abstraction is a representation of nature devoid of "realism" based on mental or conceptual reduction. There is no escaping nature through abstract representation; abstraction brings one closer to physical structures within nature itself. But this does not mean a renewed confidence in nature, it simply means that abstraction is no cause for faith. Abstraction can only be valid if it accepts nature's dialectic.

In *The New York Times* (Sunday March 12, 1972), Grace Glueck's column has a headline, "Artist-in-Residence for Mother Earth," and a photograph of Alan Gussow captioned "A sort of spiritual caretaker." Reading the article, one discovers what might be called an Ecological Oedipus Complex. Penetration of "Mother Earth" becomes a projection of the incest taboo onto nature. In Theodore Thass-Thienemann's book, *The Subconscious Language*, we find a quote from a catatonic schizophrenic, "they should stop digging (now shouting petulantly in rage) down inside the earth to draw metals out of it. That's digging down into Mother Earth and taking things that shouldn't be taken."

Simone de Beauvoir has written in *The Second Sex*, "Aeschylus says of Oedipus that he 'dared to seed the sacred fur-

row where he was formed'." Alan Gussow in *The New York Times* projects onto "earth works artists" an Oedipus Complex born out of a wish-washy transcendentalism. Indulging in spiritual fantasy, he says of representational landscape painters in his book (*A Sense of Place: Artists and the American Land*, published by Friends of the Earth,[8]) "What these artists do is make these places visible, communicate their spirit—not like the earth works artists who cut and gouge the land like Army engineers. What's needed are lyric poets to celebrate it."

Gussow's projection of the "Army engineers" on what he imagines to be "earth works artists" seems linked to his own sexual fears. Paul Shepard in his *Man in the Landscape* points out, "Those [army] engineers seem to be at the opposite extreme from esthetes who attempt to etherealize their sexuality. Yet, the engineers' authority and dominance over land carries the force of sexual aggression—and perhaps the guilt as well."

An etherealized representational artist such as Gussow (he does mediocre Impressionistic paintings) fails to recognize the possibility of a direct organic manipulation of the land devoid of violence and "macho" aggression. Spiritualism widens the split between man and nature. The farmer's, miner's, or artist's treatment of the land depends on how aware he is of himself and nature; after all, sex isn't all a series of rapes. The farmer or engineer who cuts into the land can either cultivate it or devastate it. Representing nature once removed is not the same as direct cultivation of the land. If strip miners were less alienated from the nature in themselves and free of sexual aggression, cultivation would take place. When one looks at the Indian cliff dwelling in Mesa Verde, one cannot separate art from nature. And one can't forget the Indian mounds in Ohio.[9]

One wonders what the likes of Gussow would make of America's first "earthwork artist"—Frederick Law Olmsted. Perhaps, if Gussow had lived in the mid-19th century, he would have suggested that Olmsted write "lyric poetry" instead of moving ten million horse-cart loads of earth to make Central Park. Artists like Gussow are the type who would rather *retreat* to scenic beauty spots than try to make a concrete dialectic between nature and people. Such an artist surrounds himself with self-righteousness and pretends to be saving the landscape. This is not being an ecologist of the real, but rather, a spiritual snob.

This kind of spirituality mentioned in the preceding paragraphs is what Rollo May in *Power and Innocence* calls "pseudoinnocence," which can only lead to pseudospirituality and pseudoart. May speaks of an "...insulation from the evil in the world."[10] The authentic artist cannot turn his back on the contradictions that inhabit our landscapes. Olmsted himself was full of contradictions; for instance, he wrote his wife his reaction to the California desert, "the whole aspect of the country is detestable."

In the 1962 photograph it is interesting to see the arrested construction of a water system for draining and filling a Central Park lake—five sunken pipes, guide lines, half-formed walls, dirt roads, and general rubble. All of the roughness of the process rises out of the park's earlier condition; as Elizabeth Barlow indicates, "The political quagmire was matched by the appearance of the park itself, which was rubbish-strewn, deep in mud, filled with recently vacated squatters' huts, and overrun with goats left behind by the squatters. Until they were eventually impounded, the rampant goats were a great nuisance, eating the foliage of the park's few trees."

All of this is part of the park's dialectic. Looking on the nature of the park, or its history and our perceptions of it, we are first presented with an endless maze of relations and interconnections, in which nothing remains what or where it is, as a-thing-itself, but the whole park changes like day and night, in and out, dark and light—a carefully designed clump of bushes can also be a mugger's hideout. The reason the potential dialectic inherent in the picturesque broke down was because natural processes were viewed in isolation as so many classifications, detached from physical interconnection, and finally replaced by mental representations of a finished absolute ideal. Bilious books like *The Greening of America* present one with a notion of "consciousness" without substance. Central Park is a ground work of necessity and chance, a range of contrasting viewpoints that are forever fluctuating, yet solidly based in the earth.

By expanding our dialectic outside of Central Park to Yosemite National Park, we gain insight into the development of both park sites before they were turned into "parks." The site of Central Park was the result of "urban blight"—trees were cut down by the early settlers without any thought of the future. Such a site could be reclaimed by direct earth-moving without fear of upsetting the ecology. My own experience is that the best sites for "earth art" ar sites that have been disrupted by industry, reckless urbanization, or nature's own devastation. For instance, *The Spiral Jetty* is built in a dead sea, and *The Broken Circle* and *Spiral Hill* in a working sand quarry. Such land is cultivated or recycled as art. On the other hand, when Olmsted visited Yosemite it existed as a "wilderness." There's no point in recycling wilderness the way Central Park was recycled. One need not improve Yosemite, all one needs is to provide access routes and accommodations. But this decreases the original definition of wilderness as a place that exists without human

involvement. Today, Yosemite is more like an urbanized wilderness with its electrical outlets for campers, and its clothes lines hung between the pines. There is not much room for contemplation in solitude. the new national parks like the Everglades and the Dinosaur National Monument are more "abstract" and lack the "picturesqueness" of Yosemite and Yellowstone.

In many ways the more humble or even degraded sites left in the wake of mining operations offer more of a challenge to art, and a greater possibility for being in solitude. Imposing cliffs and unimproved mesas could just as well be left alone. But as the nation's "energy crisis" mounts, such places will eventually be mined.[11] Some 5.5 millions of acres, an area the size of New Hampshire, is currently being bought up in North Dakota, Wyoming, and Montana by mining companies. "I think," says Interior Secretary Roger Morton (*Newsweek* [October 9, 1972]), "we can set the standard for a new mining ethic so that the deep seams can be mined and closely followed by an environment program that is compatible esthetically and with proper land use." One can only wonder what his notion of "esthetics" is. The precedents set by Olmsted should be studied by both miners and ecologists.

Returning to Yellowstone, which celebrated its centennial last year, we see a combining of Europe's "intoxication with ruins" with America's newly discovered "natural ruins" at the origin of the park's development. David E. Folsom, a wealthy rancher, who viewed Yellowstone in 1869, wrote in his diary "a huge rock that bore resemblance to an old castle; rampart and bulwark were slowly yielding to the ravages of time, but the old turret stood out in bold relief against the sky...." As Paul Shepard has pointed out, John Ruskin never visited America because it lacked castles. Nevertheless "Castle Rock" has become a name for many natural formations throughout the West.

New York in the 1870s yielded to different kinds of ravages. Olmsted was dismissed from his job in 1874. In a document privately printed in 1881 called *The Spoils of the Park: With a Few Leaves from Deep-laden Note-books of "A Wholly Unpractical Man,"* we get a glimpse of Olmsted's conflicts with city politics.[12] Under Boss Tweed the Park Development deteriorated into a shambles along with serious unemployment, violent labor protests, and financial panic, causing Olmsted to write in 1877 that New York City was "essentially under martial law." The Park Department was also being turned into a social welfare agency; in Olmsted's words the Park Department had become "an asylum for aggravated cases of hernia, varicose veins, rheumatism, partial blindness, and other infirmities compelling sedentary occupations." "When Charles Eliot Norton said of him (Olmsted), towards the close of his career, that of all American artists he stood "first in the production of great works which answer the needs and give expression to the life of our immense and miscellaneous democracy" he did not exaggerate Olmsted's influence." (Lewis Mumford, *The Brown Decades*.)

Entering the park at 96th Street and Central Park West, I walked south along the western side of the reservoir on a bridle path. The upper part of the park that includes Harlem Meer, The Great Hill, and the North Meadow (now filled with ball fields) was planned for lateral and horizontal views, in Olmsted's words it should be "bold and sweeping" as opposed to the lower parks' "heterogeneous" character. One has the sensation of being in a sunken forest as well. A sense of remoteness was present in this region. This sense of engulfment deepened as foliage suggested the harmonies, tonalities, and rhythms of Charles Ives's music—*Three Outdoor Scenes*, *Central Park at Night*, and *The Unanswered Question*, subtitled *A Cosmic Landscape*, in particular.

At Bank Rock Bridge is an entrance to The Ramble. On the bridge stood a sinister looking character, who looked like the type who would rip off cameras. Quickly I vanished into The Ramble—a tangled net of divergent paths. Just the day before I had been looking at stereopticon photos of how this place looked before 1900, before the vegetation Olmsted planted had grown up. At that time, the shores of The Lake still had the look of a rock strewn quarry. Olmsted had wanted to plant "rhododendrons, andromedas, azaleas, kalmias, rhodoras," but his plans remain only partly realized. Olmsted was attracted to this place before he did anything to it, because it was "exceedingly intricate" with "sweet gum, spicebush, tulip tree, sassafras, red-maple, black-oak, azalea, and andromeda." The network of paths he twisted through this place out-labyrinthed labyrinths. For what really is a Ramble, but a place to walk aimlessly and idly—it is a maze that spreads in all directions. Now The Ramble has grown up into an urban jungle, and lurking in its thickets are "hoods, hobos, hustlers, homosexuals," and other estranged creatures of the city (see John Rechy, *The City of Night*). Olmsted had brought a primordial condition into the heart of Manhattan. A small rock bridge crosses a miniature ravine, connecting tangle with tangle. Beneath leafless tree limbs the windings grow more complex, and seem to turn on themselves, so that the walker has no sense of direction. Autumn leaves smother the pathways as they lead one deeper into an infinity of curves. Flowing through The Ramble is The Gill, a stream of water which appears to be a cross between a brook and a pond, and

apparently having its source in a cave under a heap of boulders. Tiny valleys and hills are scattered in such a way as to maximize seclusion and solitude. The Lake borders The Ramble; in it is a small flat island of rock.

Moving up a wooded incline, I approached Vista Rock Tunnel near Belvedere Castle. Water was seeping and dripping over the carved rock surfaces of the tunnel and falling on the rock-walled trench. At this point I was chased by three wild dogs. Later, I found out that there are other packs of dogs roaming the park. Also I discovered that the squirrels are rather aggressive—fat dynamos rather than suburban scrawnies. A series of steps curved right into the bedrock, leading to the castle which is also a weather station. From there one looks out over Belvedere Lake and the Great Lawn, once the Croton Water Works.

Walking east, I passed graffiti on boulders. Somehow I can accept graffiti on subway trains, but not on boulders. On the base of the Obelisk along with the hieroglyphs there are also graffiti. Suddenly, one encounters the construction site of a new tunnel near The Metropolitan Museum of Art—a gray compound with a towering orange derrick in the middle. On the gray walls are more graffiti of an "ecological" sort: "Concrete and trees do not mix." "Let's not turn Central Park into an Asphalt Jungle." "Decentralize the Met!" "Save the Park!" "The Met is not good for trees and other flowering things." "Does the Met smell as nice as a tree?" "Preserve Wildlife." Olmsted's own view on buildings and museums in *The Spoils of the Park* is: "The reservoirs and the museum are not a part of the Park proper: they are deductions from it. The Subways are not deductions because their effect, on the whole, is to enlarge, not lessen, the opportunities of escape from buildings."

Passing under Glade Arch and into the Glade, I came to the Conservatory Water Pool; the overall shape of its concrete banks being an interplay of curves and right angles. The Pool had been drained, and this provided one with a vista of graceful desolation—a sea of autumn leaves. The bare trees that surround the pool rose from the ground like so much smoky lace. Here and there people sauntered in and out of the haze and sunlight, turning the area into a phantom world.

As I continued southward, near Fifth Avenue, I passed a "kiddy land," one of the latest incursions into the Park. Designed by Richard Datter in 1970, it looks like a pastiche of Philip Johnson and Mark di Suvero. A sign on the fence that surrounds it exhorted one to "Enjoy." Even cuter is the "kiddy zoo," with its Disney-type Whale.[13] In the Old Zoo some caged workmen were installing an artificial habitat.

In the spillway that pours out of the Wollman Memorial Ice Rink, I noticed a metal grocery cart and a trash basket half-submerged in the water. Further down, the spillway becomes a brook choked with mud and tin cans. The mud then spews under the Gapstow Bridge to become a muddy slough that inundates a good part of The Pond, leaving the rest of The Pond aswirl with oil slicks, sludge, and dixie cups. Maintenance on The Pond seems long overdue. The mud should be dredged out. This maintenance operation could be treated in terms of art, as a "mud extraction sculpture." A documentary treatment with the aid of film or photographs would turn the maintenance into a physical dialectic. The mud could be deposited on a site in the city that needs "fill." The transportation of mud would be followed from point of extraction to point of deposition. A consciousness of mud and the realms of sedimentation is necessary in order to understand the landscape as it exists.

The magnitude of geological change is still with us, just as it was millions of years ago. Olmsted, a great artist who contended with such magnitudes, sets an example which throws a whole new light on the nature of American art.

Robert Smithson, "Frederick Law Olmsted and the Dialectical Landscape" *Artforum* (February 1973), reprinted in *The Writings of Robert Smithson*, Nancy Holt ed. (New York: New York University Press, 1979).

1. Sharawaggi involves a Chinese influence on English landscape development. The work corresponds to the Chinese syllables Sa-lo-kwai-chi, meaning "quality of being impressive or surprising through careless or unorderly grace." See Y.Z. Chang, *A Note on Sharawadgi* (Modern Language Notes, 1930), p. 221. Also see Edward Hyams, *The English Garden* (New York), "the fact, as appears in accounts of certain gardens, Alexander Pope's garden at Twickenham, William Kent's Stowe, the same artist's Rousham, Hoare's Stoumead (and there were others), is that 'Chinese' (i.e., poetic nature), gardening was well established in Britain almost half a century before the English had any but rather tenuous contacts with Chinese gardening."

2. Hegelian dialects exist only for the mind. This is close to Thoreau's mental dialectic of mixing the local with the global. "I am accustomed," says Thoreau in his Journal, "to regard the smallest brook with as much interest for the time being, as it if were the Orinoco or the Mississippi...." See John Aldrich Christie, *Thoreau As World Traveler* (New York: 1965).

3. William Alex and Elizabeth Barlow, *Frederick Law Olmsted's New York* (New York: 1972). This important book was very helpful in assembling this essay.

4. See the chapter "The Age of Despair" in F.D. Klingender, *Art and the Industrial Revolution* (New York, 1970).

5. "The cult of Unnaturalism, I think, is the real trouble with the whole, and it is still very much with us, at any rate in academic criticism." See William Empson's introduction to John Harrison, *The Reactionaries* (New York: 1967).

6. Greenberg does show an interest in dialectics in "Necessity of Formalism" *Art International* (October 1972). "Actually it's a 'dialectical' turn that works to maintain or restore continuity: a most essential continuity: continuity with the highest esthetic standards of the past." On the other hand, formalism emerges in the essay less as a "necessity" and more as a luxury. The notion of "quality" appeals in vague notions of luxury.

7. The reductive tendency existed in English formal gardens of the 18th century. Joseph Addison, an essayist, writing in *The Spectator* (1712) had this to say: "Our British gardeners, on the contrary, instead of humoring nature loved to deviate from it as much as possible. Our trees rise in cones, globes, and pyramids." Nikolaus Pevsner speaks of Addison's dislike of mathematics in the garden but admiration for the principles of mathematical order in the universe. "The Genesis of the Picturesque" *Architectural Review*, XCVI (1944).

8. The Enemies of Art might be expected to publish such a book, but not the Friends of the Earth. "One becomes irritated with the format right from the start," says John Wilmerding in his review of this "pretentious book" in *Art in America* (November–December, 1972).

9. "From Wisconsin to the Gulf of Mexico, from Mississippi to the Appalachians, but especially in Ohio, rise tens of thousands of artificial hills. Many of them are so fantastically shaped that they defy description." C.W. Ceram, *The First Americans: A Story of North American Archeology* (New York: 1971), p. 193.

10. In *Power and Innocence* (New York: 1972), Rollo May points out in reference to Charles Reich's Book *The Greening of America* that, "Far from Consciousness III being an answer, it will be no consciousness at all, for it lacks the dialectic between 'yes' and 'no,' good and evil, which gives birth to consciousness of any sort. Reich writes: 'The hard questions—if by that is meant political and economic—are insignificant, even irrelevant.'" My feeling is that these "hard questions" are going to have to be faced—even by artists. All the bogus spiritualists, "ersatz Buddhists, Yogis and Hindus" (May) won't be of any help.

11. "In A Wilderness Bill of Rights, [Justice William O.] Douglas rails at dams as a source of power generation, and mentions alternate sources of generation: coal-fired steam, nuclear powered steam, and solar energy. But the same book denounces the havoc wreaked by mining coal to fire the steam, and there is a solemn warning about the wholesale pollution from the disposal of nuclear waste." Frank E. Smith, *The Politics of Conservation* (New York: 1964).

12. *Landscape into Cityscape: Frederick Law Olmsted's Plans for a Greater New York City* (1967). Edited with an introductory essay and notes by Albert Fein. Included is the essay "The Spoils of the Park" (1882) revealing Olmsted's concern with the politics of Central Park.

13. On March 31, 1918 *The New York Times* published a map titled "IF 'IMPROVEMENT' PLANS HAD GOBBLED CENTRAL PARK," subtitled: "Many Other Grabs Are Not Shown in the Picture, for Lack of Room." There must be a limit to "destructive innovations" (Fein). Disney-type improvements strike me as undemocratic because one must pay to enter.

# BIBLIOGRAPHY/FILMOGRAPHY

This bibliography/filmography includes only those works consulted by the author or to which he has made reference.

BOOKS

Adams, William Howard
*The French Garden, 1500–1800* (New York: Braziller, 1979).

Battcock, Gregory ed.
*Minimal Art, A Critical Anthology* (New York: E.P. Dutton, Inc., 1968).
*The New Art, a Critical Anthology* (New York: E.P. Dutton, Inc., 1966).

Beardsley, John
*Earthworks and Beyond, Contemporary Art in the Landscape* (New York: Abbeville Press, 1984, 2nd edition, 1989).
*Probing the Earth: Contemporary Land Art Projects* (Washington: Hirshhorn, Smithsonian Institution, 1977).

Berger, Maurice
*Labyrinths. Robert Morris, Minimalism and the Sixties* (New York: Harper & Row, 1989).

Boudon, Philippe
*Essai d'épistémologie de l'architecture* (Paris: Dunod, 1971, 2nd edition, 1977).

Bourdieu, Pierre
*Un art moyen. Essai sur les usages sociaux de la photographie* (Paris: éditions de Minuit, 1965).

Buchloch, Benjamin
*Ecrits théoriques I* (Villeurbanne: Artédition, 1992).

Bunn, Charles
*Crystals, Their Role in Nature and Science* (London: Academic Press, 1964).

Calabrese, Omar, Giovannoli, Renato and Pezzini, Isabella eds.
*Hic sunt leones. Geografia fantastica e viaggi straordinari* (Milan: Electa, 1983).

Cauquelin, Anne
*L'invention du paysage* (Paris: Plon, 1989).

Christo
*Running Fence* (New York: Abrams, 1978).
*Valley Curtain* (New York: Abrams, 1973).
*Wrapped Coast, One Million Square Feet* (Minneapolis: Contemporary Art Lithographers, 1969).

Cohen, Arthur A.
*Herbert Bayer Complete Work* (Cambridge, Massachusetts: MIT Press, 1984).

Damisch, Hubert
*La Théorie du nuage* (Paris: Seuil, 1972).

Desvigne, Michel and Tiberghien, Gilles A.
*Jardins élémentaires* (Rome, Villa Médicis/Carta segrete, 1988).

Didi-Huberman, Georges
*Ce que nous voyons, ce qui nous regarde* (Paris: éditions de Minuit, 1992).

Dubois, Philippe
*L'Acte photographique et autres essais* (Paris: Nathan, 1990).

Duve, Thierry de
*Résonances du Ready Made* (Nîmes: éditions Jacqueline Chambon, 1989).

Ehrenzweig, Anton
*The Hidden Order of Art* (Berkeley: University of California Press, 1967).

Friedel, Georges
*Leçons de cristallographie* (Paris: Berger-Levrault éditeurs, 1926).

Fuchs, R.H.
*Richard Long* (London: Thames and Hudson, and New York: Solomon Guggenheim Foundation, 1986).

Garraud, Colette
*L'idee de nature dans l'art contemporain* (Paris: Flammarion, 1994).

Gilpin, William
*Three Essays on Picturesque Beauty* (London: printed for R. Blamire, 1792).

Gintz, Claude ed.
*Regards sur l'art américain des années soixante* (Paris: éditions Territoire, 1979).

Greenberg, Clement
*Art and Culture, Critical Essays* (Boston: Beacon Press, 1961).

Hilton, Harold
*Mathematical Crystallography and the Theory of Groups of Movements* (New York: Dover, 1963).

Hobbs, Robert
with the contribution of Lawrence Alloway, John Coplans, and Lucy R. Lippard
*Robert Smithson: Sculpture* (Ithaca and London: Cornell University Press, 1981).

Johnson, E.H.
*Modern Art and the Objects* (London: Thames and Hudson, 1976).

Judd, Donald
*Donald Judd, Complete Writings 1959–1975* (Halifax: The Press of the Nova Scotia College of Art and Design, and New York: New York University Press, 1975).
*Donald Judd, Ecrits 1963–1990*, translated by Annie Perez (Paris: Daniel Lelong éditeur, 1991).

Kepes, Gyorgy ed.
*Arts of the Environment* (New York: Braziller, 1972).

Kern, Hermann
*Labyrinthe* (Munich: Prestel-Verlag, 1982).

Krauss, Rosalind E.
*The Originality of the Avant-Garde and Other Modernist Myths* (Cambridge, Massachusetts: MIT Press, 1985).
*Passages, in Modern Sculpture* (New York: Viking, 1977; republished by MIT Press, 1981).

Kubler, Georges
*The Shape of Time* (New Haven and London: Yale University Press, 1962).

Lebensztejn, Jean-Claude
*L'Art de la tache, introduction à la nouvelle méthode d'Alexandre Cozens* (Paris: éditions du Limon, 1990).
*Zigzag* (Paris: Flammarion, 1981).

Lippard, Lucy R.
*Overlay, Contemporary Art and the Art of Prehistory* (New York: Pantheon Books, 1983).
*Six Years: The Dematerialisation of the Art Object* (New York: Praeger, 1973).

Lyotard, Jean-François
*Le Postmoderne expliqué aux enfants* (Paris: éditions Galilée, 1986).

McGill, Douglas C.
*Effigy Tumuli, The Reemergence of Ancient Mound Building* (New York: Harry N. Abrams, 1990).

Matthews
*Mazes and Labyrinths, Their History and Development* (New York: Dover, 1975).

Meyer, Ursula ed.
*Conceptual Art* (New York: E.P. Dutton, Inc., 1972).

Mislow, Kurt
*Introduction to Stereochemistry* (New York: W.A. Benjamin, 1966).

Müller, Grégoire
*The New Avant-Garde: Issues for the Art of the Seventies* (New York: Praeger Publishers, 1972).

Newman, Barnett
*Selected Writings and Interviews* (New York: Alfred A. Knopf, 1990).

Panofsky, Erwin
*Perspective as Symbolic Form* (New York: Zone Books, and Cambridge: MIT Press, 1991).

Poinsot, Jean-Marc
*L'Atelier sans mur* (Villeurbanne: Artédition, 1991).

Reiche, Maria
*Das Geheimnis der Wüste/Mystery on the Desert/Secreto de la Pampa* (Stuttgart: édition Maria Reiche).

Reinhard, Johan
*The Nazca Lines. A New Perspective on their Origin and Meaning*, 4th edition (Lima: Editorial Los Pinos E.I.R.L., 1988).

Roger, Alain
*Nus et Paysages. Essai sur la fonction de l'art* (Paris: Aubier, 1978).

Rosenberg, Harold
*Art on the Edge: Creators and Situations* (New York: Macmillan Publishing, 1975).
*Barnett Newman* (New York: Abrams, 1978).
*The De-Definition of Art* (New York: Horizon Press, 1972).

Ross, Charles
*Sunlight Convergence Solar Burn* (Salt Lake City: University of Utah Press, 1976).

Rubin, William ed.
*Primitivism in 20th Century Art* (New York: Museum of Modern Art, 1984).

Sandler, Irving
*American Art of the 1960s* (New York: Harper & Row Icon Editions, 1988).

Schaeffer, Jean-Marie
*L'Image Précaire du dispositif photographique* (Paris: Seuil, 1987).

Schjeldahl, Peter
*The Hydrogen Jukebox, Selected Writings of Peter Schjeldahl, 1978–1990*, Malin Wilson ed., introduction by Robert Storr (Berkeley: University of California Press, 1991).

Serra, Richard
*Richard Serra, Ecrits et Entretiens, 1970–1989*, translated by Gilles Courtois (Paris: Daniel Lelong éditeur, 1990).
*Richard Serra: Interviews, Etc., 1970–1980*, in collaboration with Clara Weyergraf (Yonkers, New York: The Hudson River Museum, 1980).

Simonds, Charles and Abadie, Daniel
*Art/Cahier 2* (Paris: SMI, 1975).

Smithson, Robert
*The Writings of Robert Smithson*, Nancy Holt ed. (New York: New York University Press, 1979).

Sonfist, Alan ed.
*Art in the Land, a Critical Anthology of Environmental Art* (New York: E.P. Dutton, Inc., 1983).

Taylor, Marc C.
*Double Negative, Sculpture in the Land* (New York: Rizzoli, and Los Angeles:The Museum of Contemporary Art, 1991).

Thompson, D'Arcy
*On Growth and Form* (Cambridge: Cambridge University Press, 1942).

Tsaï, Eugenie
*Modern Dreams: The Rise and Fall and Rise of Pop* (New York: Institute for Contemporary Art, and Cambridge: MIT Press, 1988).
*Robert Smithson, Unearthed* (New York and Oxford: Columbia University Press, 1991).

Vaizey, Marina
*Christo* (New York: Rizzoli, 1990).

Varnedoe, Kirk
*A Fine Disregard: What Makes Modern Art Modern* (New York: Abrams, 1990).

Veyne, Paul
*Comment on écrit l'histoire, essai d'épistémologie* (Paris: Seuil, 1971).

Werkner, Patrick
*Land Art U.S.A.* (Munich: Prestel-Verlag, 1992).

White, John
*Birth and Rebirth of Pictorial Space* (London: Faber and Faber, 1959).

Wölfflin, Heinrich
*Principles of Art History* (New York: Dover Publications, 1950).

ARTICLES

Alloway, Lawrence
"Robert Smithson's Development," *Artforum* (November 1972), reprinted in Alan Sonfist, *Art in the Land, A Critical Anthology of Environmental Art* (New York: E.P. Dutton, 1983).
"Site Inspection," *Artforum* (October 1976).

Baker, Elizabeth C
"Artworks on the Land," *Art in America* (January/February 1976).

Bann, Stephen
"La sculpture anglaise et la tradition du paysage," *Artstudio* (fall 1988).

Bois, Yve-Alain
"The Limit of Almost," *Ad Reinhardt* (Los Angeles: The Museum of Contemporary Art, and New York: The Museum of Modern Art and Rizzoli, 1991).
"Promenade autour de Clara Clara,"

*Richard Serra* (Paris: Centre Georges-Pompidou, 1984).

Bourdon, David
"The Razed Sites of Carl Andre," *Artforum* (October 1966), reprinted in Gregory Battcock, ed., *Minimal Art, A Critical Anthology* (New York: E.P. Dutton, Inc., 1968).
"Walter De Maria: The Singular Experience," *Art International* (December 1968).

Bourgeois, Jean-Louis
"Dennis Oppenheim, a Presence in a Countryside," *Artforum* (October 1969).

Buchloch, Benjamin
"Construire (l'histoire de) la sculpture," *Qu'est-ce que la sculpture moderne?* (Paris: Centre Georges-Pompidou, 1986).

Chandler, John, and Lippard, Lucy
"The Dematerialisation of Art," *Art International*, Lugano, vol. 12, no. 2 (February 1968).

Coëllier, Silvie
"La spirale signe de la transformation: Broken Circle/Spiral Hill de Robert Smithson," *Transformation, Métamorphose, Anamorphose*, publication by Anglo-American research groups at the université François-Rabelais de Tours, no. 7 (1990).

Castle, Ted
"Nancy Holt, Siteseer," *Art in America* (March 1982).

Compton, Michael
"Some Notes on the Work of Richard Long," (London: British Council, 1976).

Crimp, Douglas
"Serra's Public Sculpture: Redefining Site Specificity," *Richard Serra/Sculpture* (New York: The Museum of Modern Art, 1986).

Criqui, Jean-Pierre
"Actualité de Robert Smithson," *Qu'est-ce que la sculpture moderne?* (Paris: Centre Georges-Pompidou, 1986).
"Ruines à l'envers. Introduction à la visite des monuments de Passaic par Robert Smithson," *Les Cahiers du Musée national d'Art moderne*, no. 43 (spring 1993).
"Trictrac pour Tony Smith," *Artstudio* (fall 1987).

David, Catherine
"L'invention du lieu," *Les cahiers du Musée national d'Art moderne*, nos. 17–18 (June 1986).

De Maria, Walter
"Compositions, Essays, Meaningless Work, Natural Disasters," *La Monte Young/Jackson MacLow, An Anthology* (New York: 1963, Munich: Heiner Friedrich Galerie, 1970).
"The Lightning Field," *Artforum* (April 1980).

Deschamps, Madeleine
"Tony Smith et'ou l'art minimal," *Art Press*, no. 40 (September 1980).

Duve, Thierry de
"Ex Situ," *Les Cahiers du Musée national d'Art moderne*, no. 27 (spring 1989).

Foote, Nancy
"The Anti-Photographers," *Artforum* (September 1976).

Fried, Michael
"Art and Objecthood," *Artforum* (June 1967); reprinted in Gregory Battcock, ed., *Minimal Art, A Critical Anthology* (New York: E.P. Dutton, Inc., 1968).

Geist, Sidney
"Brancusi: The Centrality of the Gate," *Artforum* (October 1973).

Gintz, Claude
"Smithson et son autre," *Territoires 3* (Paris: éditions Territoires, 1983).
"Smithson le tellurien," *Artistes* (February/March 1980).

Gopnik, Adam
"Basic Stuff: Robert Smithson, Myth, Science and Primitivism," *Art Magazine* (March 1983).

Graziani, Ben
"Robert Smithson's Picturable Situation: Blasted Landscapes from the 1960s," *Critical Inquiry*, XX, 3 (Spring 1994), p. 419–451.

Greenberg, Clement
"After Abstract Expressionism," *Art International* (October 1962).
Clement Greenberg, *Les Cahiers du Musée national d'Art moderne*, nos. 45–46 (fall/winter 1993).
"Modernist Painting," *Artyearbook*, no. 4 (1961), *Art and Literature*, no. 4 (spring 1965) slightly modified.
"Recentness of Sculpture," *American Sculpture of the Sixties* (Los Angeles: Los Angeles County Museum of Art, 1967), reprinted in Gregory Battcock, ed., *Minimal Art, A Critical Anthology* (New York: E.P. Dutton, Inc., 1968).

Heizer, Michael
"The Art of Michael Heizer," *Artforum* (December 1969).

Hindry, Ann
"La légèreté de l'être selon Richard Long," Artstudio (fall 1988).
"Michael Heizer ou le rhapsode planétaire," Artstudio (winter 1986–1987).

Hobbs, Robert
"A Meditation on Tony Smith's Sculpture," *Paintings and Sculptures* (New York: Pace Gallery, September 23–October 22, 1983).

Holt, Nancy
"Hydra's Head," *Art Magazine* (January 1975).
"Stone Enclosure: Rock Rings," *Art Magazine* (June 1979).
"Sun Tunnels," *Artforum* (April 1977).

Hunter, Sam
"The Sculpture of Tony Smith," *Tony Smith* (New York: Pace Gallery, April 27–June 9, 1979).

Hutchinson, Peter
"Earth in Upheaval: Earth Works and Landscapes," *Art Magazine* (November 1968).
"The Fictionalization of the Past," *Art Magazine* (December 1967).
"Science Fiction: An Aesthetic for Science," *Art International* (October 1968).

Judd, Donald
"Specific Objects," *Complete Writings 1959–1975* (Halifax: The Press of Nova Scotia Art and Design, and New York: The New York University Press, 1975).

Kertess, Klaus
"Earth Angels," *Artforum* (February 1986).

Krauss, Rosalind E.
"Richard Serra, Sculpture," *Artstudio* (winter 1986–1987).

Kuspit, Donald B.
"Charles Ross: Light's Measure," *Art in America* (March/April 1978), reprinted in Sonfist, Alan ed., *Art in the Land, a Critical Anthology of Environmental Art* (New York: E.P. Dutton, Inc., 1983).

Kurtz, Bruce
"Last Call at Max's," *Artforum* (April 1981).

Leibovici, Elizabeth
"Le point de vue d'Icare," *Architecture d'aujourd'hui* (December 1992).

Leider, Philip
"How I Spent My Summer Vacations, Art and Politics in Nevada, Berkeley, San Francisco, and Utah," *Artforum* (September 1970).

Lista, Giovanni ed.
"Art et Nature," *Ligeia, dossiers sur l'art*, nos. 11–12 (December 1992).

Lippard, Lucy R.
"Douglas Huebler; Everything About Everything," *Art News* (December 1972), reprinted in *Douglas Huebler* (Eindhoven: Van Abbemuseum, 1979).

Long, Richard
"Entretien avec Claude Gintz," *Art Press* (June 1986).

Marin, Louis
"Le sublime classique: 'les tempêtes' dans quelques paysages de Poussin," *Lire les paysages* (Saint-Etienne: C.I.E.R.C., 1984).

Mignot, Dorine
"Gerry Schum un pionner," *Artiste* (April/May 1980).

Michelson, Annette
"Robert Morris: An Aesthetics of Transgression," *Robert Morris* (Washington: Corcoran Gallery of Art, 1969).

Morris, Robert
"Aligned with Nazca," *Artforum* (October 1975).
"Notes on Art as/and Land Reclamation," *October* (spring 1980).
"Notes on Sculpture I," *Artforum* (February 1966).
"Notes on Sculpture II," *Artforum* (October 1966).
"Notes on Sculpture III," *Artforum* (June 1967).
"Notes on Sculpture IV," *Artforum* (April 1969).
"Observatory," *Avalanche*, no. 3 (1971).
"Some Notes on the Phenomenology of Making," *Artforum* (April 1970).
"Words and Image in Modernism and Postmodernism," *Critical Inquiry*, no. 16 (1979). (All articles reprinted in *Continuous Project Altered Daily: The Writings of Robert Morris* [Cambridge, MA: MIT Press, 1993].)

Owens, Craig
"The Allegorical Impulse: Toward a Theory of Postmodernism," *October*, no 12 (spring 1980), and no. 13 (summer 1980).
"Earthwords," *October* (fall 1979).
"Photography en abyme," *October*, no. 5 (1978).

Parent, Beatrice
"Land Art," *Opus International*, no. 23 (1971).

Poinsot, Jean-Marc
"L'in situ et la circonstance de sa mise en vue," *Les Cahiers du Musée national d'art moderne*, no. 27 (spring 1989).
"Quand l'oeuvre a lieu," *Parachute*, no. 46 (March–May 1987).

Prinz, Jessica
"Words en Abîme. Smithson's Labyrinth of Signs," *Art Discourse, Discourse in Art* (New Brunswick: Rutgers University Press, 1991).

Roger, Alain
"Le paysage occidental, rétrospective et prospective," *Le Débat*, no. 65 (May–August 1991).

Rose, Barbara
"ABC Art," *Art in America* (October/November 1965); reprinted in Battcock, Gregory ed., *Minimal Art, A Critical Anthology* (New York: E.P. Dutton, Inc., 1968).

Ross, Charles
"Sunlight Convergence/Solar Burn," *Arts Magazine* (December 1972–January 1973).
"Sunlight Convergence/Solar Burn: The Equinoctial Year, September 23, 1971–September 22, 1972" (Salt Lake City: University of Utah Press and Art Department, 1976).
"'Touching the Sky' Conversations with Four Contemporary Artists," by Janet Saad-Cook, *Archeoastronomy* (January 1987).

Rubin, William
"The Concept of the Museum is not Indefinitely Expendable," Interview with Lawrence Alloway and John Coplans, *Artforum* (1974).
"Talking with William Rubin," *Artforum* (October 1974).

Rubbio, Eduardo
"Robert Smithson. Vers une archéologie de futurs lointains," *Canal* (November 1982).

Scheede, Uwe
"Un Américain en Allemagne: Walter De Maria," *Les Cahiers du Musée national d'Art moderne*, no. 33 (summer 1990).

Sharp, Willoughby
"Interview with Carl Andre," *Avalanche* (fall 1971).

Smithson, Robert
*Arts Magazine* (May 1978), special issue on the artist, pp. 96–114.

Soutif, Daniel
"De l'indice à l'index, ou de la photographie au musée," *Cahiers du Musée national d'Art moderne* (spring 1991).

Steinberg, Leo
"Other Criteria," *Other Criteria, Confrontations with Twentieth-Century Art* (New York: Oxford University Press, 1972).

Tiberghien, Gilles A
"Au-dessus du volcan. En route pour le Roden Crater," *Azur* (Fondation Cartier, 1993).
"La nature comme matériau et l'expérience de l'oeuvre in situ," *Atlas de l'Art* (Encyclopédia Universalis, 1993).

Tillim, Sidney
"Earthworks and the New Picturesque," *Artforum* (December 1968).

Tortosa, Guy
"L'espace de la perception. Entretien avec James Turrell," *Artpress*, no. 157 (April 1991).

Tuchman, Maurice
"The Russian Avant-Garde and the Contemporary Artist," *The Avant-Garde in Russia 1910–1930* (Los Angeles: 1980).

Velasco, Alberto
"Robert Smithson, une critique en acte de la photographie," *Histoire de l'art*, nos. 13–14 (1991).

Wagstaff, Samuel Jr.
"Talking with Tony Smith," in Battcock, Gregory ed., *Minimal Art, A Critical Anthology* (New York: E.P. Dutton, Inc., 1968).

EXHIBITION CATALOGS

Amsterdam, Stedelijk Museum
*Gerry Schum* (1979).
*Het observatorium van Robert Morris/Robert Morris's Observatory in Oostelijk Flevoland* (1977).

Berne, Kunsthalle
*When Attitudes Become Form* (1969).

Bordeaux, Capc, musée d'Art contemporain
*Art Minimal I, De la ligne au parallélépipède* (1985), under the direction of Jean Louis Froment and Michael Bourel.
*Art Minimal II, De la surface au plan* (1987), under the direction of Jean-Louis Froment, Michel Bourel, and Sylvie Couderc.
*Sculpture/Nature* (1979), text by Jean-Marc Poinsot.

Boston, Museum of Fine Art
*Earth, Air, Fire, Water, Elements of Art* (1971).

Chicago, Museum of Contemporary Art
*Gordon Matta-Clark: A Retrospective* (1985), with an introduction by Robert Pincus-Witten.

Clermont-Ferrand, galerie Gartaud
*Dennis Oppenheim Between Drinks* (1991).

Darmstadt, Hessisches Landesmuseum
*Walter De Maria: Der Grosse Erdraum, 8 Skulpturen, 44 Zeichnungen* (1974).

Eindhoven, Van Abbemuseum
*Douglas Huebler* (1979).

Grand Rapids, Michigan, Grand Rapids Art Museum
*Grand Rapids Projects: Robert Morris* (1975).

Hanover, Gerry Schum's Fernseh Gallery
*Land Art* (1970).

Ithaca, Andrew Dickson White Museum of Art, Cornell University
*Earth Art* (February 11–March 16, 1969).

La Haye, Gemeentemuseum
*Carl Andre* (August 25–October 5, 1969).

Le Havre, musée des beaux-arts André-Malraux
*Britannica, 30 ans de sculpture* (éditions La Différence and L'Association et Conservateurs de Haute-Normandie, 1988), with essays by Catherine Grenier, Françoise Cohen, Lynne Cooke, and a critical anthology by Frédérique Mirotchnikoff.

London, Hayward Gallery
*Richard Long, Walking in Circles* (London: Thames and Hudson, 1991).

Los Angeles, Los Angeles County Museum of Art
*Robert Smithson: Photo Works* (September 9–November 28, 1993).

Los Angeles, The Museum of Contemporary Art
*Michael Heizer, Sculpture in Reverse* (1984), Julia Brown ed.
*Occluded Front* (1985), James Turrell, Julia Brown eds.

Lucerne, Kunstmuseum
*Spiralen und Progressionen* (1975).

Marseille, MAC, galeries contemporaines des musées de Marseille
*Robert Smithson, une rétrospective: le paysage entropique, 1960–1973* (September 23–December 11 1994).

Marseille, musée Cantini
*Gordon Matta-Clark* (March 12–May 30 1993).

Minneapolis, Walker Art Center
*Jan Dibbets* (1987), with an essay by R. Fuchs.

Montreal, musée d'Art contemporain
*Dennis Oppenheim, rétrospective de l'oeuvre 1967–1977* (1978).

New York, Cultural Center
*Robert Smithson: Drawings* (1974), essays by Susan Ginsburg and Joseph Masheck.

New York, The Museum of Modern Art
*Antony Caro* (1975), text by William Rubin.
*Information* (summer 1970).

New York, Pace Gallery
*Paintings and Sculptures* (September 23–October 22, 1983).
*Tony Smith* (April 27–June 9, 1979).

New York, P.S. 1 Museum
*Dennis Oppenheim, Selected Works 1967–1990* (New York: Abrams, 1990).

New York, The Solomon Guggenheim Foundation
*Robert Morris, The Mind/Body Problem* (1994).

New York, Whitney Museum of American Art
*The New Sculpture 1965–75: Between Geometry and Gesture* (1990).

Nîmes, musée d'art contemporain
*A la levée du soir, James Turrell* (1989).

Otterlo, Rijksmuseum Kröller-Müller
*Michael Heizer* (1979).

Paris, ARC, musée d'Art moderne de la Ville de Paris
*Dennis Oppenheim* (December 15–January 20, 1980).
*James Turrell* (December 20, 1983–January 1984).
*Richard Long, River to River* (March 25–May 29, 1993).
*Robert Smithson, rétrospective* (November 30, 1992–January 16, 1993), and Ithaca, the Herbert F. Johnson Museum of Art, Cornell University.

Paris, Centre Georges-Pompidou
*Barry Flanagan, Sculptures* (March 16–May 9, 1983).
*Passage de l'image* (1990).
*Qu'est-ce que la sculpture moderne?* (1986).

Paris, EPAD
*Lindau, Différentes Natures, Visions de l'art contemporain* (1993).

Paris, galerie Montaigne
*Virginia Dwan, Art Minimal, Art Conceptuel, Earthworks, New York, Les années 60–70* (1991).

Philadelphia, Philadelphia Institute of Contemporary Art
*Robert Morris/Projects* (1974).

Rotterdam, Museum Boymans-van Beuningen
*Walter De Maria* (1984).

Seattle, Seattle Art Museum
*Earthworks/Land Reclamation as Sculpture. A Project of the King County Arts Commission* (1979).

Turin, Galleria Civica
*Conceptual Art, Arte Povera, Land Art* (1970–1971).

Tuscon, University of Arizona Museum of Art
*James Turrell. The Roden Crater Project* (1986).

Washington, Corcoran Gallery of Art
*Robert Morris* (1969).

FILMS BY THE ARTISTS

Christo
*Wrapped Coast—1 Million Square Feet—Little Bay* (1969). Blackwood Productions, seventy-eight minutes.

Walter De Maria
*Three Circles and Two Lines in the Desert* (1967). Nine minutes.
*Hard Core* (1969). Sixteen minutes, color, with music for two oceans and drums composed and played by the artist.

Jan Dibbets
*Fire/Feuer/Feu/Vuur* (1968). Three minutes.
*12 Hours Tide Object with Correction of Perspective* (1969). Seven minutes.
*Vertical/Horizontal/Diagonal Square* (1970). Six minutes.
*Louvertrape* (1971). Ten minutes.
*Horizon I/Sea* (1971). Ten minutes.
*Horizon II/Sea* (1971).
*Horizon III/Sea* (1971). Five minutes.
*Horizon IV/Sea* (1971). Five minutes.
*Vibrating Horizon* (1971). Five minutes.

Hans Haacke
*Wasser und Lutt* (1965). Twelve minutes.
*H.H. Film* (1969). Thirty minutes.
*Sky Line* (1969). Eight minutes.

Nancy Holt
*Swamp* (collaboration Robert Smithson) (1971). Six minutes.
*Pine Barrens* (1971). Thirty-two minutes.
*Sun Tunnels* (1978). Twenty-six minutes.
*V-T East Coast, West Coast* (collaboration Robert Smithson) (1969). Twenty minutes.

Richard Long
*Mile Walk* (1969).

Robert Morris
*Mirror* (1969–1971). Nine minutes.
*Wisconsin* (1970–1971). Fifteen minutes.
*Observatory* (1974). Twenty minutes.

Dennis Oppenheim
*Wrist and Land* (1969). Sixteen minutes.
*Time-track* (1969). Two minutes, seven seconds.
*Kansas Ground Mutations* (1970). Eight minutes.

Robert Smithson
*Spiral Jetty* (1970). Thirty-five minutes.

FILMS ABOUT THE ARTISTS

L'Art en question
Carlos Vilardebo (1980). Fifty minutes, with Wolf Vostell, Gina Pane, Klaus Rinke, and Chris Burden, and the works of François Morellet, Richard Serra, Robert Morris, Robert Smithson, Richard Long, Walter De Maria, and Michael Heizer.

The Art of Michael Heizer
Rainer Crone (1973–1974). Forty-five minutes.

Christo's Running Fence
David and Albert Mayles and Charlotte Zwerin (1977).

Christo's Valley Curtain
David and Albert Mayles (1973). Twenty-eight minutes.

Earth + Sky
Wendy Apple (on Charles Ross).

Land Art
Ferneschgalerie Gerry Schum (1968–1969). Four television programs with Richard Long, Walter De Maria, Jan Dibbets, Dennis Oppenheim, Barry Flanagan, Robert Smithson, Michael Heizer, and Marinus Boezem.

Le Land Art ou l'art dans le paysage
Brigitte Cornand, Canal + (1994). Fifty-two minutes.

Masters of Modern Sculpture, Part Three: The New World
Michael Blackwood, text by Mary Miss (1980). Fifty-eight minutes, with Robert Morris, Richard Serra, Carl Andre, Chriso, Michael Heizer, and Robert Smithson.

Place and Process
Evander Schley and Robert Fiore (1973). With Carle Andre, Iain Baxter, Joseph Beuys, Walter De Maria, Jan Dibbets, Barry Flanagan, Hans Haacke, Michael Heizer, Les Levine, Richard Long, David Medalla, Bruce McLean, Preston McClanahan, Robert Morris, Dennis Oppenheim, Klaus Rinke, Robert Smithson, Jan Van Saun, William Wegman, and Larry Weiner.

Quand les attitudes deviennent formes
Laure Ball, Alain Franchet (1969). Eighteen minutes, with Carl Andre, Joseph Beuys, Walter De Maria, Robert Morris, Bruce Nauman, Richard Serra, Richard Tuttle, and Michael Heizer.

Robert Morris: Land Project
Hermine Freed (1971). Twenty minutes.

Robert Morris: Observatory
Hermine Freed (1971). Twenty minutes.

Stone and Flies, Richard Long in the Sahara
Philip Haas (1988). Thirty-eight minutes.

# INDEX OF WORKS